A Cultural History of the Punisher

A Cultural History of the Punisher

Marvel Comics and the Politics of Vengeance

Kent Worcester

Bristol, UK / Chicago, USA

First published in the UK in 2023 by
Intellect, The Mill, Parnall Road, Fishponds, Bristol, BS16 3JG, UK

First published in the USA in 2023 by
Intellect, The University of Chicago Press, 1427 E. 60th Street,
Chicago, IL 60637, USA

Copyright © 2023 Intellect Ltd
All rights reserved. No part of this publication may be reproduced,
stored in a retrieval system, or transmitted, in any form or by
any means, electronic, mechanical, photocopying, recording, or
otherwise, without written permission.

A catalogue record for this book is available from
the British Library.

Copy editor: MPS Limited
Cover and frontispiece image: peeterv
Cover designer: Tanya Montefusco
Indexer: Douglas Barnes
Production manager: Sophia Munyengeterwa
Typesetter: MPS Limited

Hardback ISBN 978-1-78938-845-9
Paperback ISBN 978-1-78938-858-9
ePDF ISBN 978-1-78938-846-6
ePUB ISBN 978-1-78938-847-3

Printed and bound by CPI Group (UK) Ltd, Croydon, CR0 4YY

To find out about all our publications, please visit our website.
There you can subscribe to our e-newsletter, browse or download our current
catalogue and buy any titles that are in print.

www.intellectbooks.com

This is a peer-reviewed publication.

Contents

List of Figures	vii
Preface	ix
Introduction	1
1. Trauma Culture	29
2. Trigger Happy, or Grim and Gritty	64
3. The Universe Pushes Back	97
4. Negative Dialectics	134
5. The Narratological Impasse	169
6. From Print to Screen to Icon	202
Conclusion: Those Who Need Hurting	235
Appendix	245
Bibliography	249
Index	257

Figures

I.1	Bill Sienkiewicz and George Roussos, *The Punisher Back to School Special* #1.	8
1.1	Jorge Zaffino, *The Punisher Invades The 'Nam* #52.	38
2.1	Bob McLeod, *Spider-Man* #1.32.	82
3.1	Frank Miller, *Captain America* #241.	116
4.1	Rick Buckler, *Reagan's Raiders* #1.1.	139
5.1	Sam Kieth, *The Pummeler* #1.	177
6.1	Brian Bolland, *Animal Man* #38.	209
C.1	Andy Kubert, *The Punisher* #44.	239

Preface

During the late 1980s and 1990s, I made the weekly pilgrimage to my local comic book store, Big Apple Comics, on Manhattan's Upper West Side. The three guys who worked there, brothers Stephen and David, and their friend Alex, were assiduous about setting aside Punisher titles for me. They also encouraged me to explore a wider range of comics, including small press series like *Peephole*, *Bleeding Heart*, and *Real Stuff*, and Golden and Silver Age reprint volumes. I would often visit Big Apple Comics with my friend Gene, lingering for half an hour or so before grabbing lunch at a place called Happy Burger. The Punisher often came up during these get-togethers, as did politics, movies, and music.

Big Apple Comics and Happy Burger are long gone, and Gene as well. A stretch of upper Broadway that seemed stuck in time has been smoothed over by pharmacy chains and upscale retailers. Few if any of the titles I was reading back then are still being published. If Gene were to reappear he would be taken aback by Manhattan's remorseless transformation. But people return from death in comics, not in real life.

One thing that has not changed much is the Punisher himself. The most recent unlimited series, launched in 2018, was followed by a limited, eight-part series in 2022. According to canon, the 2018–19 series was the twelfth *Punisher* series. Scripted by Matthew Rosenberg, and drawn by Szymon Kudranski, their stories were just about as entertaining as anything that featured the character in a leading role since the heyday of Garth Ennis and Steve Dillon in the early 2000s. But their creative partnership did not exactly break new ground. Nearly half-a-century since his first appearance, the Punisher remained a killing machine who haunts the mean city streets: taking down street criminals and mobsters, disrupting terrorist plots, complicating the work of the police, and tangling with more obviously heroic characters like Spider-Man and Daredevil. At the moment, Jason Aaron's 2022 series is taking a more adventurous approach. But it remains to be seen whether the character's DNA will be fundamentally altered. I have my doubts.

This book has been a long time in the making, in other words. I am delighted to acknowledge the friends and scholars I've learned from over the years—Paul

Buhle, Carolyn Cocca, Becky Conekin, Neil Cohn, Jessica Craig, Don Daley, Erin Dooley-Shepherd, Allan Dorison, Kerry Elgarten, Danny Fingeroth, Thomas Giddens, Karen Green, Bob Guldin, Tom Hart, Charles Hatfield, Jeet Heer, Chris Irving, Gene Kannenberg, Jr., David Kelleher, Stephen Kelleher, Hank Kennedy, Mark Kesselman, Peter Kraus, Peter Kuper, Justin LaLiberty, Fred Van Lente, Mark Lerer, Barbara Lipski, Derek Mainhart, Ravi Malhotra, Liz Manning, John McCarthy, Matt Murray, Tahneer Oksman, Tina Peabody, Glenn Perusek, the late Lenny Pogan, Bill Restemeyer, Richard Reynolds, Jason Rosenfeld, Bill Roundy, Roger Sabin, Jim Salicrup, Peter Sanderson, Tony Savage, Alan Schwartzman, Neil Shatzoff, the late Bill Shea, Rudy Shepherd, Tad Shull, David Terrien, Chris Toulouse, Jean Tyson, Ken Wong, and Ethan Young. Doug Barnes and Guy Lawley deserve special thanks, as do Ede Shepherd, Rhys Shepherd, and Julia Worcester. I dedicate this book to the memory of Gene Benczak (1959–99), as well as to my partner in crime, the marvelous Amy Pryor.

Introduction

Punishment is unpleasant to inflict and not particularly pleasant to discuss. But clearly we need to discuss it.

— Brand Blanshard, "Retribution Revisited" (1968)[1]

Introduction

The premise is high concept. A decorated veteran and his family are gunned down by mobsters in broad daylight in Central Park. The husband survives and becomes a vigilante. Rather than merely seeking retribution against those who murdered his wife and children, he turns a blood feud against organized crime into a war on criminality. His family was "killed by criminals, and so I hunt criminals."[2] Expert in all forms of combat, he is shrewd, motivated, and impervious to pain. He operates far beyond the confines of morality and the law. Over time, he racks up a body count in the tens of thousands. His vendetta takes him across the globe and even into outer space. It pits one man's natural law against an entire social order. But "the core of his mission lies in the dark, claustrophobic concrete canyons"[3] of his place of birth, New York City.

This, in a nutshell, is the story of Frank Castle, aka the Punisher. Inducted into the Marvel Universe (MU) amidst the urban crisis of the 1970s, the contemporary avatar of vengeance initially started out as a bit player in an already crowded Spider-Man storyworld. Castle's cultural stock soared during the following decade, which in retrospect seems inevitable but which at the time came as a surprise to many people at Marvel. Having found favor with a vocal contingent of fans, the Punisher would go on to inspire multiple series, several shelves' worth of graphic novels, and guest appearances in dozens of Marvel and non-Marvel titles, from *Batman* and *Beavis and Butt-Head* to *Moon Knight* and *Spider-Gwen*. The character's successes and achievements exemplified the trend toward edgier, more violent comics and expanded the Overton window of costumed superhero discourse. A crime-fighting technique that was once unthinkable—systematic murder—was now an option, however controversial, for the characters who carry monthly titles and the companies that publish them.

The sheer volume of printed material speaks to the character's seismic impact on comics and popular culture more generally. Between 1974 and 2022, Frank Castle was featured in close to 1000 comic books and graphic novels. He turned up in one-shots, solo titles, team-ups, and guest slots. A fair number of these stories were subsequently reprinted in hardcovers and trade paperbacks. For many retailers, the Punisher remains a proven earner. Most fans would agree that the character is part of the serial comic book pantheon, regardless of whether they follow his adventures or approve of his methods.

The scale of the Punisher's campaign of anticrime violence offers another reason why the character can be considered culturally significant. Few protagonists in all of popular culture are responsible for as many fictional murders as Frank Castle. That said, tallying the villains and henchmen that Castle has expunged in the pages of comic books and graphic novels—let alone film, streaming, and video games—is a fool's errand. In a 2011 conference call with reporters and bloggers, Marvel editor Stephen Wacker gravely claimed that "Castle has killed 48,501 people, counting back to his first appearance."[4] But given that the Punisher has demolished entire islands teeming with bad guys, this is a comically precise figure. In a story from 2005, an aide to the mayor of New York estimates that the Punisher executes a "dozen maggots a week."[5] Twelve murders a week yields just under 30,000 murders in the 48 years between 1974 and 2022. The "real" number of deaths committed in diegetic space in the print medium probably lies somewhere between these two sets of numbers: 30,000–50,000 murders, most of them premeditated and face-to-face.

The Punisher has left his mark on non-print media as well. To date, the character has featured in three studio movies, two Netflix streaming series (his own and *Daredevil*), a dozen or so video games, a score of animated television programs and direct-to-video animated movies, and numerous video tributes and mashups. Jon Bernthal's Netflix performances have been especially well-received. The character's logo and chevron can also be found on licensed and unlicensed items—socks, hoodies, sneakers, beanies, folding knives, pinball machines, shot glasses, key chains, and practically anything else one might think of, including tattoos.[6] There is even a website devoted to images of Punisher action figures playing miniature harps. "Why does he do it?," the site asks.

> Frank is doing this in memory of his family whom he communes with through songs, poems, and prayers as he gracefully waves his battle-scarred arms and hands across the strings to fill his private family shrine with harp music that moves the Punisher to joyful tears.[7]

The Punisher became a valuable piece of intellectual property (IP) during the closing decades of the twentieth century. He has become a global icon in the twenty-first.

INTRODUCTION

Along the way, control over the IP has to a significant extent slipped out of Marvel's hands. During the 2016 presidential campaign, for example, freelance entrepreneurs combined Castle's skull-and-bullets chevron with Donald Trump's distinctive hairstyle to produce the "Trumpisher." This is unlikely to be official merchandise almost by definition. As unlicensed takes on the skull chevron and related imagery proliferate, and not just in the United States, the company's grip over the character's media aesthetics seems increasingly uncertain. To a significant extent the brand's imagery, meaning, and value have been appropriated by social actors—pro-gun groups, pro-police groups, pro-Trump groups, small business owners, eccentrics with websites, and so on—to the evident chagrin of Marvel's editorial and marketing departments.[8]

While the Punisher started out as a comic book curiosity, he has transmuted into something far more socially consequential. He is no longer a mere gimmick or brand. Instead, Frank Castle has come to embody a *cause*, that of murderous vigilantism. Judging by the extent to which the wider culture has warmed to Punisheresque imagery, the banner of instant vengeance commands a powerful grip on the imagination of a great many people. At various times and places soldiers,[9] criminals,[10] pundits,[11] politicians,[12] and police associations[13] have embraced Castle's morbid iconography, as has the so-called alt-right. Punisher pins and patches were donned by White nationalist protesters at the infamous Unite the Right rally held in August 2017 in Charlottesville, Virginia.[14] If you want to let other people know that you are prepared to dispatch your enemies, sewing Castle's skull-and-bullets chevron onto your jacket or plastering a Punisher decal on your car presents the logical choice.[15]

Punisher skulls can thus be spotted on autos, trucks, and sometimes police vehicles across all 50 states. In some places they are close to ubiquitous. These decals and bumper stickers are often modified to include a blue streak that conveys the idea that Blue Lives Matter—a pointed rejoinder to the Black Lives Matter movement. A police chief in Kentucky defended placing the decals on patrol cars by arguing, "Our lives matter just as much as anybody's. I'm not a racist or anything like that. I'm not trying to stir anything up like that. I consider it to be a warrior logo."[16] In a town near Syracuse, New York, the local police chief described "the Punisher symbol on the patrol vehicles" as "our way of showing our citizens that we will stand between good and evil."[17]

The cartoonist Nate Powell draws an analogy between the contemporary uses of the Punisher logo and the Jolly Roger that pirate ships hoisted in the eighteenth century. "The 20th century," Powell argues, "cemented the death's head as a Western military symbol, from Nazi troops to numerous American units in World War II, Vietnam, and beyond." In recent years, the Punisher's version of the death's head has been "adopted as an above-the-law cultural vigilantism" by

3

"aggrieved, insecure white Americans with an exaggerated sense of sovereignty." Those who affix Confederate flags, Punisher symbols, and similar decals on their cars and trucks "have officially declared their existence as above the law, consistent with a long tradition of acting and living above it—propped up by apolitical consumer trends' normalizing impact."[18]

When asked about the character's widespread popularity amongst soldiers and police officers, the Punisher's chief creator, Gerry Conway, bristles. Even under "the most positive framing, the Punisher is a very emotionally damaged criminal," Conway insists. "He's someone who breaks the law. This is exactly what we do not need as police officers. He's not intended as a role model."[19] But this is not always the message that the stories themselves convey. In the tenth series (2014–15), Castle fights alongside a Special Forces soldier who proudly sports a Punisher shoulder patch. "We might be in different wars," the soldier avers, "but we're both in the same fight. I will always consider Frank part of my team."[20]

Just one punch

The Punisher is one of the triumphs of 1970s comics. None of the comic book vigilantes who preceded Frank Castle or followed in his wake are as famous or influential. Yet he is also part of the cultural reassessment of the 1980s, when liberalism was placed on the defensive and pessimism assumed an unfamiliar guise. If the character's modality draws on narratives of decay, deindustrialization, and the United States' experience of the Vietnam War, his campaign was valorized during the decade of greed by readers who bonded with the Punisher in a way that transformed his standing within the MU. Partly as a result of the efforts of artists, writers, and editors, and partly due to the felt needs of the mass audience, Castle has remained a comics fixture ever since.

The vigilante template harks back to developments that predate the 1960s and 1970s, of course. *Vigiles urbani* patrolled the streets of ancient Rome. The chivalrous knights of the mediaeval imagination were aristocratic vigilantes on horseback. The vengeful rebel-bandits that the historian Eric Hobsbawm recovers in *Bandits* (1969) emerged in the early modern period.[21] Nineteenth-century U.S. history is replete with guardians, regulators, and night riders who employed violent means for allegedly communal ends. Accounts of individuals and groups who stray outside the law in the name of justice are scattered across the historical record.

Antecedents to the urban vigilante can also be found in popular crime literature from the early nineteenth century onwards—cowboy novels, detective fiction, penny dreadfuls, serialized stories, and so on. The paperback distribution revolution

INTRODUCTION

after World War II played a particularly significant role in placing hard-edged fiction into the hands of the mass audience. The success of big-screen vigilantes like "Dirty" Harry Callahan and Paul "Death Wish" Kersey inspired a further outpouring of hardboiled movies, comics, and pulp fiction during the 1970s, 1980s, and 1990s.

By the time the Punisher arrived on the scene, the Vietnam War was winding down, the urban crisis was heating up, and the Watergate scandal was closing the book on Richard Nixon's second term. The popularity of the vigilante genre was an established fact. Yet it took time for the character to become an established brand. Following his inaugural appearance in *The Amazing Spider-Man* 129, Frank Castle bounced around the Marvel Universe for over a decade. As a result of his personal tragedy, the "grieving widower"[22] gave off a haunted vibe. As a secondary player, he was mocked for his shoot-first ethos. In those early years, he sometimes used "mercy bullets" that tore through the human body while depositing sedatives. This was odd given his world-view, and implausible from a medical perspective. Even when he avoided taking lives, he sprayed ammunition. But at this point, he did not leave much of an impression.

Strictly speaking, the Punisher received top billing in a black-and-white title, *Marvel Preview* 2, in 1975. But this was an isolated event. The character only came into his own with the publication of a five-issue limited series, Steven Grant and Mike Zeck's *Circle of Blood* (1986). The series' unexpected success underscored the character's connection to the zeitgeist and helped bring the character "out of the shadows and into the center ring."[23] Decades later, the Punisher remains a mainstay within the superhero sodality, albeit a controversial one. He provides the template, complains writer Grant Morrison,

> for a new generation of cookie-cutter, no-compromise superthugs. The superheroes were exposed as kin to the serial killer, deranged fascist loners, delusional narcissistic nut jobs who were barely above the level of the scum upon whom they preyed night and day. Was this what America's role models had become?[24]

While the Punisher has never been quite as prominent as the Avengers, Spider-Man, or the X-Men, the character is one of only a handful of Marvel properties to have inspired multiple feature films and video games, and to have carried five simultaneously published serial titles.[25] As a result, the Punisher's name and origin story might just ring a bell with people who do not read comics or feel any sense of personal connection with the action genre. Frank Castle's commercial viability and cultural clout underscores Lewis Lapham's unsettling claim that "fear itself these days is America's top-selling consumer product."[26]

5

Rules to be made

The Punisher is a crime fighter and an action hero. But is he a superhero? The answer is not as straightforward as it might seem. On the one hand, he dons a costume and sometimes teams up with heroes like Captain America, Daredevil, and Spider-Man. He operates in an environment that is thick with mutants, monsters, and super-empowered individuals. A decorated veteran, he is impossibly expert at marksmanship, hand-to-hand combat, and intelligence gathering. According to the *Official Handbook of the Marvel Universe* (1986), Castle received SEa Air Land (SEAL), Underwater Demolition Team (UDT), and Long Range PAtrol (LRPA) training, and was "decorated with the Medal of Honor, the Navy Cross, three times the Silver Star and Bronze Stars, four times the Purple Heart, and the Presidential Medal of Freedom."[27]

Although Frank Castle does not manifest super speed or super strength, he carries a super-arsenal. He recovers from beatings, gunshots, and stab wounds in ways that defy any ordinary definition of what it means to be human. His "fighting skills, destructive weaponry, and use of lethal force make him equivalent to a power level 6 or higher,"[28] which is only one notch below Daredevil's. His "uncanny ability, that they never talk about, to only shoot people who deserve it," can also be understood as a kind of metapower.[29]

On the other hand, the Punisher builds on pulp archetypes rather than superhero tropes. His approach owes more to dime store tough guys, such as Mickey Spillane's Mike Hammer and Don Pendleton's Mack Bolan, than to demigod acrobats like Superman or Batman. Above all, Castle's viciousness remains atypical within the context of superhero narratology. He says, "pain drives us to the edge" and that "on the edge, we stay alive."[30] He insists that "you can't have a heart in this world. It's too expensive."[31] None of this sounds superheroic.

The Punisher is arguably more of an outlaw or antihero than a hero in any conventional sense. As the literary historian Rebecca Stewart suggests, heroes "are celebrated and revered due to their commitment to their honor and pride," whereas the antihero "requires no veneration; in fact, these characters refuse to bow to the expectations of society and rebel against the rules that bind us all."[32] A related label is "aggressor." In the introduction to their landmark collection of detective fiction, William Kittredge and Steven M. Krauzer use this term to describe the "outlaw hero" who is "an active force for moral order." The aggressor's "crusade is not the result of a particular mystery," they suggest,

> but of a sudden perception—usually caused by his victimization through an act of
> violence—that there is something pervasively wrong with society. His response is

to set aside the question of individual guilt and innocence, and move unilaterally against the generalized source of corruption.[33]

Perceptive, active, unilateral: it sounds as if Kittredge and Krauzer are describing Frank Castle. Drawing on their insights, the comics historian Peter Coogan argues that the Punisher migrates between the superhero and aggressor categories depending on the context. "Within the Marvel Universe," Coogan explains, "he is fairly clearly a superhero, but his allegiance with the aggressor-hero type pushes him out of the center of the superhero formula." As the character

> became popular in the 1980s and was featured in multiple series, the Punisher switched back and forth between the aggressor formula and the superhero genres depending on whether he appeared in his own comics or made guest appearances in superhero stories, that is his definition as a superhero varied depending upon the concatenation of conventions in any particular story.[34]

Whether we define the Punisher as a superhero, antihero, outlaw, or aggressor, or all four at the same time, he retains a special kind of unruly charge.

This unruliness is nicely encapsulated by Bill Sienkiewicz and George Roussos' cover illustration for *The Punisher Back to School Special* #1, dated November 1992 (Figure I.1). Designed to evoke the look and feel of a beat-up school notebook, the illustration suggests that Castle has just fired a round from his double barrel sawed-off shotgun. The figure work is menacing but the facial expression is if anything even more brutal. Sienkiewicz and Roussos' disturbing juxtaposition of motivated violence and disaffected youth culture makes for a memorable comic book cover.

Feel bad at all

As an "index of the tensions that grip society, vigilantism can be very revealing," says the critic Rich Kreiner.[35] The personification of righteous anger, a "bandit hero"[36] like the Punisher offers the consoling fantasy of retribution. "Talk about catharsis," writes the comics editor Don Daley in *The Punisher Ashcan Edition* (1994).

> This guy may not right the wrongs, but he definitely kills the wrongdoers in a way we all at times wish we could. If you've ever been—or loved anyone who was—the victim of a violent crime, you know what I mean.[37]

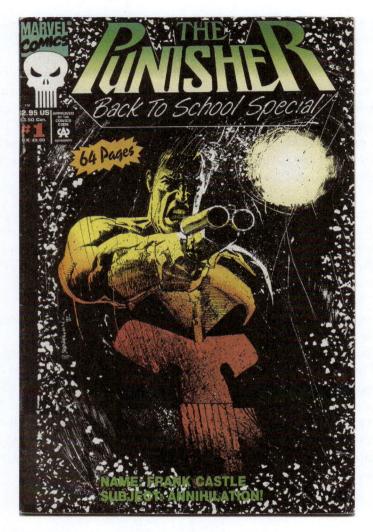

FIGURE I.1: Bill Sienkiewicz and George Roussos, *The Punisher Back to School Special* #1, cover illustration, November 1992. © Marvel Comics.

"A *one-man* war against incredible *odds*—sure, it's got a certain romantic appeal,"[38] admits the fictional character Mike "Rusty" Nails, a federal agent working for Marvel's special crime-fighting organization, Vigilante Infraction General Interdiction and Limitation (V.I.G.I.L.).

Scenarios that would be disturbing in real life can provide ablution on the page or screen. As the film critic Manohla Dargis points out, the "violently avenging hero is a durable American archetype, and denying it—and the indefensible,

INTRODUCTION

irresistible pleasures of watching primitive justice in action—is probably point-less at this stage in our history."[39] Reading about Frank Castle's forever war can be transporting, after all. And why *should* "all spilled blood be innocent?" This striking phrase appears in a story titled "Unfinished Business":

> The streets are wet with blood. Dead ghosts bleed. Our mistakes come back to haunt us. The night erupts in stinging grit. Buckshot. They've seen me. No matter. Let them think I'm gone. They're going where I want them. We all fall into dead arms. We wash our hands in dead blood. Even the night screams death. The blood of those they robbed, and cheated. Of those they killed. Innocent blood taken with-out thought, and often without intent. Our mistakes come back to haunt us. Why should all spilled blood be innocent?[40]

As longtime reader Chet C. suggests in a 1991 letters column, Punisher stories "have always struck a balance between death and depth."[41] They invoke pressing moral questions while delivering mounting body counts. Only rarely do his stories acknowledge systemic forms of violence, however, i.e., "the often catastrophic consequences of the smooth functioning of our social and political systems."[42] They fixate instead on individual perpetrators, positing and sometimes interro-gating "methods and motives" that "lie squarely within the penumbra of contro-versy."[43] While the Punisher's targets have evolved since Watergate—fewer drug dealers and many more terrorists—the character's preoccupation with extralegal violence as both crisis and solution remains unchanged. His backstory, personal-ity, and *nom de guerre* contextualize and legitimize the dogmatism of the persona. "You just take a bite outta crime anytime you please," a corrupt police officer says, admiringly. "No courts, no warrants, no rules."[44]

Over the years, the Punisher has bitten into a plethora of criminal types—drug cartels, drug dealers, arms merchants, crime bosses, street gangs, biker gangs, corrupt cops, human traffickers, intelligence agencies, white-collar criminals, corrupt officials, religiously inspired terrorists, mercenaries, pedophiles, super-villains, the Aryan Brotherhood, the Japanese Yakuza, the Chinese Triads, Jamai-can Yardies, and Albanian, Irish, Italian, Russian, and Serbian mobsters. He has extinguished foes with guns, knives, arrows, axes, bombs, gasses, poisons, mines, flames, boulders, garrotes, cars, trucks, tanks, and his fists. His campaign has attracted the attention of the FBI, the CIA, Interpol, Scotland Yard, and the New York Police Department, as well as the Avengers and Nick Fury's S.H.I.E.L.D. He has more weapons than Batman, more enemies than Spider-Man, and fewer friends than the Hulk.

This one-man army operates in a multiverse populated by supervillains, cosmic beings, intergalactic armies, high-tech agencies, and secret societies.

9

Castle's endurance is especially impressive given that he has died in stories that are considered canonical, as well as in several "imaginary stories," including the aptly-named *The Punisher Kills the Marvel Universe* (1995).[45] His most recent death, in Fallujah, Iraq, took place in *Secret Wars* (2015), which was not part of the regular Marvel Universe.[46] The MU is a complicated place.

The Punisher's two official deaths occur in the Purgatory storyline of 1998–99 and the Franken-Castle saga of 2009–10. In Purgatory, he commits suicide but is granted a second chance by his guardian angel. In Franken-Castle, he is dismembered by Wolverine's son, Daken, but gets stitched back together by a vampire. The fact that Castle has returned more than once from the great beyond suggests he really *is* some kind of superhero. Yet most of the time he comes across as a highly motivated killer who is bound by the same physical laws as the reader. As the villainous Taskmaster teases, Castle is "just *meat* and *brain* and *bone*, trying to look like a *hardass* in a world of *rock-people* and winged *gods*."[47]

Frank Castle is by no means the first comic book crime buster to embrace the hard-ass vibe. Nor is he Marvel's only vigilante, self-described or otherwise. The Marvel Database loosely identifies hundreds of the company's costumed characters as vigilantes, the bulk of whom throw punches but would never dream of executing people in cold blood.[48] But while tamer vigilantes complicate the job of law enforcement, they accept the legitimacy of the justice system and supplement rather than deconstruct the political order. Their *de facto* alliance with public authority helps explain why readers and creators regard these adventurers as fundamentally heroic. Their methods may be theatrical, but they rarely take issue with the courts or other state institutions.

Frank Castle inhabits a different epistemic reality from role models like Peter Parker and Steve Rogers. He only strikes "such blows as permit a man to know he's dying."[49] He operates under the assumption that the law itself is a fraud and a fiction. His "socially symbolic acts"[50] assume a "state of exception" under which social norms are no longer applicable. As the far right political theorist Carl Schmitt (1888–1985) observed in 1921, "If the law is not capable of saving society, then force intervenes, and does whatever is necessary."[51] Or as the ancient Roman maxim has it, *necessitas non habet legem*—necessity knows no law.

Rather than throttle evildoers, or deposit them at police stations, the Punisher executes anyone who offends his indelicate sensibilities. "I can kill whoever I want. I'm the mother (expletive deleted) Punisher," he boasts.[52] This would-be sovereign rejects "the ordinary social and ethical pieties and faces a world that he has learned to understand as fundamentally corrupt, violent, and hostile."[53] Social worker Jennifer Cooke observes that his "crusade of vengeance" is "nothing but a pointless, ever-escalating spiral of utterly negative energy."[54] S.H.I.E.L.D. agent

G. W. Bridge asks, "Can you even remember what your dead wife looked like or do you just use her as a convenient justification for casual murder?"[55] The literary historian Leonard Cassuto maintains that "inside every crime story is a sentimental narrative that's trying to come out."[56] But in this case any hint of sentimentality is buried beneath many layers of humiliation and fury.

The inadequacy project

The character's obduracy is nicely expressed in a soliloquy that Castle delivers in the limited series *The Punisher: Year One* (1995). He records himself as "a declaration of intent, so that no one will be in any doubt ... chances are, I won't be able to explain myself later":

> Sometimes the law is helpless to act, even when it *identifies* the guilty. It follows, therefore, that sometimes it is necessary to act *outside* the law, to *shame* its inadequacy, to pursue a *natural* justice. I'm not talking about *vengeance*. Revenge is *not* a valid motive. It's a tawdry, *emotional* response no better than the act that provokes it. I'm talking about ... *punishment*.[57]

To shame its inadequacy: while iconic Marvel characters are typically rooted in fantasy and science fiction, the Punisher represents an exercise in pointed social commentary. Other characters owe their powers to mythology (Thor), magic (Dr. Strange), science (Captain America), hybridity (Spider-Man), mutation (the X-Men), and technology (Iron Man). The Punisher derives his powers from how certain events, crises, and emotional states are remembered and reenacted.

Punishment, after all, is a political and social construct. Violence does not imply or claim legitimacy. Punishment does. To talk about punishment is to ask who *deserves* to be punished, who *decides* who deserves to be punished, and what *form* the punishment should take. All costumed heroes have their political moments; the murderous antihero *is* political. If "a violent death is a public event,"[58] then the Punisher's war on criminality is a public emergency.

In contrast with other costumed heroes, the Punisher remonstrates with the rule of law and challenges the state's claim to a monopoly over the use of force. Rather than simply tangling with the criminal underworld, Frank Castle pursues a reproachful project of social critique and political negation. But if the scale and duration of his contrarian undertaking are weirdly formidable achievements, its implications are catastrophically antisocial. Consider when the character executes a small-time hoodlum on Halloween,[59] and coldcocks a department store Santa, in front of groups of small children.[60] Even the amoral assassin Suspiria is more

attuned to the wider ramifications of retributive violence than Castle. In *Bloody Valentine* (2006), Suspiria knocks Castle out to prevent him from shooting a kidnapper in front of his victims. "What hit me?" the Punisher later asks. "I did," she responds. "Those kids have been through enough; they didn't need to see you blow Herman's brains out."[61]

Even if we set aside the possibility that a Punisher-style campaign might generate unwanted secondary consequences, by definition instant vigilantism can never "replace formal political institutions" and is "antithetical to their growth." As the political scientists H. Jon Rosenbaum and Peter C. Sederberg argue, "vigilantism is disorderly: that is, it inhibits the development of reasonably accurate and stable behavioral expectations."[62] Or as the sociologist Georg Simmel wryly observes, "relations of conflict do not by themselves create a social structure."[63]

Readers and pros often assume that the figure of the disorderly antihero is intrinsically ideological. At times, the Punisher's own writers have gone out of their way to reinforce this entrenched assumption. It was in a parodic vein that Matt Fraction revealed that Castle subscribes to *Edge Weapon Enthusiast, Modern Urban Camouflage, Patriot's Militia Monthly*, and *Bone and Joint*.[64] But the joke would not land were it not for the character's established reputation. It can even be argued that his actions hold "very conservative political implications"[65] in that they are rooted in a paralytic theory of politics that assumes that "self and society" are "eternally besieged by the threat of destruction, sowing a natural breeding ground for fear: a fear of loss, of anarchy, of personal and political 'non-being.'"[66] It should not come as a shock that Castle resists all talk of leniency, compassion, and human rights. "That's the trouble with talking to liberals," he snarls. "They get to you if you're not careful."[67]

On the other hand, it makes little sense to regard the Punisher as "purely reactionary," with "no project" of his own, which is how superheroes were dismissed by the late anthropologist David Graeber.[68] Castle's agenda is in fact aggressively proactive and more than a little nightmarish. "Every night I go out and make the world sane," he says in a 2004 story, in which he inserts a "fresh belt" into his 50 caliber machine gun to "finish off the wounded. To make sure no one's faking. Fire at moans. At movement. Give them the whole two hundred rounds."[69] Here the character labors on a cultural assembly line that fabricates representations of bodily harm. Or as the anti-comics crusader Fredric Wertham argues in *Seduction of the Innocent* (1954), "In many subtle and not so subtle forms the lynch spirit is taught as a moral lesson."[70]

The single most ideologically charged moment in the character's published history arrives in a Mike Baron story from 1991. Frank Castle sits in front of a campfire, shooting the breeze with his longtime associate David Linus Lieberman, who goes by "Micro." "When I started," Castle reflects,

> I thought I'd make a difference. Wipe out organized crime—*hah*! The *real* enemy's in Washington! Liberal Democrats have sold this country down the river! You know what would make a difference? Blowing away a few crooked Congressmen. Yeah, I'd even kill a few Republicans just to show I'm bipartisan.

Micro's response is suitably cautionary. "Frank, Frank, don't go *meshugganah* on me," he says. "You go after Congress and we're both dead meat!"[71] It is otherwise out of character for the Punisher to fantasize about executing politicians, however. Admittedly, when Castle confronts members of the fictitious environmental group Humans Off Planet, he snaps, "I've got enough free speech for everyone!" and proceeds to blow them away.[72] He has mocked leftist cant[73] and donned an NRA cap.[74] But the unvarnished extremism of this campfire exchange remains startling.

The classic works of political philosophy offer little support for Castle's "parallel structure of justice" and his "arbitrary viewpoint toward law."[75] As the political scientist Edward Stettner notes, "almost all political theorists have preferred a 'legal' political order and have argued against violent tactics in politics." The paradox of "the vigilante position," Stettner adds, is that "it seeks to perpetuate the existing order, but without law and without accepting the actions of the society's political institutions." Vigilantism, he concludes, "is clearly a sickness in the view of traditional theory, a perversion of both the means and the ends of politics as it should be."[76]

But while Stettner exhumes the writings of Thomas Hobbes, John Locke, and Jean-Jacques Rousseau in order to demonstrate that vigilantism poses a threat to the social order, he ignores the one prominent theorist whose work overlaps with and perhaps even informs the vigilante sensibility, the aforementioned Carl Schmitt.[77] In his famous essay on "The Concept of the Political" (1932), Schmitt argues that the "specific political distinction to which political actions and motives can be reduced is that between friend and enemy":

> Only the actual participants can correctly recognize, understand, and judge the concrete situation and settle the extreme case of conflict. Each participant is in a position to judge whether the adversary intends to negate his opponent's way of life and therefore must be repulsed or fought in order to preserve one's form of existence. Emotionally the enemy is easily treated as being evil and ugly, because every distinction, most of all the political, as the strongest and most intense of distinctions and categorizations, draws upon other distinctions for support.[78]

If some Punisher storysmiths embrace this pessimistic and divisive world-view, others take issue with the character's Schmittian foundations. The rhetorical mechanics of any specific narrative cannot be determined in advance. As the

Punisher once said, "I don't have a tribe anymore. I'm a rogue,"[79] which is as good a way of summarizing his relationship to conventional political categories as any. Empirically speaking, Marc DiPaolo's claim that Punisher is "unconcerned with corporate excess, or crimes committed by good, white, Christian men," and is only "interested in seeing the dangerous hippies and brown people of the world brought to the sword for leading a fundamentally corrupt life"[80] falls wide of the mark. DiPaolo neglects to mention that Castle describes himself as a "soldier" at war with "the corporate thieves of America" who have "had their hands in our pockets for too long";[81] that he complains that "man is determined" to destroy the last wild places "all in the name of profit";[82] and that he has butchered hundreds of white nationalists and neo-Nazis. When it comes to lines of demarcation, the Punisher's track record is intriguingly inconsistent, even if a certain tilt or predilection seems baked in.

One reason the Punisher is often framed in terms of right vs. left is because his biography presents an ensemble of identities that intersect with the so-called culture wars: blue collar, white ethnic, outer borough, combat veteran, parochial school graduate. In aggregate, these affiliations generate a mythopoetic space that helps explain and for many readers justifies the behavior of the most famous hardcore vigilante in comics. But while the template pushes all the right buttons, in practice the archetype is flexible. Instead of repeating talking points, Punisher comics provide a showcase for multivocal talent and an "alternative location for discussing the nature of justice."[83] His tales are *about* his campaign and do not necessarily embrace it. While his formulary is simple, the way it has played out in print is complex.

Critics and devotees alike regard the character as an ensemble of gestures and symbols to be bemoaned or applauded.[84] In contrast, I will approach the saga of Frank Castle as an overdetermined site of cultural production that has on occasion generated amusing and unexpected results. The character is the product of a tightly constrained embedded system,[85] one that draws on the creative labor power of visually minded writers and artists who exploit the character's rigid matrix for their own aesthetic, expressive, and discursive ends. Instead of celebrating the Punisher's coolness factor, or berating corporate America for lending its imprimatur to a killing machine, I am interested in exploring the tension between embedded constraints and creative agency. The template is not the same thing as the recorded history: what we think we know about the Punisher, and what has been attested in print, are two different things.

In the pages that follow, I harvest nearly five decades' worth of comic books and graphic novels to show how a binary-minded rageaholic ended up with a lively, sometimes ridiculous, and often socially resonant storyverse. While I refer to secondary sources, my focus is on the character's life and times as recorded

in the hundreds of Punisher-related comic books and graphic novels published between the 1970s and the present day. These primary sources provide the material resources for a close reading of the Punisher's distinctive and extreme form of justice discourse.

In developing this approach, I have drawn on the political theorist John Gunnell's concept of internal history, which "stresses the dynamics of conceptual change" as revealed by a close reading of historical texts. "By referring to my project as *internal history*," Gunnell writes, "I first of all signal my wish to move beyond the kind of externalism characteristic of rhetorical or 'presentist' histories, whether of the Whiggish or polemical variety." Intellectual history, he argues, "has rendered its subject in terms of analytical concepts and constructed traditions that have, in many instances, effectively obscured important aspects of the character of indigenous conversations and transformations within these conversations."[86]

Gunnell's methodological point is a useful and important one. Rather than assuming that "the Punisher" represents or pursues a coherent agenda, I am interested in exploring the "conversations and transformations" that writers, artists, editors, and readers have engaged in over a period of several decades. As the comics historian Martin Barker points out in the context of discussing British girls' comics, "we need subtle and cautious research instruments, able to grasp the flow and stresses of these stories to bring out the maneuvers and moments of decision that make the stories meaningful."[87] *A priori* essentialism offers a poor substitute for a close consideration of the production of seriality in multi-authored, corporate-owned texts.

The secondary literature

Although academics and cultural critics have been writing about comics and cartoons for more than a century, comics studies only achieved momentum in the 1990s.[88] Initially, the field mainly concerned itself with academy-friendly genres like alternative, non-fiction, and avant-garde comics.[89] In recent years, scholars have paid closer attention to superheroes, as reflected in the appearance of studies of superheroes and disability, gender and sexuality, race, religion, and the contributions of individual writers and artists.[90] The field has also moved beyond structuralist approaches that assume, for example, that superheroes are inherently antidemocratic or that Captain America represents an imperial monomyth.[91]

Despite this superhero turn, to date the Punisher has attracted limited scholarly attention. The main exceptions are a dozen or so articles and book chapters, and an edited collection, *Judge, Jury, and Executioner* (2021).[92] There are also online essays and reviews by fans and journalists. Not surprisingly, the quality of these

sources is uneven. One thing is certain: writers on the Punisher are rarely dispassionate about their subject matter.

Much of the existing literature is concerned with issues of human psychology. The appeal of locating the Punisher within a psychological framework should be obvious.[93] Castle is, after all, a broken man. Yet the psychological angle has its limitations. It can overlook or minimize the social dimension of his stories and their reception. And it can devolve into a literal-minded box-ticking exercise that places unwarranted confidence in what are ultimately rather fuzzy sorts of distinctions.

The more compelling issue, in my view, has to do with the historical conflicts and conditions that facilitated such an extraordinary archetype and allowed creators and readers to transform a minor character into a global powerhouse. An inherently *excessive* personality like the Punisher can tell us a great deal about consequential emotions and narratives that only occasionally find any sort of conventional outlet. "The cruder the outpouring," writes Philip Ball, "the more revealing it is of the anxieties behind it."[94]

Another theme that has attracted attention is Frank Castle's status as a Vietnam veteran.[95] Like Rambo, Castle is one of a number of high-profile fictional vets who brought the war home. The character's military service is especially relevant insofar as two key writers, Carl Potts and Garth Ennis, foregrounded the impact of his multiple tours of duty on his thinking and behavior in a small number of their stories. Largely as a result of their efforts, the bloodshed that Frank Castle witnessed and inflicted "in country" is constitutive of his transformation from family man to urban warrior. As one supporting character points out, Castle "brought that battlefield with you everywhere you went since."[96]

Yet the Vietnam-centered approach suffers its own limitations. It confronts the problem that only a tiny fraction of Punisher comics and graphic novels are set in southeast Asia. The war's fallout is occasionally acknowledged elsewhere in the corpus but is absent most of the time. It would be a mistake to assume that Punisher stories are *about* Vietnam. Another complication is that Frank Castle's military service was quietly retconned in 2011 when he became a veteran of the 1990–91 Gulf War. Given the many and profound differences between the two conflicts, placing Vietnam at the apex of the metanarrative presents certain complications. At the very least it requires bracketing a decade's worth of narratology that styles him as a Gen X-er rather than a Baby Boomer.

Castle's military background, however protean, is obviously important from the standpoint of understanding the character and his relationship to his audience. It contextualizes his physical prowess, his tactical gifts, and his facility with weapons. It supplies an explanation for how he became so dangerous. In addition, his service record is redolent of an idealized form of masculinity—a manly man living in a man's world doing manly things. Given the over-the-top quality of his gender performance

and his detachment from a culture that was remade by and after the 60s, it is a little surprising that the secondary literature on the Punisher and hypermasculinity has barely gained traction.[97] The character would seem to offer an oven-ready case study of aggrieved masculinity. His campaign does not exactly reflect a considered response to the problem of violent crime. It is, however, laden with socially resonant rage that is both gendered and racialized. White male rage, in other words.[98]

One helpful construction we will have cause to revisit in this context is that of "sovereign masculinity," a term coined by the philosopher Bonnie Mann. One of the interesting things about Mann's work is her appreciation for how the "deeply lived reality of gender" is exceptionally sensitive to feelings of shame and humiliation. The doctrine of punishment, as understood by the character, his writers, and his readers, can be viewed as a masculinist response to these unwanted feelings. Punishment can exteriorize emotions that are difficult to process. The doctrine of anticrime punishment punishes crime but it also punishes emotionality.

As Mann notes, the rhetoric of sovereign masculinity appeals to fantasies of "absolute certainty, indomitable will, and total invulnerability." It is "tied to a hypermasculine and nationalist aesthetic." "Spectacular acts of violence are *redemptive*," she claims. They are "required for the restoration of an aggrieved or wounded masculinity to sovereignty."[99] Yet in the case of the Punisher, restoration is permanently deferred. His stories are spectacular and spectacularly aggrieved, but they are never truly redemptive. The extent to which they deny any sense of closure speaks to the pessimism of the metanarrative. At the same time, Castle's inherent excessiveness ensures that his wounded masculinity is exposed rather than buried in subtext.

Pen taps the paper

The Punisher offers a case study of unconventional political theatrics. There are any number of comic book characters who generate more revenue per annum. But no other figure in pop culture so perfectly encapsulates the incendiary politics of vengeance.

To investigate this politically charged performance space, the present study is organized around three main themes. The first is that of the postwar urban crisis. The Punisher's geographically encoded stories return again and again to New York City's troubled past, anxious present, and uncertain future. As the political scientist Murray Edelman observes, "Past crises become symbols whose meanings affect later developments."[100] Frank Castle may be an avatar of male anger, but he is fixated on the Big Apple. The appeal of his exploits is connected to a discourse that remembers, revisits, and reinvents the narratology of the city's recent history.

Superheroes have long operated out of Manhattan as well as imaginary cities that resemble it. But the Punisher is *constituted* by the New York City (NYC)

experience or at least one version of it. Viewed from this perspective, his military adventures overseas serve to underscore lessons that he would internalize at home. Safety is an illusion. Institutions are corrupt. Elites are feckless. The threat of chaos lurks everywhere. And retributive violence is a rational response to a city/nation/world turned upside down.

From the Punisher's perspective, the urban crisis and the Vietnam War are two sides of the same coin: the betrayal of working-class aspirations and the collapse of liberal dreams during and after the 1960s. The metanarrative's preoccupation with urbanism in general, and NYC in particular, complicates the assumption that the seeds of Castle's campaign were planted in the killing fields of Southeast Asia. We need to look closer to home if we are to understand the sources of the character's rage and the ways in which his stories and imagery resonate within the subculture and beyond.

The second theme is that of mapping how writers have handled the character. Rather than assuming all Punisher stories point in the same direction, or that each writer presses their unique stamp on the franchise, the present study proposes that from the 1970s onwards there have been two main and contending templates that writers, artists, and editors have relied on to tell Frank Castle stories. The first template—trigger happy—does not take the character very seriously and lends itself to a parodic approach. In contrast, the second—grim and gritty—takes the character very seriously indeed. The trigger-happy template reflects how most other MU characters view the Punisher. This template is used when the character appears in other heroes' stories. The grim and gritty version, on the other hand, flatters the Punisher's self-conception and finds expression in the character's own titles. As we shall find, one of the most consequential of the Punisher scribes, Garth Ennis, fused the two approaches in a way that helped revitalize the franchise in the early 2000s.

The final theme has to do with the ways in which control over the narrative has recently slipped out of the hands of creators and corporate interests, and into the hands of motivated social actors. While Marvel continues to reap financial rewards from book sales and licensing fees, Punisher merchandise is increasingly unlicensed and unregulated. This is especially true of explicitly political uses of the character. The arm patches donned by protesters at the 2017 Unite the Right rally were unofficial merchandise, and Blue Lives Matter/Punisher materials typically lack copyright symbols. Print was central to the franchise in the 1970s, 1980s, and 1990s, with licensed t-shirts, action figures, and the like furnishing supplementary revenues. In the early twenty-first century, film and streaming, and to a lesser extent video games, became the primary means by which Punisher stories were distributed and consumed. Nowadays the imagery itself is key—skulls, guns, and grimaces. Print and screen narratives have been eclipsed by the schismatic visuals of low-intensity conflict.

As a case study in rhetoric and culture, our emphasis is on words rather than pictures—narration, dialogue, editorials, adverts, readers' letters, promotional materials, and so on. But of course, comic art itself constitutes a form of rhetoric, just as words on the page have a visual aspect. The efforts of the pencilers, inkers, and colorists who have depicted the character and his world are significant from the standpoint of discourse as well as aesthetics. Suffice to say, their efforts are not accorded the attention they deserve in this study. Rather than offering a comprehensive account of the Punisher phenomenon, which would require a heavier emphasis on visuals, a deeper dive into fan culture, and biographies of creative personnel, this monograph is almost exclusively preoccupied with the intersection of language, politics, and the popular arts.

The first chapter, "Trauma Politics," takes a step or two back from the Punisher phenomenon to explore the social and cultural context within which the character was incubated. It surveys the postwar urban crisis and looks at the vigilantes who preceded Frank Castle in film, comics, and serial fiction.

The second chapter, "Trigger Happy, or Grim and Gritty," maps the competing Punisher templates that have shaped Frank Castle's stories from the mid 1970s onwards. The trigger-happy version offers a better fit with all-ages comics, while the grim and gritty version works in an R-rated context. It is hard to be enthusiastic about vengeance in a trigger-happy environment but easy in a grim one.

The third chapter, "The Universe Pushes Back," looks at the ways in which other costumed heroes have responded to the Punisher's campaign of anti-criminal violence. For a hardened lone wolf, Frank Castle spends a great deal of time in the company of other costumed crime fighters. Some of the adventurers that Castle has interacted with over the years are relatively obscure. Others are comic book superstars, such as Captain America, Daredevil, and Spider-Man.

The fourth chapter, "Negative Dialectics," explores the Punisher's meteoric rise during the second half of the 1980s and the first half of the 1990s. This was the first time that Frank Castle entered the Marvel lineup and began to represent a potentially significant revenue stream. It was also when the character underwent what film historians refer to as a *production cycle*, the first of two Punisher production cycles to date.

The fifth chapter, "The Narratological Impasse," places a spotlight on the Punisher parodies that Marvel and its rivals published from the mid 1970s onwards. It shows how unofficial versions of the character mostly draw on the trigger-happy approach. It also examines the ways in which storysmiths have grappled with the challenge of recalibrating the character in light of the widely publicized decline in violent crime in the late 1990s and early 2000s.

The sixth chapter, "Embedded versus Detached," focuses on the recent history of the character. While Marvel continues to release both new material and reprint

volumes, the locus of production and consumption has migrated from print to screen, and from screen to iconography. The Punisher remains a fixture in the Marvel Universe, and a likely if not inevitable subject of future film and/or streaming projects. He is a member in good standing of the pop culture firmament. But he also embodies a raw, populist anger that presents an uncomfortable fit with business models and strategic plans.

Never frivolous

In the interest of full disclosure, I write from the perspective of a cultural historian who recognizes that the character has inspired powerful storytelling along with some absolute dreck. There is something "twisted, fear-inspiring" and "downright false"[101] about the Punisher, as well as a plangency that is worth pausing over. The Punisher is "bleak beyond my understanding,"[102] which is why the character makes other costumed heroes look "somewhat frivolous."

"The Punisher is diametrically opposed in the philosophy to the characters Marvel has become successful with," reader Michael H. notes, "but I maintain that Frank Castle has earned a solid footing for himself in the Marvel mythos tradition of Spidey, Cap, or the X-Men." The writer continues: "Frank Castle should stand as an example to us of both what we should and should not do. We should respect his serious devotion to duty and action—we should not respect his self-destructiveness."[103] Or as letter writer David B. points out, "don't confuse popularity and profit with heroism. The fact that this series of books is so successful is a strong commentary on our society's values, something we all should think seriously about."[104]

Frank Castle inhabits "the most gripping and violent corner of the Marvel Universe."[105] It is also the most politically charged. His saga should attract our interest for precisely this reason. When Carl Potts stepped down from scripting *Punisher War Journal*, he dropped a ruminative editorial note. "The Punisher," he pointed out, "is an odd character. He's not a hero in any traditional sense and he's certainly not someone to be emulated." Furthermore, Frank Castle "is not a happy man. He's obsessed. What he does doesn't satisfy him or solve any of society's ills. So why are so many of us fascinated by the character?"[106]

This book is inspired by that very question.

NOTES

1. Brand Blanshard, "Retribution Revisited," in *Philosophical Perspectives on Punishment*, eds. Edward H. Madden, Rollo Handy, and Marvin Farber (Springfield: Charles C. Thomas Publishers, 1968), 59.

INTRODUCTION

2. Mike Baron and Larry Stroman, *The Punisher* #1.19 (New York: Marvel Comics, May 1989), 1.

3. Steve Saffel, "Editorial," *Marvel Age* #135 (New York: Marvel Comics, April 1994), n.p.

4. Shaun Manning, "Greg Rucka Unleashes the Punisher," July 8, 2011, http://www.cbr.com/greg-rucka-unleashes-the-punisher/.

5. Garth Ennis and Leandro Fernández, *The Punisher* #6.22 (New York: Marvel Comics, August 2005), n.p.

6. See "The Punisher Skull Tattoos: Seeking Justice," Tatt Mag, https://tattmag.com/punisher-skull-tattoos/.

7. https://www.punisherharpzone.com/.

8. See, *inter alia*, Francesco Cacciatore, "Why Marvel Is Rebooting *The Punisher* (And Why it Won't Work)," Screen Rant, December 20, 2021, https://screenrant.com/why-marvel-reboot-punisher-2022-not-work-controversy/.

9. Punisher iconography could be found "on unofficial unit patches; spray painted on buildings, vehicles, and equipment, and as military tattoos," in Iraq and Afghanistan. James Clark, "Bone Deep: The Relationship between the Punisher and the Military," *Task and Purpose*, March 16, 2016, https://taskandpurpose.com/culture/bone-deep-the-relationship-between-the-punisher-and-the-military/.

10. In 2018, a Florida man was arrested "on charges of criminal mischief of more than $10,000 after repeatedly using a firearm to damage property." "He was seen on camera wearing a Punisher T-shirt," the report noted. A few months earlier, the FBI asked for the public's assistance in apprehending "a man in his mid-to-late thirties" who "wore a gray Punisher T-shirt in a December 7 robbery." Eric Rogers, "Man in Punisher T-Shirt Arrested for shooting up FPL Property," *Florida Today*, March 8, 2018, https://www.ajc.com/news/local/fbi-says-man-punisher-shirt-robbed-metro-atlanta-banks/CBm6rTbG5HJCZRQkhT1QOJ/.

11. During the first year of the COVID-19 crisis, Sean Hannity sported a Blue Lives Matter/Punisher pin on his nightly cable news program.

12. Supporters of Rodrigo Duterte, the former President of the Philippines (2016–22), sometimes refer to him as "The Punisher." On the eve of his inauguration, Duterte told a crowd in Manila, "If you know of any addicts, go ahead and kill them yourself." The Human Rights Watch estimates that "more than 12,000 people have died in the drug war, many of them victims of summary execution by the police." Felipe Villamore, "Duterte Says His 'Only Sin' Is the Killings in a Drug War," *New York Times*, September 28, 2018, A4.

13. The St. Louis Police Officers Association encourages its members to use Punisher imagery on social media, and the Detroit police union defended the use of the Punisher insignia by "special operations badges emblazoned with the skull" at Black Lives Matter protests in 2020. Doyle Murphy, "St. Louis Police Union Loves the Punisher: But the Punisher Isn't On Board," *Riverfront Times*, July 12, 2019; and James Whitbrook, "As the Punisher Skull Re-Emerges on Cops in U.S. Protests, Marvel Reckons with its Imagery," June 25,

14. Stephen Rodrick, "Jon Bernthal is Learning to Keep his Demons at Bay," *Esquire*, January 3, 2019, https://www.esquire.com/entertainment/movies/a14443788/jon-bernthal-the-punisher-cover/.

15. The iconography's confrontational aspect cannot be easily overstated. In 2017, "a 29-year-old smuggled four guns, throwing stars, pepper spray, and a knife into the Phoenix Comicon. Police found the man inside the convention dressed as the comic book character the Punisher in all black clothes, black face paint, body armor, and a belt with ammunition for his multiple guns strapped across his chest. He had allegedly come to kill police as well as fictional law enforcement." Few comic book characters are capable of summoning this kind of terroristic vibe. Kelly Weill, "Cosplayer Set Alarm for Alleged Green Power Ranger Assassination, Bragged About Knife Collection," http://www.thedailybeast.com/articles/2017/05/29/power-rangers-cosplayer-set-alarm-for-alleged-green-power-ranger-assassination-bragged-about-knife-collection.

16. Fernando Alfonso III, "Chief Removes Punisher Emblem, 'Blue Lives Matter,' From Police Cars After Public Reacts," http://www.kentucky.com/news/state/article134722264.html.

17. Charley Hannagan, "Solvay Police: Punisher Decals Stay; They Show 'We Will Stand Between Good and Evil,'" May 1, 2017, http://www.syracuse.com/news/index.ssf/2017/04/central_new_york_police_punisher_decal_shows_we_will_stand_between_good_and_evil.html.

18. Nate Powell, "About Face," February 24, 2019, https://popula.com/2019/02/24/about-face/.

19. John Annese and Rocco Parascandola, "Good for Morale or Bad Community Relations?" *New York Daily News*, November 4, 2018, 7.

20. Nathan Edmondson, Kevin Maurer, and Carmen Carnero, *The Punisher* #10.8 (New York: Marvel, September 2014), n.p. This may have been the view held by the Milwaukee police officers who called themselves "the Punishers" and who "wore black gloves and caps embossed with skull emblems while on patrol." John Diedrich, "Milwaukee Police Looked into 'Punishers' Group," *Milwaukee Journal Sentinel*, January 5, 2011, A1.

21. Eric Hobsbawm, *Bandits* (London: Weidenfeld & Nicolson, [1969] 2000).

22. Gerry Duggan and Mike Deotato, *Savage Avengers: City of Sickles* (New York: Marvel, 2019), n.p.

23. Dugan Trodglen, "Inside the Circle of Blood," *Marvel Spotlight: Punisher Movie (Inside the World of Frank Castle)* (New York: Marvel, 2008), n.p.

24. Grant Morrison, *Supergods: What Masked Vigilantes, Miraculous Mutants, and a Sun God from Smallville can Teach Us About Being Human* (New York: Spiegel & Grau, 2011), 217.

25. *The Punisher, Punisher War Journal, Punisher War Zone, The Punisher Armory*, and *The Punisher 2099* were all being published between February 1993 and November 1994.

26. Lewis H. Lapham, "Petrified Forest," *Lapham's Quarterly*, Summer 2017, https://www.laphamsquarterly.org/fear/petrified-forest.

27. Mark Gruenwald and John Byrne, *The Official Handbook of the Marvel Universe: Deluxe Edition (Paladin to the Rhino)* (New York: Marvel, September 1986), 36.
28. Brian M. Bendis and Gabriele Dell'Otto, *Secret War* (New York: Marvel, 2014), n.p. Ordinary mortals are usually 1s or 2s. Daredevil is a 7; Captain America and Spider-Man are both 8s.
29. Mark Gruenwald, quoted in Lia Pelosi, "Crime and Punishment," *Punisher Anniversary Magazine* #1 (New York: Marvel, February 1994), 3.
30. Steven Grant, Bob McLeod, and Lee Weeks, *Spider-Man* #34 (New York: Marvel, May 1993), n.p.
31. Mike Lackey and Phil Gosier, "X-Mas Stalkings," *The Punisher Holiday Special* #1.3 (New York: Marvel, January 1995), n.p.
32. Rebecca Stewart, "Editor's Introduction," in *Antihero*, eds. Fiona Peters and Rebecca Stewart (Bristol: Intellect, 2016), 7.
33. William Kittredge and Steven M. Krauzer, eds., "Introduction," *The Great American Detective* (New York: New American Library, 1978), xxix–xxx.
34. Peter Coogan, *The Secret Origin of a Genre* (Austin: MonkeyBrain, 2006), 54–55.
35. Rich Kreiner, "The Quality of Violence: Mainstream Mayhem and its Creators," *The Comics Journal* 133 (December 1989), 94.
36. Ernest Mandel, *Delightful Murder: A Social History of the Crime Story* (London: Pluto Press, 1984), 1.
37. *The Punisher Ashcan Edition* (New York: Marvel, 1994), n.p. "I live in Brooklyn," Daley told an interviewer. "I've had guns pointed at me; I've had knives pulled on me; I've been jumped. I think people are afraid." Pelosi, "Crime and Punishment," 6.
38. Steven Grant and Hugh Haynes, *Punisher War Journal* #1.67 (June 1994), n.p. All emphases in quoted material throughout the book are from the original source.
39. Manohla Dargis, "Judge, Jury and Executioner," *New York Times*, July 20, 2018, C8.
40. Steven Grant and Bill Marimon, *Punisher War Zone Annual* #1 (New York: Marvel, 1993), n.p.
41. "You always have struck a balance between death and depth, and you must continue to do so in order to keep the integrity of this comic book." Chet C., "Punisher War Journal Entries," *Punisher War Journal* #1.34 (New York: Marvel, September 1991), n.p. Marvel used to sometimes publish complete names and home addresses in its letters columns. Here I furnish the writer's first name and the first letter of his or her last name.
42. Slavoj Zizek, *Violence: Six Sideways Reflections* (New York: Picador, 2008), 2.
43. Don Daley, "Punishing Profiles," *Punisher War Journal* #1.1 (New York: Marvel, November 1988), 30.
44. Chuck Dixon and Gary Kwapisz, *Punisher War Journal* #1.55 (New York: Marvel, June 1993), n.p.
45. Garth Ennis and Dougie Braithwaite, *The Punisher Kills the Marvel Universe* (New York: Marvel, 1995); John Layman and Fabiano Neves, *Marvel Zombies vs. Army of Darkness*

(New York: Marvel, 2007); Tom DeFalco and Ron Frenz, *The Spectacular Spider-Girl: The Last Stand* (New York: Marvel, 2010); and Cullen Bunn and Dalibor Talajic, *Deadpool Kills the Marvel Universe* (New York: Marvel, 2012). Castle is also killed off in *What If...?* 2.26 (New York: Marvel, June 1991); and in *What If...?* #2.57 (New York: Marvel, January 1994). In *Wolverine* 68, an alternate version of the villainous Kingpin feeds Daredevil and the Punisher to his pet dinosaurs. Mark Millar and Steve McNiven, "Old Man Logan: Part Three," *Wolverine* #68 (New York: Marvel, October 2008), 1.

46. Nathan Edmondson and Mitch Gerads, *The Punisher* #9.20 (New York: Marvel, September 2015).

47. Fred Van Lente and Pere Perez, *Deadpool Versus the Punisher* #4 (New York: Marvel, July 2017), n.p.

48. http://marvel.wikia.com/wiki/Category:Vigilantes.

49. The Roman author Suetonius, quoted in Tom Holland, *Dynasty: The Rise and Fall of the House of Caesar* (New York: Anchor, 2015), 287.

50. The phrase is Fredric Jameson's and is taken from Ray Pratt, *Projecting Paranoia: Conspiratorial Visions in American Film* (Lawrence, KS: University Press of Kansas, 2001), 2.

51. Carl Schmitt, *Dictatorship* (London: Polity, [1921] 2003), xlii–xliii.

52. Ben Acker, Ben Blacker, and Matteo Lolli, *Thunderbolts Annual* #1 (New York: Marvel, February 2014), n.p.

53. John G. Cawelti, *Adventure, Mystery, and Romance: Formula Stories as Art and Popular Culture* (Chicago: University of Chicago Press, 1976), 150.

54. Garth Ennis and Tom Mandrake, *The Punisher* #5.26 (New York: Marvel, July 2003), n.p. The point is underscored by a minor character who tells Castle, "the violence you create, so raw and unfocused, does nothing but create more violence [...] violence cascades out and can hurt those around you." Rosenberg and Kudranski, *The Punisher: War in Bagalia*, n.p.

55. Matt Fraction, Rick Remender, and Howard Chaykin, *Punisher War Journal* #2.22 (New York: Marvel, October 2008), n.p.

56. Leonard Cassuto, *Hard-Boiled Sentimentality: The Secret History of American Crime Stories* (New York: Columbia University Press, 2009), 7.

57. Dan Abnett, Andy Lanning, and Dale Eaglesham, *The Punisher: Year One: Book Four* (New York: Marvel, March 1995), n.p. These lines are reproduced in the 2004 *Punisher* movie. Throughout this study, ellipses without brackets are in the source material while brackets indicate where I made cuts for reasons of clarity.

58. Patricia Cornwell, *Postmortem* (London: Sphere, [1990] 2010), 8.

59. Gerry Conway and Felix Ruiz, *The Punisher Annual* #1 (New York: Marvel, December 2016), n.p.

60. Andy Diggle and Kyle Hotz, *The Punisher: Silent Night* #1 (New York: Marvel, February 2006), n.p.

61. Jimmy Palmiotti, Justin Gray, and Paul Gulacy, *The Punisher: Bloody Valentine* #1 (New York: Marvel, April 2006), n.p.

INTRODUCTION

62. H. Jon Rosenbaum and Peter C. Sederberg, eds. *Vigilante Politics* (Philadelphia: University of Pennsylvania Press, 1976), 20.

63. Georg Simmel, *Conflict and the Web of Group-Affiliations* (New York: The Free Press, [1908] 1955), 20.

64. Matt Fraction, Rick Remender, and Howard Chaykin, *Punisher War Journal* #2.19 (New York: Marvel, July 2008), n.p.

65. David Graeber, *The Utopia of Rules: On Technology, Stupidity, and the Secret Joys of Bureaucracy* (New York: Melville House, 2016), 213.

66. Corey Robin, *Fear: The History of a Political Idea* (New York: Oxford University Press, 2004), 12.

67. Ennis and Mandrake, *The Punisher* #5.26, n.p.

68. Graeber, *The Utopia of Rules*, 211.

69. Garth Ennis and Lewis Larosa, *The Punisher* #6.1 (New York: Marvel, March 2004), n.p.

70. Fredric Wertham, "The Superman Conceit," in *The Superhero Reader*, eds. Charles Hatfield, Jeet Heer, and Kent Worcester (Jackson: University Press of Mississippi, 2013), 47.

71. Mike Baron and Ron Wagner, *Punisher War Journal* #1.32 (New York: Marvel, July 1991), n.p.

72. Mike Baron and Mike Harris, *Punisher War Journal* #1.37 (New York: Marvel, December 1991), n.p.

73. "No rationalizations, Micro. You were 'victimizing the underclass' and you know it! They couldn't help being murderous slime because our rotten society did them dirt. Not their fault. You believe that, you believe pigs can fly." Larry Hama and Hoang Nguyen, *Punisher War Zone* #1.20 (New York: Marvel, October 1993), n.p.

74. Chuck Dixon and Gary Kwapisz, *Punisher War Journal* #1.52 (New York: Marvel, March 1993), n.p.

75. Richard Maxwell Brown, "Vigilantism in America," in *Vigilante Politics*, eds. H. Jon Rosenbaum and Peter C. Sederberg (Philadelphia: University of Pennsylvania Press, 1976), 94, 108.

76. Edward Stettner, "Vigilantism and Political Theory," in *Vigilante Politics*, 64, 70, 74.

77. Stettner's chapter appeared in the same year that Schmitt's best-known essay, "The Concept of the Political," was first translated into English. See Carl Schmitt, *The Concept of the Political*, trans. George Schwab (New Brunswick: Rutgers University Press, [1932] 1976). We shall revisit the Schmitt–Punisher nexus in Chapter 3.

78. Schmitt, *The Concept of the Political*, 26, 27.

79. Chuck Dixon and Walter McDaniel, "Mott Haven 10454," *The Punisher Back to School Special* #1.1 (New York: Marvel, November 1992), n.p.

80. Marc DiPaolo, *War, Politics and Superheroes: Ethics and Propaganda in Comics and Film* (Jefferson: McFarland, 2011), 120.

81. Mike Baron and Erik Larsen, *The Punisher* #1.26 (New York: Marvel, November 1989), 4.

82. Don Lomax and Alberto Saichann, "Soiled Legacy," *The Punisher Summer Special* #1.4 (New York: Marvel, July 1994), n.p.

83. Steve Greenfield, Guy Osborn, and Peter Robson, *Film and the Law: The Cinema of Justice* (Oxford: Hart Publishing, 2010), 198.

84. "I knew the character was violent," complained reader Laura S., "but I never realized to what extent until I recently read an issue. I was aghast." She added, "I hope to make a career of teaching morals to the young of our country and therefore am directly opposed to the publishing of this comic. It seemed to me that the Punisher is teaching kids it is all right [*sic*] to kill. How you can publish such fodder with a clear conscience is beyond me." Laura S., "Punisher War Journal Entries," *Punisher War Journal* #1.49 (New York: Marvel, December 1992), n.p.

85. The term comes from computer engineering. It refers to "systems containing tightly coupled hardware and software components" that "perform a single function" and "form part of a larger system." See http://engineering.uprm.edu/embedded/wp-content/uploads/2013/12/Chapter1.pdf.

86. John G. Gunnell, *Imagining the American Polity: Political Science and the Discourse of Democracy* (University Park: Penn State University Press, 2004), 7–9.

87. Martin Barker, "*Jackie* and the Problem of Romance," in eds. Jeet Heer and Kent Worcester, *A Comics Studies Reader* (Jackson: University Press of Mississippi, 2008), 193.

88. On comics studies, see Frederick Luis Aldama, *Comics Studies Here and Now* (New York: Routledge, 2018); Frederick Luis Aldama, eds., *The Oxford Handbook of Comic Book Studies* (New York: Oxford University Press, 2020); Charles Hatfield and Bart Beaty, eds., *Comics Studies: A Guidebook* (New Brunswick: Rutgers University Press, 2020); Hatfield, Heer, and Worcester, eds., *The Superhero Reader*; Jeet Heer and Kent Worcester, eds., *Arguing Comics: Literary Masters on a Popular Medium* (Jackson: University Press of Mississippi, 2004); and Heer and Worcester, eds., *A Comics Studies Reader*.

89. An exception is Richard Reynolds, *Superheroes: A Modern Mythology* (Jackson: University Press of Mississippi, 1994).

90. See, *inter alia*, José Alaniz, *Death, Disability, and the Superhero: The Silver Age and Beyond* (Jackson: University Press of Mississippi, 2015); Caroline Cocca, *Superwomen: Gender, Power, and Representation* (New York: Bloomsbury, 2016); Mel Gibson, David Huxley, and Joan Ormrod, eds., *Superheroes and Identities* (New York: Routledge, 2015); Michael Goodrum, Tara Prescott-Johnson, and Philip Smith, eds., *Gender and the Superhero Narrative* (Jackson: University Press of Mississippi, 2018); Sean Guyes and Martin Lund, eds., *Unstable Masks: Whiteness and American Superhero Comics* (Columbus: Ohio State University Press, 2020); Charles Hatfield, *Hand of Fire: The Comics Art of Jack Kirby* (Jackson: University Press of Mississippi, 2011); Joan Ormrod, *Wonder Woman: The Female Body and Popular Culture* (London: Bloomsbury, 2020); and Ben Saunders, *Do the Gods Wear Capes?: Spirituality, Fantasy, and Superheroes* (New York: Continuum, 2015).

91. See John Shelton Lawrence and Robert Jewett, *The Myth of the American Superhero* (Grand Rapids: Wm. B. Eerdmans, 2002); and Robert Jewett and John Shelton Lawrence, *Captain America and the Crusade Against Evil: The Dilemma of Zealous Nationalism* (Grand Rapids: Wm. B. Eerdmans, 2004).

INTRODUCTION

92. Alicia M. Goodman, et al., eds., *Judge, Jury and Executioner: Essays on The Punisher in Print and Screen* (Jefferson: McFarland, 2021).

93. See, for example, Andrew R. Getzfeld, "What Would Freud Say? Psychopathology and the Punisher," in *The Psychology of Superheroes: An Unauthorized Exploration*, ed. Robin S. Rosenberg (Dallas: Ben Bella Books, 2008); Travis Langley, ed., *Daredevil Psychology: The Devil You Know* (New York: Sterling, 2018); and Damon Young, "The Punisher's Numb Rage," *Meanjin* 76.3 (Spring 2017): 118–23. The psychotherapist Larry Lewis puts Castle on the couch in his Youtube series, "Hero Therapy," https://www.youtube.com/watch?v=dEOTB696WZU. Also see the chapters by John Harnett, Anders Lundgren, and Matthew J. McEniry in Goodman et al., *Judge, Jury and Executioner*.

94. Philip Ball, *The Modern Myths: Adventures in the Machinery of the Popular Imagination* (Chicago: University of Chicago Press, 2021), 159.

95. See, for example, Tim Blackmore, "Doug Murray's *The 'Nam*, A Comic Battle for Vietnam at Home and Abroad," *Lit: Literature Interpretation Theory* 5(3–4) (1994): 213–25; Harriet Earle, "Conflict Then, Trauma Now: Reading Vietnam Across the Decades in American Comics," *European Journal of American Culture* 37(2) (June 2018): 159–72; Shawn Gillen, "Captain America, Post-Traumatic Stress Syndrome, and the Vietnam Era," in *Captain America and the Struggle of the Superhero: Critical Essays*, ed. Robert Weiner (Jefferson: McFarland, 2009); and Graeme John Wilson, "'When the Gunfire Ends': Deconstructing PTSD Among Military Veterans in Marvel's Punisher," *Popular Culture Studies Journal* 8, no. 1 (2020): 101–19. See also the chapters by Stephen Connor, Mike Lemon, and Kathleen McClancy in Goodman et al., *Judge, Jury and Executioner*. A thoughtful, vet-centric take is Andrew J. Friedenthal's "The Punishment of War: Marvel Comics' The Punisher and the Evolving Memory of Vietnam," *Journal of Comics and Culture* 1 (2016): 123–49. I remain unconvinced, however, that the Punisher "was in many ways designed to be an ultra-right-wing version of Spider-Man" (124), and am struck by how Friedenthal's account renders the character's New York City background almost invisible.

96. Matthew Rosenberg and Szymon Kudranski, *The Punisher: War in Bagalia* (New York: Marvel, 2019), n.p.

97. Exceptions include Carrie Lynn D. Reinhard and Christopher J. Olson, "AKA Marvel Does Darkness: Jessica Jones, Rape Allegories and the Netflix Approach to Superheroes," in *Jessica Jones, Scarred Superhero: Essays on Gender, Trauma and Addiction in the Netflix Series*, eds. Tim Rayborn and Abigail Keyes (Jefferson: McFarland, 2018); Robert Voelker-Morris and Julie Voelker-Morris, "Stuck in Tights: Mainstream Superhero Comics' Habitual Limitations on Social Constructions of Male Superheroes," *Journal of Graphic Novels and Comics* 5, no. 1 (2014): 101–17; and Friedrich Weltzien, "Masque-*ulinities*: Changing Dress as a Display of Masculinity in the Superhero Genre," *Journal of Fashion Theory* 9(2) (2005): 229–50. See also the chapters by Alicia M. Goodman, Elizabeth Jendrzey, and Meredith Pasahow, and Kelly Kanayama in Goodman et al., *Judge, Jury and Executioner*.

98. Relevant sources include Joseph Darda, *How White Men Won the Culture Wars: A History of Veteran America* (Berkeley: University of California Press, 2021); Jamie Longazel, "Blue Lives Matter and the Legacy of Blackface Minstrelsy," *Race and Class* 63(1) (2021): 91–106; and Meneka Philips, "Violence in the American Imaginary: Gender, Race, and the Politics of Superheroes," *American Political Science Review* 115(4) (November 2021): 1–14.

99. Bonnie Mann, *Sovereign Masculinity: Gender Lessons From the War on Terror* (New York: Oxford University Press, 2014), 5–6.

100. Murray Edelman, *Political Language: Words that Succeed and Policies that Fail* (New York: Academic Press, 1977), 49.

101. "Stick to action that fits the medium of comics," suggested one reader. "You don't have to avoid violence, but avoid portraying reality in such a twisted, fear-inspiring, downright false manner." Matt I., "Punisher War Journal Entries," *Punisher War Journal* #1.54 (New York: Marvel, May 1993), n.p.

102. For the would-be female Punisher Lynn Michaels, Castle's war journal "makes him sound like a psychopath. Advice I could never take. How to kill, how to view your target as nothing but a target. How to live as an animal, without joy or pleasure or companionship. And bleak beyond my understanding." Steven Grant, Chuck Dixon, and Hugh Haynes, *Punisher War Journal* #1.75 (New York: Marvel, February 1995), n.p.

103. Michael H., "War Correspondence," *Punisher War Journal* #1.74 (New York: Marvel, January 1995), n.p.

104. David B., "Punisher War Journal Entries," *Punisher War Journal* #1.58 (New York: Marvel, September 1993), n.p.

105. Stephen Wacker, "Let's Be Frank," *The Punisher* #8.12 (New York: Marvel, August 2012), n.p.

106. Carl Potts, "Editorial Note," *Punisher War Journal* #1.25 (New York: Marvel, December 1990), n.p.

1

Trauma Culture

Fear is a warning, Princess.

—Maurice Chevalier, *Love Me Tonight* (1932)[1]

When the *Daily Worker* sent Mike Davidow to Moscow to report on political happenings and daily life in the Union of Soviet Socialist Republics (U.S.S.R.) at the end of the 1960s, he was struck by the contrast between his orderly new neighborhood and the decaying metropolis he left behind. As a seasoned journalist, Davidow was well positioned to write about the United States and the U.S.S.R. His book about his experiences—*The Soviet Union Through the Eyes of an American* (1975)—makes for entertaining reading. While his portrait of the U.S.S.R. has a rosy, airbrushed quality, his depiction of life back home is both disturbing and familiar. "Americans who walk our cities' streets are bundles of worries," Davidow reminded his readers.

> They worry about their landlord. They worry about getting or keeping a job. They worry about the calamity that would strike them should they get sick and when serious illness strikes them they worry about paying the doctor and the hospital and about losing their jobs. They worry about walking the streets at night. They worry about their youth getting sucked into the expanding whirlpool of drug addiction. These are by no means a complete list of the worries.[2]

Davidow's approach was positively understated compared to the line taken by the anonymous authors of *Welcome to Fear City: A Survival Guide for Visitors to the City of New York* (1975), copies of which were distributed by off-duty police officers and firefighters to "travelers arriving at New York City's airports in June 1975."[3] The cover was decorated with an ominous black-and-white skull, while the interior pages advised anyone who was visiting on business to stay off the streets after 6 p.m., to avoid all forms of public transportation,

and to steer clear of the outer boroughs. "If you remain in Midtown areas and restrict your travel to daylight hours," the pamphlet warned, "emergency service personnel are best able to provide adequate supervision and protection." Even in "midtown Manhattan, muggings and occasional murders are on the increase in the early evening hours."[4] The authors went on to note that in the "four-month period that ended April 30, 1975, robberies were up by 21 per cent, aggravated assault was up 15 per cent, larceny was up 22 per cent, and burglary was up 19 per cent." The takeaway was clear. "The best advice we can give you is this: Until things change, stay away from New York City if you possibly can."[5]

Produced by the Council for Public Safety, *Welcome to Fear City* depicted New York City as a failed state. The *New York Times* reported that the Council was "an amalgam of 24 unions with 80,000 members serving in the uniformed services."[6] Union members had ample cause to be concerned about looming budget cuts and layoffs. But the pamphlet's take was pitiless. The pro-business Association for a Better New York compared passing out copies of the pamphlet at Kennedy Airport to "burning down the factory in a labor dispute."[7]

The journalist Kevin Baker notes that many of the pamphlet's warnings were

> ludicrous exaggerations or outright lies. The streets of midtown Manhattan weren't "nearly deserted after six in the evening," and they were perfectly safe to walk on. The city hadn't "had to close off the rear half of each [subway] train in the evening so that the passengers could huddle together and be better protected." There were still many safe and secure neighborhoods outside Manhattan, and there was neither a spate of "spectacular" robberies nor deadly fires in hotels.[8]

As even Baker admits, however,

> a frightening truth lurked beneath much of the pamphlet's calamity howling. Crime, violent crime, had been increasing rapidly for years. The number of murders in the city had more than doubled over the past decade, from 681 in 1965 to 1,690 in 1975. Car thefts and assaults had also more than doubled in the same period, rapes and burglaries had more than tripled, while robberies had gone up an astonishing tenfold. It's difficult to convey just how precarious, and paranoid, life in New York felt around that time.[9]

Whether every claim in *Welcome to Fear City* was precisely accurate is of course beside the point. Legends, half-truths, and apocrypha were integral aspects of a social and political crisis that lent a desperate sense of urgency to the

increasingly popular vigilante genre. The inevitable result was a loaded discourse about economics and crime that was also about race and class. Consider the following passage from Roger Starr's widely reviewed *The Rise and Fall of New York City* (1985):

> Necklace snatchings, pocketbook grabbing, mugging at knifepoint, subway assaults—all are accompanied with oral threats, sudden spurts of violence, and senseless injuries, even killings. White victims of these attacks understandably find themselves thinking that they have been assaulted because of their race. They forget, for the moment, that blacks are even more frequently the victims of these random crimes. For the white victims, the crimes seem to promise the outbreak of a desperate race war; and older citizens perceive large parts of the city as a battleground, too dangerous for them at all hours.[10]

The same year that Starr's race conscious *cri de coeur* appeared, public authorities reported 1683 murders, 68,270 aggravated assaults, 89,706 robberies, 219,633 burglaries, and 5706 forcible rapes[11] out of a total population of 7,164,742. Fourteen thousand felony acts were reported in the subway system alone—the equivalent of "one attack per 71,000 riders."[12]

Did these numbers invite vigilance or vigilantism? The prevailing discourse was not encouraging. Roger Starr himself warned that "the crime that has emerged in New York City threatens the very existence of the city in its present form."[13] Thomas Reppetto, president of the city's Citizens Crime Commission, said that "crime is tearing at the vitals of this city and has completely altered ordinary life."[14] The writer Sam Fussell recalled, "New York days I spent running wide-eyed in fear down city streets, my nights passed in closeted toilet-bound terror in my sublet."[15] Film critic Vincent Canby warned that the Big Apple was turning into

> a metaphor for what looks like the last days of American civilization. Its citizens are at the mercy of its criminals who, often as not, are protected by an unholy alliance of civil libertarians and crooked cops. The air is foul. The traffic is impossible. Services are diminishing and the morale is such that ordering a cup of coffee in a diner can turn into a request for a fat lip.[16]

Grappling with these kinds of oracular assertions requires more than a passing familiarity with crime statistics; it takes an appreciation for a certain kind of story. Starr, Reppetto, Fussell, and Canby were responding to the crisis on the basis of things they had witnessed and endured but also on the basis of things they *knew to be true*. All social commentary was (and remains)

narratological, whatever else it might be. And so it follows that pop culture vigilantism was not simply an opportunistic gesture on the part of publishers and film producers. Rather, a murderous vigilante like the Punisher represented a mandate for telling angry stories about a civic culture that was already telling itself angry stories.

Judgment day

It should be easy to appreciate why the prevailing discourse about the nation's most populous city shifted. As the title of the Doobie Brothers' 1974 studio album announced, "What were once vices are now habits." After the Second World War, "New York's working-class neighborhoods, its loft districts, even its City Hall, crackled with energy," writes the historian Joshua Freeman. "New York became a laboratory for a social urbanism committed to an expansive welfare state, racial equality, and popular access to culture and education."[17] The political historian Ira Katznelson suggests that the city's "bustling commerce," "diversified manufacturing," and "explosive rates of downtown construction" placed NYC "in the midstream of the period's complacent assumptions."[18] The city became the nation's symbol of a brighter tomorrow. One of the pleasures of the early seasons of *Mad Men* (2007–15) is how they recover this midcentury structure of feeling.

Yet the social critic Lewis Mumford had already concluded in the 1930s that

> the anonymity of the big city, its impersonality, is a positive encouragement to a-social or anti-social actions. Hence a professional form of surveillance, by an organized police, must take the place of neighborly scrutiny and pressure: a city of strangers lacks any other form of stabilizing check.[19]

In Mumford's view, city residents had good reason to be anxious and wary even when crime rates were low. In the absence of stabilizing pressures grounded in kinship and personal association, extraordinary measures would always be required.

Other observers started sounding the alarm about crime, corruption, and crumbling infrastructure during the Kennedy administration. Mitchell Gordon's *Sick Cities* (1963), for example, identified significant issues with the city's air quality, water quality, sanitation system, and welfare programs. Gordon insisted that for growing numbers of city residents, street crimes— muggings, purse snatchings, pickpocketing, car break-ins, and so on—had become their number one concern. "FBI crime statistics," he complained,

32

"almost suggest that it is safer, these days, to be a criminal in fear of the law than a law-abiding citizen in fear of the criminal." Part of the blame lay with "the public-relations policy of police departments, which are understandably more interested in conveying an image of police efficiency than in depicting the alarming growth of lawlessness."[20] Furthermore, big city departments like the New York Police Department (NYPD) were hidebound in their methods and slow to take advantage of what modern technology had to offer. Gordon left unmentioned the question of criminal misconduct on the part of the police force itself, however, which would roil the NYPD less than a decade after *Sick Cities* was published, largely as a result of the work undertaken by the Knapp Commission in 1970–71.[21]

For many NYC residents, the good times were winding down around the time that the Knapp Commission's hearings were being broadcast on television. "Government, the university, the media, the foundations, they are all bankrupt of practical ideas," complained the *Village Voice*'s political reporter, Jack Newfield, a few years later, in 1976. He added:

> For years, liberals ignored the rising problems of crime, foolishly believing any public talk about it was "a subtle form of racism." Eugene McCarthy said that in 1968. George McGovern said it to me in 1972. At the same time, crime was the biggest problem in Harlem and Bed-Stuy. Meanwhile, conservatives preempted the issue, won votes, and pushed repressive solutions that do not work either: capital punishment, preventive detention, no-knock laws. I see no evidence that any institution in society actually knows how to rehabilitate prison inmates, cure heroin addiction, or make the court-system function.

At the very least, ever-worsening news on the economic front aggravated the policy challenges that Newfield identified in his article. During the half-decade between 1969 and 1974, the city

> lost over six hundred thousand jobs, a 16 percent drop. Though the downturn hit all aspects of the city economy, the majority of the lost jobs were in goods-producing industries. Construction employment plunged in the face of a surplus of office space and a drastic drop in residential building. Manufacturing employment shrank by 35 percent, as the city lost over a quarter of its printing and publishing jobs, nearly a third of its jobs in apparel and textile production, and almost half its jobs making food and beverage.[22]

The social scientist John Mollenkopf reports that the "1969–72 and 1973–75 recessions devastated New York City more than any other city, with the possible

exception of Detroit."[23] The evaporation of unionized blue-collar jobs was accompanied by falling incomes, food insecurity, panhandling, homelessness, and what Freeman terms "the plague of abandonment and arson' across some areas of the city. "Hundreds of thousands" of residents "went to bed each night in terror of being woken by sirens and the possible loss of all they owned, or their very lives."[24] Kim Phillips-Fein observes that by "the early 1970s, this confident and prosperous city seemed frayed almost beyond recognition":

> New York's once-beautiful parks were dirty and deteriorating. Its glorious research library was deep in the red. The public hospitals were dilapidated, their emergency rooms overcrowded and their equipment out of date. The city university was struggling to meet demand. Fires had started to tear through the once stable neighborhoods of the South Bronx. The economy that had supported the expansive social sector of the postwar years was falling apart.[25]

The concerns of the poor overlapped with but were not coterminous with those of the elite. When Union Carbide moved out of NYC in 1975, a company spokesperson said,

> It is an image we have to contend with. And it isn't just crime and high living costs. It's the city's changing ethnic mix, which makes some people uncomfortable, and the graffiti on the subways, the dirt on the streets, and a lot of other things.[26]

Meanwhile, for editorial cartoonists the city had become "a sinking ship, a zoo where the apes were employed as zookeepers, a naughty puppy being swatted by a rolled-up newspaper, a stage littered with overturned props."[27] The conversation about "New York's seemingly eternal fiscal crisis"[28] was never merely about budget numbers.

It was around the start of his second term, in 1969, that the liberal Republican Mayor John Lindsay and his closest aides began to admit to themselves that the city was facing bankruptcy.[29] By that point, city leaders had become accustomed to borrowing large sums from the country's biggest banks and renegotiating these loans when they finally came due. They were slow to recognize the dangers of relying on a small number of creditors and mistaken in their assumption that the federal government would provide loan guarantees in the event that one or more private sector lenders baulked at lending NYC more money.

Under Lindsay's successor, Abraham Beame, their worst fears were realized. In 1975, the city's dismal climacteric produced an emergency crisis regime that brought together bankers, politicians, municipal labor chiefs, and corporate leaders

in an effort to stabilize the city's finances through "wage freezes, job cuts, and soaring taxes."[30] At this point, the city owed something on the order of $5–$6 billion in short-term debt, out of an operating budget of $11.5 billion. According to the city's budget director, Peter Goldmark Jr., "Many people believe there is little or no real security or receivables behind these obligations."[31] The severity of the crisis, and the unwillingness of the federal government to provide the city with additional loans and securities, paved the way for a coalition of unelected power brokers to impose steep rises in sales taxes, property taxes, transit fares, hospital bills, park and library fees, and tuition at CUNY along with previously unthinkable reductions in the quality of public services, from class sizes and bus routes to street cleaning and trash collection.

While the emergency crisis regime "succeeded in shifting the city's financial priorities,"[32] it conspicuously neglected to generate an improved sense of public safety. As part of the effort to reduce the gap between the city's receivables and payables, the Big Apple laid off 5000 police officers and 14,000 other city employees in July 1975. Astonishingly, "from July 1975 to November 1979, no police officers were hired or trained in the city of New York," and "no classes were held at the Police Academy."[33] Yet violent crime continued to rise even after the Police Academy reopened. The city's murder rate peaked at around 2245 in 1990 and remained well above 1500/year through the first half of the decade. As Phillips-Fein notes, "Crime statistics are notoriously slippery, subject to political considerations and changes in reporting, but the trend is clear."[34]

As crime rates spiraled upwards—and long after they started climbing back down—specific incidents were talked about and remembered in ways that barely registered the events themselves. Consider the following (true) story. In January 1984, three Columbia undergrads discovered an enormous carpet, "rolled up and tied at both ends and in the middle," in a dumpster on West 114th Street. When they carried the carpet to their dorm they found a dead body inside: "a black male in his late twenties or early thirties who had been shot once or twice in the head." The incident received negligible attention from the city's dailies. A week later, a letter writer to the *Columbia Daily Spectator* said he found it ironic that the paper had run pieces about "vocal student opposition to Columbia's gentrification of Morningside Heights while supporting the neighborhood's character. Where are those students now, when the 'character' of the neighborhood manifests itself with a dead body in Carmen [Hall]?" In this instance, a single deadly crime became an occasion for spurning an entire section of the west side of Manhattan.[35]

Dead bodies in carpets is at the heart of the Punisher metanarrative. As editor Stephen Wacker observes, Frank Castle is

a perfect distillation of 1970s paranoia, fear and the very '70s sense that the system just wasn't looking out for you. He was the first character at Marvel that seemed to reflect the world exactly as it was a particular moment, especially New York City, which was in a desperate struggle for its financial life, and a year away from a President being paraphrased as telling the town to "Drop Dead."[36]

The pace and scale of civic erosion help explain how a good kid from the outer boroughs became so disaffected that slaughtering thousands made any sense to begin with. The Punisher's historically motivated violence severs justice from the law and neutralizes any hint of complicity or weakness on the part of the lone wolf. It implies a rejection of ancient ideals of mutual aid and citizenship in favor of the moral self-sufficiency of the heavily armed freeman.

Decades on, the ghost of civic breakdown and catastrophic lawlessness continues to sterilize and legitimize the Punisher's murderousness. As Jacques Lacan points out, "at the very heart of the primary processes, we see preserved the insistence of the trauma in making us aware of its existence. The trauma reappears, in effect, frequently unveiled."[37] According to Lacan, as summarized by the comics scholar Harriet E. H. Earle, "trauma is at the origin of the subject. It is something that marks the subject irreparably, but also something that the subject doesn't experience. As such, the experiences are not mastered by the subject; instead, they produce the subject."[38] The urban crisis, as it was experienced and interpreted at the time, and subsequently invoked and reimagined, is the trauma at the origin of the Punisher. The murder of Castle's family, and the tidal wave of crime that it speaks to, is the inciting incident that confirmed his deepest fears.

The personal and social tragedy that marks and scars Frank Castle sets him apart from other comic book characters. Punisher stories preserve "the insistence of the trauma in making us"—the reader—"aware of its existence." His trauma response allows creators and consumers to process and debate issues of crime, criminal justice, and vigilantism, with a special focus on the five boroughs as the character's home base and as the exemplar of urban decline.

But while the Punisher's NYC roots and his military service are constitutive, they are ultimately only part of the equation. National and international trends are also baked into the formula. As the novelist Brian Garfield pointed out at the time, during the 1970s the country was coping with "unemployment, recession, inflation, revelations of political chicanery, crop failures, petroleum and energy crises, and all the other burdens our society has to bear."[39] These simultaneous challenges contributed to the sense that the country was experiencing a prolonged and unprecedented polycrisis. Crime was by no means the only fracture point. Military escalations in the 1960s and oil shocks in the 1970s stimulated tremendous inflationary pressures, even as globalization made itself felt

across manufacturing sectors. Factories shuttered while job losses, divorce rates, and interest rates skyrocketed. The Punisher is usually written as an embittered character and pretty much always as a pessimist. The fit between the character's crepuscular outlook and the gloomy conjuncture within which he was conceived is striking.

Less well remembered, but significant from the standpoint of inspiring numerous storylines as well as contributing to this atmosphere of mounting crisis and anxiety, were the activities of "a half-dozen significant underground groups,"[40] including the Weather Underground, the Symbionese Liberation Army, and the Black Liberation Army. Whatever their sectarian differences, these groups shared a commitment to the politics of propaganda by deed. "During an eighteen-month period in 1971 and 1972," writes journalist Bryan Burrough, "the FBI reported more than 2,500 bombings on U.S. soil, nearly 5 a day." Fewer than one percent of these "1970s-era bombings led to a fatality,"[41] and not all of them were committed by members of organized groups. What is perhaps most significant for our purposes is that the spectacle of former campus radicals detonating explosions at banks, courthouses, and military recruitment centers gave embittered patriots yet another reason to feel that the postwar American dream was on life support. Almost everything about the counterculture—from long hair and rock music to marijuana and New Age spirituality—seems tailor-made to rub someone like Frank Castle the wrong way. As the historian Rick Perlstein has observed, "what one side saw as liberation the other saw as apocalypse."[42]

Jorge Zaffino's cover illustration for *The 'Nam* #52, from January 1990 (Figure 1.1), highlights the antagonistic character of the Punisher's response to his social environment. Here he is wearing his military uniform, hunting combatants in Southeast Asia rather than criminals in the northeastern United States. But the powerful sense of fury that is expressed by this striking and combative image could be aimed at any number of targets.

The way of hatred

The term "vigilante" derives from the term given to the night watchmen of ancient Rome, the *Vigiles Urbani*, who kept an eye out for fires, burglars, and runaway slaves.[43] The concept was kept alive by tales of rebel-vigilantes such as the *Beati Paoli* and the *Vendicatori* of Sicily, two secret societies that were formed in the eleventh and twelfth centuries, respectively, and forest bandits like the Coteral gang of fourteenth-century England. There are also legendary rebels like Robin Hood of Nottingham Forest and the Swiss folk hero William Tell. The label was subsequently attached to frontier groups in the New World that sought to

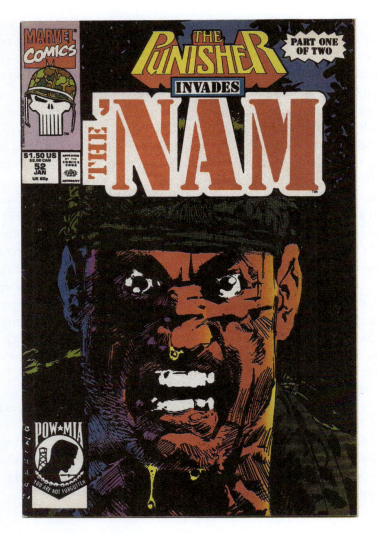

FIGURE 1.1: Jorge Zaffino, *The Punisher Invades The 'Nam* #52, cover illustration, January 1990. © Marvel Comics.

"reestablish in each newly settled area the conservative values of property, law, and order"[44] during the late eighteenth and nineteenth centuries.

The Regulators of the "predominantly Republican counties of La Grange and Noble in northern Indiana," for example, stated "as their First Resolution on January 9, 1858" that "whenever laws, made by those to whom they have delegated their authority, are found inadequate for their protection, it is the right of the people to take the protection of their property into their own hands."[45] According

to the historian Richard Maxwell Brown, nearly 100 such groups were formed between 1767 and 1897, the majority of which "were clustered in the period from 1850 to 1879 when the nation was wracked by Civil War violence in the East and the tensions of rapid frontier settlement in the West." As Brown notes,

> By the latter half of the nineteenth century the ritual-like action of organizing a vigilante movement had been carried out so many times on so many frontiers that to many settlers it often seemed an unnecessary delay to swift lynch-law justice. A local consensus in favor of immediate vigilante action without any of the traditional formalities produced *instant vigilantism*.[46]

The Regulators and similar organizations helped inspire the western genre, which occupied a central place in popular culture for much of the twentieth century and inarguably laid the groundwork for the urban vigilante. The genre has many facets and can handle more than one type of storyline. Westerns can be concerned with strangers on a stagecoach, lawmen abandoned by their neighbors, and cowpokes taming wild horses.[47] But many western heroes are rural vigilantes and are as quick to dispense instant justice as their urban counterparts. As the literary historian Richard Slotkin points out,

> The displacement of the Western from its place on the genre map did not entail the disappearance of those underlying structures of myth and ideology that had given the genre its cultural force. Rather, those structures were abstracted from the elaborately historicized context of the Western and parceled out among genres that used their relationship to the Western to define both the disillusioning losses and the extravagant potential of the new era. Violence remained as central to these new genre-scenarios as it had been to the Western, but the necessity for violence was no longer rationalized by an appeal to the progressive historical myth of westward expansion.[48]

One of the earliest of the urban vigilantes was Thomas De Quincey's The Avenger, who first appeared in an 1838 short story of the same name. "The Avenger" is about "an Englishman of rank" named Maximilian Wyndham, who avenges a spate of murders that menace "our large suburb." "I cared little in the way of love," Wyndham tells the reader. "But in the way of hatred I cared everything." Should those of faint heart "complain of the bloodshed and terror, think of the wrongs that created my rights."[49]

Another landmark text is Eugéne Sue's *The Mysteries of Paris*, which tells the story of an aristocrat who fights criminals with an exceptionally fierce sense of determination. Grand Duke Rodolphe of Gerolstein's exploits serialized between June 1842 and October 1843.[50] "I do what is just," the character explains, which is to say, "What

is just before God and my conscience."[51] He tells the reader, "some kinds of suffering are precious," and shouts, "I thirst for certain kinds of tears!" The Grand Duke maintains a secret identity, that of Rodolphe, an ordinary Parisian. This guise allows him to pursue "vice, infamy, and crime with single-minded hatred and implacable vengeance" without arousing any suspicion. His superpower is his ability to mimic the speech, mannerisms, and gait of the working man such that no one who interacts with him in one environment could possibly recognize him in the other.[52]

Alexandre Dumas' *The Count of Monte Cristo* (1844), whose eponymous hero describes himself as "placed on this earth to punish the guilty,"[53] is perhaps the best-known nineteenth-century precursor to the modern vigilante. In a crucial scene, the Count recalls his journey from "kind, trusting and forgiving" to "crafty and cruel":

> I laid in my provisions, loaded my weapons and prepared every means of attack and defense; I accustomed my body to the most vigorous exercises and my soul to the most violent shocks; I taught my arm to kill, my eyes to watch suffering and my lips to smile at the most terrible sights; from the kind, trusting and forgiving man I had once been, I made myself vindictive, crafty and cruel, or, rather, impassive like deaf and blind Fate itself. Then I set out on the path that lay before me and I reached my goal; woe to those whom I met on my way![54]

Chris Gavaler identifies yet another forerunner in Thomas F. Dixon Jr.'s *The Clansman: An Historical Romance of the Ku Klux Klan* (1905). A national bestseller, Dixon's explicitly racist novel was adapted for the screen under the title *Birth of a Nation* (1915).[55] Gavaler provocatively describes Dixon's "homicidal Klansmen" as the "first twentieth-century dual-identity costumed heroes in American lit." The Klansmen "keep their alter egos a secret and carry their costumes with them," and Dixon even gives them the first superhero mission statement: "To protect the weak, the innocent, and the defenseless from the indignities, wrongs, and outrages of the lawless, the violent, and the brutal: to relieve the injured and the oppressed." Dixon's heroes espouse a prelapsarian mythology that is much more sentimental than Frank Castle's terse rhetoric, however. While Gavaler notes that "history has tossed the Klan" into the "bad guys bin," Dixon's ideal hero-type, much like the Punisher, "was a violent, law-breaking criminal fighting for law and order."[56]

"The Vigilante" (1940), a song by the folk singer Woody Guthrie, offers a related example of amoral gunmen serving as instruments of an oppressive social order. Guthrie's lyrics recount the violence inflicted by hired men on Dust Bowl migrants during the Great Depression. One stanza reads: "Preacher Casey was just a workin' man/And he said, 'Unite all you working men'/Killed

him in the river some strange man/Was that a vigilante man?"[57] From the standpoint of this study, it is suggestive that Guthrie's song was revived in the 1970s and 1980s by Ry Cooder and other musicians with a special interest in Americana.

The first wave of fictional vigilantes were often more reluctant about using physical force than real-world Regulators or Klan members. Baroness Orczy's Scarlet Pimpernel (1905) is "a man of action" and "an English gentleman spreading English values among the benighted."[58] Johnston McCulley's Zorro (1919) is another earnest swashbuckler who has migrated across film, stage, television, and comics. The Lone Ranger (1933) operates outside the law, but "never shoots to kill, but rather only to disarm his opponent as painlessly as possible."[59] The Scarlet Pimpernel, Zorro, and the Lone Ranger are vigilantes but they are not vengeful. These heroes get testy, but are never enraged.

Private detectives such as Carroll John Daly's Terry Mack (1923) and Mickey Spillane's Mike Hammer (1947) proved far less squeamish about spilling blood than gentleman heroes like the Scarlet Pimpernel. As the literary historian Lee Server points out, Terry Mack and Mike Hammer "inhabit a sado-masochistic dream world where no license is required, either for the detective or the wild dreamer at the typewriter."[60] Mack was the first of the hardboiled detectives,[61] while Hammer was the most successful and quite possibly the most sadistic.[62] The scale of the Punisher's campaign makes Mack and Hammer look small-time, but paperback writers like Daly and Spillane opened the floodgates. In *One Lonely Night* (1951), Hammer says:

> Want to hear that philosophy? It's simple enough. Go after the big boys. Oh, don't arrest them, don't treat them to the dignity of the democratic process of courts and law ... do the same thing to them that they'd do to you! Treat them to the unglorious taste of sudden death ... Death is funny, Judge, people are afraid of it. Kill 'em left and right, show 'em we ain't soft after all. Kill, kill, kill, kill!

"Maybe I did have a taste for death," Hammer allows.[63] "It would be an understatement," conclude Stuart Hall and Paddy Whannel,

> to say that Mike Hammer enjoys killing and violence. He is pathologically committed to it. It is not simply a question, as in some other novels in the same genre, of using the crime and pursuit of the killer as an excuse to indulge the reader in violent fantasies. Hammer in Spillane novels is himself the violent agent.[64]

The same may be said of the Punisher.

Post-1960s vigilantes like Mack Bolan and Frank Castle embraced Hammer's values but set their sights on a wider array of targets. "The weather certainly

changed," writes the film scholar Thomas Schatz, "and cynicism, alienation, and frustrated romanticism reappeared, along with a nostalgic longing for the supposed simplicity of pre-'60s America."[65] Rather than avenging misdeeds, these hardboiled vigilantes declared war on the criminal underworld. In effect, they applied the maximalist strategy of propaganda by deed to criminals rather than banks. Their alienated brutality contextualizes the extraordinary mayhem that the aggressors have achieved in comparison to previous cohorts of make-believe crime fighters.

The rougher sort of vigilantism is also an aspect of comic book history. In his very first appearance, Batman crushes a "burly criminal" in a "deadly headlock" and knocks another into a tank of boiling acid. "A fitting ending for his kind," he intones, adding, "And I swear by the spirits of my parents to avenge their deaths by spending the rest of my life warring on all criminals."[66] The early Superman could be equally spiteful. In one early story, an 'armament profiteer' clutches a test tube and cries, "I've got it at last—what I've always sought—the most horribly destructive gas on earth!" When Superman bursts through the window, the profiteer drops the vial and chokes to death. Once he is certain the profiteer is dead, Superman exclaims, "One less vulture!"[67]

Less well-known than Batman or Superman is DC's Vigilante, who first appeared in *Action Comics #42* (November 1941). Like many midcentury heroes, Vigilante had a sidekick, Jimmy Leong, who went by "Stuff the Chinatown Kid."[68] Leong was eventually killed off, but DC remains stubbornly attached to the Vigilante moniker. Over the years the sobriquet has been applied to no fewer than seven different characters. The second, Adrian Chase, enjoyed a particularly tumultuous run in the 1980s. We will return to his tragic saga at the end of Chapter 4.

Dark streets

The advent of a *ressentiment*-addled vigilante in the pages of *The Amazing Spider-Man* reflected deep-seated social and cultural trends. Far from heralding the arrival of the murderous antihero, Frank Castle was the comic book version of an archetype that had already proven popular across a range of media. Don Siegel's *Dirty Harry* (1971) proved particularly consequential in terms of inspiring imitators and reframing the national conversation about policing, crime, and victims' rights.[69] As the writer Hal Draper told his radio listeners in 1972, *Dirty Harry* is a

> well-made right-wing movie, virtually a Birchite propaganda film, made with the cooperation of the great liberal mayor of San Francisco and his great liberal Police Department. Harry, a San Francisco police detective, is a mad-dog sadist killer in plain clothes, with a badge, who hates people, blacks, browns, and himself (more or less in

that order) and who is shown to be a great hero who rescues civilization from a crazy killer, who is also in plain clothes but minus a badge [...] And so the audience is set up to root for Dirty Harry as he denounces Supreme Court decisions as soft on crime, and indicts the bleeding-hearts who release an insane murderer to kill more people just because they're civil libertarian do-gooders. This enlightening film even shows you that this mad dog (I mean the sniper) gets himself beat up deliberately in order to accuse Dirty Harry of doing it—so who can believe any stories about police brutality now?[70]

Mad dogs like Harry Callahan and Mack Bolan were very much on the minds of Gerry Conway and his colleagues as they worked to affix an unappeasable gunman onto a canvas that already included aliens, mutants, dinosaurs, werewolves, vampires, time travelers, living planets, and night nurses. Conway himself cites both *Dirty Harry* and the Executioner series as key influences.[71] In 1987 he told a reporter, "I was fascinated by the Don Pendleton Executioner character, which was fairly popular at the time, and I wanted to do something that was inspired by that, although not to my mind a copy of it."[72] Conway later said in an interview with *Marvel Visions* that the

> Punisher was going to be a one-issue villain, to be defeated at the ending. Instead, something strange happened. The writer became fond of his villain. The character voice was stronger than I thought, so I made him more of a man than I had planned him to be. Originally he was gonna be one of Spidey's non-powered super-villains, like Crime Master or The Big Man, but there was something different about him. He seemed too interesting to be killed or sent to jail at the end of the issue.
>
> I liked the idea of the Punisher, a loner, operating on the outside of the law and society, in a war to destroy all crime. I thought it would be interesting to have him go after Spider-Man, because the *Daily Bugle* had been calling him a criminal. The Punisher was a tough, unpredictable character. My inspiration was *The Executioner* series ... the paperback books by Don Pendleton. They're modern equivalents of the pulps. That's what gave me the idea for the lone, slightly psychotic avenger. There's even a little of the Shadow in the Punisher.[73]

The film historian Eric Lichtenfeld points out that 1970s-style vengeance storytelling brings together three established genres: the western, film noir, and the police procedural. This combination, he says,

> would prove to be an effective choice: *noir*'s urban, hard-bitten milieu was an appropriately cynical, disaffected stage for the pulverizing of human life, while the Western's mythos would legitimize violence as a righteous force to tame the 1970s' social wild.[74]

For "more than three decades," he concludes, "the American action film has represented potent ideas of what America is."[75]

Along with *Dirty Harry*, Hollywood's other famous contribution to vengeance culture is Michael Winner's *Death Wish* (1974), which was released a few short months after the Punisher's debut in *The Amazing Spider-Man*.[76] *Death Wish* and *Dirty Harry* inspired four sequels each, and a *Death Wish* remake was released in 2018, to dismal reviews. The Dirty Harry films are more nuanced than the Death Wish series, which quickly devolved into a pulpy rote exercise, although *Death Wish 3* (1985) has a manic quality that has to be seen to be believed. There are novelizations of the first four Dirty Harry films along with a dozen original Dirty Harry novels. All sixteen titles evangelize on behalf of Harry Callahan's old-school value system and his never-ending battle against junkies, psychos, and "the awesome caseload that threatened to bury the Homicide Division under the creeping glacier of the crime rate."[77]

While the big screen version of Brian Garfield's 1972 *Death Wish* novel celebrates the protagonist's one-man war on street criminals, the novel itself offers an ambivalent character study. The hero—Paul Benjamin in the book, Paul Kersey in the movie—is a devoted family man who lives on the Upper West Side. One day his wife and daughter are attacked in their apartment. His wife never recovers from her injuries, and his daughter dies after spending weeks in a coma.[78] Shocked out of his liberal complacency, Paul embraces the retributive lifestyle. Both the film and the novel are propelled by his violent acts, but the novel pays closer attention to the psychological breakdown that accompanies the character's "right-wing radicalization."[79] The following passage makes the character's fascist impulses explicit:

> He found he was looking from face to face along the rows of crowded passengers, resentfully scanning them for signs of redeeming worth: if you wanted to do something about overpopulation this was the place to start. He made a head-count and discovered that of the fifty-eight faces he could see, seven appeared to belong to people who had the right to survive. The rest were fodder [...] Their lives were unending litanies of anger and frustration and complaint; they whined their way from cradle to grave. What good were they to anyone? Exterminate them.[80]

Garfield was "no fan of the film, charging that it advocated violence."[81] In penance he wrote a sequel, *Death Sentence* (1975), which is even more scornful in its treatment of Paul's "appeasement of his private demons."[82] The hero relocates to Chicago, where he accidentally kills the intended victim of two of his targets and inspires inept copycats. An acquaintance who connects the dots tells Paul,

> it's time to quit. You've tried an experiment, it didn't work out—you found a drug that cures the disease but kills the patient [...] If you keep going, more innocent

people will suffer. Things inside you will compel you to make mistakes until they find you and put you away; or you'll get killed by one of your intended victims.[83]

As the journalist Susan Faludi points out,

the cowboy's progeny would become ever more grotesque—as *Dirty Harry*'s Harry Callahan and *Death Wish*'s Paul Kersey and all the other avenging vigilantes who patrolled the late-twentieth-century celluloid landscape sought retribution in the name of murdered and violated wives and young women.[84]

Without the trail blazed by Don Siegel and Michael Winner, it is difficult to imagine B-movies like James Glickenhaus's *The Exterminator* (1980) or William Lustig's equally lurid *Vigilante* (1983)—which ends with the hero using a car bomb to assassinate a soft-hearted judge—getting financed or released. The voiceover to *Vigilante*'s trailer ticks all the right boxes:

An asphalt jungle. An urban skyline of fear. Waiting. Watching. Destroying. You're not safe anymore to walk the streets, when every hour 163 more people become victims of assault. You live at the mercy of the animals who inhabit the streets of every city. People who place little value on their lives, and even less on yours. You live in a country where 12 women are raped every minute. Where 65 people are murdered each day. It's happening now. It's happening this minute. The police are powerless. The law is corrupt. And the courts turn them loose. There is only one alternative. It's time to take a stand. Because time is running out. You're not safe anymore. Their numbers are growing. And you must wage a war to eliminate the problem yourself. Vigilante.[85]

Action movies from this era often referenced NYC's decline, as did other genres with an eye for begrimed realism, such as cops-and-robbers, horror, and sometimes science fiction. Films like *Escape from New York* (1981), *The French Connection* (1971), *Fort Apache the Bronx* (1981), *Mean Streets* (1973), *The Taking of Pelham One Two Three* (1974), *Taxi Driver* (1974), *The Warriors* (1979), and *Wolfen* (1981) all rely on local dialects, location shots, and uneasy musical scores to put across that "gritty, grimy atmosphere that can't be reproduced on a Hollywood soundstage."[86] The blaxploitation genre proved equally adept at using the mean streets as a backdrop for tales about criminals, lone wolves, and the police, as reflected in films like *Shaft* (1971), *Super Fly* (1972), *Black Caesar* (1973), and *Hell Up in Harlem* (1973). Not every crisis movie was shot in New York's five boroughs or landed at the box office. Seventies-era tough guy cinema nevertheless provides a window onto the cultural landscape within which Marvel's writers, artists, editors, and readers were operating as the Punisher was coming into focus.

45

Filmmakers continue to revisit themes of crime and vengeance, but usually out of a sense of cinematic homage rather than sociological compulsion. With a smattering of exceptions, contemporary vigilante movies rarely exhibit the kind of negative energy that fuels *Dirty Harry* or *Vigilante*. *John Wick* (2014) offers slick visuals and a sensational body count, but the hero's anger is personalistic—*you killed my dog*—rather than antisocial and anti-institutional. The many thrillers that appeared in the wake of September 11th were concerned with transnational terrorists and governmental conspiracies rather than street criminals and crime bosses. Revenge is a theme in the Jason Bourne movies, and in post-9/11 Bond films like *Casino Royale* (2006) and *Quantum of Solace* (2008), but that does not make them vigilante movies.[87]

Primetime television was slower to warm to the vigilante construct. Detectives like Columbo who growl but eschew bloodshed do not count. That said, shows like *The A-Team* (1983–87), *The Equalizer* (1985–89), and *Hunter* (1984–91) flirted with the kind of revanchist bravado that had already captivated filmgoers. It is suggestive of the pressures on primetime programs that each of these series was toned down by the end of their first seasons. *The A-Team*'s third episode, "Children of Jamestown," penned by series creator Stephen J. Cannell, is gloriously downcast. When the Team finds itself in a tight spot, John "Hannibal" Smith says, "That's why you gotta, right now, accept death. It calms you. We'd rather die than end up in jail."[88] It would be hard to find anything similar from later seasons. *T. J. Hooker* (1982–85) is remembered as a goofy William Shatner vehicle, but in the pilot the former Captain Kirk plays a whiskey-guzzling divorcee who tells the police cadets that,

> There's a war going on out on our streets. People are scared. They have a right to be. The body count is high. Homicide, assault, forcible rape, burglary, armed robbery— all up. Street savvy hoods have no fear. Not of the courts, not of prison. When a bust does stick, we house them, give them color TV, and their wives on weekends. If that makes sense to you, then you and I are about to have a problem, because I'm your instructor here and I *love* to weed out airheads and marshmallows.[89]

Serial fiction

The true stomping ground of the urban vigilante was neither television nor film but serial pulp fiction. A remarkable volume of ultraviolent paraliterature gushed forth in the 1970s and 1980s. Examples include James Dockery's The Butcher series (1970–82), featuring a hero "who literally makes his enemies soil themselves in fear";[90] Joseph Rupert Rosenberger's Death Merchant series (1971–88), with "thorough descriptions of the science behind hand grenades";[91] Lionel Derrick's

inelegantly named Penetrator series (1973–84);[92] and Andrew Sugar's The Enforcer series (1973–79), an "action series with a sci-fi twist as terminal cancer patient Alex Jason is approached by the John Anyrn Institute, an organization founded on Ayn Rand's selfishness-is-a-virtue bullshit philosophy."[93] Doug Masters' TNT series (1985–86) is arguably "the most demented of them all [...] in book six, *Ritual of Blood*, TNT investigates the disappearances of recently married millionaires, leading back to a woman named Bluebeard and a family of inbred, humanoid spiders."[94] Other oddities include Gilbert A. Ralston's Dakota Warpath series (1973–75), about "a modern Indian warrior [who] fights new battles in today's west,"[95] and Warren Murphy and Richard Sapir's The Destroyer: Remo Williams series (1971–), whose hero can "run on sand without leaving a trace, and even run on semi-liquid surfaces (e.g., wet cement) without sinking in."[96]

These seven series alone generated hundreds of titles. And yet they represent a fraction of the roughly 150 men's adventure series that were launched in the 1970s and 1980s.[97] According to James William Gibson, a typical entry featured a "minimum of 20 but sometimes as many as 120" graphic descriptions of violence. "Most series came out four times a year with domestic print runs of 60,000 to 250,000 copies," he adds.[98] Very few of these series are still being published. Most are long out of print. Moralistic and violent, these books were mostly cast in a realistic vein, although some titles incorporated fantasy, horror, and/or science fiction elements. As one critic pointed out, these series' heroes might have been bloodthirsty, but they "are not amoral killers." Instead,

> They're people who believe that the Menace is not unbeatable, if you use the right weapons. Theirs is a tough, questionable ethic, but one that is a fit answer to the fantasy needs of the '70s. Because we have so long felt helpless, our hero is utterly competent. Because turning the other check has only made us victims twice over, he administers not mercy but ruthless justice. Because religious skepticism and political complicity have undermined our trust in authority, he is independent and self-justified.[99]

The most successful of these franchises, the Executioner series, spans hundreds of instalments. Along with *Death Wish*, *Dirty Harry*, and the novels of Mickey Spillane, the Executioner is constitutive of the Punisher's metanarrative. The Executioner's creator, Donald Pendleton (1927–95) penned just under 40 titles before leasing the rights to Harlequin Enterprises. By the time he stepped down the series was an international hit.[100] While the paperback market seems well served by Executioner titles, there could be room for the brand to expand into other media. To date, a handful of Executioner comic books and graphic novels have appeared.[101] There is also talk of a film adaptation. Ironically, the main challenge in developing the

property is finding ways to distinguish Mack Bolan from his better-known progeny, Frank Castle.[102]

The Bolan storyverse is as high concept as the Punisher's. Mack Bolan "returns home from Vietnam to discover his father had slaughtered his own family, protecting them from what he believed would be an even worse fate at the hands of the mobsters he was indebted to."[103] "Why defend a frontline 8,000 miles away when the *real* enemy is chewing up everything you love back home?" Bolan asks. "What is needed here is a bit of direct action, strategically planned, and to hell with the rules."[104] Bolan then strikes a series of blows against criminal outfits in different parts of the country. He gathers information, identifies pressure points, and then mounts his attack. Each mission generates fresh leads, which he uses to work his way up the criminal food chain.

Despite their fundamental similarities, there are key differences between Bolan and Castle. Bolan is as lethal as Castle, but he is a comparatively humane and grounded figure, prone to moments of reflection and regret. He is also less cynical about human nature. It is difficult to imagine the Punisher being depicted in the same manner as Pendleton writes about Bolan in *Nightmare in New York* (1971):

> He did not view his actions as a holy crusade which was self-justified; quite often his self-doubts were immense and his revulsion to killing almost overpowering. He did not gladly sacrifice the earlier plan of his life to this gory walk through the valley of death; like most men he had desired for himself the simple things that gave life meaning—what Bolan termed "the three F's of the good life: friends, family, freedom." Reluctantly he had surrendered this quiet ambition to the three B's—"bullets, bombs, and blood."[105]

While there are multiple ways of telling a plausible Punisher story, to date none of his writers have considered the possibility that Castle might harbor a "revulsion to killing" that is "almost overpowering." The Punisher's lack of compunction about taking human life is one of his defining characteristics. But while Bolan and Castle have their differences, there are important similarities as well. Most obviously, they are both ex-military men who deploy extralegal violence to take down violent criminals. The Punisher offers a streamlined version of the Bolan archetype, but with a showier costume and far less self-doubt.

In his introduction to *The Executioner: Death Squad* (1996), comics writer Mike Baron characterizes the relationship between the Punisher and the Executioner in the following terms:

> At a time when the toughest fictional heroes might bump off a bad guy or several, Bolan was going after hundreds. Thousands. The sheer scale of his slaughter lifted

him out of the humdrum, creating the model for all the great slaughterers to follow, from Rambo to the Punisher.

Baron also admits that "Having written the Punisher, I will tell you right now he's based on the Executioner. Gerry Conway created the Punisher, but perhaps borrowed is a better term."[106]

If Don Pendleton was troubled by Marvel's slippery ethics, he did not seek restitution. As he told one interviewer,

> Let's just say the Punisher has taken a lot of liberties with my work. Anyone who knows the history of the Executioner has known that all along. I elected many years ago to just let it pass, feeling that there is room for both of us in this industry.

Admittedly, the Punisher "took a lot of what I consider 'signature pieces' including Bolan's War Journal, the War Wagon, and various situations which the Punisher incorporated."[107] Shortly after the character was introduced, Marvel published a lengthy interview with Pendleton that may have helped smooth things over. The conversation covers Pendleton's military service, and his dealings with publishers, but steers clear of the Punisher–Executioner nexus.[108]

An intriguing twist on the genre is supplied by Barry Malzberg's *Lone Wolf* series (1973–75). Writing under a pseudonym, Mike Barry, Malzberg (1939–) cashed in on the vigilante boom and deconstructed it at the same time. His antihero Burt Wulff, a Vietnam vet and NYPD officer, believed that the city was almost kaput:

> It was only a matter of time now: two years, maybe three and the last vestiges of safety and wealth would collapse and New York City, the cities all over the country, would collapse into the pools of hell that surrounded them.[109]

When Wulff receives a tip about a dead body in an apartment on West 93rd, he discovers his own fiancée splayed on the floor from an overdose. Something inside him snaps. "I'm going to kill some people," he vows. "I'm going to kill a *lot* of people."[110] He tosses his badge but keeps his service revolver.

Wulff works his way up the heroin supply chain, taking out hired guns and mafiosos until his death toll climbs into the hundreds. He initially blames organized crime for his fiancée's death but discovers that she was murdered by another officer. This bitter truth produces an even greater loss of perspective. "Rage was overtaking him," the reader learns. All he could do was take things "step by step" until "a sudden stab of revulsion, some aspect in the enemy's eyes, would trigger off an eruption from the layers of grief and rage buried within" and "his perilous control over himself would lapse."[111] He was "turning now into an indiscriminate

killer." If you "were in the business of death, you could not go into it halfway […] Wulff's own great wheel was spinning and spinning in the night, and where it came up death was delivered."[112]

Malzberg starts with the genre's conventional trappings but over the course of fourteen books turns them inside out. At first, Wulff comes across like a sympathetic character, but even in the first novel, there is a recklessness to his actions that suggests a disregard for collateral damage. And with each successive volume, Wulff becomes more and more estranged. Eventually, he decides that killing people was "all that humanity itself could be. Expiration. The administration of grace which marked the passage between the living and the dead, and that at the very end of time might be all that would stand to make the difference."[113] But when he is not chasing phantoms, Wulff muses about why others fail to appreciate his tactics and motives. He comes to wonder whether his actions might bring him into conflict with the police, many of whom initially sympathized with his campaign. After all, in his mind Wulff "had not specifically been acting against the law." Instead, "he had been acting outside of it." He was "delivering his message of justice to those who had needed that message for a long time but could not be touched by the normal processes because the framework of social retaliation had broken down."[114]

By the final volume, Wulff is reduced to randomly tossing grenades into seedy bars. "As long as the Lone Wolf is in business," he vaingloriously insists, "they would never be able to destroy the country."[115] In the end, he is gunned down by his former partner, who has come to realize that, "when killing becomes the major activity—the *modus operandi*—and is repeated over and over again, you begin to phase out the moral distinctions."[116] As Malzberg later told a blogger, "I knew exactly what I wanted to do before I typed the first line and I proceeded with conscious intention. Burton Wulff got ever crazier by intention."[117]

Murderous vigilantes like Mack Bolan, Burt Wulff, and Frank Castle are the legatees of an extended social crisis that left a lasting impression on the culture at large. They embody the anger, anxieties, and rhetoric that coursed through the body politic in the 1960s–80s, filtered through the lens of militarism, masculinity, humiliation, and grief. Yet each series envisions divergent outcomes for the hardboiled vigilante. Mack Bolan embarks on a journey that takes him from lone wolf to team player. Over time, his antisocial tendencies are harnessed for productive ends. In contrast, Burt Wulff's mounting sense of isolation drives him over the edge. Punisher stories point in both directions. At times, Frank Castle bottles up his sociopathology. At other moments, he acts in ways that are recklessly self-destructive.

For transparently commercial reasons, the Punisher is destined to return to a default position, one in which the character is back on track, prepping for his

next engagement. His plot armor allows him to cleave to his mission while evading capture or death. The Executioner and the Punisher are more famous than the Lone Wolf, but Barry Malzberg's sobering take on the vigilante construct reminds us that there are few plausible options for someone who engages in a campaign of extralegal violence. Maintaining the status quo requires that the reader not ask how such a system-defying risktaker is so rarely imprisoned or killed.

How the city be

If the late 1960s and early 1970s provide the primary signifiers for the intransigent vigilante genre—seedy streets, rising crime, corrupt officials, disaffected vets, hard drugs—the era that followed further justified and reinforced the tropes of antisocial entertainment. The "social chaos left behind by the crisis and the cuts endured"[118] long after the crisis regime placed the city's finances on a banker-friendly footing. The threat of civic breakdown was manifested by specific events, such as the blackout of July 14, 1977, and the rioting that erupted in its wake. After the

> night was over, the police had arrested thousands of looters, the firefighters had responded to over one thousand fires, entire car lots were looted, stores ransacked, and the main boulevards of the boroughs were a parade of people struggling to run weighed down with as much merchandise as they could carry.[119]

There were allegations of police misconduct: the 83rd Precinct in the Bushwick area of Brooklyn "was told to hang on to its 133 accused looters for a couple of days, until central booking was ready for them." The prisoners "had been wedged into an open courtyard between the cells and the property room. Several cops threw McDonald's hamburgers down to them from the detective squad on the second floor. At least one officer urinated on them."[120]

The social imagination was similarly inflamed by the Son of Sam slayings in 1976–77, the attack on the Central Park jogger in 1989, and the 1990 murder of 22-year-old Brian Watkins, who was stabbed to death on a busy subway platform as he tried to prevent his mother from being robbed.[121] Each of these incidents offered an occasion for mobilizing civic outrage and renewing calls to unleash the police, impose longer prison sentences, and restore the death penalty. Shortly following the Central Park media storm, a *New York Newsday* columnist warned,

> in some parts of the city, community, family and neighborhood in the traditional sense are gone. What we have left is a new form of capitalism gone wild in an

environment without government or law, in which human bodies and souls are for sale and the market is regulated by the power of the gun.[122]

Meanwhile, the real estate developer Donald Trump used the attack on the Central Park jogger as an occasion to place full-page advertisements in all four city dailies with the headline, "Bring Back the Death Penalty! Bring Back Our Police!" The text itself argues for a Schmittian agenda motivated by raw anger:

> Mayor Koch has stated that hate and rancor should be removed from our hearts. I do not think so. I want to hate these muggers and murderers. They should be forced to suffer. And when they kill, they should be executed for their crimes. They must serve as examples so that others will think long and hard before committing a crime or an act of violence. Yes, Mayor Koch, I want to hate these murderers and I always will. I am not looking to psychoanalyze them or understand them. I am looking to punish them.[123]

The ads cost the developer nearly $100,000 and launched his career as a public figure. But the convictions of the Central Park Five "were vacated based on DNA evidence and the detailed and accurate confession of a serial rapist." Trump continued to insist that the plaintiffs should have received the death penalty. "They admitted they were guilty," he told CNN. "The police doing the original investigation say they were guilty. The fact that that case was settled with so much evidence against them is outrageous."[124]

Trump's unshakeable belief in the guilt of the Central Park Five—"I want to hate these killers and always will"—speaks to ways in which the negative dialectic of vigilantism had retained its potency long after the era of stagflation and deindustrialization had given way to the finance/services/real estate boom of the 1990s. Primed by lived experience, social networks, and media reportage, residents became accustomed to thinking about the city's health through the prism of crime statistics. Along with local television news, the *New York Post*—purchased by Rupert Murdoch for $30.5 million in 1976—continues to play a notable role in proffering stories about violence, race, and politics. Even when crime rates dropped to levels last recorded shortly after the Second World War, outlets like the *Post* continued to promote horror stories that lent a patina of common sense to the vigilante construct.

As the example of the Regulators makes plain, vigilantism is by no means confined to the world of fiction. Richard Hofstadter and Michael Wallace point to the postwar neighborhood watch groups that organized street and car patrols "out of a sense of dissatisfaction with existing police protection."[125] By the early 1980s, in NYC alone, there were 65,000 registered block watchers and "135

neighborhood car patrols out on the streets, manned by 50,000 volunteers who sometimes drive as often as once a week."[126] The Guardian Angels offer the best-known example of this form of neighborly vigilantism. Founded in 1979, the Angels garnered national attention when they organized safety patrols in the New York subway system. The fact that the group's founder, Curtis Sliwa, later admitted that he faked several of the group's "early crime-fighting exploits," merely dented the group's reputation.[127] Another example of real-world vigilantism is the astonishing story of Bernie Goetz, who was dubbed the "Subway Vigilante" in late 1984 after shooting four alleged muggers on the number 2 subway line. The New York Court of Appeals summarized the incident as follows:

> Canty approached Goetz, possibly with Allen beside him, and stated, "Give me five dollars." Neither Canty nor any of the other youths displayed a weapon. Goetz responded by standing up, pulling out his handgun, and firing four shots in rapid succession. The first shot hit Canty in the chest; the second struck Allen in the back; the third went through Ramseur's arm and into his left side; the fourth was fired at Cabey, who apparently was then standing in the corner of the car, but missed, deflecting instead off of a wall of the conductor's cab. After Goetz briefly surveyed the train scene around him, he fired another shot at Cabey, who then was sitting on the end bench of the car. The bullet entered the rear of Cabey's side and severed his spinal cord.[128]

"In his confession," writes Wendy Kaminer, "Goetz described the pleasure he took in his attack," "I know and God knows what was in my heart. [...] It was attempted, cold-blooded murder. My problem was I ran out of bullets."[129] New Yorkers were divided on his actions. Readers' letters to the *Times* ran "about 5 to 1 in his favor" and read as if they were lifted from movie posters. "People have been running scared," wrote one correspondent. "Here's someone who struck back." "Why have you not written again and again and again about the utter failure of the police and the courts to protect the ordinary citizen?," asked another. "They used to hang people for stealing horses," opined a third reader. "It worked!"[130]

A *Daily News* poll conducted shortly before Goetz's first trial "found that only 19 percent of white New Yorkers favored indicting him at all, although 51 percent of African Americans did."[131] While Goetz was charged with assault, reckless endangerment, attempted murder, and several weapons-related offences, he was acquitted of all charges except one, that of carrying an unlicensed firearm.[132] Goetz later received 1,049 votes when he ran for mayor in 2001 on an anti-crime, pro-animal rights platform.[133]

The Punisher's cultural reach is connected to the fact that the urban crisis lasted far longer and cut far deeper than is often remembered. In 1989, during a televised

mayoral primary debate, the city's comptroller, Harrison J. Goldin, admonished the incumbent mayor, Ed Koch, for insisting that "almost everybody wants to come to New York":

> Ed, I think that we're not going to save New York until we get a mayor who recognizes that there are an awful number of people who want to leave here, who would leave if they could. We need a mayor who would acknowledge that, because that's what it's going to take to begin to improve the quality of life. That's why businesses aren't coming to New York. That's why businesses are leaving New York. Because of the crime situation. Because of the public schools' deterioration. Because you can't find an affordable apartment.[134]

Crime control

Throughout this chapter, we have approached the study of vigilantism as a four-box matrix: fiction, non-fiction, less violent, and more violent. We have assumed that the first two boxes offer yes/no propositions while the third and fourth boxes are organized along a spectrum.[135] While this way of thinking about vigilantism helps us distinguish, say, the Lone Ranger and Zorro from Mack Bolan and Frank Castle, it ignores the vigilante's underlying *goals*.

An alternative typology, one that is attuned to "the intended purposes of vigilante action," can be found in H. Jon Rosenbaum and Peter C. Sederberg's *Vigilante Politics* (1973). Rosenbaum and Sederberg distinguish between three types of vigilantism: "crime-control, social-group control, and regime control." The first is "directed against people believed to be committing acts proscribed by the formal legal system" and is "initiated by private persons' who view the state as "ineffectual in protecting persons and property."[136] The second is "directed against groups that are competing for, or advocating a redistribution of, values within the system." As the example of the Klan makes plain, "not all violence perceived as supportive of the status quo is exercised against 'normal' criminal activity."[137] The third involves "extralegal establishment violence against the formal instruments of government," such as "Stalinist terror against elements of the party" and "the criminal activities of those involved in the Watergate operation."[138] In effect, crime-control vigilantism centers around individuals, social-group vigilantism centers around groups, and regime-control vigilantism centers around institutions. In each case, the vigilante "over-identifies with authority rather than rebelling against it."[139] The vigilante is engaged in a politically charged activity, even if he or she may not think of themselves as politically minded.

The Punisher is a crime-control vigilante. His ire is directed at those who threaten and inflict physical harm. While Frank Castle occasionally takes on white-collar criminals, he is most often concerned with "street crime." He scrupulously avoids picking targets on the basis of creed, color, ethnicity, sexual orientation, or national origin.[140] Although he quite naturally finds hippies and liberals deplorable, that does not mean that hippies or liberals are Castle's enemies. Nor does he express any interest in promoting one political tendency or faction over another. The Punisher's vigilantism advances the case for tough-on-crime policies like longer prison sentences and the death penalty, except when the tough-on-crime position is being parodied or argued with. But while his campaign touches on policy debates, it does not invite readers to get involved in politics.

In the real world, crime-control vigilantism on the scale of a Burt Wulff or a Mike Hammer—let alone a Mack Bolan or a Frank Castle—is less common than social-group or regime-control vigilantism. It is the other way around in the realm of fiction.

NOTES

1. The screenplay for Paramount's *Love Me Tonight* was written by Samuel Hoffenstein, George Marion, Jr., and Waldemar Young. The film was directed and produced by Rouben Mamoulian.

2. Mike Davidow, *Cities Without Crises* (Moscow: Novosti Press Agency Publishing House, 1974), 11.

3. Karen Strike, "Welcome to Fear City," https://flashbak.com/welcome-fear-city-new-york-city-1975-399218/.

4. http://researchdestroy.com/welcome-to-fear-city.pdf.

5. https://flashbak.com/welcome-fear-city-new-york-city-1975-399218/.

6. Glenn Fowler, "'Fear City' Booklet Rights Again Upheld," *New York Times*, June 18, 1975, https://timesmachine.nytimes.com/timesmachine/1975/06/18/105340305.html?pageNumber=33.

7. Fowler, "'Fear City' Booklet."

8. Kevin Baker, "'Welcome to Fear City' – The Inside Story of New York's Civil War, Forty Years On," *The Guardian*, May 18, 2015, http://www.theguardian.com/cities/2015/may/18/welcome-to-fear-city-the-inside-story-of-new-yorks-civil-war-40-years-on.

9. Baker, "'Welcome to Fear City.'"

10. Roger Starr, *The Rise and Fall of New York City* (New York: Basic Books, 1995), 114–15.

11. http://www.disastercenter.com/crime/nycrime.htm and http://www.nytimes.com/1985/08/21/nyregion/new-york-leading-other-cities-in-us-in-population-gain.html. While the NYPD still uses the awkward term "forcible rape," the FBI stopped using the

term in 2013. http://www.nytimes.com/2012/08/24/us/definition-of-rape-is-shifting-rapidly.html.

12. Charles J. Hanley, "In Subway Crime, N.Y. Still Leads the World," *Los Angeles Times*, March 17, 1985, http://articles.latimes.com/1985-03-17/news/mn-35322_1_subway-crime.

13. Starr, *The Rise and Fall of New York City*, 116.

14. Quoted in Fred Siegel, *The Prince of the City: Giuliani, New York and the Genius of American Life* (New York: Encounter, 2007), 44.

15. "Caught in this nightmare," Fussell continues, "I needed something, anything, to secure my safety." He finds his answer in bodybuilding. Samuel Wilson Fussell, *Muscle: Confessions of an Unlikely Bodybuilder* (New York: Open Road, 1991), 11.

16. Quoted in Dominic Sandbrook, *Mad As Hell: The Crisis of the 1970s and the Rise of the Populist Right* (New York: Anchor, 2011), 126.

17. Joshua B. Freeman, *Working Class New York: Life and Labor Since World War II* (New York: The New Press, 2000), 55.

18. Ira Katznelson, *City Trenches: Urban Politics and the Patterning of Class in the United States* (Chicago: University of Chicago Press, 1981), 2.

19. Lewis Mumford, *The Culture of Cities* (New York: Harcourt, Brace, Jovanovich, [1938] 1970), 266.

20. Mitchell Gordon, *Sick Cities: Psychology and Pathology of American Urban Life* (New York: Penguin, 1965), 162.

21. Barbara Davidson, "The Knapp Commission Didn't Know it Couldn't Be Done," *New York Times*, January 9, 1972, https://www.nytimes.com/1972/01/09/archives/the-knapp-commission-didnt-know-it-couldnt-be-done-the-knapp.html.

22. Freeman, *Working Class New York*, 255.

23. John Mollenkopf, *A Phoenix in the Ashes: The Rise and Fall of the Koch Coalition in New York City Politics* (Princeton: Princeton University Press, 1994), 13.

24. Freeman, *Working Class New York*, 275–76.

25. Kim Phillips-Fein, *Fear City: New York's Fiscal Crisis and the Rise of Austerity Politics* (New York: Metropolitan, 2017), 21.

26. Quoted in Freeman, *Working Class New York*, 276.

27. Jonathan Mahler, *Ladies and Gentlemen, The Bronx is Burning: 1977, Baseball, Politics, and the Battle for the Soul of the City* (New York: Farrar, Straus and Giroux, 2005), 8.

28. The words are the Punisher's, taken from Terry Havanagh and Scott McDaniel, *Spider-Man, Punisher, Sabretooth: Designer Genes* (New York: Marvel, 1993), n.p.

29. Michael Armstrong, *They Wished They Were Honest: The Knapp Commission and New York City Police Corruption* (New York: Columbia University Press), 23.

30. Sandbrook, *Mad As Hell*, 127.

31. Baker, "'Welcome to Fear City.'"

32. Kim Moody, *From Welfare State to Real Estate: Regime Change in New York City, 1974 to the Present* (New York: Verso, 2007), 61.

33. Michael Oreskes, "Fiscal Crisis Still Haunts the Police," *New York Times*, July 6, 1985, http://www.nytimes.com/1985/07/06/nyregion/fiscal-crisis-still-haunts-the-police. html?pagewanted=all.

34. Phillips-Fein, *Fear City*, 55.

35. "Students Find Corpse Wrapped Up In a Rug," January 30, 1984, and "Letters," February 6, 1984, http://spectatorarchive.library.columbia.edu/cgi-bin/columbia?a=d&d= cs19840130-01&e=-------en-20--1--txt-txIN and http://spectatorarchive.library.columbia. edu/cgi-bin/columbia?a=d&d=cs19840206-01&e=-------en-20--1--txt-txIN------#. The victim has never been identified: http://bwog.com/2015/10/29/tbt-to-when-carman-was-even-spookier-than-it-is-today/.

36. Stephen Wacker, "Let's Be Frank," *The Punisher* #8.1 (New York: Marvel, October 2011), n.p.

37. Quoted in Harriet E. H. Earle, *Comics, Trauma, and the New Art of War* (Jackson: University Press of Mississippi 2017), 36.

38. Earle, *Comics, Trauma, and the New Art of War*, 37.

39. Brian Garfield, *Death Sentence* (Greenwich: Fawcett, 1975), 67.

40. Bryan Burrough, *Days of Rage: America's Radical Underground, the FBI, and the Forgotten Age of Revolutionary Violence* (New York: Penguin, 2016), 5.

41. Burrough, *Days of Rage*, 5.

42. Rick Perlstein, *Nixonland: The Rise of a President and the Fracturing of America* (New York: Scribner, 2008), 377.

43. Cecilia Ricci, *Security in Roman Times: Rome, Italy and the Emperors* (New York: Routledge, 2018), chap. 5.

44. Andrew Dagilis, "Siren Song of Blood: The Rise of Bloodthirsty Vigilantes in Comics," *The Comics Journal* 133 (December 1989), 91.

45. Dagilis, "Siren Song of Blood," 91.

46. Richard Maxwell Brown, *Strain of Violence: Historical Studies of American Violence and Vigilantism* (New York: Oxford University Press, 1975), 102–03.

47. See *Stagecoach* (1939), *High Noon* (1952), and *The Strawberry Roan* (1948).

48. Richard Slotkin, *Gunfighter Nation: The Myth of the Frontier in Twentieth-Century America* (Norman: University of Oklahoma Press, 1998), 633.

49. Thomas De Quincey, "The Avenger," reprinted in Thomas De Quincey, *On Murder* (New York: Penguin, [1838] 2006), 39, 59, 67, 80.

50. The series "was such a success that it saved the staid and respectable *Journal des Débats* from looming bankruptcy." Peter Brooks, Foreword to Eugène Sue, *The Mysteries of Paris*. London: Penguin, [1842–43] 2015), xiii.

51. Sue, *The Mysteries of Paris*, 81.

52. Sue, *The Mysteries of Paris*, 84–85.

53. Alexandre Dumas, *The Count of Monte Cristo* (New York: Bantam, [1842–43] 2015), 392.

54. Dumas, *The Count of Monte Cristo*, 411.

55. *Birth of a Nation* was the first motion picture to be screened at the White House and the first to be reviewed in the pages of the *New York Times*. See Thomas Cripps, *Slow Fade to Black: The Negro and American Film, 1900–1942* (New York: Oxford University Press, 1977), 27.

56. Chris Gavaler, *On the Origins of Superheroes: From The Big Bang to Action Comics No. 1* (Iowa City: University of Iowa Press, 2015), 179, 180, 190.

57. https://www.woodyguthrie.org/Lyrics/Vigilante_Man.htm.

58. Sally Dugan, *Baroness Orczy's The Scarlet Pimpernel: A Publishing History* (London: Routledge, 2016), 22, 1.

59. Quoted in Gavaler, *On the Origin of Superheroes*, 165. In the course of the Punisher's second appearance, Spider-Man says to himself, "What do I really know about this guy? He's like a modern-day Lone Ranger." Gerry Conway and Ross Andru, "Shoot-out in Central Park!" *The Amazing Spider-Man* #135, reprinted in *Essential Amazing Spider-Man* #6 (New York: Marvel, [1975] 2004), n.p.

60. Crime writer Ross Macdonald, quoted in Woody Haut, *Pulp Culture and the Cold War* (London: Serpent's Tail, 1995), 87.

61. Lee Server terms Carroll John Daly's 1923 story "Three-Gun Terry" the "first detective story in the new hard-boiled style." Lee Server, *Danger is My Business: An Illustrated History of the Fabulous Pulp Magazines, 1896–1953* (San Francisco: Chronicle Books, 1993), 63.

62. 'By 1953, Spillane's first six novels had topped 17 million copies sold, and Mike Hammer's creator had pulled past Erskine Caldwell and was now in second place as the best-selling author behind Erle Stanley Gardner'. Kenneth C. Davis, *Two-Bit Culture: The Paperbacking of America* (Boston: Houghton Mifflin, 1984), 180. Another useful overview is Lee Server, *Over My Dead Body: The Sensational Age of the American Paperback, 1945–1955* (San Francisco: Chronicle Books, 1994).

63. Quoted in Stuart Hall and Paddy Whannel, *The Popular Arts* (Durham: Duke University Press, [1965] 2018), 145.

64. Hall and Whannel, *The Popular Arts*, 144.

65. Thomas Schatz, *Hollywood Genres: Formulas, Filmmaking, and the Studio System* (New York: McGraw Hill, 1981), 149.

66. Reprinted in Bob Kane and others, *Batman Archives Volume 1* (New York: DC, [1939] 1990), 10–11.

67. Jerry Siegel and Joe Shuster, *Superman: The Dailies, 1939–1942* (New York: Sterling Publishing, 2006), 62–80.

68. Seriously, DC?

69. *Dirty Harry* cost $4 million to make, grossed $35 million, and was the fourth highest-grossing film of 1971. (The left-populist vigilante movie *Billy Jack* came in fifth.) Together, the five Dirty Harry movies have raked in over $225 million. See http://www.boxofficemojo.com/movies/?id=dirtyharry.htm.

70. Hal Draper, "Cops, Dirty Harry, and Junious Poole," *KPFA Commentary*, January 27, 1972, http://www.marxists.org/archive/draper/1972/01/cops.htm.

71. http://caryscomicscraze.blogspot.com/2016/06/writer-gerry-conway-talks-about.html and https://graphicpolicy.com/2016/05/24/tidewater-comicon-2016/.

72. http://www.cbr.com/comic-book-legends-revealed-567/.

73. Pat Jankiewicz, "Origin of the Species: The Story Behind Marvel's Big Bang Theory!" *Marvel Vision* #15 (New York: Marvel, November 1997), 30.

74. Eric Lichtenfeld, *Action Speaks Louder* (Middletown: Wesleyan University Press, 2007), 4.

75. Lichtenfeld, *Action Speaks Louder*, 8.

76. 1974 was also the year that European cinema embraced the hardboiled vigilante. Enzo G. Castellari's *Il cittadino si ribella* went into production a few weeks before *Death Wish* and offers a similar tale of a respectable citizen who resorts to extraordinary violence in the wake of a personal tragedy. Retitled *Street Law* for the North American market, the hard-bitten screenplay features a scene in which the hero says, "I'm tired of trusting my life with people who don't give a damn. Tired of taking it on the chin. Tired of being a docile, good citizen. The state is almighty. We owe it our allegiance. And what do we get in return? Nothing."

77. Phillip Rock, *Dirty Harry* (London: W. H. Allen, 1971), 6.

78. The daughter dies in the novel but survives the first film only to be raped and murdered in *Death Wish II* (1982).

79. Brian Garfield, *Death Wish* (New York: The Overlook Press, [1972] 2018), 63.

80. Garfield, *Death Wish*, 7.

81. Rob Hart, "Murder and Mayhem Pick: Death Wish." https://murder-mayhem.com/death-wish-brian-garfield.

82. Brian Garfield, *Death Sentence* (Greenwich: Fawcett, 1975), 39.

83. Garfield, *Death Sentence*, 230.

84. Susan Faludi, *The Terror Dream: Fear and Fantasy in Post-9/11 America* (New York: Metropolitan, 2007), 286.

85. https://www.youtube.com/watch?v=XWMw5XXwxxY.

86. "Gritty, Grimey New York City – Early 70s to Mid 80s," http://www.imdb.com/list/ls050641513/.

87. These distinctions are elided in Tom Pollard's book on Hollywood and 9/11, which lumps the 2004 *Punisher* movie with *Mystic River* (2003), *Sorry, Haters* (2005), and *Rambo IV* (2008) on the grounds that "each of these films reference terrorism, foreign or domestic." Tom Pollard, *Hollywood 9/11: Superheroes, Supervillains, and Super Disasters* (Boulder: Paradigm, 2011), 162.

88. http://www.imdb.com/title/tt0504158/. *The Equalizer*'s pilot opens with gunplay in a crowded subway station. Subsequent episodes offer kinetic sequences as well as notes of pure rage. But over time, the balance between action and melodrama shifted in favor of the latter. In the case of *Hunter*, season one episodes often close with cop-hero Rick Hunter

using his service revolver to slay the ep's main villain. After season one, episodes usually end with Hunter and his partner, Dee Dee McCall, playfully bantering.

89. https://www.youtube.com/watch?v=SMz2rOsnkhc.

90. Joe Kenney, "The Butcher #1: Kill Quick or Die," Glorious Trash, January 21, 2016, http://glorioustrash.blogspot.com/2016/01/the-butcher-1-kill-quick-or-die.html.

91. Gordon M. Jackson, "The Weirdest Spy Action Novels Ever Published," Gizmodo, February 11, 2015, https://gizmodo.com/the-weirdest-spy-action-novels-ever-published-1685259336.

92. The Penetrator "doesn't execute. He doesn't destroy. He doesn't liquidate. He penetrates! Huh?" "The Pentrator," Spy Guys And Gals, 2012, https://spyguysandgals.com/sg ShowChar.aspx?id=644.

93. "More Reviews of Books About Shootin' Fellas," Mighty Blowhole, May 18, 2012, http://mightyblowhole.blogspot.com/2012/05/more-reviews-of-books-about-shootin.html.

94. Jackson, "The Weirdest Spy Action Novels Ever Published."

95. Gilbert A. Ralston, *Dakota Warpath* (New York: Pinnacle 1973), front cover.

96. http://www.internationalhero.co.uk/r/remo.htm. In the film adaptation, *Remo Williams: The Adventure Begins* (1985), Wilford Brimley's surrogate-father character explains that, "our cops are corrupt, our judges are bought, our politicians are up for sale. Everywhere you look, slime is on the loose. You're going to be the Eleventh Commandment, 'Thou shalt not get away with it.'"

97. Brad Mengel, *Serial Vigilantes of Paperback Fiction: An Encyclopedia* (Jefferson: McFarland, 2009).

98. James William Gibson, *Warrior Dreams: Violence and Manhood in Post-Vietnam America* (New York: Hill and Wang, 1994), 6–7. Another oddball is Alexander L'Hiboux, aka the Owl, who spits, "You live only because, so far, you've managed not to make anyone mad enough to kill you." Robert D. Forward, *The Owl* (New York: Pinnacle Books, 1984), 211. See also Robert D. Forward, *The Owl: Scarlet Serenade* (London: New English Library, 1990).

99. Dan Hagen, "Execution, Destruction, and Other Entertainments," *Marvel Super Action* #1.1 (New York: Marvel, 1975), 50.

100. The Executioner series inspired four spin-off series: SuperBolan (1983–), Able Team (1982–91), Phoenix Force (1982–92), and Stony Man (1982–).

101. Innovation published three issues of *Mack Bolan: The Executioner: War Against the Mafia* by Don and Linda Pendleton in 1993. IDW published five issues of *Don Pendleton's The Executioner: The Devil's Tools* by Doug Wojtowicz in 2008. The best is Linda Pendleton's 1996 black-and-white graphic novel *The Executioner: Death Squad*, with pencils and inks by Sandu Florea, published by Vivid.

102. Executioner comics occasionally reference the Punisher. A house advert for the Innovation series warns: "Don't *Punish* Yourself With Imitations!," while a villain in the IDW series refers to Bolan as the "definitive lone crusader. Honestly, anyone else is just a *pretender*."

The Executioner 2: War Against the Mafia (August 1993), inside back cover, and Doug Wojtowicz and Si Gallant, *Don Pendleton's The Executioner 4: The Devil's Tools* (July 2008), n.p. When a fan asked, "When are you going to team up the Punisher with Mack Bolan," editor Carl Potts quipped, "As for the team-up, you know the Punisher only works with *professionals*." "Punishing Mails," *The Punisher* #2.27 (New York: Marvel, December 1989), 31.

103. Jackson, "The Weirdest Spy Action Novels Ever Published."

104. Donald Pendleton, *The Executioner #1: War Against the Mafia* (New York: Pinnacle, 1969), 13–14.

105. Donald Pendleton, *The Executioner #7: Nightmare in New York* (New York: Pinnacle, 1971), 8–9.

106. Mike Baron, "Back to the War," Linda Pendleton and Sandu Florea, *The Executioner: Death Squad* (Jamaica Estates: Vivid, 1996), 3.

107. http://www.donpendleton.com/mack-bolan-war-wagon.html.

108. *The Executioner's* first publisher, Pinnacle Books,

> was a very wobbly enterprise, and I still wonder how it ever got off the ground. David Zentner, the publisher, was virtually a one-man show. He had been publishing "adult" books; a guy starts where he can, I guess. With the Executioner, Zentner saw a chance to move into the more legitimate realms of publishing and we sort of took a chance on each other. He created Pinnacle and I created Mack Bolan; the "chance" has paid off rather well, but it was not always evident that it would do so. I was the sole Pinnacle author for more than a year. Of their first ten publications, eight were my books.
>
> David A. Kraft, "The Executioner Speaks Out! An Exclusive Interview with Don Pendleton," *Marvel Preview* #2 (New York: Marvel, 1975), 50.

109. Mike Barry, *The Lone Wolf 1: Night Raider* (New York: Berkley, 1973), 130.

110. Barry, *The Lone Wolf 1*, 11.

111. Mike Barry, *The Lone Wolf 10: Harlem Showdown* (New York: Berkley, 1975), 62.

112. Barry, *The Lone Wolf 10*, 138–39.

113. Mike Barry, *The Lone Wolf 14: Philadelphia Blowup* (New York: Berkley, 1975), 72.

114. Barry, *The Lone Wolf 10*, 87.

115. Barry, *The Lone Wolf 14*, 16.

116. Barry, *The Lone Wolf 14*, 138–39.

117. Ed Gorman, "The Lone Wolf Series," June 6, 2012, New Improved Gorman, http://newimprovedgorman.blogspot.com/2012/06/lone-wolf-series-by-mike-barrybarry_06.html.

118. Phillips-Fein, *Fear City*, 295.

119. Jefferson Cowie, *Stayin' Alive: The 1970s and the Last Days of the Working Class* (New York: The New Press, 2010), 220.

120. Mahler, *Ladies and Gentlemen, the Bronx is Burning*, 214.
121. Rudy Giuliani's biographer, Fred Siegel, writes bitterly about Watkins' murder:

> Then there was the case of twenty-two year old tourist Brian Watkins, in Gotham with his family for a visit to the U.S. Open Tennis tournament. A wolf pack of eight black and Hispanic youths, who were not from impoverished backgrounds, set upon the family at a subway station. When Brian came to his mother's defense, he was stabbed to death. The attack was part of an initiation ritual for a gang that required a mugging for membership.
>
> Siegel, *The Prince of the City*, 44.

122. Quoted in Jim Sleeper, *The Closest of Strangers: Liberalism and the Politics of Race in New York* (New York: Norton, 1990), 248–49.
123. http://assets.nydailynews.com/polopoly_fs/1.1838466.1403324800!/img/httpImage/image.jpg_gen/derivatives/article_970/trump21n-1-web.jpg?enlarged.
124. Sarah Burns, "Why Trump Doubled Down on the Central Park Five," *New York Times*, October 17, 2016, https://www.nytimes.com/2016/10/18/opinion/why-trump-doubled-down-on-the-central-park-five.html.
125. Richard Hofstadter and Michael Wallace, "Reflections on Violence in the United States," in Richard Hofstadter and Michael Wallace, eds. *American Violence: A Documentary History* (New York: Knopf, 1970), 24.
126. Diana Shaman, "Neighborhood Security Patrols Double," *New York Times*, January 24, 1982, https://www.nytimes.com/1982/01/24/realestate/neighborhood-security-patrols-double.html.
127. David Gonzalez, "Sliwa Admits Faking Crimes for Publicity," *New York Times*, November 25, 1992, http://www.nytimes.com/1992/11/25/nyregion/sliwa-admits-faking-crimes-for-publicity.html.
128. http://www.courts.state.ny.us/reporter/archives/p_goetz.htm.
129. Kaminer, *It's All the Rage: Crime and Culture*, 26.
130. Sydney H. Schanberg, "New York; The Bernhard Goetz Mailbag," *New York Times*, January 19, 1985, http://www.nytimes.com/1985/01/19/opinion/new-york-the-bernhard-goetz-mailbag.html.
131. John Cline, "Bernie's *Deathwish*: History and Transgression in New York City," in Robert G. Weiner, ed. *Cinema Inferno: Celluloid Explosions from the Cultural Margins* (Lanham: Scarecrow Press, 2010).
132. Goetz was later sued by one of the defendants, Darrell Cabey, in civil court. Adam Nossiter, "Bronx Jury Orders Goetz to Pay Man He Paralyzed $43 Million," *New York Times*, April 24, 1996, https://www.nytimes.com/1996/04/24/nyregion/bronx-jury-orders-goetz-to-pay-man-he-paralyzed-43-million.html.
133. https://en.wikipedia.org/wiki/2001_New_York_City_mayoral_election.
134. Sleeper, *The Closest of Strangers*, 15–16.

135. The distinction between fiction and history seems straightforward enough until we consider the case of Robin Hood, who was at least inspired by reports of forest bandits who donned "robbing hoods." See Michael Wood, *In Search of England: Journeys into the English Past* (Berkeley: University of California Press, [1999] 2008), chap. 4.

136. H. Jon Rosenbaum and Peter C. Sederberg, "Vigilantism: An Analysis of Establishment Violence," in H. Jon Rosenbaum and Peter C. Sederberg, eds. *Vigilante Politics* (Philadelphia: University of Pennsylvania Press, 1976), 10.

137. Rosenbaum and Sederberg, *Vigilante Politics*, 12.

138. Rosenbaum and Sederberg, *Vigilante Politics*, 18.

139. Rosenbaum and Sederberg, *Vigilante Politics*, 24.

140. Punisher stories published by Marvel, that is; fan-fiction and mash-ups are another issue altogether.

2

Trigger Happy, or Grim and Gritty

The meaning of stability is not limited to prices.

—West German Chancellor Helmut Schmidt (1974)[1]

Rage is the animating principle of the hardboiled vigilante metanarrative. It is the root of the Punisher's energy and appeal. Frank Castle's perpetual flame sets him apart from heroes who evince a more ambivalent relationship to negativity. If provoked, Wolverine can go berserk. Bruce Banner can transform into the Hulk. Thor can be pushed over the line. Even Spider-Man gets cranky from time to time. But these are transitory states of being. By contrast, the Punisher is never not angry.

The Punisher's very name says something about his emotional state. Appellations like "Spider-Man" and "Batman" offer readers limited information about the character's inner life. By comparison, "the Punisher" is unusually suggestive. By definition, a punisher is someone who favors physical force and is driven by strong views and powerful emotions. Cruelty, binarism, and judgmentalism are implied by his nom de plume, and underscored by his costume and origin story.

Frank Castle's fierce and implacable character logic fuses melodrama (the murder of his family) with lived experience (the urban crisis and the Vietnam War).[2] The pressures generated by these destabilizing shocks are mutually reinforcing. A heady combination of history, geography, and soap opera motivates his violence, rationalizes his crimes, thrills his audience, and situates his trauma. His early creators found his anger intriguing from a storytelling perspective yet troubling from a moral one. Their willingness to make light of the character encouraged other writers to offer their own assessments of the merits and downsides of a one-man crusade founded on rage and negativity.

As the moral philosopher Martha Nussbaum points out, to feel anger "you have to be capable of causal thinking: someone did something to me, and it was wrong."[3] This helps to explain the curious admixture of animalism and calculation in the Punisher's documented persona. For Frank Castle, his Schmittian enemies have committed three principal wrongs. The first is the murders of his wife and

children. Second and related is the catastrophic decline of his city. Finally, there are the lies and betrayals of U.S. foreign policy, as viewed through the prism of military service. The form his anger takes in any given story tells us what he and by extension his creators and audience might be expected to care about.

Criminality offers a compelling outlet for an outrage that all too often produces mayhem. The apparent ubiquity of criminal activity allows for an endless procession of scenarios and antagonists. The topic lends itself to sensationalism, soap boxing, and lurid graphics. Castle's anticrime crime wave conforms to what psychologists refer to as the "availability heuristic," which offers a "quick strategy for making judgments about the likelihood of occurrence."[4] This device, "through which the frequency or probability of an event is judged by the number of instances of it that can readily be brought to mind,"[5] helps explain why he cannot stop thinking about crime. When Castle thinks about his family, what comes to mind is violent and organized crime. When he considers his city, he zeroes in on those he blames for its decline: street criminals, drug lords, bankers, and corporate swindlers. And when he confronts foreign policy questions, such as in stories set in Washington, DC, and in the Garth Ennis-authored Vietnam War stories, he encounters decadent foreigners and well-heeled traitors. Gangsters, street criminals, and gaseous elites are the concentric circles of the Punisher's Sisyphean crusade.

Frank Castle's ontological insecurity, and the rage it underwrites, represent a marked departure from conventional superheroics. Even today, despite the coarsening of superhero discourse, Castle remains a dyspeptic outlier within the context of the serial comic book marketplace. While a handful of Marvel, DC, and Charlton antiheroes predate and anticipate the Punisher, none can match the character's body count or commercial vitality. He is at the center of one of the most significant developments in mainstream comic books over the past half-century: the emergence (in the 1970s) and success (in the 1980s) of a new strain of (anti)heroism, one that promises carnage rather than benevolent interventionism.

Expressive potential

While the Punisher is the product and symbol of a specific historical conjuncture, he has become emblematic of the cause of anger more generally. When artists render the character, they are expressing both a personality and an emotional state. The variability of their portraits, and the fact that their efforts are almost always convincing, is part of a larger story, which is that anger enjoys a surprisingly plastic relationship with the field of visual representation.

In *Understanding Comics* (1993), Scott McCloud argues that emotions can "be made visible," and that "all lines carry with them an expressive potential."[6]

McCloud then offers a series of black and white drawings that seek to encapsulate, with varying degrees of success, distinct emotional states—pride, madness, serenity, anxiety, and so on. For years, I have asked students to select the most effective of these images. They almost always pick his rendition of *anger*.

Anger can assume an array of guises. Typing a phrase such as "angry cartoon face" or "drawing of anger" into a search engine will yield a remarkable diversity of results.[7] The reader can confirm what I found when I undertook this experiment: that the first 100 images will summon the concept of anger in radically divergent ways. When I tried it, emanata were common but not prevalent. Clenched fists showed up in three of the 100 images, flames in four, and puffs of steam in six. None of these devices seemed essential but each was broadly persuasive. Facial features were also arranged in disparate ways. While fully 90 percent of the images featured cartoon faces with open eyes, in seven cases, the eyes were clamped shut, and, in three cases, they were missing altogether.

In most cases (91), the faces were slightly contorted, but in nine instances, the linework was inexpressive, conveying a sense of distance or chilliness. A majority (58) displayed clenched or bared teeth, while the remainder showed closed mouths (35), or no mouth at all (7). And in some cases, strong colors signified anger. Red was employed in over a quarter of the images (27), yellow was not uncommon (12), and nearly ten percent (9) featured figures with icy blue irises. A slim majority (52) were black-and-white. Gender was another aspect of this impromptu survey. Seventy of the images were either gender-neutral or weakly gendered, i.e., suggestive but not definitive. Thirty were unambiguously gendered. Half of the unambiguously gendered faces were male and the other half were female.

Cartoonists have access to a wide range of options when it comes to representing anger, in other words. They can employ well-established devices like fists, flames, or steam, or dispense with them altogether. They can draw eyes and mouths open or shut. They can deploy red as a signifier, or yellow, or blue, or black-and-white. They can invoke or elide conventional gender roles. They can distort and scrunch up the lines around the eyes and mouth, or make a statement using inexpressive linework. McCloud's interpretation of anger does not even bother with a face, let alone dialogue. All he offers is a messy eruption of ink. Yet anyone who glances at the panel will grasp what he is driving at. It is not just that anger is easy to render, which is noteworthy in its own right. It is that anger can be captured using such starkly contradictory elements.

What makes anger so malleable and expressible? Perhaps the answer has something to do with the attachment it claims on the modern psyche. For millions of people, anger is tangible in a way that, say, serenity is not. "America has always been an angry nation," writes the essayist Charles Duhigg. And for good reason, he says, since anger

is one of the densest forms of communication. It conveys more information, more quickly, than almost any other type of emotion. And it does an excellent job of forcing us to listen to and confront problems we might otherwise avoid.[8]

The social uses of anger help to explain why so many people have a passing familiarity with the Punisher even if they do not read comics or follow action heroes. Within the confines of the superhero genre, Frank Castle offers the functional equivalent of McCloud's inky outburst. The "winds of war call to him."[9] The Punisher offers what Slavoj Žižek lyrically terms "divine violence," which is "the domain of the violence which is neither law-founding nor law-sustaining."[10] "I must *kill* for the *sake* of *heaven*!"[11] cries the Foolkiller, a Punisher forerunner whose rage is fueled by a lethal cocktail of moral righteousness, hatred of the counterculture, and contempt for all social norms:

> There I was—Heaven's 18-year old *gift* to the earth—and the world was coming *apart* all around me. And it was *all* the work of *fools*! Criminals ... protesters ... dope pushers ... *mocking* the Lord and the military! All thru the sixties—I *watched*—wondering *why* I could not save the world. Asking myself what I had done *wrong*! And then the answer *came* to me: our times called for a *different* breed of savior—an *active agent* against the fools![12]

Like the Foolkiller, the Punisher is an "active agent" who hears the "winds of war" and secretly asks himself "what I had done *wrong*." But Frank Castle's inner life is more interesting and complex than the Foolkiller's. The Foolkiller is close to a stick figure, whereas Castle's emotional state assumes a variety of hues. His trauma manifests itself in divergent ways. Sometimes his behavior is stoical. At other times, he comes across as churlish. "Walk with me Francis," asks a nun. "You can tell me about yourself." "I don't do that," he snaps.[13] At other times, Castle behaves in a way that is merely erratic. His dialogue is usually mission-focused and even-keeled but intense feelings are sometimes etched on his face. During Mike Baron's run, Castle is patient and diligent. Garth Ennis' version, by contrast, nurtures an anger that is "building inexorably": "not raging, not even burning, just colder and colder by the minute."[14] Baron's Punisher is PG-13; Ennis' is R-rated. Ennis' Castle is far more liable than Baron's to find himself in situations where extreme violence is required if he is to survive. And in the Ultimates universe, an updated version of the Marvel Universe that launched in 2002, Mark Millar's Punisher displays a volcanic quality. He bulks up on super-soldier serum and erupts like the Hulk. "*Punish me!*" he screams at a squad of S.H.I.E.L.D. soldiers. "Hit *me*, you @#%$&!"[15]

Emotion is a virtue

Many of Marvel's best-known characters—Spider-Man, the Fantastic Four, Iron Man, the Hulk, Silver Surfer, and so on—launched in the psychedelic 1960s. Captain America and Submariner date to the communitarian 1940s. Frank Castle's contemporaries are neither trippy nor folksy. Instead, they include cantankerous misfits like Ghost Rider (1972), Moon Knight (1975), and Wolverine (1974), each of whom pushed the comics mainstream towards a dourer valiancy. "As optimism about the future gives way to pessimism, so hero is replaced by anti-hero," observes a psychology student in the series *Marshal Law*.[16] Frank Castle is the most single-mindedly homicidal of this damaged cohort, but Wolverine and company are each unsavory in their own way. The "realignment of the superhero proved both profound and long-lasting."[17] No character embodies this shift from hero to antihero more vividly than the Punisher.

The idea of inserting a pessimistic lone wolf into the Spider-Man storyverse was first proposed by the writer Gerry Conway. When Conway took over Stan Lee's writing duties on *The Amazing Spider-Man* #111 in the summer of 1972, he was still in his teens. Having attended parochial high school, Conway was "used to an authoritarian environment." "Marvel was liberating," he later recalled, "because that company was pure chaos. There were no adults in the room."[18] Within a year, Conway began working with his colleagues to bring "the first gun toting vigilante in modern comics"[19] into focus. Conway had a knack for inventing eccentrics who worked well in Spider-Man tales, such as Tarantula, Tombstone, and the Jackal. The Punisher, the least flamboyant of these creatures, was the only one to make the leap to the majors.

Long before Frank Castle became a postmodern global phenomenon, there was the challenge of devising his basic look. Conway proposed placing a skull-based chevron on a dark, body-fitting costume; John Romita, Sr. took this basic idea and ran with it. Romita was "responsible for the huge skull on the Punisher's chest, expanding Conway's original idea of a smaller white skull on a black jump-suit."[20] In Romita's version, the "eyes of the skull were in conjunction with his pectorals. The skull's cheeks were his rib cage. The nose was the base of his breastbone. And, of course, the skull's teeth made up his belt."[21] "Of all the designs I've done," Romita later remarked, "the one that's probably made the most impact is the Punisher costume."[22] Ross Andru, who penciled Castle's first appearance, "brought the costume and character to life, showing the Punisher to be a man of action with a permanent scowl."[23] Baseline aesthetic parameters were locked in from this point forward.

Gerry Conway initially planned on calling the new vigilante "the Assassin." But as Stan Lee "rightly pointed out, we could never have done a series on the Assassin

or turned him into a hero. Stan came up with the Punisher name, Gerry naturally decided to go with it, and he came out in *The Amazing Spider-Man* #129."[24] Incoming editor-in-chief Roy Thomas, along with the writer/editors Archie Goodwin and Len Wein, reportedly offered constructive advice and feedback during this formative period as well.[25] But if Ross Andru, Archie Goodwin, Stan Lee, John Romita, Roy Thomas, and Len Wein all had a hand in the project, it was Gerry Conway who came up with the character's outer borough background, his traditionalist ethos, his military service, and the inciting incident in Central Park that sets him off. It was the mild-mannered Conway, in other words, who turned Frank Castle into a pissed-off New Yorker.[26]

Conway initially conceived of Castle as "a henchman for the 'real' villain of the issue, the mysterious Jackal. But in the plotting and writing of the book he took on a life of his own." Conway had a "love-hate passion for this character from the moment he spoke his first words." "I loved him for his conviction, his commitment," but "hated him for the ease with which he used violence and deadly force. In my initial conception of the man I made him a villain, but in the writing he turned into a hero."[27] *The Amazing Spider-Man* #129 "sold extremely well," and "something about the Punisher made Spider-Man writers extra creative."[28]

The Punisher's bruiser persona traces back to his earliest appearances. Writers tasked with devising new stories operate within a narratological matrix in which murder is simultaneously the problem and the solution. Asking "what does the Punisher do all day?" makes little sense. His name furnishes the answer. How and where punishment happens, and the obstacles that the character faces as he seeks to inflict punishment, are decisions that rest in the hands of the creative team. But the matrix is real. A Punisher who never punishes is not a variation on a theme, but a test of the reader's patience.

Trip down

The Punisher's character logic is rooted in sociology rather than genetics. At one point, Castle notes that, "my people believe they're descended from Mediterranean pirates,"[29] but the context suggests that he is referring to Sicilians in general rather than his family per se. Born and raised in Queens,[30] Frank attended public schools,[31] watched *Gunsmoke*[32] and *Lost in Space*,[33] and delivered pizzas.[34] "Most of my childhood I spent in my imagination," he later recalled:

> I was alone a lot. I had a tendency to drift away. To me, the poems in the books my mother had inherited were an escape. They spoke of wilder worlds than any comic book or movie could evoke. They seemed to *burn* with color. I marched through

Mandalay, across the Orient with Kipling's British Army, wandered a never-ending garden, in the Rubaiyat of Omar Khayyam, followed Coleridge's sacred river down to the sunless sea.[35]

Frank Castle's parents, Mario Lorenzo "Renzo" Castiglione and Louisa Castiglione, were hardworking fisherfolk who emigrated to the United States from Sicily.[36] Mario Castiglione was "taller than the other men," and it "always seemed like there was so much more of him."[37] Mario served in the U.S. Marine Corps during the Second World War and fought in the battle of Iwo Jima, for which he was awarded the Purple Heart and Bronze Star. After the war, he found employment as a construction worker at the Brooklyn Naval Yard.[38] Mario and Louisa changed the family name to Castle when Frank was 6 years old.[39] Castle's first name is Francis, and his middle initial is "G."[40] He is usually depicted as an only child, but for some reason, writer Nathan Edmondson was permitted to introduce an unnamed sister, as well as a brother in law, niece, and nephew, into the ideologically turbocharged tenth *Punisher* series (2014–15).[41]

According to Marvel lore, Frank Castle spent three tours of duty in Vietnam. This was later retconned to service in the 1990–91 Gulf War.[42] Andrew J. Friedenthal points out that Castle "was a disciplined, exemplary Marine, one of the United States' best, who had survived various battles and massacres only to come home and see his family murdered in a similar fashion."[43] While the published stories occasionally refer to his military service, they rarely refer to his experiences as a sniper and point man.[44] In *The 'Nam* (1986–93), however, we learn that Castle appropriated his skull motif from an enemy sniper. The sniper wore "a tiny monkey's skull hung by a thong around his neck."[45] We subsequently discover that Castle "learnt to love Claymore mines in 'the 'Nam. They fire hundreds of ball bearings at high velocity in a wide arc."[46]

Further details about Castle's military service can be gleaned from three of the fiercest Punisher titles ever published: *Born* (2003), *Punisher: The Tyger* (2006), and *Punisher: The Platoon* (2018), all written by Garth Ennis. While *Born* depicts his final tour of duty, when he signs up with "the Great Beast" to take part in a "war that lasts forever,"[47] *Platoon* focuses on Castle's first tour, "the one where—just maybe—he still has a chance."[48] *The Tyger* is mainly concerned with Castle's childhood but includes poignant material about his first and second tours of duty. "You know I hate war stories,"[49] he tells Micro, but admits elsewhere that "They're always there. The memories. They color everything I do. Everything I think. Crystal clear. Etched on my brain. They come tumbling back like potatoes from a broken sack."[50]

The story of Frank Castle's first crush, Lauren Buvoli, ends in tragedy. She commits suicide after she is sexually assaulted by the son of a local mobster.[51]

The significance of this biographical detail should be self-evident. After Lauren, comes his high-school sweetheart and future wife, Maria, who was born Maria Elizabeth Falconio. She is his one true love. "Will Frank be getting a girlfriend?" queried reader Joseph B. in a 1990 letters column. Editor Don Daley responded: "Joe, there seems to be a couple of candidates vying to be the Punisher's girlfriend, but they face tough competition from beyond this mortal veil."[52] His relationship to his romantic past may not be entirely healthy, of course. As Castle admits in a 1989 graphic novel, "In the dark, all women feel like Maria."[53]

Maria and Frank had two children, Barbara and Frankie, later amended to Frank, Jr.[54] His daughter, referred to as Christie in several stories in the 1990s, currently goes by Lisa, or sometimes Lisa Barbara. He also had two paternal uncles, Fredo and Rocco Castiglione, an unnamed sister-in-law and a brother-in-law named Jake.[55] If Frank Castle was once part of an extended blue collar network by way of blood, marriage, and military service, his daemon hunts alone.

Along with *Born*, *The Tyger*, and *The Platoon*, the most in-depth sources on how Frank Castle gave way to the Punisher are a trio of standalone graphic novels: *The Punisher: Intruder* (1989), *The Punisher Invades the 'Nam* (1994), and *The Punisher: Year One* (2009). In tandem, these disparate sources provide the character with a thickly layered background. But even the most carefully constructed backstories can be ignored, contradicted, or erased out of existence. In the 2022 series, Jason Aaron replaces Garth Ennis' grounded portrait of a thoughtful working class kid with a shock-horror background in which a sociopath sets a man on fire with gasoline at the age of ten. "Once, when he was 8, he'd tried to tell some of the kids about his *dreams*," Aaron's narrator murmurs. "Dreams of ninja and red armor and a gnarled dagger stabbing into his enemies again and again and again." But "the school sent a letter home to his parents. Frank learned it was best to lie whenever anyone asked what he was thinking."[56] No doubt the retconning will continue. At some point, Marvel may announce that Frank Castle is the veteran of an imperial adventure that has yet to begin.

Living off negativity

Marvel has long published stories that ridicule the Punisher for his paranoia, self-destructiveness, and unidimensional thinking, while simultaneously profiting from titles that apotheosize his tenacity and his violence. These contrasting templates occasionally appear side-by-side on the racks of comic stores. Both are consistent with the Punisher's character logic, in that they always circle back to the politics of vengeance. Yet they are readily distinguishable.

The two templates hark back to the character's earliest stories, which were scripted by Gerry Conway and editor/writer Archie Goodwin. Conway authored the first Punisher appearance, and the earliest iteration of the character's origin story, while Goodwin penned the first story in which the character was the central protagonist. Between them, Conway and Goodwin wrote fewer than a dozen Punisher tales. But their impact on the character's trajectory is as consequential as that of writers who subsequently produced dozens or even hundreds of treatments.

Version A—trigger-happy—builds on the strong-willed but dim-witted character who first surfaces in the pages of *The Amazing Spider-Man* #129. The term itself is inspired by a snippet of dialogue in *The Amazing Spider-Man* #175 (1977), in which J. Jonah Jameson, referring to Spider-Man and the Punisher, insists that the "blasted web-spinner and his trigger happy sidekick are no friends of mine!"[57] Until the 1986 *Circle of Blood* limited series, the quasi-comical version of the character was the prevailing one. More recently, the grimmer approach has predominated, to the point where the Punisher's trigger happy aspect has been obscured. In effect, the character has been retconned by fandom. The vehemence of the grim and gritty iteration serves to expunge the memory of the trigger happy version.

The trigger happy iteration has been part of the published history from the outset, however. When this version of the character turns up, it is almost always in the pages of other character's titles. The trigger happy approach takes an openly skeptical attitude towards Castle's aims and methods. In this take, the character is portrayed as paranoid, manic, and more than a little hapless. His choleric manner represents a gimmick and a calling card. The Sandman leaks sand, Deadpool breaks the fourth wall, trigger happy Punisher fires off rounds. He performs enmity. But while his heart is in his work, in these stories, his abrasive personality grates on other heroes, and his confrontational tactics backfire. This version of the character can be thuggish, disturbed, and/or flaky, but whatever the precise emotional coloration his over-the-top performance is myopic and self-defeating. Trigger-happy Castle is so angry that he can't shoot straight. Punisher parodies usually take the trigger happy template and run with it.

Version B—grim and gritty—traces back to two terse stories from the mid 1970s: "Death Sentence," by Gerry Conway, and "Accounts Settled, Accounts Due!," by Archie Goodwin. These black-and-white tales appeared in *Marvel Preview* #2 (1975) and *Marvel Super Action* #1 (1976), respectively.[58] "Death Sentence" is particularly noteworthy for including the first published take on the Punisher's origin story, which takes the form of a two-page flashback. Journalists and scholars often attach the gritty label to the Punisher, but this early period makes it clear that grimness is a choice. "Death Sentence" and "Accounts Settled, Accounts Due!" are more sympathetic to the Punisher's methods and goals than the Spiderverse stories, and provide the foundations for the grimmer template.

In grim and gritty stories, readers are encouraged to regard the aggressor as a "complex character" with "many faults"[59] who nevertheless raises valid concerns. In these stories, lawlessness and corruption has spiraled so far out of control that a one-man campaign of furious violence somehow meets the demands of the moment. While the grim version might occasionally toss off an acerbic joke or two, most of the time the gritty warrior is deadly serious. Stories like "Death Sentence" and "Accounts Settled, Accounts Due!" confront readers with their own passivity. Why aren't *you* outraged? Why aren't *you* doing something?

These competing paradigms are the product of distinct publishing imperatives. The trigger-happy approach leans in an all-ages direction and works well with mass circulation titles. The grim version offers a better fit with mature readers whose purchasing habits can accommodate titles with a higher price point. In the 1970s, *The Amazing Spider-Man* could still be found at newsstands and grocery stores, while *Marvel Preview* was sold at specialty outlets. *The Amazing Spider-Man* #129 (1974) and *Giant-Size Spider-Man* #4 (1975) sold for 20 cents and 50 cents respectively, while *Marvel Preview* #2 (1975) retailed for a dollar. Black-and-white Marvel magazines were designed to emulate the Warren publications that circumvented the Comics Code. These magazines anticipate the MAX imprint that Marvel launched in 2001. MAX continues to offer "creators the chance to spread their wings and unleash their imagination" and promises "harsh language, intense violence, perhaps even some partial nudity."[60]

Trigger happy Punisher mainly shows up when the character makes a guest appearance in other characters' storylines. By contrast, the grim version is reserved for solo series. The trigger happy version reflects how other characters view Frank Castle; the gritty version suggests how Castle sees himself. When the character pops up in animated films and TV programs, the trigger happy version is invariably foregrounded.[61] In *Spider-Man: The Animated Series* (1994–98), for example, the Punisher wields non-lethal weapons. The live-action Punisher movies, by contrast, are grim and R-rated. Each of the three films is grittier than the one that precedes it.[62] Fans of the latter approach have been known to complain about stories in which the Punisher is "misused." As reader Alan H. complains, "Too many times I have seen his character terribly misused in guest appearances in other books where the writer may have a strong opinion against the nature of Frank's outlook on justice."[63]

If the trigger happy approach lends itself to comedy, grim and gritty is a better fit for the writers, artists, and editors who are in broad sympathy with the character's methods and values. This helps explain why self-described conservatives such as Mike Baron, Chuck Dixon, and Nathan Edmondson are associated with the second template, while the left-leaning Gerry Conway's scripts portray the Punisher's war against crime as delusional.[64] A moderate liberal like the late writer/editor

Mark Gruenwald, who said that "I see him as a psycho and a vigilante, and I'm glad he's not my friend,"[65] would be unlikely to characterize the Punisher, as writer Larry Hama has, as a "justified reaction in response to a society which is so bent on being 'politically correct' that it has forgotten how to protect its own." "That's the psychosis," Hama adds. "It's not what the Punisher does. It's not a matter of conscience, it's a matter of awareness, and the Punisher is aware of the criminal element."[66] Mike Baron offered a similar take when he attributed the character's popularity to "the average citizen's outrage at the failure of society to punish evil."[67] Yet despite these differences, both approaches stand in contrast with other, more socially acceptable forms of vigilantism, as we shall see in the next chapter.

The remainder of this chapter explores the genealogy of these contending templates. The first section spotlights the Punisher's *Amazing Spider-Man* appearances, while the second considers Castle's earliest hardboiled stories, as well as the 1.0 version of his origin story. In tandem, these sections underscore the gulf between the vaudevillian version and a Punisher who keeps "a little interrogation unit" in his basement, "rigged with a bunch of torture machines I liberated from an old pal who used to make this stuff for the CIA."[68] The interrogation unit is hidden on the Lower East Side. Castle jokingly refers to it as "Baby Guantanamo." Writers often make a point of having the Punisher say things like, "Frank Castle died with his family."[69] This is a twist on a famous trope: "You can't kill me because I'm already dead."[70] When trigger happy Castle mourns that he died alongside his wife and children, it suggests that he is wrestling with inner demons. When the grim version says something similar, it signifies that he has slipped beyond basic moral precepts.

Trigger happy

The Amazing Spider-Man (1963–2012) was a flagship series of the Silver Age. Virtually every significant figure in Spider-Man's life, from Aunt May and J. Jonah Jameson to Doctor Octopus and the Green Goblin, was first introduced in its pages. The early issues were scripted by Stan Lee and penciled by Steve Ditko, but by the time the Punisher was on the scene, writer Gerry Conway, artist Ross Andru, cover artist John Romita, and editor Roy Thomas held the creative reins.

Spider-Man is a kinetic hero who soars above the streets of Manhattan. His alter ego, Peter Parker, is a do-gooder whose neurosis delineates Silver Age from Golden Age storytelling. Beset with money problems, Parker juggles work, school, family, and friendships, usually without much success. At several points, he threatens to drop out of the superhero biz altogether. If anything, Parker's romantic life is even more fraught. His feeble attempts to kickstart relationships with Liz Allen

and Betty Brant go nowhere, and his first serious girlfriend, Gwen Stacy, dies in his arms after a horrific battle with the Green Goblin. (Their epic confrontation takes place on either the Brooklyn Bridge or the George Washington Bridge; the artwork suggests the former, while the text refers to the latter.) His relationship with Mary Jane Watson is the longest lasting but has endured many ups and downs.

Gwen Stacy's shocking death is recounted in "The Night Gwen Stacy Died" (*The Amazing Spider-Man* #121–22). Her demise provoked an outpouring of grief on the part of many readers,[71] and, as Geoff Klock notes, serves as "the transition between the early superhero stories" of the Silver Age, and "more 'adult' superhero narratives like *The Dark Knight Returns* and *Watchmen*."[72] Peter Parker himself was still in mourning when the Punisher arrived a few issues later. As he muses in *The Amazing Spider-Man* #126, "Ah! What's the *point*? Every time I even think about Gwen being dead, the whole world goes *black* for me. I keep trying to *minimize* it, to lighten the load—but nothing works. *Nothing*."[73] Happiness is always fleeting in superhero narratives but this was a particularly stressful period in the life of the redoubtable Queens native.

The Amazing Spider-Man #129 makes it clear that trouble will continue to follow our Spidey. The cover places Spider-Man in the Punisher's reticle, nervously dodging a fusillade of bullets. "He's *Different*! He's *Deadly*!" the cover exclaims. He's the "most lethal *hired assassin* ever!" This tagline suggests that the character was still coming into focus, since the claim that Castle kills for money is inconsistent with his principled vigilantism. Suffice to say, the "hired assassin" label was soon dropped.

As the story opens, the Punisher is in full regalia, blasting bullets into a plaster statue of Spider-Man. He is there at the prompting of another over-the-top character, the green-skinned Jackal. "You *like* the death—the *killing*—the joyful *revenge*," he smirks. "I kill only those who *deserve* killing, Jackal," the Punisher replies. "And Spider-Man deserves to *die*!" "A crazed pointy-eared super-villain with a penchant for cackling at the top of his lungs,"[74] the Jackal manages to convince Castle that Spider-Man murdered Norman Osborn, aka the Green Goblin, at the conclusion to the events depicted in "The Night Gwen Stacy Died." As Frank Castle takes his misplaced rage out on the plaster dummy, Peter Parker makes his way to the *Daily Bugle*. When the newspaper's publisher spots the free-lance photographer, J. Jonah Jameson insists that Parker bring him photos of the Punisher, whom he describes as "the most newsworthy thing to happen to New York since *Boss Tweed*." "Easy for Jameson to *say*," thinks Parker, "but how do I *find* this Punisher guy?"

Tracking down Castle turns out not to be much of a problem, however, since the Punisher is already looking for Parker. When they finally meet, Spider-Man struggles to convince Castle that they are on the same side. "Your kind of scum

has ruled this country *too long*, punk," the Punisher rants, "and I'm out to put a *stop* to it." "It's not something I *like* doing," he adds, "it's simply something that has to be *done*." After all,

> I've got nothing to *lose* by risking what's left of my *life* wiping out your kind of *parasite*. You're all *alike* ... using whatever means to get control of the public ... drugs, gambling, *loan-shark* operations ... some of it *legitimate* but all of it *evil*. Sometimes I wonder if that evil's rubbed off on *me*. But I know that doesn't *matter*. All that matters is the *job*.[75]

This stew of dubious assumptions ("you're all alike"), bizarre accusations ("drugs, gambling, loan-shark operations"), and self-pity ("what's left of my life") represents an unvarnished cry for help. When, in true Marvel fashion, Castle finally figures out that he has been played, he does not pause to consider whether his judgement might be fundamentally impaired in some way. "When I met the Punisher," the Jackal later recalls, he was "*nothing*." But "I showed him how to *channel* his *anger*," he boasts. "*I* gave him direction. *Purpose*. Molded him into what he is today."[76] The Punisher recalls these events differently. "When I was *young* and *angry*—when I was *stupid*—he *manipulated* me. Almost made me *kill* an *innocent*. Almost *tainted* me."[77] The fact that the Punisher fails to subsequently kill this conniving villain is somewhat surprising.[78]

Once Castle determines that the Jackal is the story's true nemesis, the door is opened to a rapprochement between Spider-Man and the Punisher. When they next meet, Parker poses the obvious question. "What's this whole *kick* you're on? You said you were a Marine—so how come you're fighting over here?" Castle responds, "That's my business, super-hero, not *yours*," adding, "Maybe when I'm dead it'll *mean* something ... but right now I'm just a *warrior*, fighting a lonely *war*."[79] His words are grim but the fact that he bought the Jackal's story in the first place strains credibility. There is a cartoonish quality to the Punisher's behavior in these *Amazing Spider-Man* issues. In this iteration, the character lacks any sort of self-awareness.

And yet, in terms of his media aesthetics, this early incarnation is not all that different from those that follow. From the outset, Frank Castle is tall, muscular, and middle-aged. He is driven by rage and devoted to his weaponry. His abundant black hair and Mediterranean features hint at an Italian ancestry that later stories would confirm. But Ross Andru's pencils make him look shifty, with thick eyebrows and ominous shadows that streak across his face. Presumably the intent was to keep the reader guessing as to whether the character was heroic or villainous. As we have seen, the costume is another element that was locked into place early on. In *The Amazing Spider-Man* #129, Castle dons more or less the same

outfit he wears today—black Kevlar body suit, ammunition belt, oversized skull-face emblem, and gloves and boots. The main difference is that nowadays the gloves and boots are black rather than white. The character's costume is different from the snazzier, more colorful styles favored by Spider-Man and others. It serves to underscore the binary nature of the Punisher's worldview. His ensemble makes it clear that he is more concerned with waging war than making friends.

There was little indication in these early appearances that the Punisher would become an A-lister. The fan mail was encouraging but nothing more. The story "was very much like #126 and #127," observed Amos R., who noted that "the Punisher was a misguided good guy." Michael B. complained that, "The story: seems familiar. Could I have read something like it about a man named Mack Bolan?" Reader Brian S. praised Gerry Conway for scripting "a very good story." The Punisher

> was a human being, with human emotions and human frailties. He was so caught up in self-righteous indignation against the evil which he thought that Spider-Man had committed, that he was unable to see the true evil in the Jackal. After reading this story, I thought about all the times I'd ever judged a person hastily, without knowing all the facts.[80]

The extent to which Spiderverse stories in the late 1970s and early 1980s mock the character and the archetype is striking. The mocking tone that pervades these stories reflects the extent to which creators and editors at Marvel regarded Castle's brand of vigilantism as contestable, if not utterly problematic. Before he became a licensing goldmine, the Punisher was a minor piece of fungible intellectual property that writers could deploy when a story called for a specific type of hot head. Castle became typecast as someone who would pop into a story, fire off a few rounds, and make life difficult for the main hero. He had a distinctive persona and was more argumentative than other secondary cast members. But he was fundamentally unserious.

Thus, in *The Amazing Spider-Man* #134 and #135 (1974), the Punisher's second and third appearances, the crime-controller once more has a hard time distinguishing the good guys from the bad. When he spies Spider-Man with the Tarantula, a prominent MU villain, his instinctive response is to point a gun at Spidey's head. "You fooled me once *before* with your '*Mister Innocent*' act," the Punisher exclaims in a dramatic splash page. "*This time you're going to die!*" This is the prelude to another dust-up, during which Spider-Man points out, "I don't know what you use for *brains*, but pal, you're really *blowing* it!" "*Blast* it to *Hades*—NO!" screams the Punisher, as the Tarantula takes advantage of their kerfuffle and flees. "You have my *apologies*, Spider-Man ... It appears I was *wrong*

about you, after all." By the issue's end, the Tarantula is tied up in webbing, with the Punisher mocking Parker for his faith in the criminal justice system. "Do you *believe* all that, wall-crawler? Are you truly that ... *idealistic*?" "Yeah, I'm idealistic," Spidey responds, "until something better comes along." Castle does not buy it. "What about *you*, Punisher?" asks Spider-Man. "Don't *you* have any ideals?" "I did—*once*," Castle scornfully replies.[81]

In *Giant-Size Spider-Man* #4 (1975), the two frenemies "join forces to save the world," or so the cover promises. They work together to free a group of Americans who are trapped in a remote encampment where toxins are being tested on human subjects. When they meet at the Punisher's safe house, Spider-Man learns that the Punisher has been trying for weeks to locate the camp and shut it down. "*Why*?" asks Spider-Man. "To set up another battle in your crazy *war against crime*?" "Precisely," the Punisher curtly responds.[82] Later, as he tosses off smoke bombs and makes his way through the encampment, Castle boasts, "This is what I've trained for all my life. *Nothing* could stop me now."[83] His body movements make him seem tough but his misshapen gas mask looks silly.

A year later, in *The Amazing Spider-Man* #162 (1976), the Punisher and Spider-Man find themselves trapped inside the tram that connects Roosevelt Island to Manhattan's Upper East Side, facing a barrage of gunfire. "*Hellfire*!" shouts the Punisher. "Somebody's turning this car into a *shooting gallery*!" For complicated and not terribly plausible reasons, the Punisher pins the blame on Spider-Man's friend, the X-Men cast member Nightcrawler. "You're getting paranoid in your old age," Spidey tells him. A few pages later, after they have made their way to safety, Spider-Man reflects on his relationship with Castle. "Battling *crime* and *injustice* is only a *pastime* for me [...] For him it's a way of *life*!"[84]

Justice is a game

The Amazing Spider-Man #162 heralds the first appearance of the self-described "two-bit *punk*" who will go on to become the Punisher's most reliable adversary: Billy Russo, aka Jigsaw. The fact that this tenacious villain has managed to not get killed in continuity after all this time speaks to his special status. In *ASM* #162, we find out that Castle had previously tossed Billy Russo "head-first thru a *plate glass window*," which explains the character's hideous patchwork face. Russo seeks a rematch but finds himself soundly defeated by a Nightcrawler, Spider-Man, and Punisher team-up. After their battle, Castle confesses, "I don't even *remember* him!"[85] The plot-armored Jigsaw comes into sharper focus for him in subsequent appearances. But in the comics at least, Jigsaw is more obsessed with Castle than the other way around.

Richard Reynolds, Geoff Klock, and others point out that villains often resemble the heroes they torment. "Every major member" of Batman's "villains gallery," Klock says, "operates as a kind of reflection of some aspect of Batman's personality or role so that an understanding of one of the villains always sheds light on Batman himself."[86] Applying this insight to the Punisher/Jigsaw relationship, we might conclude that Jigsaw's chaotic exterior reflects the Punisher's fractured psyche and internal distress. In confronting Jigsaw, Castle gains a measure of respite from his own inner turmoil. "The Punisher decides to make *sport* out of me an' my face time and time and time again," Jigsaw complains:

> We scrap. We *tussle*. Loads of times. Me and him. And you know what? I can't never seal the deal. And he—he always *lets me live*. A little worse for wear, of course. I'm tellin' you, Irish. He's like a kid what pulls off the wings off flies just to watch 'em wiggle. He digs the *torture*.[87]

What Jigsaw views as persecution, Castle regards as clemency. "A prison shrink asked me once why I show Billy Russo mercy," he says. "How do you tell someone that a serial killer reminds you of yourself? Always knew if I killed Jigsaw it'd be like acknowledging that there exists no redemption for the likes of us."[88] S.H.I.E.L.D. agent G. W. Bridge offers a different assessment:

> You know why you've never killed Jigsaw? You, who's killed muggers and rapists and dealers and pimps and jaywalkers? You're the ugly girl with the even uglier friend, Frank, and you keep him around so you don't feel so bad. He's not your nemesis, Frank. He's not your enemy. He's the only guy alive that *aspires* to be you, who looks at your nothing of a life and says—that's it. That's what I want. He's your mirror.[89]

The Punisher's psychological scars are on full display on the cover to *The Amazing Spider-Man* #174 (1977). In the center of the image, a villain named Hitman holds a gun on J. Jonah Jameson. The Hitman's gaze is directed towards Spider-Man, who has just burst through one of Jameson's windows. Surrounded by glass shards, Spider-Man's pose is graceful and balletic. At the same exact moment, the Punisher bursts through a different window. But if Spider-Man looks elegant, the Punisher's body language is thuggish, as if he is having a tantrum. When the scene is reprised in the interior pages, the Punisher is angrier at Spider-Man—for moving into his line of fire—than at Hitman. Castle grabs Jameson's secretary and creates such a commotion that the villain makes a getaway, much like the Tarantula in #135. "The *Punisher*! I'd almost *forgotten* about him!" sighs Spider-Man, underscoring the distinction between starring and supporting roles.[90] In *Captain America* #241

(1979), Castle looks similarly foolish as his bullets bounce off the Cap's shield and howls, "This is war, and crime is the enemy! There's only one way to fight it!"[91]

Meanwhile, in *Daredevil* #181 (1982), written and penciled by Frank Miller,[92] Castle resembles a human ferret as he foments trouble between Bullseye, the "deadliest assassin the world,"[93] and the mighty Kingpin. At this point in his career, Marvel's writers could have quite easily turned Castle into another MU villain. Few readers would have objected. As the beloved Peter Parker says in *The Amazing Spider-Man* #285 (1986), on the eve of the Punisher's breakout role in *Circle of Blood*, he says: "He's a homicidal looney-tune! The guy runs around and *shoots* anyone *he* thinks is a criminal!"[94] Or as Parker zings Castle in *The Amazing Spider-Man* #202, "I'll see you in the funny papers!"[95]

The tendency to treat the Punisher as *non compos mentis* reaches its apogee in the pages of *Peter Parker, Spectacular Spider-Man* #81–83 (September–November 1983). In this three-part tale, Castle cracks down on littering and jaywalking. When he spies a couple tossing their newspaper on the ground, he screams "littering is a crime" and promptly starts shooting. A cabbie hears gunshots and runs a red light. This only inflames Castle, who fires at the cabbie.[96] Three years later, in the *Circle of Blood* limited series, his rash behavior is attributed to "time-delayed" drugs that Jigsaw managed to slip into his food. "Dark chemicals had wormed into my brain, throwing up fear and pain and violence that I had buried with another life," Castle mutters, by way of explanation.[97]

As Marvel's writers struggled to reconcile the Punisher's violent proclivities with the Spiderverse's kid-friendly ethos, *The Amazing Spider-Man* #201 reveals that Castle preferred mercy bullets to the more familiar kind. In the following issue, readers learn that with the flick of a dial Castle's gun could launch either ordinary ammunition or the merciful variety. Readers might reasonably have assumed that mercy bullets were the Marvel Universe equivalent of rubber bullets, but in *Peter Parker, The Spectacular Spider-Man* #81 (1983), we learn that "each shell contains a powerful—and painful—sedative."[98] With these bullets, the Punisher could, according to MU logic, shoot up a room full of bad guys without killing anyone. If a parent or retailer complained, Marvel could point to this magical product and ask, in effect, where's the harm?[99]

Fans learned more about these unusual projectiles when Spidey gets shot at point blank range in *The Amazing Spider-Man* #201. As the story opens, Frank Castle is rushing around while Spider-Man tries to get him to slow down. "You just *can't* shoot apart everyone who looks *nasty* at you," Spider-Man insists. "You an' me better have a *long talk*!" "I said I don't have time to waste," Castle replies. "I won't be stopped by anyone ... and that includes *you*!"[100] The Punisher then plugs the web-spinner in the stomach. Once Spider-Man recovers, their bickering resumes.

Parker spots the Punisher's battle van, and tells himself, "I better get in on the *action* before there's a string of *bloodied bodies* left in that madman's wake." When he finally catches up with Castle, he accuses him of "shooting up everyone who looks *cross-eyed* at you." The Punisher later informs Spidey that one day, "you will understand that granting mercy to scum is a tragic *mistake!*"[101] This coming from a guy who—comically, temporarily, and paradoxically—packs mercy bullets.

While the grim and gritty version has come to define the character, the trigger happy version remains a constituent component of the franchise. In 1990, when the Punisher was approaching the height of his popularity in the subculture, Marvel published trading cards featuring the company's best-known characters. One of the cards shows Spider-Man in conversation with the Punisher. Spider-Man brandishes a stick mic: "Punisher," asks Spidey, "is your real name Frank Castle?" "Yes," the hardened vigilante replies, "but I prefer Francis!" The reverse side is similarly parodic. "Why do you have a skull on your shirt?" Parker asks. "Because a portrait of my face would look silly," Castle deadpans.[102] Their relationship may have an inherently comical quality, as suggested by Bob McLeod's cover illustration for *Spider-Man* #32 (March 1993), which draws a vivid contrast between a quizzical web-crawler and our steely-faced warrior (Figure 2.1).

Grim and gritty

Contemporary readers might be surprised to learn that Spider-Man once enjoyed the rhetorical upper hand when he dismissed Frank Castle as someone waging a "crazy war against crime." The now-standard conception of the character is nicely captured in a story from 1994, where his friend Micro says, "Come on, *lighten up*. You can't be *grim and gritty* all the time." "Yeah? Watch me."[103] The unsmiling version that currently predominates was first sketched out in a stan-dalone Punisher story that appeared in the pages of *Marvel Preview* (1975–80), an irregularly published black-and-white magazine. And at the time, this grittier conception of the character was the outlier.

Attentive readers would have gleaned that Marvel was considering publishing a solo Punisher title from an editorial note that appeared in *Giant-Size Spider-Man* #5 (1975). "The response to the Punisher's appearance" in the previous issue was "awesome," the editorial stated, with "one overwhelming request" that "perme-ated virtually every letter of comment, until the clamor became a command which your ever-responsive Marvel Madmen could not resist." "We're nothing if not responsive people," the writer claims,

A CULTURAL HISTORY OF THE PUNISHER

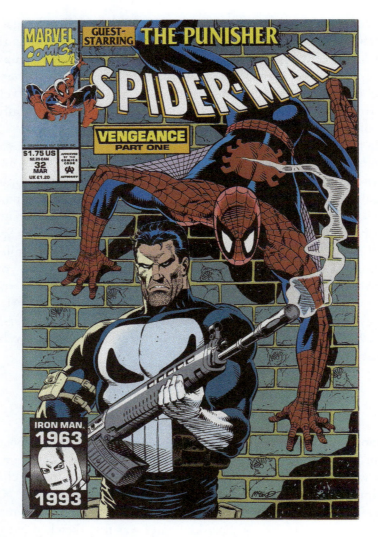

FIGURE 2.1: Bob McLeod, *Spider-Man* #1.32, cover illustration, March 1993. © Marvel Comics.

and we can take a hint when it's thrown at us from at least 40,000,000 different directions. So there's no sense mincing words—the Punisher will be making his full-fledged b & w magazine debut in the second issue of *Marvel Preview*!![104]

While this overstated the degree of fan interest, most letter writers relished the new character. "I really dig him," wrote Gene L.

He's the only superhero who uses guns and fists, and he has a hidden lab and a special car. Hmmm, I can recall others having that, except they don't use them anymore. Why don't you give the Punisher his own book, or if that's too much to ask, let him join the Defenders?[105]

Another reader, Dave F. admitted that, "For some strange reason, I like the Punisher character, despite his near-mindless violence. I figure that this was kind of a try-out shot to test reader reaction to the Punisher, and if it goes well, I move that the Punisher be granted his own feature."[106] Meanwhile, Roy L. exclaimed that "Teaming Spidey with the Punisher was sheer genius!"[107] Eric K. pronounced that the Punisher was "the best character to come around since Deathlok," even though Castle predated the reanimated human cyborg by several months.[108] But reader John S. expressed reservations about a character who "claims to be on the side of law and order" and yet "is a cold-blooded killer." He pointed out, "All we know about him is that he was once a Marine who appears to still be fighting some kind of war, and that he has enough problems to make Spidey's look like a birthday party."[109]

Marvel poured time and energy into its black and white anthologies. And these kinds of titles presented an ideal venue for reimagining the Punisher as a heroic tough-guy whose methods could achieve quick results. In his official history of the company, Les Daniels quotes editor Roy Thomas to the effect that "Stan really wanted to go with the black-and-white magazines." But "for all the effort expended on them," reports Daniels, titles like *Marvel Preview* and *Marvel Super Action* "never really took off." Stan Lee reluctantly concluded that "readers like color," Daniels suggests. He adds, "Not enough readers appreciated the chance to see clean, crisp, large reproductions of unadorned pencils and inks; and these publications never really fulfilled Marvel's original intention, which was to move beyond the Comics Code restrictions" on graphic depictions of sex and violence.[110]

Edited by Marv Wolfman, with Len Wein and Archie Goodwin serving as consulting editors, *Marvel Preview* #2 includes not only the Punisher's first solo story but the in-depth interview with Don Pendleton referred to in the previous chapter. The issue's delightfully lurid cover, by commercial illustrator Dwight Graydon ("Gray") Morrow, shows the Punisher shooting up an East Side apartment full of poorly dressed goons. Written by Gerry Conway and penciled by Tony DeZuniga, "Death Sentence" takes up almost half of the entire issue. From a storytelling perspective, it is more in the modality of an Executioner novel than a Spider-Man comic.

As the story opens, the Punisher is perched on a Manhattan rooftop, brandishing a sniper rifle. He is acting on a tip that someone might try to assassinate a prominent elected official at an open-air rally. "I didn't *care* about the politician

haranguing the crowd below—I'd had *enough* of his kind when I was younger and believed that sort of drivel," he says to himself. "But I knew what another assassination would do to this country—and *that* was something I cared about." The tip pays off, but when he hunts down the would-be assassin the Punisher is shocked to discover that he is an army buddy who has fallen on hard times. "You get back home," his friend explains, and "nobody even wants to *look* at you."[111] Before Castle can induce his old pal to spill the beans, a bomb tossed out of a nearby helicopter kills the hapless vet. The Punisher spends the rest of the story tracking down and killing the conspirators who have been manipulating traumatized veterans.

Interestingly, the Punisher is the story's only costumed character. The other cast members are conspirators, government agents, and veterans who get caught up in industrialist Mark Christanson's feverish scheme to "*overthrow* this country's government in the name of our *own* organization—the *International Industrial Alliance*."[112] While we do not learn much about the Alliance, it seems well-funded and vaguely right-wing. When the trail leads Castle to Christanson's Midwest hideaway, he insultingly refers to it as a "*mansion* overlooking Chicago, one of those steel-and-glass monstrosities people build today instead of *houses*."[113] He subsequently infiltrates the Alliance and sets off a massive detonation that takes out the core conspirators along with a few dozen mercenaries.

When the FBI agent Dave Hamilton is interviewed on live television about the explosion, he casually dismisses the International Industrial Alliance as a "psychopathic group of men, trying to *take over* our government. But their kind we've learned to deal with. They don't concern me." Given that we watched the conspirators toss a bomb out of a helicopter over Manhattan, this seems a tad cavalier. Hamilton's real beef, of course, is with

> the so-called *Punisher*, who's responsible for the destruction caused this evening. We can't allow a man like that to take the law into his own hands ... And I intend to track him down—and stop him, any way that I can—if it takes me the rest of my life.[114]

Brave words, but the thread was dropped and Dave Hamilton has yet to return to the MU.

It should be admitted that Agent Hamilton's concerns were not entirely baseless. *Marvel Preview* #2 marks the first time that the Punisher engages in acts that could result in the injury or death of noncombatants. Although Marvel insists that the Punisher always protects the innocent, his actions in this story seem reckless. After all, any cooks, servants, and cleaning staff who worked for the Christanson household would have perished in the explosion, although to be fair there is no indication in the story itself that anyone was in the house at the time except for

tycoons and hired guns. Still, it seems odd that an industrialist hosting dozens of people at his estate would do so without domestic help. Did the mercs and businessmen serve their own drinks and scrub their own dishes, or did the staff deserve to die because of their choice of employer?

As the story's explosive finale suggests, "Death Sentence" offers a more efficient, ruthless, and violent version of the Punisher than the one presented in *The Amazing Spider-Man* and *Giant-Size Spider-Man*. Here his actions are deliberate, his planning methodical, his reliance on deadly force unequivocal. Even though he wears a form-fitting spandex costume with matching white gloves and boots, the other characters take him at face value, as do the authorities. The reader is meant to take him seriously as well. When it comes to righteous murder, this iteration is the real deal. Readers were not expected to emulate the Punisher's methods, but for the first time, they were encouraged to sympathize with his agenda.

"Death Sentence" is also notable for giving readers a closer look at the precipitating event that leads Castle to take up the Punisher mantle, the murder of his family. During a lull in the action he reflects on the fact that, "there's a *war* going on in this country—between citizen and *criminal*—and the citizens are losing—just as my *family* lost … Just as *I* lost, so long *ago*." He then flashes back to that fateful day. "Please, darling," teases his wife, as they look for a quiet spot in Central Park. "Don't *walk* so fast. We're going on a *picnic*—not a combat *patrol*!" "Old habits die hard," responds her husband, apologetically. "This is the first morning in almost a year when I haven't wakened in a sleeping bag. It's good to be home."

As they turn a corner, they stumble onto a mob hit. "Seems we've got *company*, Bruno," says one of the mobsters. "Too bad for them they wandered in during our little family *execution*," says another. "Now they're *witnesses*—and we can't let them *go*." "Get out of here, honey! *Run!!*," Castle shouts, as gangsters discharge their weapons. "I think I've been—*shot*—Honey. Don't worry—nothing—serious? Honey? Answer m—*no*. Dear lord, *no*. *Noooo*." He then tells himself, "After a thing like that, I suppose a man *does* go—mad."[115]

These pages convey a great amount of information. While we are not given the names of his children or his wife, they are clearly members of a tight, loving family. They are also photogenic in a wholesome sort of way. Before she gets shot, Castle's wife utters the phrase, "Dear God in *Heaven*" in a manner that is more akin to a prayer than a curse. This suggests that she is a churchgoer or at the very least a believer. And in this family, the men defend the women. When the firing commences, the son tries to shield his sister, just as his father flings himself in front of his wife. These emotionally fraught panels convey the idea that Frank Castle comes from a culturally conservative, patriotic, religious background, and that he believes in family values. The fact that we are not privy to the names of the wife and kids is indicative of their ceremonial function. They symbolize lost

innocence, and underscore how much has been taken from Castle. His family also offers a pointed contrast with the "family" of criminals that one of the shooters refers to, which is bound together by greed rather than love.

Another key text in the development of the grim and gritty approach is the 1976 story "Accounts Settled, Accounts Due!" It was written by Archie Goodwin and drawn by Tony DeZuniga and Rico Rival and appeared in the pages of *Marvel Super Action* #1, which was another short-lived black-and-white title. The cover describes the Punisher as "America's Greatest Crime Destroyer" and shows Castle emerging out of a massive fireball with guns blazing. Meanwhile, the back cover promises "Cover-to-Cover Excitement as *Marvel Super Action* Unleashes an Avalanche of Violent Adventure."[116]

As the story opens, Castle receives a visitor, Audrey, who describes herself as "your *date* for the evening." When she spots his costume she exclaims, "My *God*! That tunic—you're *him*! The one the newspapers say *hunts down* and *destroys* criminals!" "Does that *change* anything?" he asks. Not really, she says, since "a lady in *my* line of endeavor learns never to *judge* people." She proposes that he "stretch out and *relax*" and talk about himself, since "conversation helps a person *loosen up*." For the next few pages, he does just that, talking not only about the events in Central Park but about his war against "the second largest family on the East Coast."[117]

After listening to how Castle has rubbed out mobsters up and down the Eastern seaboard, Audrey asks if he ever feels satisfied. "I've wondered too, Audrey," he replies. "Every time I go after *any* kind of criminal scum, I *always* wonder: 'Is *this* the time I feel my family's *avenged*?' And every time ... it never seems *enough*." "Hey," Audrey sighs. "I had you *tell* me all this to get it off your *chest*, love! But you sound grimmer than *ever*." She then pulls a long knife out of her underwear and prepares to strike a lethal blow. But Castle has a firearm hidden beneath his pillow, and he shoots her at point blank range. As Audrey bleeds out he explains that he has spent months trying to track down the syndicate's most "effective assassin." "But you know what, Audrey?" he says to her fresh corpse. "It still isn't enough."[118] This ghastly scene recalls Mickey Spillane's best-selling *I the Jury* (1947), which also closes with the murder of an amoral femme fatale at the hands of a sadistic antihero.

The juxtaposition of Audrey's comeliness, her ruthlessness, and the elaborate way in which the Punisher stages her murder is reminiscent of the more transgressive side of the men's adventure genre. In "Death Sentence," we discover that Frank Castle is capable of mowing down dozens of people. In "Accounts Settled, Accounts Due!," we find out that he can murder a half-naked woman while holding her dying gaze. The contrast between the playful banter of the Spiderverse, and the cold and terrible things that people do to each other in these noirish stories is a stark one.

Sharp-eyed readers may recognize that Audrey resembles another woman in Castle's life—his wife Maria, as depicted in the "Death Sentence" flashback. They

are both slender blondes with long straight hair, looking as if they stepped out of the pages of a fashion magazine. To some extent, their resemblance reflects the fact that the same artist worked on both stories. But the other women in Tony DeZuniga's pages resemble neither Maria or Audrey. If Audrey is Maria's malevolent doppelganger, then killing her may serve a psychological function for Castle. If he could not save the life of his wife, at least he could exterminate her evil twin. But as the script makes plain, no amount of bloodshed can slake the Punisher's thirst for justice and revenge.

There are significant differences between Ross Andru and Tony DeZuniga's visual conception of the character. Andru's artwork is twitchy and cartoony and features a heavier use of motion lines. His rendering of Castle's face is inkier and greasier, making it seem as if Castle is some kind of biker. DeZuniga utilizes a more realistic and spare rendering, with fewer lines and more white space. His version gives the impression of a more sensitive and intelligent individual than Andru's, whose Punisher is rather brutish. But their styles are broadly similar, especially in terms of how muscular and stocky they make the character. A wider array of visual approaches would emerge once the character achieved lift-off in the late 1980s.

Marvel Super Action #1 includes commentary by Archie Goodwin as well as a handful of letters that the company received in response to the Punisher's appearance in *Marvel Preview* #2. In his editorial, "Behind the Action," Goodwin admits that "the Punisher is an unusual choice for a lead character":

> In my own head, I think he's the dark side of us all. He's the part that screams in rage at the million frustrations and injustices, major and minor, plaguing the average person in the twentieth century. He's the violent part of us that *yearns* to do something about it. Quickly. Simply. Finally. Yet we know we can't. If everyone was the Punisher, we'd have anarchy; chaos. A solution as bad, if not worse, than any of the problems. The vigilante as hero is a concept that's been with us a long time. It's been a favorite one in comics, and in pulp fiction prior to that. The Punisher carries the tradition to its logical—and deadly—extreme. In doing so, does he become as bad as those he sets himself against? I think that's part of the character's fascination, and I think it's an aspect that, given time and future issues, we'll certainly try to explore.[119]

Letter writers mostly concurred with Goodwin's mixed assessment. While Jack F. termed the Punisher "one of Gerry Conway's best creations," reader Tony D. described him being "in the same tradition of bloodlust crime fighting as the Avenger and the Executioner." He warned that "with a character like the Punisher, you can't do much anyway." Dave F. summed up the Frank Castle as a "madman who (like so many in real life) believes he can judge the good or bad in a person

solely by his own viewpoint." Reader Roger K. praised Conway's script and DeZuniga's pencils but complained about the character's amorality. "I can feel for him," he confesses, "but not *with* him." He adds,

> for me to allow to one man what I will not assign to the representatives of two hundred million is absurd. For a man to declare bloody, violent war upon other men for their crimes is but the first step; it must lead to the Punisher's reaction on the last page, declaring war on a potential ally [Dave Hamilton] because of his methods. And it must, in the end, lead to drawing your gun when your neighbor sneezes.

Responding to Roger K.'s comments, Goodwin noted that

> no one who wrote in could agree with, or find any sane logic behind the Punisher's attitudes and modus operandi. In fact, a couple were so vehement in expressing their opposing views that we could never print them without some *extensive* editing.

Goodwin went on to say that the

> nice thing about receiving such an opinionated and heavy response to a feature is it shows a strong reader involvement that really isn't found that often in comics. From all indications, the Punisher may very well be the first series in comics that the readers can (and maybe, in a way, *should*) love *and* hate at the same time![120]

These exchanges pose a problem for those who insist, with the Marxist writer Ernest Mandel, that "People don't read crime novels"—or presumably comic books—"to improve their intellect or to contemplate the nature of society or the human condition, but simply for relaxation."[121]

Don't write me

Over the years, Marvel has issued *The Amazing Spider-Man* #129 in a variety of formats, with the company treating the Punisher's inaugural appearance as a major event. But when it came time to compile the *Classic Punisher* (1989) trade collection, Marvel overlooked the character's Spiderverse appearances in favor of Conway's "Death Sentence" and Goodwin's "Accounts Settled, Accounts Due!" As this editorial decision makes clear, these stories are foundational, despite the fact that they left little impression on how the Punisher was treated by writers and artists during the 1970s and early 1980s.

"Death Sentence" and "Accounts Settled, Accounts Due!" are some of the only black-and-white Punisher stories ever published. Setting aside these unusual one-offs, the bulk of black-and-white stories that feature the character appeared in the sixteen issues of *The Punisher Magazine* from 1989 to 1990. Tellingly, *The Punisher Magazine* shuttled back-and-forth between tough guy storytelling and parodic humor. While the magazine mostly recycled Mike Baron's gritty stories from the character's first unlimited series, the magazine found room for a fake letters column, titled "The Punishment Fits the Crime." "Dear Frank," ran one letter. "Count me in!" "Don't write to me—I'm fictional," he helpfully responded. Another correspondent pleaded, "Please renew my subscription to *The Punisher*, *The Punisher Magazine*, and *The Punisher War Journal*. I especially enjoy the Punisher's Arsenal Pages in the *Journal*—they're really helpful when I'm making up next year's budget!" The letter was signed, "Toodles, Dick Chaney [sic], Secretary of Defense."[122]

Contending positions

The sweeping and reductive term "the media" is often used to suggest that reportage and entertainment all point in the same direction. "That's what the media *wants* you to think," and so on. But a careful reading of the Punisher corpus reminds us that divergent viewpoints can exist under the same corporate umbrella. Left and right-leaning writers have used the Punisher for distinctive ends, and there is no reason to think that the character's stakeholders favor one approach over the other. Whenever two or more Punisher titles appear on the racks of comic book stores in the same month, they offer contrasting arguments about crime, morality, and justice.

The two Punisher templates are a case in point. At one time, they reflected distinct formats and marketing strategies: trigger-happy for floppies; grim-and-gritty for older teenagers and adults. One reason why the gritty model predominates is that in recent years, Marvel has shifted its focus from an all-ages audience towards adult fandom. But ideological issues are also at stake. Parody is the natural home of critics of militarism and hypermasculinity, while a grittier approach offers a better fit for creators and readers who sympathize with the character's methods and goals. And as we have learned, artists enjoy a gamut of options when it comes to rendering crime-control vigilantism. Punisher storytelling varies widely in tone and texture not only because many different artists and writers have worked on the character but because anger itself assumes a multiplicity of guises.

Trigger-happy Punisher can be just as wrathful and violent as the grim-and-gritty version. But the connotations are different. Broadly speaking, the

trigger-happy version harbors psychological issues, while the gritty iteration exposes unresolved social problems. Both approaches provide room for politically charged commentary about laws, institutions, and justice. They are both cultural indices of social fear. But only in a gritty environment would the hero kill a woman who resembles his recently deceased wife. That is truly bleak.

NOTES

1. Quoted in Tony Cliff, *The Crisis: Social Contract or Socialism* (London: Pluto Press, 1975), 10.
2. Character logic can be defined as what a reasonable person would accept as plausible for the character. The concept highlights the extent to which a character's deepest contours—costume, powers, origin story, nomenclature—carry narratological weight. It is not quite the same as Roy T. Cook's broader notion of "fictional truth," in which "certain claims regarding the objects, events, characters, and locales described by the fiction are true-in-the-fiction, in the sense that competently understanding and interpreting the fiction requires assent (of some sort) with respect to those claims." Thus, "Snoopy is a beagle" is "true of the fictional world described by Schulz," whereas "Snoopy is an aardvark is obviously false in the fictional world described by Schulz." Roy T. Cook, "Intertextual Metafiction In and About Reality," *Inks: The Journal of the Comics Studies Society* 2.2 (Summer 2018), 185.
3. Martha Nussbaum, *The Monarchy of Fear* (New York: Simon and Schuster, 2018), 24.
4. www.psychologydictionary.org/availabilityheuristic/.
5. https://www.oxfordreference.com/view/10.1093/oi/authority.20110803095436724.
6. Scott McCloud, *Understanding Comics: The Invisible Art* (Northampton: Tundra, 1993), 118, 124.
7. I undertook these searches via Google on January 15, 2018.
8. Charles Duhigg, "The Real Roots of American Rage," *The Atlantic*, January/February 2019, https://www.theatlantic.com/magazine/archive/2019/01/charles-duhigg-american-anger/576424/.
9. Tom DeFalco et al., *The Amazing Spider-Man* #284 (New York: Marvel, January 1987), n.p.
10. Slavoj Žižek, *Violence: Six Sideways Reflections* (New York: Picador, 2008), 204–05.
11. Steve Gerber and Val Mayerik, *The Man Thing* #4 (New York: Marvel, April 1973), 32.
12. Gerber and Mayerik, *The Man Thing* #4, 14. The inimitable Foolkiller returns in Chapter 5.
13. Matthew Rosenberg and Szymon Kudranski, *The Punisher: War in Bagalia* (New York: Marvel, 2019), n.p.
14. Garth Ennis and Leandro Fernández, *The Punisher* #6.22 (New York: Marvel, August 2005), n.p.
15. Mark Millar, Leinil Yu, and Stephen Segovia, *Avengers vs. New Ultimates Part IV* (New York: Marvel, July 2011), 2.
16. Pat Mills and Kevin O'Neill, *Marshal Law* (New York: DC, [1989] 2014), 195.

17. Aldo J. Regalado, *Bending Steel: Modernity and the American Superhero* (Jackson: University Press of Mississippi, 2015), 219.

18. Dana Forsythe, "Punisher Creator Gerry Conway: Cops Using the Skull Logo are Like People Using the Confederate Flag," *Syfywire*, https://www.syfy.com/syfywire/punisher-creator-gerry-conway-cops-using-the-skull-logo-are-like-people-using-the.

19. Pat Jankiewicz, "Origin of the Species: The Story Behind Marvel's Big Bang Theory!," *Marvel Vision* 15 (New York: Marvel, March 1997), 30.

20. Matt Brady, "Punisher Plus 25: Anatomy of a Comic-Book Craze," *Comics Buyer's Guide* 1344 (August 20, 1999), 38.

21. Jim Krueger, "The Art of War," *Punisher Anniversary Magazine* 1 (New York: Marvel, 1994), 25.

22. Jankiewicz, "Origin of the Species: The Story Behind Marvel's Big Bang Theory!," 30.

23. Brady, "Punisher Plus 25: Anatomy of a Comic Book Craze," 38.

24. Quoted in Brady, "Punisher Plus 25," 38.

25. Jordan Raphael and Tom Spurgeon, *Stan Lee and the Rise and Fall of the American Comic Book* (Chicago: Chicago Review Press, 2003), 151–52. To give a sense of the generations involved: Ross Andru (1927–93), Gerald F. Conway (1952–), Archie Goodwin (1937–98), Stan Lee (1922–2018), John V. Romita Sr. (1930–), Roy William Thomas (1940–), and Leonard Norman Wein (1948–2017).

26. Given this production history, it is somewhat unfair that one Marvel publication characterized the Punisher as a "hastily-conceived throw-off" who "inexplicably transcended" his "humble beginnings" to become one of "today's hottest heroes." See Tom Brevoort and Mike Kanterovich, "Why Is the Punisher So Cool?," *Marvel: Year-in-Review '92* (New York: Marvel, 1992), 28.

27. Gerry Conway, "War Files," *Punisher Anniversary Magazine* 1 (New York: Marvel, February 1994), 8–9.

28. Jankiewicz, "Origin of the Species: The Story Behind Marvel's Big Bang Theory!," 30.

29. Chuck Dixon and Joe Kubert, *Punisher War Zone* #1.34 (New York: Marvel, December 1994), n.p.

30. Most of the time, at least. In the MAX universe, he was born and raised in the Flatbush neighborhood of Brooklyn. See Garth Ennis and Goran Pavlov, *Punisher: The Platoon* (New York: Marvel, 2018), n.p.

31. "High school," he remembers. "I didn't mind the studies. The quiet times. I just didn't fit into the 'in' crowd. The cliques. The games." Don Lomax and Dave Hoover, "Brain Drain High," *The Punisher Back to School Special* #1.3 (New York: Marvel, October 1994), n.p.

32. Chris Henderson and Mike Harris, *Punisher: The Prize* (New York: Marvel, 1990), 13.

33. Eliot R. Brown, editorial commentary, *Punisher Armory* #1.3 (New York: Marvel, April 1992), n.p.

34. Chuck Dixon and Mark Texiera, *Punisher War Zone* #1.37 (New York: Marvel, March 1995), n.p.

35. Garth Ennis and John Severin, *Punisher: The Tyger* (New York: Marvel, February 2006), n.p.
36. Mike Baron and Mark Texeira, *Punisher War Journal* #1.25 (New York: Marvel, December 1990), n.p.
37. Ennis and Severin, *Punisher: The Tyger*, n.p.
38. Ennis and Severin, *Punisher: The Tyger*, n.p.
39. Mike Baron and Klaus Janson, *The Punisher* #1.1 (New York: Marvel, July 1987). Mario and Louisa's second son, Michael, was stillborn. "I knew Mom wept for my brother in the early mornings," Castle later remembered. Ennis and Severin, *Punisher: The Tyger*, n.p.
40. Chuck Dixon and Kevin Kobasic, *The 'Nam* 69 (New York: Marvel, June 1992).
41. Castle rescues his relations from the Howling Commandos, but does not interact with them directly. "You thought you could find a Castiglione? That I would fall apart, desperate to save my family? I abandoned that name long ago, Sergeant … along with the *sentiment* it implies." Nathan Edmondson and Mitch Gerads, *The Punisher* #9.14 (New York: Marvel, March 2015), n.p.
42. The retcon was announced in Greg Rucka and Marco Checcetto, *The Punisher* #8.4 (New York: Marvel, December 2011).
43. Andrew J. Friedenthal, "The Punishment of War: Marvel Comics' The Punisher and the Evolving Memory of Vietnam," *Journal of Comics and Culture* 1 (2016), 126.
44. "Point man" is a term for the soldier who takes the lead position in a group formation that is moving through hostile territory.
45. Roger Salick and Mike Harris, *The 'Nam* #52 (New York: Marvel, January 1991), 2. The cover features a "POW*MIA You are Not Forgotten" insignia.
46. Lee Stevens and Mike Ratera, *Super Soldiers* #1.8 (New York: Marvel, November 1993), 4.
47. Garth Ennis and Darick Robertson, *Born* #4 (New York: Marvel, 2003), n.p.
48. Garth Ennis and Goran Pavlov, *Punisher: The Platoon* (New York: Marvel, 2018), n.p.
49. Larry Hama and Hoang Nguyen, *Punisher War Zone* #1.20 (New York: Marvel, October 1993).
50. Don Lomax and Alberto Saichann, *The Punisher Invades The 'Nam: Final Invasion* (New York: Marvel, 1994), n.p.
51. Ennis and Severin, *Punisher: The Tyger*, n.p.
52. "Punishing Mails," *The Punisher* #1.95, n.p.
53. Steven Grant and Mike Zeck, *Return to Big Nothing* (New York: Marvel, 1989), n.p.
54. Mike Baron and Klaus Janson, *The Punisher* #1.11 (New York: Marvel, September 1988).
55. *Punisher War Journal* #1.25 (New York: Marvel, December 1990); *The Punisher* #1.100 (New York: Marvel, March 1995); and *What If …?* #2.10 (New York: Marvel, February 1990).
56. Jason Aaron, Jesus Saiz, and Paul Azaceta, *The Punisher* #13.3 (New York: Marvel, July 2022), n.p.

57. Len Wein and Ross Andru, "Big Apple Battleground!" *The Amazing Spider-Man* #175 (New York: Marvel, December 1977), 2.

58. The comics artist Tim Truman claims that the term "grim and gritty" was first used in connection to a First Comics series titled *Grimjack*, in the mid 1980s. See Brian Cremins, "'I Asked for Water (and She Gave Me Gasoline)': Tim Truman's *Scout* and Social Satire in the Independent Comics of the 1980s," *International Journal of Comic Art 5*, no. 2 (Fall 2003): 346.

59. Alan H., "Punisher War Journal Entries," *Punisher War Journal* #1.71 (New York: Marvel, October 1994), n.p.

60. Or so Marvel announced in its official press release when the MAX was first announced. See https://www.cbr.com/marvels-new-ratings-system-explained/.

61. Most of the Punisher's animated appearances are cliched; the 83-minute *Avengers Confidential* movie is close to unwatchable.

62. *The Punisher* (1989), *The Punisher* (2004), and *Punisher: War Zone* (2008). I return to these films in Chapter 6.

63. Alan H., *Punisher War Journal* #1.71, n.p.

64. In this context, see Mike Baron, "Comic Books' Conservative Roots," http://www.hollywoodintoto.com/nexus-mike-baron-conservatives/; Dan Wickline, "Punisher Creator Gerry Conway Responds to Police Decal Controversy," https://www.bleedingcool.com/2017/02/25/punisher-creator-gerry-conway-responds-police-decal-controversy/; Jude Terror, "Gerry Conway Talks Politics: Except for Foreign Policy, Obama Made Nixon Look Like a Socialist," https://www.bleedingcool.com/2017/09/08/gerry-conway-talks-politics-except-foreign-policy-obama-made-nixon-look-like-socialist/; and Chuck Dixon and Paul Rivoche, "How Liberalism Became Kryptonite for Superman: A Graphic Tale of Modern Comic Books Descent into Moral Relativism," *Wall Street Journal*, June 8, 2014, https://www.wsj.com/articles/dixon-and-rivoche-how-liberalism-became-kryptonite-for-superman-1402265792. Nathan Edmondson served as Director of International Programs at the Leadership Institute before becoming a full-time writer in 2009. The Institute "teaches conservatives of all ages how to succeed in politics, government, and the media." Alumni include Mitch McConnell, Mike Pence, and elected officials from all 50 states. See https://www.leadershipinstitute.org/aboutus/morton.cfm.

65. Quoted in Lia Pelosi, "Crime and Punishment," *Punisher Anniversary Magazine* 1 (February 1994), 6.

66. "Our society has become so complex," Hama argues, "that the lines of punishment have become blurred. We, as a society, live in fear of killing one innocent person and in the process are willing to let those who are guilty off free, essentially." The Punisher, he noted, "is a reaction to a system that doesn't work." See Pelosi, "Crime and Punishment," 4, 6.

67. "Mike Baron Interview," *Comics Interview* (1988), cited in Bradford W. Wright, *Comic Book Nation: The Transformation of Youth Culture in America* (Baltimore: Johns Hopkins University Press, 2001), 320.

68. Mark Millar and Leinil Francis Yu, *Ultimate Avengers* #2.7 (New York: Marvel, June 2010), n.p.

69. See, *inter alia*, *The Punisher: Year One* 4 (New York: Marvel, 1995), n.p. "Castle's *dead*," the Punisher informs a police detective. "Died in Central Park." "Please, Castle ... I ..." "*Don't turn around*. Castle's *dead*. I told you." A variation on this theme can be found in the 2004 movie novelization: "Frank Castle was alive. But his eyes were those of a dead man." Dave A. Stern, *The Punisher* (New York: Del Rey, 2004), 136.

70. This line is recycled in the trailer for the 2004 *Punisher* movie; see https://www.youtube.com/watch?v=G59cD1NSbS8.

71. Kieran Shiach, "The Lasting Impact of 'The Death of Gwen Stacy," http://comicsalliance.com/tribute-death-of-gwen-stacy/.

72. Geoff Klock, *How to Read Superhero Comics and Why* (New York: Continuum, 2006), 83.

73. Gerry Conway and Ross Andru, "The Kangaroo Bounces Back!" *The Amazing Spider-Man* 126, reprinted in *Essential Amazing Spider-Man* #6 (New York: Marvel, [1973] 2004), n.p.

74. Brevoort and Kanterovich, "Why Is the Punisher So Cool?" 28. "Yeah, here's a hero who can tell the players without a scorecard," they snark.

75. Gerry Conway and Ross Andru, "The Punisher Strikes Twice!" *The Amazing Spider-Man* #129, reprinted in *Essential Amazing Spider-Man*, n.p.

76. David Lapham, *Daredevil vs. Punisher: Means and Ends* #2 (New York: Marvel, September 2005), n.p.

77. David Lapham, *Daredevil vs. Punisher: Means and Ends* #1 (New York: Marvel, September 2005), n.p.

78. In *The Amazing Spider-Man* #148 (New York: Marvel, September 1975), we learn that the Jackal is Miles Warren, a professor of biology at Empire State College, where Peter Parker attends classes. Secretly in love with Gwen Stacy, he creates the Jackal persona, complete with a green bodysuit and razor-sharp claws, to take down Spider-Man, whom he blames for Stacy's death.

79. Conway and Andru, *The Amazing Spider-Man* #129, n.p.

80. Gerry Conway and Ross Andru, "The Spider's Web," *The Amazing Spider-Man* #131 (New York: Marvel, June 1974), 18–19.

81. Gerry Conway and Ross Andru, "Shoot-Out in Central Park!" *The Amazing Spider-Man*, #135 reprinted in *Essential Amazing Spider-Man* #6, n.p.

82. Gerry Conway and Ross Andru, "To Sow the Seeds of Death's Day!" *Giant-Size Spider-Man* #4 (New York: Marvel, 1975), 9.

83. Conway and Andru, *Giant-Size Spider-Man* #4, 31.

84. Len Wein and Ross Andru, "Let the Punisher Fit the Crime!" *The Amazing Spider-Man* #162 (New York: Marvel, November 1976), 3, 14.

85. Wein and Andru, *The Amazing Spider-Man* #162, 17, 31.

86. Geoff Klock, "The Revisionary Superhero Narrative," in *The Superhero Reader*, eds. Charles Hatfield, Jeet Heer, and Kent Worcester (Jackson: University Press of Mississippi, 2013), 123.

87. Matt Fraction and Howard Chaykin, *Punisher War Journal* #2.18 (New York: Marvel, June 2008), n.p.

88. Matt Fraction, Rick Remender, and Howard Chaykin, *Punisher War Journal* #2.21 (September 2008), n.p.

89. Matt Fraction, Rick Remender, and Howard Chaykin, *Punisher War Journal* #2.22 (October 2008), n.p.

90. Len Wein and Ross Andru, "The Hitman's Back in Town!" *The Amazing Spider-Man* #174 (November 1977), 31.

91. Mike W. Barr, Frank Springer, and Pablo Marcos, "Fear Grows in Brooklyn!" *Captain America* #241 (January 1979), 23.

92. Frank Miller and Klaus Janson, "Last Hand," *Daredevil* #181 (New York: Marvel, April 1982).

93. Editorial copy, Daniel Way, and Steve Dillon, *Bullseye: Greatest Hits* #1.2 (New York: Marvel, December 2004), 1.

94. Tom DeFalco, Jim Owsley, and Alan Kupperberg, "The Arranger Must Die!" *The Amazing Spider-Man* #285 (New York: Marvel, February 1986), n.p.

95. Marv Wolfman, Keith Pollard, and Jim Mooney, "One For Those Long Gone!" *The Amazing Spider-Man* 202 (New York: Marvel, March 1980), 18.

96. Bill Mantlo and Al Milgrom, *Peter Parker, The Spectacular Spider-Man* #1.81 (New York: Marvel, August 1983), n.p.

97. Steven Grant and Mike Zeck, *The Punisher: Circle of Blood* (New York: Marvel, [1986] 1988), 13. See also Brian Cronin, "The Abandoned An' Forsaked – Did Punisher Just Shoot That Litterer?" CBR, December 20, 2011, https://www.cbr.com/the-abandoned-an-for-saked-did-punisher-just-shoot-that-litterer/2/.

98. Bill Mantlo, Al Milgrom, and Jim Mooney, "Stalkers in the Shadows," *Peter Parker the Spectacular Spider-Man* #81 (New York: Marvel, August 1983), n.p.

99. In the Marvel-DC mashup Amalgam, "Trevor Castle" joins forces with his ex-wife, Diana Prince, to kick some villainous butt. "I thought you had taken to using *dummy* bullets," she says. "I did. But the dummies kept getting up," he responds. John Ostrander and Gary Frank, *Bullets and Braces* #1 (New York: Marvel, April 1996), n.p.

100. Marv Wolfman and Keith Pollard, "Man-Hunt!" *The Amazing Spider-Man* #201 (New York: Marvel, February 1979), 5.

101. Wolfman, Pollard, and Mooney, "One For Those Long Gone!" *The Amazing Spider-Man* #202, 11, 14, 30.

102. http://www.tradingcarddb.com/ViewCard.cfm/sid/74396/cid/5316483/1990-Impel-Marvel-Universe-155-Spider-Man-Presents:-Punisher.

103. George Caragonne and Eric Fein, "The Killing Season!" *The Punisher Holiday Special* #1.2 (New York: Marvel, January 1994), 3.

104. "The Spider's Web," *Giant Size Spider-Man* 5 (July 1975), 42.

105. *Giant-Size Spider-Man* #5, 41.

106. *Giant-Size Spider-Man* #5, 41.

107. *Giant-Size Spider-Man* #5, 41.

108. Deathlok first appeared in *Astonishing Tales* #25 (New York: Marvel, August 1974).

109. *Giant-Size Spider-Man* #5, 42.

110. Les Daniels, *Marvel: Five Fabulous Decades of the World's Greatest Comics* (New York: Abrams, 1991), 161.

111. Gerry Conway and Tony DeZuniga, "Death Sentence," *Marvel Previews* #2 (New York: Marvel, 1975), 10.

112. Conway and DeZuniga, "Death Sentence," 34.

113. Conway and DeZuniga, "Death Sentence," 30.

114. Conway and DeZuniga, "Death Sentence," 38–39.

115. Conway and DeZuniga, "Death Sentence," 21–23.

116. A second issue never appeared, although Marvel revived the title a year later in an unrelated context.

117. Archie Goodwin, Tony DeZuniga, and Rico Rival, "Accounts Settled, Accounts Due!" *Marvel Super Action* #1 (New York: Marvel, 1976), 7–9.

118. Goodwin, DeZuniga, and Rico, "Accounts Settled, Accounts Due!" 24–25.

119. Archie Goodwin, "Behind the Action," *Marvel Super Action* #1, 2.

120. "Re: Action!" *Marvel Super Action* #1, 4–5.

121. Mandel, *Delightful Murder*, 10.

122. *The Punisher Magazine* #9 (New York: Marvel, April 1990), 24.

3

The Universe Pushes Back

In my simple way I am a kind of justice. Do you know any reason why you should wait any longer for what you deserve?

—Leslie Charteris, *The Saint: The Happy Highwayman* (1935)[1]

In *Discipline and Punish* (1975), Michel Foucault observes that by "the beginning of the nineteenth century, the great spectacle of physical punishment disappeared" across large parts of Europe. "The tortured body was avoided," he adds; "the theatrical representation of pain was excluded from punishment. The age of sobriety in punishment had begun. By 1830–48, public executions, preceded by torture, had almost entirely disappeared."[2] But if "sobriety in punishment" became the watchword for civic authorities, the "theatrical representation of pain" became a hallmark of the burgeoning print culture that accompanied urbanization and mass literacy in the nineteenth and twentieth centuries.

After all, the Punisher is part of a lineage of print that encompasses the Grand Duke of Gerolstein, the Count of Monte Cristo, Terry Mack, and Mike Hammer. But even the most vicious of these forerunners were modest in their ambitions. Frank Castle murders on a scale that is operatic. His body count is not only visually daring; it speaks to an altogether entrenched pessimism about politics, one that dares to imagine, in Eric Hobsbawm's words, "a more general 'revolution of destruction', which tumbles the whole world in ruins, since no 'good' world seems possible."[3]

The Punisher's anti-system orientation is perhaps his most intriguing feature. Frank Castle is not exactly a concerned citizen who steps up when the authorities fail to do their job. Nor is he someone, like the Grand Duke, who slips out of society and into the state of nature to fight crime. He is a far less respectable or consoling figure. From the vantage point of Thomas Hobbes, Castle is a Judge "without Authority from the Sovereign," and his campaign "is not Punishment; but an act of hostility."[4] For as Hobbes argues, "neither private revenges, nor injuries of private men, can properly be stiled [styled] Punishment; because they proceed not from publique Authority."[5] John Locke similarly warns that it is

unreasonable for Men to be Judges in their own Cases, that Self-love will make men partial to themselves and their Friends. And on the other side, that Ill Nature, Passion and Revenge will carry them too far in punishing others. And hence nothing but Confusion and Disorder will follow.[6]

As Locke suggests, the self-loving individual who punishes others is more likely to produce "Confusion and Disorder" than safer streets. Of course, from Frank Castle's perspective, disorder is the fault of others, or rather that of a social order that "lacks the capacity to offer the protection obedience exchange that Hobbes prefers."[7] While classical liberals like Hobbes and Locke readily allow for what they view as legitimate forms of punishment, they are alert to the dangers posed by individuals whose passions (in Locke's words) "will carry them too far." For Castle, on the other hand, passion is a tool in his ill-mannered forever war.

Frank Castle is a would-be leviathan, a "subject that produces its own image of authority," in the words of Michael Hardt and Antonio Negri. "This is a form of legitimation that rests on nothing outside itself and is reproposed ceaselessly by developing its own language of self-validation," they add.[8] Or as Bonnie Mann argues, "the sovereign man obeys no law but his own," and "enjoys an entitlement to act that is unabridged by the rights of others."[9] Castle's safe houses and battle vans may not afford him the capabilities that nation states enjoy, but he maintains a state-like capacity "to command, to forbid, to allow, to punish."[10]

A degree of overlap between the Punisher and canonical political philosophy can be found in the works of Carl Schmitt, particularly Schmitt's emphasis on the friend/enemy distinction, his insights into the protracted crisis of liberal democracy, and his concept of the state of exception. For Schmitt and the Punisher, friends are innocents and enemies are without rights. Castle sometimes muses about whether anyone is truly innocent, but this simple binary is nevertheless inscribed onto his character logic. As Schmitt writes, the "distinction of friend and enemy denotes the utmost degree of intensity of a union or separation, of an association or dissociation."[11] From Castle's perspective, the criminal justice system protects the specious rights of the accused and neglects to treat criminals as enemies of the people.

Schmitt's phrase "utmost degree of intensity" encapsulates Castle's daily routine, even if the vigilante is consumed by processes of separation and dissociation rather than union and association. Schmitt says that only "the actual participants can correctly recognize, understand, and judge the concrete situation and settle the extreme case of conflict," which is consistent with the Punisher's outsider status and his near-refusal to allow others to follow in his footsteps. When Schmitt suggests that the friend/enemy distinction "can neither be decided by a previously determined general norm nor by the judgment of a disinterested

THE UNIVERSE PUSHES BACK

and therefore neutral third party,"[12] he articulates at an abstract level what Castle has been testily trying to explain to the costumed community for several decades.

The crisis and exhaustion of liberal democracy is another important theme in Schmitt's work. As Anthony Peter Spanakos argues, "Schmitt's analysis of the profound and prolonged crisis of Weimar Germany centered on his critique of liberal parliamentary democracies." By failing to "recognize as enemies certain groups," the Weimar Republic hastened its own demise. Liberal democracies "are characterized by discussion not decision," and they constrain and divide rather than centralize and empower political authority. As a result, "there is no obvious constitutional claimant who can be sovereign because the multiple potential agents (president, parliament) do not make the decision to use emergency powers to protect the state."[13] By placing a greater premium on principles rather than safety, liberal democracy turns into a self-negating project, Schmitt argues. This is the same point that the Punisher makes when he complains that heroes like Daredevil and Spider-Man would rather prop up the system than wage total war.

Rather than placing his trust in the social contract, the Punisher rationalizes his campaign as an open-ended state of exception. "War and uproar are two most significant cases when this right is put into practice," argues Schmitt, but the state of exception is allowable whenever "public tranquility and security" are placed in jeopardy. "It is a right of exception, a *ius speciale* [special right], in contrast to the normal right of sovereignty, which is a *ius generale* [general right]." The right of exception, Schmitt maintains, "should only be subject to *ius divinum* [divine right]; it is superior to all other legal limitations" and is "above the ordinary constituted forces."[14]

The Punisher may not believe in divinity, but he most definitely assumes that the public tranquility is imperiled. Schmitt even sounds like Castle when he points out that, "If everything depends upon the concrete situation and upon the target that ought to be achieved, then the distinction between just and unjust becomes a useless formality."[15] "When today one nevertheless still speaks of fundamental norm, basic law, etc.," Schmitt writes, "one does so because of the after effect of traditional formulas, which have long since become empty."[16] Here he is supplying words for what the character feels in his bones.

As the Italian philosopher Giorgio Agamben points out, the state of exception "appears as the legal form that cannot have legal form,"[17] which means that it "negates the law itself."[18] What Schmitt and Castle regard as necessity, Agamben views as "modern totalitarianism," which he defines as a "civil war that allows for the physical elimination not only of political adversaries but of entire categories of citizens who for some reason cannot be integrated into the political system."[19] Frank Castle's campaign "exemplifies the state of exception by acting as a central entity exerting supreme power that supersedes legality."[20] Schmitt had designated

99

authorities rather than vigilantes in mind when he made the case for *ius speciale* in the defense of public safety. He is not suggesting that anyone with a spare rocket launcher should shoot up a "rockhouse."[21] But any sophisticated justification of the Punisher rests on Schmittian principles.

Produce the gun

The Punisher poses a special challenge for other costumed heroes. By summarily executing evildoers whom mainstream superheroes should have caught and turned over to the authorities, he makes them look ineffective. "If the *super heroes* actually did their jobs I wouldn't have anything to do," Castle points out.[22] At the same time, the Punisher makes other heroes seem weak and complicit when they fail to stop his ever-mounting body count. As Steve Rogers admits,

> By letting the Punisher go free, we are *condoning* what he *does*. We're saying we only defend the *lives* of the *just*. When we do that, we put ourselves *above* the law. *Worse*, we're *making* our *own* law.[23]

When they first meet, in *Captain America* #241 (January 1979), Captain America and the Punisher are tracking an underworld courier with ties to organized crime. The Captain intends to take the man into custody. But the "ebony executioner"— as Frank Castle is described in a narrator's box, on account of his costume—hopes the underling can lead him to the "two rival *mob bosses*" he intends to kill. The two heroes end up on a Manhattan rooftop, arguing about civil liberties:

> "Captain America! I've followed your career for years, sir—and I admire what you stand for—but this is none of your business! Either back off—now—or I'll be forced to deal with you as I would any criminal scum!"
> "Punisher, listen! You can't kill those mob bosses in cold blood! Even they have rights!"
> "Rights?! They gave up their rights when they chose the path of crime! Now it is my job to punish them—*and the Punisher never misses!*"[24]

Their fight predictably ends in a draw. Captain America muses to himself about how the "Punisher's black outfit" makes him look like "a Nazi." He is "a strange, fanatical crusader who's bent on exterminating all organized crime!" At their next meeting, the Punisher tells Captain America, "This is a war, and crime *is* the enemy! There's only one way to fight it!!" "But if you fight on their terms, you're no better than they are!," the Captain retorts. "We're very much alike, the Punisher

and I," he concludes. "Each of us are fighting a very personal war. But he's got to be stopped."[25] The stage is set for future encounters—in guest appearances, standalone graphic novels, and company-wide events such as *Civil War* (2006–07).

The contrast between the flag-wearing optimist and the armed pessimist is both visual and conceptual. Steve Rogers and Frank Castle are military vets who look back on midcentury America with fondness. But they operate according to different sets of values. The Captain has an aversion to guns, a sunny disposition, and an unshakeable belief in humanity. He is the product of a war that enjoyed overwhelming public support. In contrast, the Punisher is a psychologically scarred paranoiac who doesn't "trust people in masks"[26] and declares that "my luck comes thirty to a clip!"[27] Until Castle's backstory was retconned, he was a veteran of the Vietnam War, which unlike the Second World War is rarely commemorated as a good war. And no one refers to Captain America as a lone wolf. "The advantage of working alone," Castle snarls, "is that everyone else is *fair game*."[28] Captain America wears a costume because he believes that some ideals are worth defending. The Punisher does not defend. He attacks.

Their motives also diverge. Captain America is an enhanced super-soldier whose mission is self-evidently patriotic. The Punisher's very name implies contempt for "self-righteous *prattle*."[29] "The prisons are so crowded. The courts are so jammed," he jests, as he takes out some muggers.[30] Yet despite his rep as a man of action, when the Punisher brushes up against other crime fighters he feels a need to explain himself, if only to acknowledge that the truth lies "buried real deep … underneath a lifetime of hard choices."[31] Frank Castle poses as a loner, but there are heroes he loves to argue with and topics he loves to argue about.

In this chapter, I explore Castle's argumentative relationship with the superhero milieu to better understand his antagonistic stance vis-à-vis law, justice, and the social contract. Frank Castle is not simply meaner or more aggressive than other heroes. His defiant lethality sets him apart from the superhero mainstream. His lack of interest in the law as a force for good is atypical, as is his indifference to the common good. His interactions with Captain America, Daredevil, and Spider-Man highlight the gulf between his views and theirs. While there are antiheroes whose narratives share the murk and gloom of the Punisher storyverse, at best he merely tolerates his competitors. As we shall find, Castle has innumerable enemies, a paucity of allies, and a knack for making frenemies.

Only the drama

Even though the Punisher "doesn't mix easily with a broad spectrum of characters,"[32] he has battled alongside and fought against some of Marvel's biggest stars.

His fraught relationships with Captain America, Daredevil, and Spider-Man trace back to his early days, while his playful encounters with younger heroes like Cloak & Dagger and Power Pack date to the Clinton era. He occasionally forms makeshift alliances, and at one point joins forces with Venom, the alien symbiote, who "is actually more outright psychotic than Castle."[33] He has also journeyed to the DC universe, where he predictably antagonizes Batman.[34]

Despite his record of accomplishment, a handful of miscreants have eluded the Punisher's grasp. Perhaps the most famous of these is Wilson Fisk, aka Kingpin. Fisk is an ambitious bully who in his own way loves New York. Comics scholar Ryan Litsey describes him as "a galvanizing force for social and political change," who "like Machiavelli's Prince, deploys lies, amorality, and violence to achieve socially useful ends."[35] Another seemingly indestructible cast member is the Punisher's nemesis, Jigsaw. The fact that Billy Russo endures when so many far more capable enemies have been killed off remains counter-intuitive. Still another elusive adversary is Bullseye, the killer-for-hire who can turn any object into a weapon. Bullseye not only finds pleasure in tormenting Castle but is the better marksman.

Kingpin, Jigsaw, and Bullseye advance distinct rationales in defense of their actions. Kingpin is willing to do what he regards as necessary for the sake of his beloved New York; Jigsaw views himself as a victim of a gross injustice; and Bullseye is a sadistic hedonist. As it happens, these are all warped variations on the Punisher's own exculpatory arguments. Like Kingpin, Castle "does what needs to be done." Like Jigsaw, he is scarred, albeit by what happened to his family and city rather than at the hands of a crime-controller. And while the Punisher loathes Bullseye's amoralism, both men derive satisfaction from the thrill of the chase. They kill with gusto. Castle does not like or trust any of these men, but he has more in common with them than he does with ordinary New Yorkers, whose motivations are banal and incomprehensible.

Despite his reputation as a loner, the Punisher has been a member of two superhero teams: Marvel Knights, whose members include Black Widow, Daredevil, Luke Cage, and the martial arts expert Shang-Chi, and Thunderbolts, whose roster boasts Deadpool, Elektra, and Red Hulk. Ironically, Marvel Knights was initially formed to deal with Castle, with Daredevil describing him as "the greatest evil this city faces."[36] All is soon forgiven as they fight side-by-side in an alternate NYC that Castle describes as "pre-*Giuliani*."[37] The group takes on a pair of diabolical Euro-billionaires, which makes sense given that Continentals are always villains in the Punisherverse. These team-ups play up Castle's trigger-happy aspect and emphasize the extent to which his extremism compromises his ability to work with others. If the Punisher were the hero of these kinds of appearances, it would cast conventional heroism in a poor light.

Yet it barely makes sense that Frank Castle would join a superhero team in the first place. From the Punisher's skewed but more or less consistent perspective,

the MU is composed of four main groups: civilians, cops, costumes, and criminals. Civilians and cops are noteworthy if they are criminals in disguise. Costumes are irritating at best, and criminals are loathsome. While Castle once welcomed "a little super-powered help,"[38] he basically hates having "these so-called super heroes running around."[39] "*I don't trust people in masks*!," he yells.[40] He views himself as "a *good guy* doing what the other good guys don't have the *guts* to do—put away creeps and sleezos *permanently*."[41] "I'm not one of those bleeding heart *superheroes*," he boasts. "I play by the same rules as my *enemies*."[42] "And people say *I'm* crazy. I'm the *sanest guy* this town has ever seen."[43] A *Daily Bugle* editorial advances a similar argument: "It is the opinion of this newspaper that while his methods may be ghastly, Frank Castle protects *the common man* while our so-called 'super heroes' destroy *schools* in their never-ending fisticuffs against one another."[44]

Given that Castle regards phrases like "*civilization* and *rehabilitation* and *fair hearing* and *law and order*" as outrageous untruths, the fact that he often ends up collaborating with do-gooders is mildly ironic.[45] His popularity makes sense in endogenous terms, however. Fans of one type of character, e.g., a crime-control vigilante, may be more willing to purchase titles that feature, say, sock-hopping teenagers, when one of their favorite heroes makes an appearance. There is a storytelling rationale at work here but a commercial logic as well.

Creative mayhem

Questions of justice—how to define it and how best to defend it—are at the heart of the Punisher mythos. These questions are often foregrounded when the character interacts with other MUers. As I have suggested, a mass murderer whose *raison d'etre* is punishment is someone whose actions are inherently political. Superheroes who collaborate with state actors are punting when it comes to the question of justice. Handing criminals over to the authorities is the safe thing to do. But a character who kills rather than apprehends, on the grounds that "the ones you take out today won't hurt anyone tomorrow,"[46] is entering liminal space. Stepping around legal niceties is something costumed heroes do all the time. Vitiating the rule of law is another thing entirely.

The Punisher expresses none of the ambivalence that Jack Bauer voices in a *24* novel:

> The law was a fine instrument, a useful tool. But it occurred to him that it was a tool that often was too clumsy, like a shovel with too long a handle. There were times when you wanted to cut it short. *When did I start thinking that way?* he wondered.[47]

A closer match with the Punisher's outlook is articulated by Lee Child's Jack Reacher:

> I had no laws to worry about, no inhibitions, no distractions. I wouldn't have to think about Miranda, probable cause, constitutional rights. I wouldn't have to think about reasonable doubt or rules of evidence. No appeal to any higher authority for these guys. Was that fair? You bet your ass. These were bad people.[48]

In both his happy and gritty guises, the Punisher views the law as an empty shell. "Laws crack and warp," he explains. "Misused. Twisted. Corrupted. Until all law is nothing but words. Words, built on nothing. I am wildfire. Scorching bare the field. This is my law. Free of words."[49] Or as he says elsewhere, "I used to believe in due process, constitutional rights, Miranda. But that was a lifetime ago. The Punisher don't play that."[50] While he has claimed that "I've got *no interest* in *senseless bloodshed*—only *justice*,"[51] Castle never stops to wonder what "sensible" bloodshed might look like, or whether "justice" is more than just a synonym for hurting people who hurt people. "Man thinks he's fighting a war," notes Kingpin. "Which is the only thing about him I admire. Thinking he can win ... that's the sad part."[52]

Other superheroes are often struck by the gulf between his discourse and theirs. "Castle's impatience *grates* on me," complains Stephen Strange.[53] But the Punisher takes pride in the "*difference* between me and these "heroes.'" When "the *Punisher* takes 'em out, they're out *permanently*,"[54] he says, using the third person. The mad scientist Doctor Octopus proposes that Castle "takes a much more *pragmatic* approach to stopping crime,"[55] while a minor character describes Castle as an ordinary mortal "crossed with a lot of *Rottweiler*."[56] "I just want to rack up a body count!"[57] is a motto few other Marvel heroes could plausibly espouse.

Given that his *modus vivendi* is "creative mayhem,"[58] it might be tempting to assume that Castle's actions lack any sort of coherent rationale. But this is far from the case. Punisher stories mock, debate, advocate for, and puzzle over his alegality with a level of seriousness that is easy to overlook given the brutality of his campaign.[59] Yet when the Punisher asserts his sovereignty, his arguments are often cursory. "I *never* ask myself those questions," he insists. "I *never* forget where I am, or *who* I am, or *why* I'm doing this. I *can't* forget. That's *why* I'm the *Punisher*."[60] "I'm no hero," he says. "Then what are you?," asks a bystander. "A guy who does what needs to be done."[61] Castle exhibits little interest in whether his campaign helps or hurts those he claims to protect, and he is indifferent to the secondary consequences of his actions. His approach supports art historian Scott Bukutman's observation that the "superhero heads for marginalized sites, sites of nonproduction or spectacular destruction, not to impose order but to

participate in, belong to, the chaos."[62] As a despondent character observes in a *Punisher Annual*, "the *law* isn't what makes us *Americans*. *Hate* is."[63] Or as the anarchist theorist Peter Kropotkin noted in 1902, "The idea of *Punishment* is born, and soon drives away every other conception."[64]

Editors often expound on the Punisher's "imperatives of argument"[65] in their published commentaries. But whereas Don Daley and Carl Potts highlight the character's contempt for corruption and hypocrisy, Rick Remender locates him within the framework of Ayn Rand's philosophy of Objectivism. This may be a stretch, in that Punisher stories are reliably indifferent to Aristotle and free markets. But the fact that Ayn Rand was fascinated by the murderer William Edward Hickman, and "used this killer as an early model for the type of 'ideal man' she promoted in her most famous books,"[66] is intriguing. Remender is certainly on the money when he describes Frank Castle as someone who sees "the world as black and white, right and wrong, nothing in the middle; if you prey on humanity, if you kill the innocent, you lose your membership among the breathing."[67] When Castle defends his actions he does not seek to convince anyone—except his extradiegetic audience—or even change anything. Yet his character logic dictates that he sticks to his guns.

As it happens, there are other possible points of contact between the worlds of Ayn Rand and Frank Castle. Steve Ditko, who penciled and co-plotted the first 38 issues of *The Amazing Spider-Man*, infused his work with Objectivist themes. Two of Ditko's characters, the Question and Mr. A, are early crime controllers who helped pave the way for Frank Castle. Ditko outlined his approach in a 1968 interview:

> When Blue Beetle got his own magazine, they needed a companion feature for it. I didn't want to do Mr. A, because I didn't think the Code would let me do the type of stories I wanted to do, so I worked up the Question, using the basic idea of a man who was motivated by basic black & white principles. Where other heroes' powers are based on some accidental super element, the Question and Mr A's "power" is deliberately knowing what is right and acting accordingly. But it is one of choice. Of choosing to know what is right and choosing to act on that knowledge in all his thoughts and actions with everyone he deals with. No conflict or contradiction in his behavior in either identity. He isn't afraid to know or refuse to act on what is right no matter in what situation he finds himself.[68]

Comics publishers have on occasion pushed creators to develop in-house versions of other company's characters. But there is no reason to suppose that Gerry Conway was instructed to imitate existing characters or promote a political agenda. Instead, what links Ditko's efforts to the Punisher are two shared premises. First, as Ditko himself argues, "Only through black and white principles can

man distinguish between good and evil [...] Men can attempt to choose contradictions, gray principles, like men can choose to be dishonest, corrupt, but that choice only leads to evil'.[69] This is indeed how Castle views the world. In contrast to Ditko, however, Gerry Conway was not convinced that this argument was *correct*. He merely thought that a character who views the world in these terms might be productive from a storytelling perspective. Second, that someone who is motivated by "black and white principles" would naturally assume they enjoyed the right to "dispense due justice,"[70] i.e., to summarily execute wrongdoers. This also applies in the case of the Punisher.

A major difference between Ditko's vigilantes and Conway's has to do with their respective attitudes towards the justice system. The Question and Mr. A are offended by the system's shortcomings. They are not opposed to the administration of criminal justice *per se*. The Punisher, on the other hand, regards the whole business as a sick joke. He is not merely angry at "blue collar criminals, or the economically disadvantaged."[71] He is also enraged by the men and women who benefit from the system without heeding the law themselves. This two-pronged approach is captured by the writer Steven Grant in *Return to Big Nothing* (1989):

> They laugh at the law. The rich ones who buy it and twist it to their whims. The other ones, who have nothing to lose, who don't care about themselves, or other people. All the ones who think they're above the law, or outside it, or beyond it. They know all the law is good for is to keep good people in line. And they all laugh. They laugh at the law. But they don't laugh at me.[72]

Castle carries no particular beef against police officers. They are "just doing their job"[73] but sometimes interfere with his mission.[74] "Though the policeman is sworn to keep the peace," he explains, "his kind have never understood me. They enforce laws. I punish those who break laws. There's a subtle difference."[75] "Often wonder how these guys stand it," he confesses. "Working in the system. Rules and frustrations. I's to dot and t's to cross. I couldn't do it in a million years."[76] As he observes elsewhere, "It's not about respect, officers [...] but reality!"[77]

Street cops usually turn a blind eye to his activities. Some celebrate his achievements.[78] A few are "not even sure" he exists.[79] "To the Punisher," a police officer exclaims as he hoists a cold beer. "While we're busy chasin' our tails he's out there doing something to reduce the scum population."[80] "There's not a cop in New York City who wants the Punisher caught," notes Lieutenant Martin Soap, who heads the Punisher Task Force. "Every cop in the department loves him. They're always saying how he does half the job for us."[81] Or as a heavily muscled officer admits during an interrogation, "I get *it*. What you do, why. I get it." But Castle is scornful. "Mouth-breather," he tells himself. "I've heard he beats his cat."[82]

The Punisher views the mass of humanity through the same negativistic lens. "Civilians!," he complains. "They don't understand the nature of this war."[83] "When you get right down to it," he says elsewhere, "most people are creeps."[84] "This city is a cesspool," he later tells himself, at a time when crime rates were dropping and the economy was booming. "Not a place for decent people. If there are any decent people. And sometimes, I think there aren't."[85] Babies and small children excepted, perhaps. After helping a mobster's wife give birth, he points his gun at her. "I just had a baby, for chrissake," she cries. "Oh my God, I haven't even seen him. I don't … can I just … What does he look like?" "He looks like they always look," he says before he shoots her. "Innocent."[86]

The Punisher is "the friggin' patron saint of New York but they all vilify him … despise him," concludes Stuart Clarke, who collaborates with Castle during the second *Punisher War Journal* series (2007–09). "How many lives has he saved by cutting down the weeds in this city? How many New Yorkers owe Frank Castle their lives?," he asks. The S.H.I.E.L.D. agent whom Clarke is addressing, Diamonelle, is better known to fans by her birth name, Lynn Michaels. She responds with a series of well-aimed questions:

> Does one life saved measure up to all the people he killed that didn't deserve to die? The two-bit crooks working as bodyguards? The laid-off *schlub* who signed on to rob a jeweler to feed his family or buy his sick mother's medication? How many splintered and shattered lives is he at the root of?[87]

From the Punisher's standpoint, civilians "need a constant *reminder* of how *ugly* the war is'.[88] Even costumed heroes forget that "this is a *war*."[89] 'You're all dirt," Castle exclaims, as he fires rounds in the direction of Daredevil, Moon Knight, and Spider-Man, who are all standing near a "filthy dirty" cop.[90] Castle is similarly disinclined to cut any slack for elites who cocoon in their "nice, warm uptown penthouses."[91] There is a "*stink* of *corruption* coming *down* off it all," says Castle, and he is determined to "follow it *up*. No matter *where* it leads. No matter *who*. No matter how *high*."[92] This is a well-worn trope in mass entertainment.

As we consider the Punisher's overdetermined relationship to issues of morality and justice, it is useful to keep the Roman god Janus in mind. Castle's rage points in two directions. He is infuriated by those who claim to care about justice as well as by those who could not care less. The populist charge of his discourse would not be as effective if he was only concerned about street criminals. Adding "oilmen and generals, computer billionaires and senators, captains of industry"[93] to the mix lends his stories a class-conscious aspect. His blue-collar credentials are strong. It makes intuitive sense that he would harbor some resentment towards

the rich and powerful. In the hands of some writers at least, the Punisher's rhetoric carries multilayered implications.

Light of day

The Punisher mainly consorts with costumed heroes whose powers are proportionate to his own. As the writer Peter David explains, the idea of Castle battling someone like the Hulk is "inherently absurd, because the power levels of the characters are so disparate."[94] Whether these encounters are one-time or recurrent, they spotlight the issue of extrajudicial murder. Costumed adventurers do not normally object to the idea of throwing punches and knocking heads. But very few are comfortable with the concept of instant vigilantism that the Punisher embodies.

Guest appearances with younger heroes inevitably downplay the bleaker side of the Castle drama. His encounters with Cloak & Dagger[95] and with the super-empowered Power Pack end with handshakes.[96] In *The Unbeatable Squirrel Girl*, he threatens Doctor Doom but hastily apologizes when someone assures him, "It's just cosplay!"[97] But in *Runaways*, the teens find themselves in Castle's crosshairs when they ally with Kingpin. "They're frozen," he thinks. "Like they're looking at the angel of death. It's a good start."[98] Then there is the time he drops in on Archie and his friends in Riverdale. "The Crossover You've Been Dreading" relies on a tired doppelganger plot but features a knowing sense of humor.[99] "Y'know, I'm kinda grim 'n' gritty myself!," exclaims Archie, after he and Castle share "an early morning breakfast at Pop's." "Then go take a *bath*," Veronica quips.[100] The writer, Batton Lash, modelled the script after *Abbott and Costello Meet Frankenstein* (1948). In Lash's words, "Bud and Lou have their usual antics, but the Frankenstein monster, the Wolf Man, and especially Dracula are really scary. From one extreme to another!"[101]

When the Punisher appears in his own titles, the aesthetic tends to reflect his world-view. In other characters' titles, he either conforms to the house style or sticks out like a sore thumb. When he works alongside Cloak & Dagger and Power Pack, and confronts the Runaways, Castle is rendered smaller than usual so as to fit into narratives in which preteen and teen characters are the primary heroes. The same thing applies when he confronts Doctor Doom in *The Unbeatable Squirrel Girl*. But in *Archie Meets the Punisher*, his menacing visage is deployed for comedic effect. All Archie has to do is show up and the contrast between his winsome innocence and Castle's world-weary gigantism provides the punchline.

Mostly his guest appearances are testy. "Thought guys like *Spider-Man* were too *soft* ... too *easy* on criminals," muses the hero Darkhawk. But ... there's the *law* ... the *courts* ... and without them there's *anarchy*." "What makes you think

there isn't *anarchy* already, Hawk?" Castle retorts.[102] When the cybernetic hero Deathlok insists, "I can't let you kill anyone," Castle replies, "Your idealistic nature will turn innocent civilians into *dead* civilians!"[103] In *Secret Defenders*, the Punisher is approached by Strange in his astral form and exclaims, "Forget it! I don't *believe* in Dr. Strange." "In that case, *Punisher*," replies the world's greatest magician, "I fear you may have to *start*."[104] As he lays out his plan to take down a transdimensional monster, Stephen Strange points to a tarot card labelled "Justice" with a picture of Frank Castle. 'The Punisher as the personification of *justice*', he purrs.[105] When the Punisher later solicits the Doctor's assistance the magician reminds him, "We're not *friends*. We don't have the sort of *relationship* where—we don't have any *relationship*."[106]

Even Deadpool, the murderous merc-with-the-mouth, has reservations about Frank Castle. This is despite the fact that they are "practically on the *same team*."[107] As their 2017 miniseries commences, the two extremists exchange insults and gunfire. "Wilson," Castle mutters. "Motor-mouthed, muddle-headed, arrested adolescent with delusions of competence." In return, Deadpool labels Castle a "shoot-first-ask-questions-never, humorless, fascist hard-ass,"[108] but insists that he carry on, because "monthly revenue depends on you!"[109] Deadpool's postmodernism ultimately offers a poor fit with Castle's monochromatic sensibility. "Thanks for nothing, righteous fury and vengeance," Deadpool jests, as he slays the Punisher outside of continuity in *Deadpool Kills the Marvel Universe* (2012).[110]

Blow through barricades

The Punisher's interactions with other antiheroes occasionally acknowledge their common ground. "I believe some people deserve to *die*,"[111] Wolverine says at one point in agreement, sounding a lot like his temporary confederate Frank Castle. Ghost Rider shares Castle's indifference to "things like probable cause and search warrants and physical evidence."[112] But Castle dubs Ghost Rider a "freak"[113] and says admiringly, "helmet laws mean nothing to this guy."[114] "Don't know exactly who or what this Ghost Rider is," the Punisher decides, but it "doesn't matter. As long as he doesn't give me any reason to put him away, we'll get along just fine."[115] Their skill sets are different, but they are both "extremely dangerous."[116]

Moon Knight enjoys a more ambivalent relationship with retributive violence. In outline he resembles Batman—a playboy with gadgets but garbed in white rather than black.[117] His fortune gives him access to advanced weaponry, but he suffers from schizophrenia as a result of the stress of having to maintain multiple aliases. The son of a rabbi, he is a "warrior priest for his lord Khonshu,"[118] "one of the Gods of Celestial Heliopolis, worshipped by the ancient Egyptians."[119] While

he sometimes resorts to lethal means,[120] Moon Knight is less bloodthirsty than Castle.[121] "She's down, Punisher. There's no need to kill her," Moon Knight says. "We take the other side down permanent," Castle retorts.[122] "He *likes* the heat; *thrives* on it," Moon Knight reflects. "The danger is what he lives for. But, Lord help me, I'm the same. I just control it better."[123] "Which is worse?" he asks. "The madman who *knows* his motives are rooted in evil? Or the one convinced he's on the side of *justice*?"[124] "Vengeance must be tempered by justice," Spector finally concludes. And because they are in a Moon Knight title, he gets the last word.[125]

Wolverine, who also goes by Logan, is the most volatile of the X-Men. His healing factor and adamantium claws give him an edge over Castle. They have fought on numerous occasions, including in a manga-style Marvel Knights mini-series and the Franken-Castle story arc.[126] They both have anger management issues. At one point, the Wolverine threatens to "gut ya like a fish!" as Castle drives a steamroller over his decumbent body.[127] When they first meet, the Punisher refers to Wolverine as "the wild runt,"[128] while Wolverine calls Castle a "dangerous loose cannon— always walkin' the line, always in danger of going over." These are "traits I can empathize with," he admits, but if Castle "is stepping over the line it may take a kindred soul to show him the way back. Or if needed … to take him down."[129]

In *Ghost Rider/Wolverine/Punisher: The Dark Design* (1994), a civilian describes all three as men who "look into the abyss and stay on the side of good." Their adversary Blackheart is not convinced. "Is it that you only perform these gestures of heroism," he wonders, "to justify the pleasure that you receive by releasing your dark sides?"[130] In another story, Wolverine notes, "You've got the stink of death on you, Punisher—just like me!" "As long as the innocent are protected our cause is just,"[131] Ghost Rider insists. In a subsequent team-up, the Punisher confesses, "I stepped over the line so long ago I don't remember where the line was." "Vigilantes involved in an ethical dilemma," snorts the villain.[132]

A representative exchange takes place when Logan and Castle investigate an Amazonian village "where A-list crooks find sanctuary from the law."[133] After making a critical misstep they find themselves chained to a tree. The village's leaders plan on having them fight a battle royale. "We've heard all your *bitter arguments*," one of their captors explains. "You've been *aching* to get at each other's throats. Wolverine thinks the Punisher is a brainless hothead … and Frank Castle considers the big bad feral mutant to be little more than a *limp-wristed liberal*."[134] After they escape captivity, Logan and Castle make their way back into the jungle. The ensuing dialogue captures their essential difference: Wolverine *gets* mad, the Punisher *stays* mad:

'We'll catch our breath," Castle explains, 'then go back to that town and *finish business*."

"Uh-uh," Wolverine replies. 'Let them rot in this stinkhole. There are fates worse'n death."

"So you say."

"Look, Frank, you can't kill every bad guy on the planet."

"*I can't?*"

"Okay—okay. Say you succeed. Say you do kill every last evildoer there is. What then? Will that make you stop hurting? Will that make you feel like a *whole person* again? [...] That bug-infested shanty-town is a fate worse than death, anyhow. Best just forget all about the poor citizens of Erewhon."

"*Forget* them? Soon as I get enough hardware, I'm coming back and taking care of *all* of them," vows the Punisher.

"You'll be on your own."

"Suits me."[135]

Nations, laws, people

Captain America, Daredevil, and Spider-Man represent all-ages friendly brands with a global reach across a variety of formats, from comics and video games to movies and streaming. While each of these famous heroes have taken lives,[136] they always revert to type. In different ways they encapsulate customs and mores that predate the 1970s. And when they tussle with Frank Castle, they draw the sharpest possible line between their values and his.[137]

How they go about arguing with the Punisher is another question. The three heroes advance distinct claims when they push back against Castle. Captain America's pitch focuses on duty, service, and love of country. The fact that Steve Rogers tells Castle to "Wake up, soldier!" when they first meet is hardly accidental. He seeks to appeal to the Punisher's sense of patriotism. The Captain's approach can be characterized as nationalistic and communitarian in nature. It places a strong emphasis on the connections that bind the individual to the community at large.

Daredevil, in contrast, is an institutionalist. He is a believer in the sanctity of the country's founding documents, such as the Declaration of Independence and the Constitution, and in the value of the public institutions, such as the court system, that derive from these documents. As a graduate of Columbia Law School, Matt Murdock hopes to convince Castle that the law is something to uphold rather than disdain. Although Murdock recognizes that the system is imperfect he insists it can be made to live up to its commitments.

Spider-Man's approach is neither communitarian nor institutional. Instead, the wall-crawler views the world through a humanitarian lens. The health and well-being of individuals are his primary focus, and he likes to remind the Punisher

that bystanders could get hurt as a consequence of his actions. Peter Parker rarely refers to abstractions like nationalism or the law. His perspective is summed up by the famous credo of detective Hieronymus "Harry" Bosch: "everybody counts or nobody counts."[138]

Captain America, Daredevil, and Spider-Man are allies of the social order, which is why their arguments bounce off Castle's emotional plating. He rejects peaceable forms of vigilantism and pushes back against anything that resembles blind optimism. Yet he retains a soft spot for flag and country, even if he "doesn't hide behind a mantle of patriotism."[139] But if Castle does not scorn nationalism in the same way that he mocks legalism and humanism, it seems unlikely he will ever be featured in a comic that is "accomplished through the support and efforts of the Marvel Entertainment Group, the Federal Bureau of Investigation, the Office for Substance Abuse Prevention, the American Council for Drug Education and the National Institute on Drug Abuse." This sounds like a job for Captain America.[140]

A-List: Captain America

The Punisher and Captain America inevitably quarrel when they meet. While it is an exaggeration to say that "the Punisher represents the antithesis of Captain America,"[141] their differences are stark. Even when they take part in the same battles the Punisher operates on his own, whereas the Captain is a team player. In a 1992 Marvel UK miniseries, they work with other heroes to defeat Charnel, an alternate reality Baron Strucker. As Castle blasts away at Charnel's minions on his own, Captain America collaborates with She-Hulk, Scarlet Witch, and Reed Richards, leader of the Fantastic Four, to formulate a plan. In this iteration of the MU, Charnel kills the Punisher along with everyone else who dons a costume. "Punisher's war journal *ends*," reads the narrator's box.[142] Captain America perishes alongside his teammates; Castle dies alone.

In the same year, Marvel issued a Punisher/Captain America allegory, *Blood & Glory*, that was inspired by the Iran-Contra scandal of the 1980s. D. G. Chichester's provocative, left-leaning story revolves around a deep-state conspiracy to funnel money from drug and arms sales to a right-wing Latin American dictator. One of the conspirators uses doctored files to manipulate Castle into thinking that the Captain has been smuggling military-grade weapons in and out of the United States. The first issue ends on a cliffhanger as a distraught Punisher snipes Captain America in the chest. In the next issue, Castle discovers that he was set up. "All *wars* begin with some form of *betrayal*," Castle observes. When he catches up with Captain America, who has recovered from his wounds, they combine forces. "Figured I owed you!," he tells Cap, by way of apology.[143]

Even as they stand together, their differences are glaring. "Eagle Scout thinks differently," Castle observes. "Never understood the stand-up kind. Putting themselves in the spotlight. My *war* stays in the *shadows*." "One thing straight up front," Captain America tells his nominal partner. "I don't like you and I *despise* what it is *you do*! Your methods make me sick!" Castle wants to get even with the conspirators who deceived him about the "guy ... who wears *flags*," while the Captain is looking "for someone to *care* that some of the *good* this country still stands for is being *raped*." "You didn't get all those decorations in just one tour," Rogers pleads; "I just thought ... never mind." "Six tours, G.I. Joe, and *still counting*," replies the Punisher, who is impressed by Captain America's patriotism, even if he does not quite buy into it. "There's a *dichotomy* between us," Castle concludes, "more than the *wars* that made us what we are!"[144] Yet despite their differences, they both want to take down those who, in the words of the Captain, "have sold out *democracy*."[145]

They join forces despite the fact that the Punisher's "battlefield *symbols* aren't red, white, and blue—they're *blood red* and *personal*." In the final issue, the heroes stand together as the dictator's U.S.-made planes rain ammo on their position. "Now it's the *stars* and *stripes* fighting a war with the *tactics* of *Nazis*," explains the narrator. When they take the fight to the nation's capital, Captain America smacks the Attorney General (AG) around while the Punisher executes a high-ranking government official at point blank range. As the Captain pounds the AG into submission, Castle advises that he "*Lower* the *shield*, man! Just *walk away*!" He warns,

> it's *lonely* as hell once you get here! There's *nothing* ... but the cold satisfaction of *punishment*! Every war I've gone into I've watched the *symbols* behind them all fail in the heat of *battle*. There aren't that many things left to believe in ... don't take away one more.

At the story's end, the two heroes exchange salutes at Arlington National Cemetery. But they can never be friends. "You *should've been* over there," the Punisher remonstrates, referring to the Vietnam War. "I'm *not* saying that to *condemn*! It's just ... we *needed good men* at our *backs, Captain*."[146]

In *Captain America and the National Superhero* (2013), Jason Dittmer claims that the

> geopolitical order expressed in Captain America is one in which the United States enacts a liberal internationalist hegemony. The world is envisioned as a realist one of sovereign and equal states, but the United States has a special role to play, purportedly as a result of its morality, objectivity, and power.[147]

Far from celebrating the "morality, objectivity, and power" of the United States government, however, *Blood & Glory* is scathing in its depiction of imperial policy-making. Dittmer's insistence that "Captain America is imagined to exist in a world where American force is only used in self-defense or to protect the public order"[148] discounts even the possibility that the character could be written in ways that critique or satirize liberal internationalism.

But if Captain America offers "iconic shorthand" for the "world-redemptive view of America's destiny," which Robert Jewett and John Shelton Lawrence stipulate as being rooted in "certain strands of biblical thought that were popular in colonial times,"[149] then what are we to make of deconstructive superheroics? The lesson may be that writers-for-hire enjoy significant latitude when it comes to unspooling the implications of Captain America's patriotism, the Punisher's war on crime, and so on. After all, readers would lose interest if all the Cap did was regurgitate Pax Americana. The same holds for the Punisher, despite the fact that he presents an unusually rigid archetype. Structuralist modes of analysis tend to understate the wiggle room that creators enjoy when tasked with the challenge of attracting new readers while keeping old ones on board.

A better-known Captain America—Punisher meetup occurs during the epochal *Civil War* event. This post-9/11 story "crossed over into nearly all Marvel titles," and offers "an allegory of the War on Terror and the USA Patriot Act" in which "the government enacts the Superhero Registration Act, a law that requires all superpowered heroes to become licensed agents of the government or risk arrest as outlaws."[150] The superhero community splits into two camps: those who are prepared to go public and those who prefer to remain in the shadows. The Punisher sides with Captain America and others who believe that costumes should operate "under a self-directed moral code," as opposed to those, such as Iron Man, who maintain that superheroes "need to be trained and properly regulated."[151]

The Punisher only plays a supporting role in *Civil War*, but it is a memorable one. As the Captain and his allies plot to break into the "negative zone prison" where rebel heroes are being held captive, two costumed villains volunteer their support. "You guys ain't the *only* ones scared we're headed for a police state, Captain," explains Goldbug. "The super-criminal community's more concerned about Stark's plans than *anyone*." "We just came by to let you know we're here if you *need* us', adds the Plunderer. Antagonized by their presence, the Punisher promptly guns them down. "You murderous piece of trash," exclaims Captain America, as he punches Castle in the jaw. But the Punisher refuses to fight back. "I wonder why he wouldn't hit *Cap*," asks one of the other heroes. "Are you *kidding* me?," replies Spider-Man. "Cap's probably the reason he went to *Vietnam*. Same guy, different *war*." "Wrong," retorts Captain America. "Frank Castle is *insane*."[152]

There is an odd twist to this saga. The fight over the Superhero Registration Act ends when the Captain turns himself over to the authorities. As he enters the courthouse, a brainwashed Sharon Carter shoots the man she loves. In the second *Punisher War Journal* series, Castle dons a costume that combines elements of the Punisher and Captain America costumes. Fans sometimes refer to this as his "Captain Punisher" phase. When Castle realizes that the burden of following in Captain America's footsteps is "just too heavy," he hands the costume over to Bucky Barnes.[153] The faith that Frank Castle places in the living symbol of midcentury patriotism lands him in trouble in the Secret Empire story arc from 2018. Cosmic forces conspire to create a version of Captain America who serves Hydra rather than the state. Castle becomes Captain America's enforcer, and proudly dubs himself "God's red right hand." He tells Black Widow that the Hydra version of the Captain promises to build "An army to wage the same war I've been fighting my whole damn life." When he grasps his mistake, he goes after Hydra. "I was tricked, manipulated by the one man I thought I could trust," he admits.[154] Yet their relationship has always been contentious, as Frank Miller's cover illustration for *Captain America* #241, from January 1979, makes plain (Figure 3.1).

A-List: Daredevil

The Punisher's attitude towards Captain America is one of grudging admiration. "I'm a soldier. I *know* honor. I *know* respect," he says.[155] For his part, Captain America considers Frank Castle "a *mad dog* gone feral"[156] who was "a *good* soldier once. In some twisted way, he probably thinks he's being one *now*."[157] Daredevil, on the other hand, is a "red clown"[158] and "the crimson wimp of Hell's Kitchen."[159] Castle rejects the idea that the city is better off because of Daredevil. But as reporter Ben Urich tells Foggy Nelson, "you remember what it used to be like. One *wrong turn* and you were staring down the barrel of a gun." As a result of Daredevil's efforts, "every week there's a new *coffee* chain or a *fast food* joint, or some trendy *outfitters*." "Matt didn't fail, Foggy. Everything he did, to make the Kitchen safer, it *worked*."[160]

Daredevil's character logic points in a different direction from Captain America's. As Graham Ferris and Cleo Lunt note, Matt Murdoch is the "heroic comic equivalent of Atticus Finch, the lawyer as hero archetype." Like Murdoch, Atticus Finch "is both a well-respected and tolerant member of his community and a lawyer willing to face opprobrium and personal damage in the conduct of his professional work as a court-appointed defense lawyer."[161] If wearing Old Glory strikes Castle as excessive, then living a double life as an attorney crime fighter seems ridiculous. As Paul Young points out, "Matt's determination to forgive

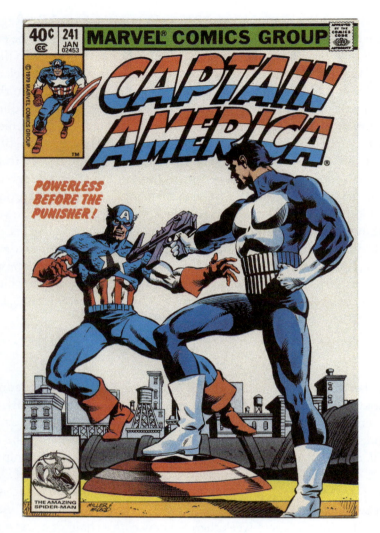

FIGURE 3.1: Frank Miller, *Captain America* #241, cover illustration, January 1979. © Marvel Comics.

rather than prosecute whenever possible places Daredevil in a unique situation among comic-book vigilantes."[162] And unlike the Punisher, "he does not hate the criminal as much as feel outrage at the injustice of crime."[163] For his part, Murdock concedes that he and Castle will never be friends:

> We've got a healthy mutual *dislike*, based on the contrast in our inherent *beliefs*. My code says every *individual*, *no matter* his past, deserves a *second chance*. In his

uncompromising *ruthlessness*, nobody stands in his way. Crossing the line of the law is required before the Punisher puts up the crosshairs. Never having gone over, I don't worry about becoming a target—but I can *unnerve* him, putting at odds my relative *innocence* and his refusal to use *lethal force* on the "undeserving" of punishment.[164]

Black Widow tells them, "You have done this so much you could speak each other's words." She turns to Daredevil and asks, "What would be his next line? *Say it*! He would say, '*Stay out of my way, altar-boy.*'"[165] Or as Daredevil warns in 1996, "I'm going to be *watching* you, Castle."[166] It is little wonder that Daredevil describes Castle as "*my* nemesis, *my* opposite number,"[167] and admits that he "*hates* him with *every fiber* of his being."[168] "Who made the Punisher judge, jury, and executioner?," Daredevil wonders.[169]

Their inaugural meetup, in a 1988 story titled "Child's Play," was penned by Frank Miller, the creative force behind *The Dark Knight Returns* (1986), *300* (1998), and *Holy Terror* (2011). When the blind lawyer first senses Castle he thinks, "His heartbeat is *strong*. His movement's confident, fluid. He's in excellent shape. And he's a killer." "You have your *methods*," the Punisher duly informs Daredevil, "and so do I." "Mine don't include senseless brutality," Daredevil replies. Castle tells Murdock that "If we *must* fight let it be as allies. Together we could *terrorize* the underworld—*eliminate* the enemy we *share*!" The horned hero rejects his offer. "Whether you kill innocents or criminals, it's *murder*—and that makes *us* enemies, Punisher. I'm bringing you in, just like any common—*urrg*!" The "urrg" registers the fact that Castle has just plugged Murdock with a tranquilizer. "You're a *good* man, Daredevil," he whispers. "But not good *enough*."[170]

The stark differences in their fighting styles are suggestive of their philosophical divide. Daredevil breaks up fights; the Punisher starts them. Murdock uses a club; Castle wields an arsenal. David Lapham's *Daredevil Vs. Punisher: Means and Ends* (2005) consists almost entirely of fisticuffs followed by spirited back-and-forths. While Lapham's pencils showcase Daredevil as a master of the fighting arts—quick, fluid, unpredictable—the Punisher is all muscle and gunpowder. "He's *faster* than me," Castle says. "His boxing *alone* could put down the champ. Then there's *this* junk—Eastern—far, *far* up some high, snowy *mountain-top* Eastern." The accompanying panels show Castle taking a series of hard blows. "It doesn't matter," Castle boasts. "I can *take it*. I'm a *rock*."[171] Agility and grace vs. blunt-force trauma. "I'm not *like* him," the Punisher explains. "I'm a *soldier* trained to kill."[172]

When he isn't patrolling the rooftops of Hell's Kitchen, Murdock spends his time insisting that the law serves noble ends. "You can't take the law into your hands," he tells one youngster.

> We're only *human*, Billy. We can be weak. We can be evil. The only way to stop us
> from killing each other is to make *rules*. Laws. And stick to them. They don't always
> work. But mostly they do. And they're all we've got.[173]

But his pleas land on deaf ears. "You want to waste your time running maggots through the criminal justice merry-go-round, that's your problem," the Punisher snarls. "But once I get 'em, they're mine. And I don't waste time. I waste maggots."[174] "I've got no time for your 'big picture' whining," he adds.[175]

Daredevil places his faith in the law, and in the Almighty. The Punisher holds the view that "anyone can die."[176] Castle once believed in "summer walks and safe, quiet neighborhoods. He believed goodness is its own reward, and America belongs to the people."[177] No more. While Murdock and Castle were both raised as Catholics, only one of them stuck with it. After graduating from high school, Castle attended seminary college, but dropped out "when I couldn't shake the feeling that the guilty should be punished before they were forgiven."[178] "There is so much hatred in the world, so much suffering," he tells Father Angus. "How could God allow this to happen?"[179] In Garth Ennis' *Born* (2003), Castle switches sides and swears an oath to "the great beast" during a terrible battle near the Cambodian border. The beast grants Castle "what you've wanted all these years [...] a war that lasts forever, a war that never ends."[180] "I'll see you in hell," he tells one criminal, "because I'm going there too."[181]

Castle sometimes espouses an atheistic position. In one story, a punk stumbles across an injured Punisher and says, "Well look at this, there *is* a God!" "No ... *there* ... isn't," Castle mutters as he slips out of consciousness.[182] He does not exactly sound like a good Christian when he walks into a pagan temple and says, "the only thing worse than church is a Satanic church."[183] And he can be flippant about religious doctrine. "Heard a story once. Someone died to save the world. I forget the details."[184] He expresses disappointment when his go-to informant, Mickey Fondozzi, finds God. You "can't even trust a snitch anymore," he sighs.[185] And yet, in the *Intruder* graphic novel, Castle claims, "I merely carry out His will";[186] in a 1990 *Punisher* story he attends confession;[187] and in a 1993 *Punisher War Zone*, he sadly admits he is unlikely to enter the gates of heaven.[188] "Another man," he says, hedging his bets, "*might* see *His* face up there. Me ... I see nothing but cold stars above."[189] The Punisher refers to himself as an "angel of death,"[190] while Daredevil lights votive candles and regularly goes to confession.[191] "Does he ever stop preaching?," Castle wonders.[192]

"His story will never have a happy ending," Murdock explains to Rachel Cole-Alves, a former marine who follows in Castle's footsteps. "His life is nothing to envy,"[193] and "he is *always* a problem."[194] Their differences are highlighted in 2002's *Marvel Knights Double-Shot*, which features the two heroes in

back-to-back stories. In "Dirty Job," Murdock chases down thieves and muggers, and playfully taunts Kingpin. In contrast, in "Roots" the Punisher tracks a mobster to a dentist's office, where he proceeds to yank out the mobster's teeth before sending him to hell. Each panel is rendered from inside looking out as if a camera had been placed inside the Don's throat. The result is visually arresting but grotesque.[195]

A-List: *Spider-Man*

If Daredevil is meddlesome, Spider-Man is a "fool."[196] Even Daredevil disparages Parker as "too young and stupid to be in this world!"[197] While Spider-Man "protects innocents," and might have the makings of "a good soldier,"[198] he always sticks his nose "where it doesn't belong."[199] "He's getting *away*!! And it's *your fault*, Spider!,"[200] Castle complains.

The web-spinner presents something of a paradox. As the literary historian Ben Saunders notes, Spider-Man is "more given to expressions of depressive self-loathing than any other superhero." Yet when he dons his costume he becomes "humorous, playful, and light-hearted."[201] As we learned in the last chapter, the Punisher initially sizes up Peter Parker as the "kind of scum" who "has ruled this country *too long*."[202] He derides Parker's assumption that "killing *anybody*, unless in self-defense, is against the law, immoral, and flat-out *wrong*!" "You live by *your* moral code, Spider-Man, I'll live by mine," he snarls.[203]

In turn, Spider-Man views Castle as a "homicidal psychopath,"[204] as a "costumed loony toon,"[205] and as *Soldier of Fortune*'s favorite cover boy."[206] He asks whether it occurs "to you that your trigger-happy routine brings you down to the same level as the crooks you hate so much?" What Spider-Man fails to comprehend is that

> every time he puts on that mask ... he protects this city's *criminal element* from their own inbred system of selective elimination! Instead of letting them kill each other, he ties them up and delivers them to the *police*, who delivers them to the *courts* ... who put them back on the street! Well, I am the answer to that problem.[207]

"Crime is war," Castle insists. "And our side is losing!"[208] "That's what I don't like about working with you," Parker retorts. "Too many *bodies*." "That's what I don't like about working with you—not *enough*," the Punisher snaps back.[209]

Peter Parker is lighter and shorter than Frank Castle. He weaves and soars, while Castle charges like a bull and maintains a low center of gravity. Parker is "fast, agile, heart of gold. Saying I'm wrong. Saying I'm evil. Saying all life is

precious."[210] But the fact that Spider-Man has a sense of humor gives him a certain edge. "You again!," the Punisher exclaims. "What the @#$% do you *want* from me?" "Uh, let me *think*," says Parker, as he clings to Castle's battle van. "A spare Kleenex perhaps?"[211] When they work together to take down white nationalists who claim to be "saving the world from the inferior races," Castle spares the life of a fascist in a wheelchair. The man "assumes I'm going to execute him," he observes. But since "he's not going to do any more harm," I should "let him live. That Spider-idiot must be getting to me."[212]

On another occasion, they are on the trail of smugglers importing "coffee barrels full of raw cocaine" into New York Harbor. They trace the smuggling ring back to the U.S. Army. "I don't get it," Spidey whines. "Seems simple enough," the Punisher shrugs. "The drug lord who's amassing the largest store of illicit substances in world history is ... *the United States of America!*"[213] But the fact they are up against military personnel gives Castle pause. "I notice you've stocked up on *non-lethal* weapons," Spider-Man says. "Already made this month's *kill quota*?" "When I go against the mob, I've no compunctions about using their own methods against them," the Punisher explains. "But this is the U.S. Army. *Soldiers*. I used to be one myself and I don't like the idea of slaughtering G.I.s who may think *they're* just doing their *duty*." "My gosh! There's a human being under all that macho?" "Yes, I'm human," Castle concedes. "It's my greatest *weakness*. But I don't let it stop me. And that's my greatest *strength*."[214]

We learn that the feds are stockpiling drugs on the assumption that "the economy is tottering, and if it should fall, *gold* would be nothing but lumps of metal! But drugs will *always* maintain their value!" A cabal hopes to establish a "*cocaine standard*," which Castle finds "sick" but "tricky." Americans are "battered daily with political scandals, increasing crime and poverty. What would this kind of knowledge do to their *morale*?"[215] The two heroes destroy the "powdered bliss"[216] without revealing the conspiracy. As a result of their actions, "taxes will be raised to cover an unexpected deficit in government funds." "If I didn't laugh I'd probably cry!," says Parker, who concludes that Castle is a "killing machine" with "*no* sense of humor."[217]

Spider-Man entertains fantasies about taking the machine down. "I'm not going to swing by and just let this Punisher dude mow down people in public," he pledges.[218] In another story he warns Castle, "I've *seen* you kill people. Okay, maybe they weren't the nicest people—but consider *your* career *over!*" "Hey *watch* it!" he yelps, as the Punisher shoots at him. "Stay away and it won't be an issue," Castle insists.[219] "I've let him *escape* too many times," Spider-Man broods. "All the people he's *killed* because I couldn't hold him ... *never* again."[220] He says the same thing to Castle's face. "I *rationalized* it. I *kidded* myself—because you went after *bad* guys! I didn't *like* it, but I *lived* with it!"[221]

Captain America, Daredevil, and Spider-Man are colorful. The Punisher is monochromatic. Steve Rogers and Frank Castle have similar body types, but the Captain is clean-shaven and has better posture. Daredevil moves like Gene Kelly—"clearly muscled" yet balletic—whereas Castle crouches, lumbers, and lunges. Spider-Man, in contrast, is "slender, elegant" like Fred Astaire. He reaches for the sky with a "casual nonchalance."[222] When the Punisher appears in one of their titles, the Big Apple retains its energy and charm. But when Captain America, Daredevil, or Spider-Man visit the Punisher on his home turf, the city is as he sees it—menacing, claustrophobic, and filled with blacks and greys. He finds it difficult to convince them to take his war seriously because they inhabit different material realities.

The Punisher is a justice warrior who harbors serious doubts about the concept of justice. He shoots to kill and will defend his approach when admonished by other crime fighters. At the same time, he describes himself as free of words and compares himself to wildfire. He scorns talk of civilized values yet maintains a soft spot for Captain America. Dr. Strange refers to him as the personification of justice. But he is also its enemy.

NOTES

1. Leslie Charteris, *The Saint: The Happy Highwayman* (New York: Avon, [1935] 1939), 56.
2. Michel Foucault, *Discipline and Punish: The Birth of the Prison* (New York: Vintage, 1979), 14.
3. Eric Hobsbawm, *Bandits* (London: Weidenfeld & Nicolson, [1969] 2000), 70.
4. Thomas Hobbes, "Of Punishments and Rewards," in *Philosophical Perspectives on Punishment*, ed. Gertrude Ezorsky (Albany: SUNY Press, [1651] 1972), 4.
5. Hobbes, "Of Punishments and Rewards," 4.
6. John Locke, *Two Treatises of Government* [1689], quoted in Edward Stettner, "Vigilantism and Political Theory," in *Vigilante Politics*, eds. H. Jon Rosenbaum and Peter C. Sederberg (Philadelphia: University of Pennsylvania Press, 1976), 65.
7. Anthony Peter Spanakos, "Hell's Kitchen's Prolonged Crisis and Would-be Sovereigns: Daredevil, Hobbes, and Schmitt," *PS: Political Science and Politics* #47.1 (January 2014): 97.
8. Quoted in Bonnie Mann, *Sovereign Masculinity: Gender Lessons From the War on Terror* (New York: Oxford University Press, 2014), 203–04.
9. Mann, *Sovereign Masculinity*, 207.
10. Carl Schmitt, quoted in Mann, *Sovereign Masculinity*, 209.
11. Carl Schmitt, *The Concept of the Political* (New Brunswick: Rutgers University Press, [1932] 1976), 26.
12. Schmitt, *The Concept of the Political*, 27.
13. Spanakos, "Hell's Kitchen's Prolonged Crisis and Would-be Sovereigns," 95.

14. Carl Schmitt, *Dictatorship* (New York: Polity, [1921] 2014), 13.

15. Schmitt, *Dictatorship*, 14.

16. Carl Schmitt, *Constitutional Theory* (Durham: Duke University Press, [1928] 2008), 66.

17. Giorgio Agamben, *State of Exception* (Chicago: University of Chicago Press, 2005), 1.

18. Chris Comerford, "The Hero We Need, Not the One We Deserve: Vigilantism and the State of Exception in Batman Incorporated," in *Graphic Justice: Intersections of Comics and Law*, ed. Thomas Giddens (London: Routledge, 2015), 184.

19. Agamben, *State of Exception*, 2.

20. Comerford, "The Hero We Need, Not the One We Deserve," 192.

21. Which is more or less what happens in Mike Baron and Klaus Janson, *The Punisher* #2.1 (New York: Marvel, July 1987). "Rock" refers to crack cocaine.

22. Matt Fraction and Ariel Olivetti, *Punisher War Journal* #2.12 (New York: Marvel, December 2007), n.p.

23. Greg Rucka and Carmine Di Gianomenico, *Punisher War Zone* #3.1 (New York: Marvel, December 2012), n.p.

24. Mike Barr, Frank Springer, and Pablo Marcos, *Captain America* #241 (New York: Marvel, January 1979), 14–15.

25. Barr, Springer, and Marcos, *Captain America* #241, 23, 30.

26. Brian Michael Bendis and David Marquez, *The Defenders* #3 (New York: Marvel, September 2017), n.p.

27. D. G. Chichester, Jorge Zaffino, and Mark Texeira, *Terror Inc* #6 (New York: Marvel, December 1992), 8.

28. Mike Barr and John Ross, *Killpower: The Early Years* #3 (London: Marvel Comics UK, November 1993), n.p.

29. D. G. Chichester and Jorge Zaffino, *Terror Inc* #7 (New York: Marvel, January 1993), n.p.

30. Chuck Dixon and John Hebert, *Punisher War Journal* #1.45 (New York: Marvel, August 1992), n.p.

31. Fabian Nicieza and Mark Bagley, *The New Warriors* #9 (New York: Marvel, March 1991), 19.

32. Mark Gruenwald, "Mark's Remarks," *Marvel Age* #113 (New York: Marvel, June 1992), n.p.

33. Robert Sodaro, "Jump into the Pyre: An In-Depth Look at the Venom/Punisher Matchup," *Marvel Age* #126 (New York: Marvel, July 1993), 12.

34. "I'll have to take this one hard," vows Batman. "Teach him to stay out of my city." Batman then warns that if Castle returns, "I'll see you in a cell out on Blackgate with the other murderers." Denny O'Neil and Barry Kitson, *Batman/Punisher: Lake of Fire* (New York: DC, 1994), n.p.; and Chuck Dixon and John Romita, Jr., *Punisher/Batman: Deadly Knights* (New York: Marvel, 1994), n.p.

35. Wilson Fisk "possesses the type of virtue necessary to create order from chaos, a villainous heroic virtue." Ryan Litsey, "The Kingpin," in Robert Moses Peaslee and Robert G. Weiner, eds. *The Supervillain Reader* (Jackson: University Press of Mississippi, 2020), 233–34.

36. Chuck Dixon and Ed Barreto, *Marvel Knights* #1.4 (New York: Marvel, October 2000), n.p.

37. Chuck Dixon and Ed Barreto, *Marvel Knights* #1.9 (New York: Marvel, March 2001), n.p.

38. Al Milgrom and Mark Bagley, *The Amazing Spider-Man* #357 (New York: Marvel, January 1991), 22.

39. Fabian Nicieza and Mark Bagley, *The New Warriors* #8 (New York: Marvel, February 1991), 3. Or as he points out elsewhere, "Too many idiots in masks out there already. You think heroes don't kill? Heroes get people killed all the time." Charles Soule, Reilly Brown, and Szymon Kudranski, *Daredevil/Punisher: Seventh Circle* #2 (New York: Marvel, August 2016), n.p.

40. Brian Michael Bendis and David Marquez, *The Defenders* #1.3 (New York: September 2017), n.p.

41. These words are spoken by Quasar, who aspires to "learn how you manage to *do* all the cool things you do—without so much as a *single super-power.*" "I don't use sidekicks," Castle snips. Mark Gruenwald and Andy Smith, *Quasar* #1.42 (New York: Marvel, January 1993), 14–15.

42. Al Migrom and Mark Bagley, *The Amazing Spider-Man* #353 (New York: Marvel, November 1991), 16.

43. Matt Fraction and Ariel Olivetti, *Punisher War Journal: Civil War* #1 (New York: Marvel, January 2007), n.p. And yet, in *Punisher Kills the Marvel Universe*, Castle achieves "justice for the little people, the forgotten men," by executing "the heroes and the villains. The mutants and the monsters. Anything that calls itself a superhuman." Garth Ennis and Dougie Braithwaite, *Punisher Kills the Marvel Universe* (New York: Marvel, 1995), n.p.

44. Fraction and Olivetti, *Punisher War Journal Civil War* #1, n.p.

45. Garth Ennis and Steve Dillon, *The Punisher* #5.1 (New York: Marvel, August 2001), n.p.

46. Fabian Nicieza and Pat Olliffe, *Nomad* #6 (New York: Marvel, October 1992), 29.

47. John Whitman, *24 Declassified: Trinity* (New York: Harper, 2008), 152.

48. Lee Child, *Killing Floor* (New York: Penguin, [1997] 2012), 216.

49. Chuck Dixon and Dave Eaglesham, "Lost Lands," *The Punisher Back to School Special* #1.2 (New York: Marvel, October 1993), n.p.

50. Don Lomax and Dave Hoover, "Brain Drain High," *The Punisher Back to School Special* #1.3 (New York: Marvel, October 1994), n.p.

51. Greg Wright, Dan Chichester, and John Hebert, "The Cutting Edge," *The Punisher Annual* #2 (New York: Marvel, 1991), n.p.

52. Joss Whedon and Michael Ryan, *Runaways* #26 (New York: Marvel, July 2007), n.p.

53. John Barber et al., *Doctor Strange/The Punisher: Magic Bullets* #2 (New York: Marvel, March 2017), n.p.

54. Chris Cooper, Richard Case, and Al Bigley, *Darkhold: Pages from the Book of Sins* #5 (New York: Marvel, February 1993), n.p. As the Hulk points out during a 2012 team-up, "Something tells me if it lives and breathes, this guy has a gun that can kill it." Jason Aaron and Steve Dillon, *The Incredible Hulk* #8 (New York: Marvel, July 2012), n.p.

55. Christopher Yost and David Lopez, *The Superior Spider-Man* #22 (New York: Marvel, August 2013), n.p.
56. Peter Milligan and Lee Weeks, *Wolverine/Punisher* #1 (New York: Marvel, May 2004), n.p.
57. D. G. Chichester and Larry Stroman, *Punisher/Black Widow: Spinning Doomsday's Web* (New York: Marvel, 1992), n.p.
58. As the Hulk tells Castle, "So you're in town after this *Frost* guy [a syndicate fixer], and you figured you'd indulge in some creative mayhem on the side." Peter David and Dale Keown, *The Incredible Hulk* #395 (New York: Marvel, July 1992), 30.
59. Not always, of course. Some of his appearances simply require that he fire off rounds and say things like, "I don't let vermin go [...] I *stamp them out!*" Larry Hama and Gary Erskine, *Blaze* #10 (New York: Marvel, May 1995), n.p.
60. Larry Hama, Kerry Gammill, Tom Morgan, and Tom Palmer, *Double Edge: Alpha* #1 (New York: Marvel, August 1995), n.p.
61. Gregg Hurwitz and Laurence Campbell, *The Punisher* #6.62 (New York: Marvel, November 2007), n.p.
62. Scott Bukutman, "A Song of the Urban Superhero," in *The Superhero Reader*, eds. Charles Hatfield, Jeet Heer, and Kent Worcester (Jackson: University Press of Mississippi, [2000] 2013), 191.
63. Gerry Conway and Felix Ruiz, *The Punisher Annual* #11.1 (New York: Marvel, December 2016), n.p.
64. Peter Kropotkin, *Organised Vengeance Called Justice* (London: Freedom Press, [1902] 1948), 6.
65. Albert O. Hirschman, *The Rhetoric of Reaction: Perversity, Futility, Jeopardy* (Cambridge: Harvard University Press, 1991), x.
66. Mark Ames, "How Ayn Rand Became a Big Admirer of a Serial Killer," Alternet, https://www.alternet.org/books/how-ayn-rand-became-big-admirer-serial-killer.
67. Both quotations are taken from Rick Remender, untitled editorial comment, *The Punisher: Dark Reign* #1 (New York: Marvel, December 2009), n.p.
68. "The Question's Fraternal Twin," *Marvel Main* 4 (1968), https://web.archive.org/web/20060821184600/http://www.vicsage.com/misc/mistera.php.
69. Quoted in Jason Bainbridge, "Spider-Man, the Question, and the Meta Zone: Exception, Objectivism, and the Comics of Steve Ditko," *Law Text Culture* 12 (2012), 231.
70. Bainbridge, "Spider-Man, the Question, and the Meta Zone," 232.
71. Garth Ennis and Tom Mandrake, *The Punisher* #3.24 (New York: Marvel, June 2003), n.p.
72. Steven Grant and Mike Zeck, *Return to Big Nothing* (New York: Marvel, 1989), n.p. Or as Castle scornfully asks the Avengers, "why should I protect the government's rich friends? These punks probably just got what they deserved." Mark Millar and Leinil Francis Yu, *Ultimate Avengers* #1.3 (New York: Marvel, August 2010), n.p.
73. Mark Gruenwald and Andy Smith, *Quasar* #42 (New York: Marvel, January 1992), 28.

74. In a 1983 story, the Punisher breaks out of prison by knocking the guards unconscious and stealing their clothes. "Only the fact that they are peace officers guarantees their survival," explains the narrator. Bill Mantlo, Al Milgrom, and Jim Mooney, *Peter Parker, The Spectacular Spider-Man* #81 (New York: Marvel, August 1983), n.p.

75. Bill Mantlo, Al Milgrom, and Jim Mooney, *Peter Parker, The Spectacular Spider-Man* #82 (New York: Marvel, September 1983), n.p.

76. Garth Ennis and Steve Dillon, *The Punisher* #3.22 (New York: Marvel, April 2003), n.p. This description is voiced by the social worker Jen Cooke when Castle rescues her from a horde of underground dwellers.

77. D. G. Chichester and Ron Garney, *Nightstalkers* #6 (New York: Marvel, April 1993), n.p.

78. "Some of us believe in what you do," says one officer. "Like it or not, you started something." The Punisher responds by saying, "You help people. I gave all that up a long time ago. You don't do what I do. Nobody does." Matthew Rosenberg and Szymon Kudranski, *The Punisher: Street by Street, Block by Block* (New York: Marvel, 2019), n.p.

79. Chuck Dixon, Tristan Shane, and Brad Parker, *Code of Honor* #1.1 (New York: Marvel, January 1997), n.p.

80. Dixon, Shane, and Parker, *Code of Honor* #1.1, n.p.

81. Garth Ennis and Steve Dillon, *The Punisher* #4.2 (New York: Marvel, May 2000), n.p. As a police captain admits, "a lot of cops like that this guy's out there." Garth Ennis and Leandro Fernandez, *The Punisher* #7.25 (New York: Marvel, November 2005), n.p.

82. Marc Guggenheim and Leinil Francis Yu, *Punisher: Trial of the Punisher* #1 (New York: Marvel, November 2013), n.p.

83. Mantlo, Milgrom, and Mooney, *Peter Parker, The Spectacular Spider-Man* #82, n.p. He gripes about "these pain-in-the-neck civilians" in Danny Fingeroth and Mike Manley, *Darkhawk* #9 (New York: Marvel, November 1991), 9.

84. Mike Baron and Whilce Portacio, *The Punisher* #1.10 (New York: Marvel, August 1988), 30.

85. David Lapham, *Daredevil vs. Punisher: Means and Ends* #1 (New York: Marvel, September 2005), n.p.

86. Jason Aaron and Roland Boschi, *PunisherMAX X-Mas Special* #1 (New York: Marvel, February 2009), n.p.

87. Matt Fraction, Rick Remender, and Howard Chaykin, *Punisher War Journal* #2.22 (October 2008), n.p.

88. D. G. Chichester, Margaret Clark, and Klaus Janson, *Punisher and Captain America: Blood & Glory* #1 (New York: Marvel, 1992), n.p.

89. Dwayne Turner and Christopher Ivy, *Cage* #4 (New York: Marvel, July 1992), 15.

90. Brian Michael Bendis and Mark Brooks, *Ultimate Spider-Man Annual* #2 (New York: Marvel, October 2008), n.p.

91. Terry Havanagh and Scott McDaniel, *Spider-Man, Punisher, Sabretooth: Designer Genes* (New York: Marvel, 1993), n.p.

92. Chichester, Clark, and Janson, *Punisher and Captain America: Blood & Glory* #1, n.p.

93. Garth Ennis and Richard Corben, *The Punisher: The End* (New York: Marvel, June 2004), n.p.

94. Peter David, "But I Digress," *Comics Buyer's Guide* #1344 (August 20, 1999), 58.

95. When a snitch informs the Punisher that Cloak and Dagger are dealing drugs, he approaches them directly. "I'm not inclined to accept the word of drug dealing scum without verification," he assures them. "After all, I'm a rational man!" Terry Austin and June Brigman, *Strange Tales* #14 (New York: Marvel, May 1988), 3.

96. When he helps Power Pack rescue a kidnapped writer, he tells them, "you'll have to stay out of it—my line of work is too dangerous for little girls." Their assistance nonetheless proves invaluable. "I can't wait to write this one up," he later reflects. "Dear War-Journal: Today I played patty-cake with two little kids [...] oh brother!" Terry Austin and Whilce Portacio, *Power Pack* #46 (New York: May 1989), n.p.

97. Ryan North and Erica Henderson, *The Unbeatable Squirrel Girl* #1.3 (New York: Marvel, March 2015), n.p. The joke is on the Punisher, since the man in the costume really *is* Doctor Doom.

98. Joss Whedon and Michael Ryan, *Runaways* #2.25 (New York: Marvel, June 2007), n.p.

99. There was also that time he showed up in a daydream shared by MTV's Beavis and Butthead. "When Punisher kicks ass, it stays kicked," Butthead exclaims. "The only thing cooler than violence is dirty stuff. Huh-huh-huh-huh." Mike Lackey and Rick Parker, *Beavis and Butt-Head* #1 (New York: Marvel, March 1994), 4.

100. Batton Lash, John Buscema, and Stan Goldberg, *Archie Meets the Punisher* #1 (New York: Marvel, August 1994), 50.

101. Steven Thompson, "Fear and Punishment in Riverdale: Archie Meets the Punisher," *Back Issue!* #102 (Raleigh: TwoMorrows, February 2018), 70.

102. Fingeroth and Manley, *Darkhawk 9*, 25. In a 1993 limited series, he tells himself, "Thinking too much can cause confusion, dull the edge. Can't afford to lose any sharpness." When Micro insists that "thinking deep about things doesn't turn your brain to mush, just the opposite," Castle snorts that he has "heard it all before." Carl Potts and Gary Erskine, *Wolverine and the Punisher: Damaging Evidence* #1 (New York: Marvel, October 1993), n.p.

103. Gregory Wright and Denys Cowan, *Deathlok* #7 (New York: Marvel, January 1991), n.p. In the "Dark Reign" storyline, the Punisher battles a superhero named Sentry, who tells him, "Your war is over. The good guys won [...] but you never listen." Rick Remender and Jerome Opena, *The Punisher: Dark Reign* #1 (New York: Marvel, December 2009), n.p.

104. Roy Thomas and Andre Coates, *Secret Defenders* #4 (New York: Marvel, June 1993), 15, 11. Castle's epistemological realism makes him a sceptic when it comes to paranormal phenomena. During a guest appearance in the Malibu series *Foxfire*, the Punisher asks for "some convincing explanations for what the hell's going on!" "Would you believe a parallel dimension?" asks a visitor from the Ultraverse. "Alien mercenaries? Malevolent super-witch cyborgs?" Castle scornfully says "no," but the reader is aware that these are all correct answers. Ian Edginton, Dan Abnett, and Kevin J. West, *Firefox* #4 (Calabasas: Malibu, May 1996), 6.

THE UNIVERSE PUSHES BACK

105. Roy Thomas and Andre Coates, *Secret Defenders* #5 (July 1993), 4. But in a later story, after chasing down a coke dealer, Castle says "He gets away this time and he'll never meet justice. Not that I'm interested in justice. I don't even believe in it." Chuck Dixon and Russ Heath, *The Punisher* #1.90 (New York: Marvel, May 1994), n.p.

106. John Barber, Jason Muhr, and Andrea Broccardo, *Doctor Strange/The Punisher: Magic Bullets* #1 (New York: Marvel, February 2017), n.p. At the end of the mini series, Castle writes in the pages of his War Journal that, "I can say without reservation, magic is as bad as *ever*." John Barber, Jason Muhr, and Andrea Broccardo, *Doctor Strange/The Punisher: Magic Bullets* #4 (New York: Marvel, May 2017), n.p.

107. Jimmy Palmiotti, Buddy Scalera, and Georges Jeanty, *Deadpool* #54 (New York: Marvel, July 2001), n.p. Deadpool creator Rob Liefeld sums him up as "Spider-Man meets Punisher." Michael Eury, "The Evolution of Deadpool: An Interview with Fabian Nicieza," *Back Issue!* #102 (Raleigh: TwoMorrows, February 2018), 62.

108. Fred Van Lente and Pere Pérez, *Deadpool Versus The Punisher* #1 (New York: Marvel, June 2017), n.p.

109. Fred Van Lente and Pere Pérez, *Deadpool Versus The Punisher* #5 (New York: Marvel, August 2017), n.p.

110. Cullen Bunn and Dalibor Talajić, *Deadpool Kills the Marvel Universe* (New York: Marvel, [2012] 2016), n.p.

111. Greg Rucka and Carmine Di Gianomenico, *Punisher War Zone* #3.1 (New York: Marvel, December 2012), n.p.

112. Chuck Dixon and Gary Kwapisz, *Punisher War Journal* #1.57 (New York: Marvel, August 1993), n.p. "I could see Punisher and Ghost Rider hanging out," notes Hawkeye. "Same M.O." Ben Acker, Ben Blacker, and Gerardo Sandoval, *Thunderbolts* #1.28 (New York: Marvel, September 2014), n.p.

113. Mike Baron and Mark Texeira, *Punisher War Journal* #1.30 (New York: Marvel, May 1991), n.p.

114. Chuck Dixon and Gary Kwapisz, *Punisher War Journal* #1.58 (New York: Marvel, September 1993), n.p.

115. Howard Mackie and Javier Saltares, *Ghost Rider* #6 (New York: Marvel, October 1990), 20.

116. Howard Mackie and Salvador Larroca, *Over the Edge* #4 (New York: Marvel, September 1995), n.p.

117. "People always wonder about the costume. Wonder why *Moon Knight* wears *white*. It's so they can see me coming. I want them to be *afraid*." Andy Diggle and Billy Tan, *Shadowland* #3 (New York: Marvel, November 2010), n.p.

118. Mike Benson and Jefte Palo, *Moon Knight* #27 (New York: Marvel, April 2009), n.p.

119. http://marvel.com/universe/Khonshu#axzz59BVJzBH8.

120. Luke Cage describes Moon Knight as "hardcore—seen it all, done it all. Killed it all." Christos N. Gage and Mike Perkins, *House of M: Avengers* (New York: Marvel, 2008), n.p.

121. "About time we met," says Moon Knight, as if they are at a business luncheon. Mike Baron and Bill Reinhold, *The Punisher Annual* #2 (New York: Marvel, 1989), 11.

122. Charles Dixon and Sal Velluto, *Marc Spector: Moon Knight* #9 (New York: Marvel, December 1989), 21. As he reminds Spector, "I don't need your approval. I have my reasons and they're good enough for me." Charles Dixon and Sal Velluto, *Marc Spector: Moon Knight* #20 (New York: Marvel, November 1990), 14.

123. Charles Dixon and Sal Velluto, *Marc Spector: Moon Knight* #21 (New York: Marvel, December 1990), 19.

124. Dixon and Velluto, *Marc Spector: Moon Knight* #21, 28.

125. Terry Kavanagh and Ron Garney, *Marc Spector: Moon Knight* #36 (New York: Marvel, March 1992), n.p.

126. Tom Sniegoski, Christopher Golden, and Pat Lee, *Wolverine/Punisher: Revelation* #1–4 (New York: Marvel, June–September 1999); Daniel Way, Marjorie Liu, Stephen Segovia, and Paco Diaz, *Dark Wolverine* 88–89 and *Franken-Castle* #19–20 (New York: Marvel, September–November 2010).

127. Garth Ennis and Darick Robertson, *The Punisher* #5.17 (New York: Marvel, December 2002), n.p. Wolverine tells Castle that "Ya think people see you as the 'cure' to the 'disease' like ya fancy yourself? You're just a different kinda 'disease' is all." The Punisher retorts: "You tell me no innocents ever get caught up in one of your famed berserker rages? If you were really the 'hero' you make yourself out to be, there's only one way to make sure that never happens again … kill yourself. Trouble is, you ain't got the guts." Frank Tieri and Terry Dodson, *Wolverine* #186 (New York: Marvel, April 2003), n.p.

128. This 1988 two-issue story is reprinted in Carl Potts and Jim Lee, *Punisher/Wolverine African Saga* (New York: Marvel, 1989), n.p.

129. Potts and Erskine, *Wolverine and the Punisher: Damaging Evidence* #1, n.p. As Wolverine later tells Castle, "We have similarities … treading an unsteady line in our quest to do good." Carl Potts and Gary Erskine, *Wolverine and the Punisher: Damaging Evidence* #3 (New York: Marvel, December 1993), n.p.

130. He might have a point. Howard Mackie and Ron Garney, *Ghost Rider/Wolverine/Punisher: The Dark Design* (New York: Marvel, 1994), n.p.

131. Howard Mackie and John Romita, Jr., *Ghost Rider/Wolverine/Punisher: Hearts of Darkness* (New York: Marvel, 1991), n.p.

132. Chuck Dixon and Gary Kwapisz, *Punisher War Journal* #1.58 (New York: Marvel, September 1993), n.p.

133. Milligan and Weeks, *Wolverine/Punisher* #1, n.p.

134. Peter Milligan and Lee Weeks, *Wolverine/Punisher* #5 (New York: Marvel, September 2004), n.p.

135. Milligan and Weeks, *Wolverine/Punisher* #5, n.p.

136. See https://www.cbr.com/times-captain-america-has-killed/; http://whatculture.com/comics/10-times-daredevil-was-forced-to-kill, and https://screenrant.com/times-spider-man-killed-people/.

THE UNIVERSE PUSHES BACK

137. This section draws on my chapter "To Shame Its Inadequacy: The Punisher and His Critics," in Alicia M. Goodman et al., eds., *Judge, Jury and Executioner: Essays on The Punisher in Print and On Screen* (Jefferson: McFarland, 2021), 15–26.

138. Michael Connelly, *The Last Coyote* (New York: Grand Central Publishing, 1996), 10.

139. "I'm an American, but I don't hide behind a mantle of patriotism. I'm just an honest citizen who's had it with bullshit super-secret intelligence agencies spying on ordinary citizens, pushing coke, and blowing away cabinet appointees." Mike Baron and Bill Reinhold, *Punisher: Intruder* (New York: Marvel, 1989), n.p.

140. Peter David and Sal Velluto, *Captain America Goes to War Against Drugs* (New York: Marvel, 1990).

141. Cord Scott, "The Alpha and the Omega: Captain America and the Punisher," in Robert G. Weiner, ed., *Captain America and the Struggle of the Superhero: Critical Essays* (Jefferson: McFarland, 2009), 125.

142. Dan Abnett and Liam Sharp, *Death's Head* #4 (London: Marvel UK, May 1992), n.p.

143. D. G. Chichester, Margaret Clark, and Klaus Janson, *Punisher and Captain America: Blood & Glory* #2 (New York: Marvel, 1992), n.p.

144. Chichester, Clark, and Janson, *Punisher and Captain America: Blood & Glory* #2, n.p. Marvel canon is all over the place as far as Castle's tours of duty are concerned. The usual number is three; here it is six.

145. Chichester, Clark, and Janson, *Punisher and Captain America: Blood & Glory* #2, n.p.

146. D. G. Chichester, Margaret Clark, and Klaus Janson, *Punisher and Captain America: Blood & Glory* #3 (New York: Marvel, 1992), n.p.

147. Jason Dittmer, *Captain America and the National Superhero: Metaphors, Narratives, and Geopolitics* (Philadelphia: Temple University Press, 2013), 133.

148. Dittmer, *Captain America and the National Superhero*, 134.

149. Robert Jewett and John Shelton Lawrence, *Captain America and the Crusade Against Evil: The Dilemma of Zealous Nationalism* (Grand Rapids: Wm. B. Eerdmans Publishing, 2003), 5–6.

150. Matthew J. Costello, *Secret Identity Crisis: Comic Books and the Unmasking of Cold War America* (New York: Continuum, 2009), 229, 234.

151. Costello, *Secret Identity Crisis*, 235.

152. Mark Millar and Steve McNiven, *Civil War* (New York: Marvel, 2014), n.p.

153. Matt Fraction and Leandro Fernández, *Punisher War Journal* #2.11 (New York: Marvel, November 2007), n.p.

154. Nick Spencer, Andrea Sorrentino, and Leinil Francis Yu, *Secret Empire* (New York: Marvel, 2018), n.p.

155. Tom Lyle and Joe Bennett, *Spider-Man/Punisher: Family Plot* #2 (New York: Marvel, February 1996), n.p.

156. Matt Fraction and Ariel Olivetti, *Punisher War Journal* #2.2 (New York: Marvel, February 2007), n.p.

157. Steven Grant and Hugh Haynes, *Punisher War Journal* #65 (New York: Marvel, April 1994), n.p.
158. Carl Potts and Jim Lee, *Punisher War Journal* #1.2 (New York: Marvel, December 1988), 12.
159. Carl Potts and Jim Lee, *Punisher War Journal* #1.9 (New York: Marvel, October 1989), 30.
160. Andy Diggle and Roberto de la Torre, and Marco Checchetto, *Shadowland: After the Fall* (New York, Marvel, 2011), n.p.
161. Graham Ferris and Cleo Lunt, "Devil's Advocate: Representation in Heroic Fiction, Daredevil, and the Law," in *Graphic Justice: Intersections of Comics and Law*, ed. Thomas Giddens (London: Routledge, 2015), 45–46. Jim Shooter, Marvel's editor-in-chief from 1978 to 1987, explained how he approached the character from an editorial standpoint. "How about if we have a hero that's concerned for the victims? Great. This guy's a lawyer so it fits! This guy's a crusading lawyer, concerned for the victims." David M. Singer, "Chatting with Jim Shooter," in *Jim Shooter: Conversations*, eds. Jason Sacks, Eric Hoffman, and Dominick Grace (Jackson: University Press of Mississippi, 2017), 41.
162. Paul Young, *Frank Miller's Daredevil and the Ends of Heroism* (New Brunswick: Rutgers University Press, 2016), 78.
163. Mark Lerer and Pat O'Neill, "The Future of Daredevil," *Marvel Age* #5 (New York: Marvel, August 1983), 10.
164. D. G. Chichester and Scott McDaniel, *Daredevil* #309 (New York: Marvel, October 1992), 9.
165. John Figueroa and Alberto Ponticelli, *Marvel Knights* #2.2 (New York: Marvel, June 2002), n.p.
166. John Ostrander and Tom Lyle, *Punisher (Marvel Edge)* #4 (New York: Marvel, February 1996), n.p.
167. Chuck Dixon and Ed Barreto, *Marvel Knights* #1.15 (New York: Marvel, September 2001), n.p.
168. Lapham, *Daredevil vs. Punisher: Means and Ends* 1, n.p.
169. John Figueroa, Alberto Ponticelli, and Nathan Eyring, "Serious People," *Marvel Knights Doubleshot* #4 (New York: Marvel, September 2002), n.p.
170. Frank Miller and Klaus Janson, *Daredevil and the Punisher: Child's Play* (New York: Marvel, 1988), n.p.
171. Lapham, *Daredevil vs. Punisher: Means and Ends* 1, n.p.
172. David Lapham, *Daredevil vs. Punisher: Means and Ends* #4 (New York: Marvel, November 2005), n.p.
173. Miller and Janson, *Daredevil and the Punisher: Child's Play*, n.p.
174. Baron and Portacio, *The Punisher* #2.10, 24.
175. D. G. Chichester and Lee Weeks, *Daredevil* #292 (New York: Marvel, May 1991), 25. "What the heck is going on in Daredevil's head?," asked one reader. "He's no hero: he's a menace to society. He should be killed off!" Ramon O., "Punisher War Journal Entries," *Punisher War Journal* #1.61 (New York: Marvel: December 1993), n.p.

THE UNIVERSE PUSHES BACK

176. Steven Grant and Bob McLeod, *Spider-Man* #32 (New York: Marvel, March 1993), n.p.

177. Steven Grant and Hugh Haynes, *Punisher War Journal* #1.66 (New York: Marvel, May 1994), n.p.

178. Carl Potts and David Ross, *Punisher War Journal* #1.13 (New York: Marvel, December 1989), n.p.

179. Mike Baron and Bill Reinhold, *The Punisher: Intruder* (New York: Marvel, 1989), n.p.

180. Garth Ennis and Darick Robertson, *Born* #4 (New York: Marvel, 2003), n.p.

181. Scott M. Gimple and Mark Texeira, *Punisher: Nightmare* #1 (New York: Marvel, March 2013), n.p.

182. Potts and Lee, *Punisher War Journal* #1.2, 26. Or as he taunts a doctor in a 2019 limited series, "You ever patch up a soul, doc? You ever order a 'soul transfusion'? Don't shovel that &@#% at me." Gerry Duggan and Marcelo Ferreria, *The War of the Realms: The Punisher* (New York: Marvel, 2019), n.p.

183. Ben Acker, Ben Blacker, and Kim Jacinto, *Thunderbolts* #1.29 (New York: Marvel, October 2014), n.p.

184. Stephen Grant and John Hebert, "Red Christmas," *The Punisher Holiday Special* #1.1 (New York: Marvel, January 1993), n.p.

185. Chuck Dixon and Ed Barreto, *Marvel Knights* #1.11 (New York: Marvel, May 2001), n.p.

186. Mike Baron and Bill Reinhold, *The Punisher: Intruder* (New York: Marvel, 1989), n.p.

187. Mike Baron, Bill Reinhold, and Mark Farmer, *The Punisher* #1.30 (New York: Marvel, February 1990).

188. Dan Abnett and Hugh Haynes, *Punisher War Zone* #1.17 (New York: Marvel, June 1993), n.p.

189. Richard Rainey and Val Mayerik, *Punisher War Journal* #1.43 (New York: Marvel, June 1992), n.p.

190. Carl Potts and David Ross, *Punisher War Journal* #1.15 (New York: Marvel, February 1989), 24.

191. Chichester and Weeks, *Daredevil* #293, n.p.

192. Carl Potts and Jim Lee, *Punisher War Journal* #1.3 (New York: Marvel, February 1989), 4. Don Daley admitted that religious issues were "not handled as well as they could be, and I also think that a little of it has been sort of forced on his character." Lia Pelosi, "Crime and Punishment," *Punisher Anniversary Magazine* #1 (New York: Marvel, February 1994), 4.

193. Mark Waid and Marco Checchetto, *Daredevil* #11 (New York: Marvel, June 2012), n.p.

194. Soule and Brown, *Daredevil/Punisher: Seventh Circle* #1, n.p.

195. Garth Ennis and Joe Quesada, "Roots," and Rob Haynes, "Dirty Job," in *Marvel Knights Double Shot* #1 (New York: Marvel, June 2002), n.p.

196. Steven Grant, Bob McLeod, and Steve Weeks, *Spider-Man* #34 (New York: Marvel, May 1993), n.p.

197. Bendis and Brooks, *Ultimate Spider-Man Annual* #2, n.p.

131

A CULTURAL HISTORY OF THE PUNISHER

198. Joseph Harris and Michael Lopez, *Spider-Man vs. Punisher* #1 (New York: Marvel, July 2000), n.p.

199. Nel Yomtov and Alex Saviuk, *The Adventures of Spider-Man* #1 (New York: Marvel, April 1996), n.p.

200. Tom Lyle, Shawn McManus, Mike Harris, Mike Manley, and Dick Giordano, *Spider-Man/ Punisher: Family Plot* #1 (New York: Marvel, February 1996), n.p.

201. Ben Saunders, *Do the Gods Wear Capes? Spirituality, Fantasy, and Superheroes* (New York: Continuum, 2011), 74.

202. Gerry Conway and Ross Andru, *The Amazing Spider-Man* #129 (New York: Marvel, February 1974), n.p.

203. Gerry Conway and Sal Buscema, *The Spectacular Spider-Man* #143 (New York: Marvel, October 1988), 30. "We've had our differences, but we've also fought side by side," he later concedes. Howard Mackie and John Romita, Jr., *Spider-Man* #89 (New York: Marvel, March 1998), 21.

204. Kavanagh and McDaniel, *Spider-Man, Punisher, Sabretooth: Designer Genes*, n.p.

205. Brian Michael Bendis and Mark Bagley, *Ultimate Spider-Man* #61 (New York: Marvel, August 2004).

206. David Micheline and Erik Larsen, *The Amazing Spider-Man* #330 (New York: Marvel, March 1990), 19.

207. Tom DeFalco, Jim Owsley, and Alan Kupperberg, *The Amazing Spider-Man* #285 (New York: Marvel, February 1987), n.p.

208. Gerry Conway and Sal Buscema, *The Spectacular Spider-Man* #141 (New York: Marvel, August 1988), 4. The "war on crime is not a walk in the park," he says elsewhere. Carl Potts and David Ross, *Punisher War Journal* #1.14 (New York: Marvel, January 1990), n.p.

209. John Ostrander, Tom Nauck, and Michael Ryan, *The Spectacular Spider-Man* #1000 (New York: Marvel, June 2011), n.p.

210. Steven Grant and Hugh Haynes, *Punisher War Journal* #1.68 (New York: Marvel, July 1994), n.p.

211. Yomtov and Saviuk, *The Adventures of Spider-Man* #1, n.p.

212. Potts and Ross, *Punisher War Journal* #1.15, 30.

213. Micheline and Larson, *The Amazing Spider-Man* #330, 30.

214. David Micheline and Erik Larsen, *The Amazing Spider-Man* #331 (New York: Marvel, April 1990), 11.

215. Micheline and Larsen, *The Amazing Spider-Man* #331, 20.

216. Grant and Haynes, *Punisher War Journal* #1.66, n.p. "We all live in the dark, eyeing only masks but taking them as faces. Illusions sold to us as powders, images, or dreams. Anything to keep the light out. They lie here, arms punctured, lives punctured, dreaming of bliss. I took powdered bliss from a dead man's hand and put it away."

217. Micheline and Larsen, *The Amazing Spider-Man* #331, 29, 16.

218. Bendis and Bagley, *Ultimate Spider-Man* #61, n.p.

219. Steven Grant and Bob McLeod, *Spider-Man* #33 (New York: Marvel, April 1993), n.p.
220. Grant, McLeod, and Weeks, *Spider-Man* #34, n.p.
221. Grant and Haynes, *Punisher War Journal* #1.68, n.p.
222. These descriptions of Fred Astaire and Gene Kelly are taken from Beth Genné, *Dance Me a Song: Astaire, Balanchine, Kelly, and the American Film Musical* (New York: Oxford University Press, 2018), 133.

4

Negative Dialectics

*I sat there on the chair and stared at the hall but I didn't see anything.
All I saw was what was in my mind: what I was going to do to them
all. For everything.*

—Ted Lewis, *Get Carter* (1970)[1]

After *Circle of Blood*, Frank Castle was no longer a third-tier punching bag with an Antisocial Personality Disorder.[2] He was a recognizable member of the Marvel line-up, with an impressive and ever-growing number of titles and appearances to his credit. The character's impact on superhero storytelling, and the comics subculture, was most pronounced in the wake of *Circle*'s unanticipated success, which was also when violent crime rates were peaking in New York City. Castle's importance to the industry and the subculture in this period was reflected not only in encouraging sales figures, and a growing back catalog, but also in the contagious popularity of the hardboiled archetype, a theme I will return to in the next chapter.

More Punisher comics appeared between 1986 and 1995 than in any other ten-year period. Most were written and edited by a small number of individuals, notably Mike Baron, Don Daley, Chuck Dixon, Steven Grant, and Carl Potts. These men collaborated closely, of course, with Russ Heath, Jr., Klaus Janson, Joe Kubert, Jim Lee, John Romita, Jr., and other pencilers, inkers, colorists, and letterers. Together this small cohort crafted a readily identifiable and sometimes almost plausible version of a mob/drug/gang-obsessed crime controller who was written and drawn in such a way as to allow the audience to root for his success without embracing his deeds. Their initially profitable interpretation spawned a fanbase that facilitated the expansion of the franchise into ancillary product lines such as t-shirts and posters, a process of brand extension that foreshadowed the more recent globalization and politicization of Punisheresque iconography. This generative period of hardboiled storytelling can be described as the first of two Punisher production cycles,[3] a concept I have imported from film studies.

The film historian Zoë Wallin defines production cycles as "ongoing industrial activities that manifest at specific moments in time and discuss their operations in practical, commercial terms."[4] Unlike modern genres, which are sometimes described in ways that evoke eternal abstractions, production cycles are clearly rooted in specific historical conjunctures. From the perspective of Wallin and others, the biblical movies of the 1950s, the beach movies of the 1960s, and the vigilante films of the 1970s–80s each represent distinct movie industry cycles. Each is associated with short-lived product segments driven by volatile market trends. At the same time, each responded to notable changes in the external environment, from backlash politics and demographic shifts to crime waves and moral panics.

The concept of the production cycle thus helps focus our attention on historical questions rather than generic ones. As Wallin notes, "the timeliness of cycles, in contrast to the broad, transhistorical conceptions of genre, renders them useful social documents." Production cycles can tell us a great deal, she suggests, about "how contemporary issues were discussed, subcultures were shaped, and social upheaval was both reflected upon and exploited."[5] But while production cycles can be creatively generative, they tend to be characterized by a boom/bust dynamic that reflects the contradictory impact of overinvestment on friable entertainment trends.

During the first Punisher production cycle, creators embraced the zeitgeist and leaned into Frank Castle's anger. A broadly consistent interpretation of the character was developed and marketed across a variety of titles and formats. Readership numbers rose and fell in a manner that is consistent with the model's assumptions. In the initial phase, Castle's market share grew even as his grievances remained unchanged. The supporting cast expanded and his backstory was fleshed out. Mike Baron played a particularly vital role in sculpting a personality whose behavior was excessive but more or less comprehensible. Once Baron stepped away from scripting the first unlimited Punisher series, the cycle entered its second phase. In the early 1990s, Castle's actions became increasingly erratic as Marvel ramped up the character's dysregulated rage—what Black Widow refers to as his "runaway testosterone."[6] In a story arc that played out over the first half of the decade, the Punisher's compulsions were shown to be not only reckless but dangerously counterproductive. The character's regression over the course of this cycle—his negative dialectic—is arguably the greatest of all Punisher storylines. It is epic in scale and precautionary in its implications.

Counter production

There is an all too obvious connection between the emotional charge of the first Punisher production cycle and the forward march of Reaganism. Like Frank

Castle, Ronald Reagan was relegated to the margins during the 1970s but flourished in the decade that followed. Like Castle, Reagan feared that the American Dream was in peril. And like Castle, Reagan sounded themes of loss and betrayal. In his 1989 Farewell Presidential Address, Reagan spoke about how "those of us who are over 35 or so years of age grew up in a different America." Back then,

> movies celebrated democratic values and implicitly reinforced the idea that America was special. TV was like that, too, through the mid-1960s. But now we're about to enter the 1990s and some things have changed. Younger parents aren't sure that an unambivalent appreciation of America is the right thing to teach modern children. And as for those who create the popular culture, well-grounded patriotism is no longer the style. Our spirit is back, but we haven't reinstitutionalized it. We've got to do a better job of getting across that America is freedom—freedom of speech, freedom of religion, freedom of enterprise. And freedom is special and rare. And freedom is fragile, it needs production.[7]

Chastised by critics, but admired by fans, the two men placed crime and morality at the center of their political discourse. More specifically, they each lent their support to law-and-order causes like tougher policing, longer prison sentences, the war on drugs, and the death penalty.[8] The politician could have been speaking for the vigilante when, in a speech to the Justice Department, he defined criminals as "this dark, evil enemy within."[9] Reagan also sounded like Castle when he told the International Association of Chiefs of Police in 1981 that "For all our science and sophistication, for all our justified pride in intellectual accomplishment, we should never forget: the jungle is always there, waiting to take us over."[10] If Castle is the cultural distillate of the postwar urban crisis, Reagan was one of its electoral beneficiaries. It was during the Reagan administration that the Punisher found his calling.

The timing is at least suggestive. Frank Castle was stepping onto the center stage just as the 39th President was at the zenith of his popularity. This does not mean that Punisher stories called on readers to vote for a specific political party. The principle of writerly autonomy still held. Furthermore, bankers, captains of industry, and white nationalists all offered convenient targets for the Punisher's wrath along with street criminals, drug lords, and crime bosses. The affinity between the conservative ascendancy and Castle's rising fortunes is nevertheless palpable. In this "atmosphere of anger and resentment," writes the comics historian Les Daniels, Castle "came into his own." He had been presented as a "dark and somewhat undesirable character, a contrast to Marvel's more humane and ethical heroes. By the mid-1980s, however, the time seemed right to unleash him with both guns blazing."[11]

If Punisher comics embody the anti-permissive cultural production that the President called for in his Farewell Address, there is an obvious twist. The character has a self-destructive aspect that does not quite accord with Reagan's soaring rhetoric. The appreciation of America that Punisher stories communicate can hardly be described as unambivalent. His orgy of violence is not exactly well-grounded. Rather than embracing Reagan's sunny disposition, the Punisher abhors positivity. What Ronald Reagan sought from "those who create the popular culture," and what he and his supporters received in return, were two different things.

Into the circle

The *Circle of Blood* miniseries proved a "massive sales success"[12] and became a key turning point in the entire saga. When the series "became the hottest thing on the stands, Marvel's eyes were finally opened to the potential of their ultraviolent new superstar."[13] Furthermore, Grant and Zeck's triumph set the path for the series and graphic novels that followed.

Steven Grant had "been trying to get a Punisher series off the ground for years."[14] "I wanted to write about a world," he explained, in which "the people charged with upholding the law were often the same people who broke it." Until artist Mike Zeck got on board, Marvel's editors "wanted nothing to do with it."[15] "Mike was a very hot property," Grant explained, "and he made a Punisher project—especially a limited series—much more palatable to Marvel." The "general attitude toward him inside the company was very one-sided," he added. One staffer "scornfully told me that Marvel's readers would "not be interested in the adventures of a homicidal maniac.'" "When I put in the memo for the limited series," Carl Potts recalled, "everyone from editorial to marketing thought I was joking." And when the first issue went on sale, "Marvel did little to promote it. Nevertheless, it sold out three hours after it hit the shelves,"[16] and the "order lines were flooded with reorder attempts."[17]

Circle of Blood opens inside Rikers Island Prison, which in the story is a maximum-security prison. (In the real world, a majority of those detained at Rikers are awaiting trial. The story's conflation of accused and convicted is indicative of the Punisher's tetchy relationship to due process.) The inmates get jumpy when they realize that the Punisher has arrived. "Funny how animals always panic," he spits. "They always beg for mercy. They don't even know what the word means."[18] After busting a few heads, he escapes with the aid of a secret society called the Trust. The warden assures him that the Trust is composed of "concerned citizens; industrialists, financiers, ex-military, movie stars, journalists—*all* kinds of people. All *legit*." "But I have always worked alone," the Punisher muses.[19] For a brief

moment he considers joining them: "Justice by committee? There's too much room for bias ... corruption ... Isn't there?"[20] His expression makes it clear that he is at least open to the idea.

But Castle soon learns that he is being manipulated by a cabal that is turning former inmates into mindless Punisher clones. As one conspirator explains, "We needed men who could kill without conscience."[21] "The Trust wants things done fast, and they don't care how many innocent people get caught in the crossfire," the Punisher concludes.[22] "The goals are good," but their "methods are insane."[23] Determined to bring the group down, Castle takes out most of its operatives. When the Warden had told him earlier that "things in this country are out of control, especially *crime*,"[24] the Punisher had allowed himself to imagine there were others who saw the world as he did. He needed reminding that the only authority he can count on is himself.

In this noirish environment, it makes perfect sense that *Circle of Blood*'s love interest, Angela, is covertly working for the Trust. "Everything I have is *yours*," she whispers, as she slips off her robe.[25] After their night of passion, Castle broods about his mission. "A mob boss dies, someone else takes his place. Nothing changes." Frustrated by the fact that "I can't kill all of them," haunted by the day 'when I'll be too slow," he wonders if there might be a "better way."[26] Angela listens patiently, but later on tries to kill him when he asks too many questions. Her betrayal gives him yet another reason to retreat into his shell.

Grant and Zeck traded an amped-up zealot for a fed-up tough guy. "Previous writers," Grant insisted, "had battered his character into uselessness."[27] The "unspoken philosophy creeping through a lot of Marvel stories at the time" was that "the Punisher was a criminal," and "must be insane." "We didn't think the Punisher's backstory was remotely as interesting as his character," Grant said. "By the time the book came out, we were in the middle of the Reagan years," and "America was starting a love affair with violence." Along with "the rest of American culture," the comics marketplace "was getting hungrier for edgier, more sophisticated material." As Mike Zeck admitted, "I thought it could find its market, but I didn't really foresee the Punisher becoming a flagship character and supporting multiple titles."[28]

While Zeck's involvement helped ensure that the series was greenlit, his contributions are uneven. His faces are inconsistent, and in his hands Castle's physical form switches from bulky to stick figure. Where Zeck excels is not so much in figuration as in pacing and energy. His pages move faster than those penciled by his predecessors. Tony DeZuniga's pages, for example, are comparatively staid, although his figure work is exceptional and some of his panels are stunning. As the first Punisher artist, Ross Andru's competent linework benefited from Frank

Giacoia and Dave Hunt's aggressive inking but not necessarily from the garish palette that Dave Hunt and other Marvel colorists favored in this period.

The Punisher's traditionalist *machismo* gelled nicely with the Reagan-era ethos of bulked-up masculinity. The era's fusion of patriotic malevolence and hypermasculinity is memorably celebrated in Rick Buckler's cover illustration for *Reagan's Raiders* #1 from 1986 (Figure 4.1). The cultural historian Yvonne Tasker says that the action genre provides evidence of "a gradual redefinition of images of masculine identity" during the second half of the twentieth century which "evolved partly through the commodification of the male body."[29] Yet despite this larger trend,

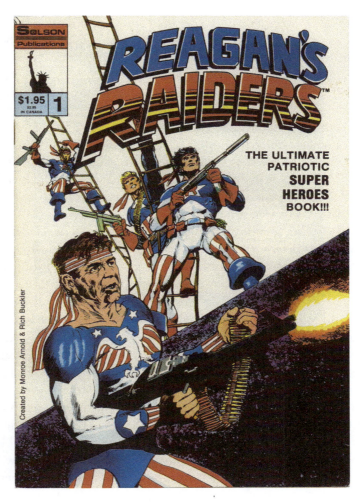

FIGURE 4.1: Rick Buckler, *Reagan's Raiders* #1.1, cover illustration, 1986. © Solson Publishers.

there is a striking degree of continuity between Castle's early visuals and later iterations. While there are stark differences between the depiction of the ideal male form in, say, *Dirty Harry* (1971) and *Rambo* (1985), the Punisher was already brawny in *The Amazing Spider-Man* #129 (1974) and "Death Sentence" (1975).

Each creative team makes figurative choices, of course. Castle is sometimes handsome and sometimes brutish, for example. But this is not the type of difference that scholars of body culture tend to highlight. As far as the hypermasculine form is concerned, the Punisher and his creators were ahead of the curve. He has always had an alpha male, pumped-up body type. At the same time, there is less cheesecake in Punisher comics than one might expect. While many Punisher pages have a pulpish quality, male-on-male violence rather than the female body is most often spotlighted. Visceral thrills rather than soft-core titillation.

Another set of design challenges has to do with depicting Marvel's version of New York City. Ross Andru's pencils are in keeping with the way the city is represented throughout the full run of *The Amazing Spider-Man*, albeit without the range and sensitivity that Steve Ditko brought to the assignment. This means midtown offices, boxy skyscrapers, and rooftops with water towers, rendered in a way that accentuates the costumed hero's acrobatic feats. Tony DeZuniga's work in 'Death Sentence' similarly spotlights the Big Apple's verticality, its crowded spaces and narrow alleyways. He also uses more close-ups than Andru. Meanwhile, Mike Zeck zeroes in on the subway system and an oddly metallic version of Rikers Island. In *Circle of Blood* the metropolis is far more menacing than it had been during the character's first decade.

The *Circle of Blood* collection that showcases Zeck's pencils also features a forward by editor/writer Carl Potts and an afterword by writer Mike Baron. Their essays reflect the balancing act Marvel faced as it sought to reposition the character in the marketplace. Potts adopts a psychological approach, noting that the Punisher is "a man obsessed." After all, "why does he go after all criminals? He feels guilty for not being able to protect his own family." Castle "not only needs to avenge them but he needs to be *punished* for failing them." In the real world, "the Punisher's type of justice would probably lead to chaos. However, we can enjoy the cathartic effect the fiction brings us."[30] This sense of catharsis is heightened by the shame and humiliation that Castle holds from not being able to protect his *city*. That his wife and children are murdered in one of New York's iconic public spaces underscores the degree to which their fate is intertwined with that of the metropolis.

Baron's afterword is much more politically charged. "Judges and lawyers feel they're 'above' ordinary concerns," he complains. While polls show "that most Americans are overwhelmingly in favor of capital punishment," the message "can't seem to get by the special interest watchdog groups." "The police and the courts may constantly disappoint us," he concludes, 'but the Punisher never does. So read

and enjoy—and don't let the 'liberals' make you feel guilty. The Punisher knows what's right—it's really quite simple, when you think about it."[31] Capital punishment advocacy, the barely concealed subtext of the hardboiled vigilante genre, is made explicit in Baron's aggrieved essay. What he overlooks is how Grant's left-populism skewers the rich and powerful who embrace the same ethos that Baron admires.

Circle of Blood is rarely considered alongside Frank Miller's *Dark Knight Returns* (1986) or Alan Moore and Dave Gibbons' *Watchmen* (1987). Yet all three were aimed at older readers and were distributed via specialty shops. None was stamped with the seal of the Comics Code Authority and each sought to go beyond what was permissible under the Code. *Circle of Blood* was part of what comics scholar Jordana Greenblatt describes as the "turn in mainstream comics to more adult-oriented offerings,"[32] where, in the words of Geoff Klock, "the building density of tradition becomes anxiety"[33] and where "darker, morally ambiguous" texts "raise questions about the relationship of heroes and subjectivity."[34] In these kinds of stories, emotions run deep and heroes can be as embittered as villains, if not more so.

Circle of Blood shares with *Dark Knight Returns* and *Watchmen* a preoccupation with the personal and social costs of vigilantism. It too has a revisionist aspect but it mainly revises Frank Castle rather than superheroes *per se*. The series is best remembered for its prison fight scenes, but it offers morally ambiguous villains, bouts of introspection, and a candid depiction of casual sex. It draws not only on the adventure genre but paranoia cinema like *The Parallax View* (1974) and *Three Days of the Condor* (1975), in which appearances are deceiving, authorities cannot be trusted, and vigilantism is misconceived unless it targets elites as well as street criminals.

Superhero comics—a tightly constrained embedded system *par excellence*—pretty much require that a character named the Punisher uses violence as a means of meting out justice. It should come as no surprise that *Circle of Blood* features conflict on almost all of its pages. Fights erupt between Castle and other prisoners, Castle and mobsters, Castle and other Punishers, and Castle and the Trust. But the fact that the Punisher is pitted against an insidious conspiracy financed by respectable citizens reflects a deliberate choice on the part of the writer, rather than simple character logic. Rather than satirizing the Punisher's war on organized crime, or celebrating his crime control obsessions, Steven Grant's left-populist script raises pointed questions about the steps that desperate, powerful people might take to protect their privileges.

Don't bother me with rights

Gerry Conway lent Castle an animating cause; Baron gave him a personality. Methodical and restrained, Baron's Punisher is relatively detached from the rest

of the Marvel Universe. He locates Frank Castle in a specific personal space—hostile to conventional politics, skeptical about civic institutions, vaguely patriotic, old-line without being far right. This version of the Punisher rarely goes berserk, except on the cover (for example, see Figure C1).

Mike Baron regarded working on the first unlimited series as a "priceless opportunity to inject contemporary excitement into a monthly comic book."[35] Throughout his tenure, he sprinkled details about Castle's inner life—his soft spot for animals, his taste in jazz and blues, and his reading habits—into his stories.[36] He was the first writer to give the character a romantic life—enough to validate his masculine bona fides but not enough to distract him.[37] Baron's Punisher is soulful, which helps rationalize his violence. In Baron's hands, the Punisher's finely honed sense of anger reflects a powerful sense of betrayal rather than bloodlust or wounded pride.

This internalist history complicates James William Gibson's claim that a prime example of "sometimes cruel scenes of men leaving women for war, a recurrent motif in Freikorps literature," is when

> the comic-book hero Punisher literally has to push a woman off him while they are on a mission. "Cool it," he says to Conchita Ortiz, another vigilante. "Let's keep it business. Fate throws us together. But that doesn't mean we have to act like those animals down there."[38]

But this scene can hardly count as an example of "men leaving women for war," given that after their exchange, Castle and Ortiz proceed to fight "those animals" side-by-side. Gibson more accurately describes the Freikorps as "several thousand soldiers" who "formed their own paramilitary force" that

> regularly attacked leftist demonstrations and hunted down and killed key organizers. To them, war was a way of life complete with its own obligations, affiliations, and psycho-sexual dynamics. The novels and memoirs written by these men permeated German culture in the 1920s and 1930s and were a central component of the rising fascist movement.[39]

Punisher comics are a window onto a political backlash that was significantly driven by rising crime rates. But that does not mean that they are the contemporary equivalent of the politically predictable Freikorps novels.

The Punisher's supporting cast at this point included Max the rottweiler, tech guru David "Microchip" Lieberman, and our old friend Jigsaw. The contrast between the hardened street fighter and Micro the sidekick adds a note of odd-couple comedy to the storytelling. "Ours is a relationship that is tenuous at best,"[40]

the hacker sighs. Only rarely does Castle refer to Micro as a friend.[41] They are briefly joined by Micro's son Louis, who is also a computer whiz. When Louis is slain during a difficult mission, Castle coldly insists, "Microchip will understand." He evinces little or no remorse when he returns Junior's body to his distraught father.[42] One reader, Troy S., found the tale "graphic and disturbing." The Punisher "remains coldly unemotional at the loss of one of his troops," said reader Malcolm B. "I can hardly believe my eyes!" complained Gary G.[43] The Punisher's indifference to Louis' passing would prove a lasting source of friction between Castle and Micro.

The success of *The Punisher* inspired ancillary titles: *Punisher War Journal*, *Punisher War Zone*, *The Punisher Armory*, and *The Punisher 2099*.[44] There were also seasonally-themed one-offs,[45] pin-up and equipment pages,[46] and the first *Punisher* movie (1989). Not all readers were happy with this policy of brand extension. "Does the Punisher know how to do anything but kill?" moaned reader Tim J.[47] With each new series, the character became increasingly bloodthirsty. And yet by the mid 1990s sales figures were falling. In the summer of 1995, Marvel decided that the formula had stalled and cancelled every Castle-related title. The company then inexpertly relaunched the character a few months later.[48]

Baron's scripts revolve around gangs, crack, and movie references.[49] Jigsaw shows up a few times, as does the charismatic terrorist Saracen, whom Castle finally guts in *The Punisher: Empty Quarter* (1994).[50] In one memorable issue, our hero takes on pill-popping teens who hang out in the school basement. He lands a job as a substitute teacher, and at one point turns his class over to his star student, who dispatches Jean-Jacques Rousseau's social contract theory on the basis of patently nonsensical arguments. Castle and his pupil teach that Rousseau "first posited this contract," even though most authorities credit Thomas Hobbes. Her insistence that the social contract is "a half-truth" because "there are no rights" in nature is a non sequitur.[51] Other stories make fun of liberals,[52] vegetarians,[53] and death penalty opponents.[54] "It's one of the great failures of our criminal justice system that we aren't permitted to use torture," Baron's Punisher inveighs, "even in those cases where it's so clearly justified."[55]

Several of Baron's villains face right, however. At one point Castle tangles with the Army of the New American Revolution, whose members believe that "unless white Christians stand together, this country will collapse!"[56] He also confronts a retired Army Colonel who runs an academy that turns out to be a front for child pornography,[57] and takes on a coke-addled banker who boasts that "nothing comes close to the thrill of slicing up bums."[58] Chuck Dixon is another conservative who injected caitiffs into the storyverse, including the "Sword of Liberty," a group of "paramilitary crazies" who "believe that America is under siege by

foreign powers."[59] The presence of these malefactors, and others like them,[60] underscores Castle's indifference to conventional lines of demarcation.

Micro proves the more ideological of the two. The Punisher is so wrapped up in his own thoughts that he is surprised to learn his partner is a supporter of Israel. "Didn't know he was political," Castle murmurs.[61] In the "Origin of Micro" mini-series, the villain is an academic who warns his students that "capitalism is inherently racist" and that "the banks are crooked." Micro retorts that "socialism's killed a lot more people than capitalism" and "you keep trying to demonize the very system which supports this university."[62] Castle might well agree and yet he also regards Wall Street as a "monument to the robber barons. They steal behind closed doors—bloodless crimes—but there's blood down the road. The blood of little people caught in the gears of high finance."[63] This sounds suspiciously similar to what a *Jacobin* contributor might argue.

Baron's "Star-Spangled Burner!" (#44) proved especially controversial. As the story opens, a rap artist named Arc Light torches the Stars and Stripes in front of a group of small-town residents. A scuffle ensues. After rescuing the rapper, Castle learns that Arc Light likes to visit "whitebread midwestern communities" in order to "give 'em a taste of my higher powers." He then offers a sample: "The nature of art is debatable/like Stevie Wonder examining an elephant. For me, the answer is creatable/for others the answer is not relevant." "Whoa—*hold it*!," Castle exclaims. "I don't know art from pudding but I know music—and rap isn't music! It's just bad poetry set to a beat!" "Well, ain't you a liberal sucker," Arc Light snorts.

When armed locals interrupt their debate about art and music, Castle tags them with his 9 mm. "I'm a performance artist, too. My art consists of blowing away crooks."[64] Improbably enough, the thugs work for a state legislator who runs a meth lab out of an abandoned factory. Before the inevitable shootout, the Punisher tells his new friend that he should "learn how to do something other than grunt in rhythm." "Man, you are simultaneously patronizing, insulting, and racist. Why don't you just call me a little monkey?" "Who are you calling racist? Some of my best friends are black!" "Lord, how did I know that was coming. Okay—name one." "Uh ... er ... okay! Hubert Brooks! Old pal of mine from the Bronx." "When was the last time you saw ol' Hubert?" Arc Light wonders.[65] But the Punisher gets the final word. "Think carefully before you burn another flag," he says. "You don't know what you're setting off," as the factory burns to the ground.[66]

Letter writers debated these culture war issues. "Thought provoking," said reader Andrew D. "'Flagburner' was Marvel at its best," wrote Mikey B. "I'm still behind you 100 per cent," Shane L. added.[67] Others were negative. "You make me sick!," scoffed Roger I: "I want to tell you something, Mr. 'Liberal' Baron. My uncle died in Vietnam doing battle for his country and the flag. People like you and these flag-burning #&*%@#%& should get the *&%# out of the country!"[68]

144

Victor D. complained, "Lately, you guys have been making him [Castle] look like Waldo the Gutless Wonder."[69] Other letter writers found Baron's plots predictable, which seems a little unfair. Floyd B. warned that "these stories are becoming homogenous." Chris C. said, "there have been so many gang wars I've lost track."[70] Jacob G. said the plots had "been reduced to nothing more than another installment of 'The Misadventures of Punisher and Microchip.'"[71] "I used to read your title," confessed D. A. G., "but I soon grew tired of the same old 'Punisher beats on drug smugglers' stories, so I quit."[72] My favorite is from a reader who boasts:

> Man of Action—that's what my friends call me after beating the c**p out of two drug dealers about three years ago. They were giving dope to two 17 year-olds. I'm very Anti-Drug. It was happening in a cemetery in my town. They said, "What the blank do you want?" I said, "Your blanken heads you lousy stinken son of blanked dope dealers." I beat the living c**p out of them. I used Karate and other special skills, and said, "get the bleepin' h*** out of this town—if you come back you're dead! As long as I'm living here you're not going to poison any more kids with your drugs." I also stopped a dope deal in one of your parking lots. You could call me a vigilante but I would just call me someone who cares.

Carl Potts' editorial response? "Um ... no comment."[73]

Along for the ride

Some of the post-Baron material is haphazardly off-beat, with one reader, Steven S., complaining that "the book's passion left when Mike Baron did."[74] The interminable "Eurohit" storyline pits gritty Frank Castle against such trigger-happy villains as Snakebite, Tarantula, Batroc the Leaper, and Rapido, who sports a chain gun in place of his right arm. Outfitted in a purple jumpsuit and orange boots, Batroc says things like, "Zut alors! I thought 'eed seen me zen!"[75] Astonishingly, readers ate it up.[76] Some letter writers still preferred to explore political themes, however. "Most of my comic collecting friends are surprised that I am such a Frank fanatic," one reader confessed:

> I don't believe in capital punishment, nor, in looking at it responsibly, what Frank is doing. But I'll be the first to admit that a part of me cheers when the Punisher kills another bad guy. There seems to be no solution to the rising crime rate. The problem gets even more complicated when you consider that there are often psychological and sociological excuses for evil and crime. But the Punisher's way is simple: if he sees you doing something wrong, you're dead. No questions asked. It's refreshing to read, especially after watching the six o'clock news. And the Punisher is fiction, so it's ok.[77]

Reader Todd S. voiced similar sentiments: "The Punisher is one of these characters I've always had mixed feelings about. Sometimes his storylines are very exciting and intriguing, and other times I find myself dismayed that Frank Castle could be such a popular character."[78] Paolo V. defended the character as "the most realistic and ultimate hero set out to rid society of such low-life scum trying to ruin the world with horrible crimes."[79] While some correspondents focused on characterization and artwork, others commented on what an editor at DC referred to as the "role of the vigilante in today's society [...] not just in body counts, but in the ways such actions influence others and have an impact on our day-to-day activities."[80]

Over time the character found a home, if not quite a family, inside the Marvel Universe. Guest appearances by Bullseye, Daredevil, Doctor Doom, and others suggested that Castle was making waves beyond his own storyverse. His cast expanded to encompass not only Micro and Jigsaw, but his dog Max, snitch Mickey Fondozzi, and several vigilante wannabes. His vendetta also brings him into conflict with Wilson Fisk, who dubs him "a bothersome mosquito not easily swatted."[81] First introduced as a Spider-Man villain in the 1960s, Kingpin is the type of entitled chieftain that the Punisher normally exults in cutting down to size. But writers kept inventing new ways to explain how such a high-profile villain could survive Castle's wrath. Baron's take is representative. If Fisk disappears, Micro explained, "we'll see a power struggle gang war like you wouldn't believe," with "women and kids caught in the crossfire." "Okay," says Castle, wanly.[82] Or as Micro later notes, "Better to live with a *beast* we know than a *rabid* one."[83]

The Punisher clearly could keep his emotions in check. "I'm no careless nut job with a cause," he insists.[84] But as the 1990s wore on, Castle walked the same path as the paperback antihero Burt Wulff. The post-Baron stories leave a bitter aftertaste. "We are all carrying death," Castle says at the start of "Suicide Run." When a smuggler asks, "What are you *waiting* for? *Shoot*," Castle obliges him. "Death is always a surprise," he scoffs.[85] "The point is to punish," he adds. "Punish a dozen. Punish a hundred. Punish every sinner until there's no sinners left. Anything else is surrender."[86] One would-be Punisher says that "Vengeance is our only comfort," but these words could just as easily have been uttered by Castle himself.[87]

The authorities eventually develop countermeasures. V.I.G.I.L. is launched after Congressman Bernard Modine watches Castle execute a drug dealer in front of well-heeled funders at a private gala.[88] Around the same time, Marvel began to hint they might be "sending Frank to that big abandoned warehouse in the sky."[89] "It was with a heavy heart that I read that Frank Castle isn't going to be the Punisher anymore. At first I thought it was some sick twisted joke," confessed one reader.[90] "I found out that you're about to let the Punisher get punished to the point of no return," reported another. "Now, if this is just one of those marketing things,

I won't mind. If it's permanent, though, you've just lost a very loyal reader." Don Daley's response was evasive: "Although we agree that the Punisher is the greatest, it's time to shake things up."[91] The result was the high-profile, best-selling series "Suicide Run," in which Castle crashes a crime boss conclave. "It's a trap," warns Micro. The Punisher concurs:

> "Possibly the biggest mob gathering since Appalachia in the sixties.[92] All the stars together in one room. I'm going to be there," Castle says.
>
> "*Alone*, I hope."
>
> "You should want this as badly as I do. These are the kind of skells who took your son away from you."
>
> "I'm *over* that, Frank. He wouldn't want me to keep tearing my guts out for him. He wouldn't want me to *kill* myself just to take out some lowlife bums. I don't think Maria and the kids would want that for *you*."
>
> "Not. Another. Word," the Punisher replies, as he storms out of the room.[93]

Castle manages to rub out the bosses, but he is soon pursued by "every gun in four states and Canada."[94] V.I.G.I.L. shutters Castle's safe houses while various Punisher imitators take to the streets. Their ranks include former New York police officer Lynn Michaels, the couch potato known as Idiot Punisher, and the inexperienced Payback, whom Micro hopes will act with greater finesse than Castle. It is hard to know how readers kept them straight. "I hate crossovers as much as anybody," Don Daley admitted. "But *this* one actually has lasting consequences."[95] Was he right? Yes and no. By the conclusion of "Suicide Run," Castle's "ability to be the Punisher has been severely compromised."[96] "With nowhere to run, nowhere to hide, and no one to help him, the Punisher fights on alone, unarmed, against impossible odds."[97] Meaner than ever, he returns to his old stomping grounds. "Get back in your car," he snarls at a suburbanite couple. "These streets are for predators only."[98] Violent crime may have been on the decline in New York City, but for the Punisher, the 70s never ended.

Start the clock

In the series' closing issues, the Punisher hunts down an elusive crime boss named Cringe, who is "like smoke on a windy day."[99] His search takes him to East New York, which "looks like a nuclear test range, only it's more dangerous,"[100] and then Newark, where he gets trapped in a factory subbasement that has been made up to resemble "where I lived with Maria and the kids." He growls as a taped message informs him that tonight, "the *Punisher* will die."[101]

So who is Cringe? None other than Micro himself. "I'm going to try to save you from your greatest enemy, the man who will eventually *kill* you ... *yourself!*,"[102] the hacker explains. But when Castle escapes, Micro becomes the Punisher's next target.[103] Just as Castle is about to execute his former ally, former S.H.I.E.L.D. agent Stone Cold Smalls tosses a grenade at the two men and Micro dies in the explosion. "Micro took a lot of the blast. In the end he *was* useful,"[104] the vigilante sneers. As Micro himself once acknowledged, "Frank's not the kind of guy who *has* friends."[105]

The remaining cast members vie for supremacy in a city that has turned into a war zone. Fearing he has killed a pair of tourists during (irony alert) a gunbattle in Central Park,[106] Castle decides to turn himself over to the authorities. He is just about to surrender when Kingpin hands him "dossiers on my ... competitors." "And if I take them all down? You know I'm coming for you next." "I'm counting on it," Kingpin replies.[107] Their brief concord results in a fresh spasm of mayhem, at which point Nick Fury intervenes and takes Castle to "a place far away above the clouds"—the S.H.I.E.L.D. helicarrier. The drama proves too much for Castle to process, and he collapses into a state of catatonia. As the three series—*The Punisher*, *PWJ*, *PWZ*—wind down, an impassive Punisher is locked in solitary confinement. "It's been a long journey," reads the elegiac postscript.[108] Roughly 250 Punisher comics and graphic novels were released between 1987 and the summer of 1995. This is a lot of ink and paper to expend on a character most pros assumed would be unable to sustain a single miniseries.

Hammer in the palm

While the distinction between *The Punisher* and *Punisher War Journal* (*PWJ*) was left blurry, the focus of *Punisher War Zone* (*PWZ*) was on "story arcs by different creative teams happening at many different stages of the Punisher's life."[109] Not everyone appreciated this proliferation of titles. "Having a sister comic called *Punisher War Journal* is somewhat stupid," argued reader Rakesh P. "What next, may I ask? Microchip's memoirs?"[110] *PWJ* recycled the same anti-drug tropes as the original *Punisher* series, with Castle reminding readers that the trade "is *littered* with victims of corruption, *murder*, kidnapping, extortion, and so on."[111] In one issue, dealers ship their product into the United States by "murdering children and stuffing the bodies with coke,"[112] and in another, pot growers prove as depraved as other types of drug merchants, with Micro dismissing marijuana as "the product of killers."[113] Castle slaughters dealers and growers with impunity but draws the line at consumers. Yet he sometimes wonders "if I should just take them all down."[114]

Crime lords and big-time drug merchants proved reliable targets; environmentalists and animal rights activists offered a less obvious foil. In one story, an outfit called Green Planet plans on dumping plutonium waste in the Colorado Rockies. "But won't that stuff kill lots of animals?" asks a naive member. "Try to look at the *big* picture," snorts Professor Artemus Greel, the group's shady guru. "We're trying to save *all* of spaceship Earth, right? Sacrifices must be made." Greel is the *n'est plus ultra* academic, complete with a beard, glasses, and rumpled clothes. "I could give up," Castle admits, when the professor briefly outfoxes him. "But I don't like the way Greel was smiling at me."[115]

He then confronts an eco-cabal called Humans Off Planet (HOP) that pals around with terrorists. In *Empty Quarter* (1994), HOP members attend "the first world international terrorist convention" alongside representatives of "IRA, Hezbollah, Shining Path, AIM, Khmer Rouge, Tamil militia," and others. With capable help from the Israeli secret agent Rose Kugel, Castle slaughters the attendees.[116] In "The Kamchatkan Konspiracy," HOP teams up with a Russian general to destroy an Alaskan oil refinery—another narrative in which the largest threat to nature is posed by its putative defenders.[117] The green terrorists are funded by a Jane Fonda stand-in who takes potshots at Castle before switching sides. "You're middle-aged and politically naive," Castle tells her. "What makes you so nasty?," the actress replies, as they lock lips. While the Punisher is willing to forgive her "eco-nut" past, Micro is not so forgiving. "Listen, I realize I've made mistakes—I was filled with revolutionary zeal," she explains. "Spoken in true communist, self-critical fashion," Micro says scornfully.[118]

Baron's "Controversy" features a smug radio personality who insists that "the leftist pinko commies, animal rights nuts, pro-abortion rights people, members of the so-called gay community and *peace* crowd—they and plenty of others all want me dead." His paranoia proves prescient when HOP activists kidnap the "stinking meat eater" in order to "save the lives of hundreds of animals!" The Punisher guns down the activists and rescues his new friend. "Let me buy you a steak ... if you don't mind contributing to the destruction of the rainforest," barks the grateful host.[119]

Don Daley revealed that the issue "really engendered some interesting mail." "If I wanted to read stuff like this," complained Mitch N., "I'd read the *National Review* and not a comic book. Let me know when you start showing both sides of a story again." Reader Tim D. suggested that "the right-wing humor in *PWJ* just about makes up for all the left-wing proselytizing that I see so much more often in comics." But 13-year-old André J. was outraged:

I can't believe this, the Punisher actually could save someone like this fascist, slimeball, anti-abortionist, anti-peace, anti-ethical, anti-environmental, anti-feminist *idiot*!

Why don't you have the Punisher go and join an Aryan Peace club. I am deeply mad at the writers of this comic. Well, I guess I shouldn't keep reading *PWJ* knowing the Punisher hates me because I'm half Portuguese. Thank you for the insult. You just lost a reader.[120]

Some of Baron's stories adopted a different tack. In "Panhandle," Castle turns his attention to the Savings and Loans (S&L) crisis of the late 1980s–early 1990s, during which over a third of the country's S&L institutions were shuttered. He investigates the "fat cats" who "rip off what the little cats spend their whole lives saving." "A boring crime," Castle pronounces, just before he discovers that one of the bankers uses his ranch as a front for heroin trafficking. After draining the man's finances, Castle hands the money over to the victims of his swindles. "To panhandles and panhandlers," he toasts. "Texas Checking Account Massacre!," screams the cover, which features the Punisher crashing through a window as he yells, "Pay-back Time, Sleazeball! With Interest!"[121]

Trouble naturally follows the Punisher wherever he goes. "I've seen the cities turned over to the dirtbags one street at a time," he tells one small town sheriff. "The whole country is a war zone."[122] Whenever he travels outside the country he ends up dodging bullets. "New York will seem like a vacation after this trip," he jokes, after tangling with Filipino pirates.[123] Another gag involves the customized vans that the Punisher routinely demolishes. Each van comes equipped with sonar, scuba gear, parachutes, a four-barrel minigun, a 40 mm grenade launcher, tear gas, white fog, pain field generators, mounted machine guns, anti-personnel charges, three phone lines, an internal air supply, a fire suppression system, and an underside escape hatch.[124] "Micro will skin me alive if I lose another battle van," he sighs.[125] As he steals "a few hundred thousand" from a chemist who works for the cocaine trade, he notes that the cash "only makes a down payment on what a new van will cost. Maybe I'll wait until morning to tell Micro about it."[126]

Lynn Michaels, the female Punisher, is first introduced in the pages of *PWZ*. Her motivations are fleshed out in *PWJ*. She resigns from the police force when a child killer receives a reduced sentence on a technicality. "I can't pretend that what we do makes a *difference*," she tells her captain. "Ten *years* you're tossing away," he responds. "That's *madness*." "Maybe a little more madness is what this town *needs*," she retorts.[127] She dons a Punisher-style bodysuit and takes out the child murderer with a sniper rifle. "I'm *the Punisher* now!," Michaels exults.[128] But the costume also makes her a target. "I dressed like him out of anger," she admits. "To goad them. I can't afford anger anymore. Not if I'm going to carry out Frank's work."[129] She then wonders whether "I made a mistake taking all this on."[130] Perusing Castle's war journal, she is dismayed to discover that "He was a monster, and I've made myself his heir."[131] Suitably chastened, she and her

friend Payback make their way to her family's farm in Iowa. "It's over, *isn't it?*," she sighs.[132]

Readers seemed unnerved by the prospect of a female replacement. "Fans will have trouble accepting another Punisher," insisted Jacob G.[133] "Hmm, a female Punisher," he later mused.[134] "A lady Punisher is a stupid idea and I'm a lady," grumbled Cindy L.[135] Jacob G. estimated that "probably 80 per cent of Punisher fans, myself included, figured Frank would survive. The rest are probably whiny, tired, disenfranchised fanboys hoping Frank would retire his guns."[136] Many fans were attached to the character and his thickening backstory. Others doubted whether anyone could hope to fill Frank Castle's shoes. Marvel may have been keen on shaking things up, but for some readers, a female Punisher was a step too far, if not a contradiction in terms.

A recurrent theme for letter writers was the lack of realism in the depiction of weaponry. "Twice in the story he [Castle] mentions the use of 5.66mm ammo. I believe you meant him to be using the 5.56mm (.223 cal.) NATO round," chided Skip K.[137] Reader Jon R. pointed out that "single action automatic weapons don't go 'click-click-click'. Just one click is sufficient."[138] Shyldon S. criticized the way that the character was drawn "firing a rifle" with his support arm "stuck out like a chicken wing."[139] Castle's age provided another bone of contention. The idea that he was in his early 40s bothered Roz L.: "My dad *can't* be the same age as the Punisher. The Punisher? My dad?" "A middle-aged Punisher," scoffed Chris G. "Do I hear a crisis in the brewing?" "I place him in his late 20s," opined regular lettercol contributor Uncle Elvis, which suggested that Castle was in middle school during the Vietnam War. Don Daley assured readers that "Marvel time arrests, or at least severely slows the aging process."[140] But Castle's status as a Boomer gradually became untenable, and his military record was quietly retconned. Letter writers fretted about sound effects and Castle's advancing years, but acquiesced in his descent into savagery.

Duration infinite

Launched at the apex of the character's popularity, *Punisher War Zone* was described as "the hottest book to debut in this country in a loooooooooong time."[141] The series crisscrossed Castle's timeline and provided the ideal format for filling in the backstories of secondary characters like ex-police officer Lynn Michaels, Mickey Fondozzi the snitch, and sultry Rosalie Carbone. The Punisher's rottweiler also gets a moment in the spotlight. A "strong and savage fighter," Max shared a tight bond with Castle, "stronger on some levels even than Microchip."[142] "We had an uneasy alliance, Max and I did," Castle confesses. "I hate that dog. Sure

miss him."[143] The very "structure of sovereign masculinity, in which the will of the manly man is the only source of meaning,"[144] makes it hard for Castle to admit that he cares about anything but his mission.

Given his viciousness, and his distrust of others, the Punisher's relationship with Micro is inherently fraught. At the very least, he does not find it easy to open up. When they work together to track down an unsecured nuclear device, Micro says, "Frank [...] if we don't find the device and I don't see you." "Hit the road, Micro. We're on the clock," Castle retorts.[145] Between his son's death and Castle's abrasiveness, it is little wonder that Microchip feels the need to see a therapist. But when he tries to keep his sessions on the down low, Castle ferrets out the information. "I followed you, Micro. I saw you and your buddy talking. What do you talk about, Micro?," Castle probes. Their conversation is unflinching:

> "A *shrink*! I got nobody else to talk to!"
> "What do you talk to him about?"
> "About my son. My boy. I still miss him, Frank. And everything we do to pay back the kind of animals who killed him hasn't changed that. I can't *bury* it like you do. I have to talk to someone, and *you* don't want to hear it!"[146]

PWZ captures "the spirit of the Punisher's anti-heroism, his despair, and his dark crusade against the evil ones who prey on the weak and innocent," claimed reader Ty M.[147] A relieved Jason H. said that "Punisher stories had become violence for violence's sake, and generally the art had been far less than inspiring. Now, we have *War Zone*."[148] "Probably everyone across the country is fanatical in their raving about this title,"[149] James S. exclaimed. Will C. was even more enthusiastic in his assessment: "This comic book is the best thing since oxygen."[150] But the Punisher's "hardboiled vet act"[151] became increasingly negativistic as time went on. "Nothing makes me happier than the sound of high-velocity bullets smacking into vermin flesh," he boasts during "Suicide Run."[152] The dehumanizing notion that lawbreakers are "animals" is an established trope, as is Castle's hypermasculine preoccupation with death. A year later, the character rejects the very concept of happiness. "I don't have a heart, and the only people I cared about are dead."[153] During a rooftop struggle with another serial killer, he offers a bleak soliloquy: "I'm beyond life and death. I feel nothing. No desire, no satisfaction. No pain. I'm already dead. He thinks death makes him powerful. That death is control. Death is cheap. Anyone can kill. I don't *care*."[154]

Reader Frankie T. asked whether Frank Castle was "a Republican or a Democrat."[155] Respondents Victor L. and Jody H. suggested that he was either "somewhat apolitical"[156] or "an independent."[157] Locating a man who is "already dead" on the political map is a challenge.

Producing freedom

Circle of Blood collected previously published floppies.[158] Some of the other volumes from this period offered standalone stories that paired Castle with Spider-Man, Black Widow, Captain America, and lesser-known characters like US Agent and Paladin. Outfitted with bookstore-friendly ISBNs, these team-ups mostly came in the guise of trade paperbacks, although a few were glossy hardcovers. As the industry shifted from newsstand distribution to the direct market, these graphic novels began to take up shelf space in specialty stores, bookstore chains, and independent bookshops. Punisher volumes contributed to this process of comics gentrification even as they preserved the sociopolitical reflexes of an earlier conjuncture.

Graphic novels from this period are mostly exercises in genre, from Cajun horror and Scottish folklore to western gunfights and Rambo-style war theatrics.[159] Unfamiliar settings promised novelty even as the vigilante and his cast revisited well-worn syntactical grooves. *Punisher: The Prize* (1990) combines a conventional narrative about drug dealers appropriating Iron Man tech with a morose portrait of one man's midlife crisis. "Why *do* I do it?," Castle wonders. "If I *died* down there—no one would have *cried*. No one would have *cared*." As he sits in a studio audience watching a taping of *Late Night with David Letterman*, Castle fears he will not be missed: "I'm just that nutcase with the gun." But then again, "Maybe someday I'll earn that prize of a normal life. Maybe ... someday. Maybe. Then again ... maybe *not*," as an image of a skull forms in his irises. As the back cover asks, "Is the Punisher ready to give up his war?"[160]

Dilemmas of this type are built into the character's constrained system, as is the possibility of lesser or greater artwork. *The Punisher: Assassin's Guild* (1988) and *The Punisher: Kingdom Gone* (1990) are elevated by Jorge Zaffino's haunting use of blacks, while *The Punisher: Intruder* (1989) investigates the connection between vigilantism and Catholicism with the assistance of Bill Reinhold's expressive pulp imagery.[161] *Return to Big Nothing* (1989) strikes all the familiar notes of serial men's fiction—brothels, explosions, drug-addled punks, Vietnam-era flashbacks, and a prison breakout—while featuring delightfully melodramatic artwork by Mike Zeck, whose amped-up illustrations are given room to breathe.[162] The graphic novel format allowed artists like Reinhold, Zaffino, and Zeck to decompress the pacing and incorporate a greater number of splash pages. Readers who forked over 20 bucks were more likely to savor each page, and perhaps even to read the book more than once, which of course shaped how editors handled these kinds of assignments.

Two titles by the gifted Jim Starlin paid special attention to the social–psychological roots of Castle's rage. Starlin adds a measure of science fiction and deep-state conspiracies to *Punisher P.O.V.* (1991), a miniseries about a pair of

hippies who were expelled from the Weather Underground "for being *too radical and violent.*"[163] A story about Castle's efforts to track down these "bad customers" then morphs into a gothic novelette about genetics, vampires, and mad scientists. Yet at its core, *Punisher P.O.V.* is about a straight arrow who is appalled by his generational brethren. Starlin's follow-up, *Punisher: The Ghosts of Innocents* (1993), weaves a less tangled story about a "thug with quick reflexes" who distracts the Punisher long enough to get a bus full of schoolchildren killed.[164] For the remainder of the story, their ghosts follow Castle wherever he goes.[165] The character is already haunted by the loss of his family and the collapse of his city. Here he is plagued by the knowledge that even his best efforts are insufficient, which is a problem that is endemic to the superhero condition.

Just hardware

Devoid of plot or figuration, *The Punisher Armory* (1990–94) represents a modernist extension of the "equipment pages" of the late 1980s. The series was described by its creator, Eliot R. Brown, as a "still life with notes," with each issue exhuming the "art and technology of warfare, hunting, sport shooting, espionage, police methodology, and clandestine operation philosophy."[166] In practice, this means page after page of illustrated guns, knives, grenades, tasers, mace, batons, flares, crossbows, binoculars, flamethrowers, parachutes, med kits, body armour, flotation devices, diving equipment, entry shields, signal scramblers, rappelling gear, door rams, gas masks, land mines, tranquilizer darts, infrared detectors, noise attenuators, and anti-tank weapons. The death of the subject turns into a fetishistic gaze, in other words.[167] The covers promise "32 Explosive Pages of Bone-Blasting Weaponry!" and "The Must-Have Book by the Ultimate Payback Warrior!"[168] According to a poster on a message board, "many a young survivalist cut his teeth reading" the *Punisher Armory*.[169] The notion that survivalists would have appreciated what Eliot Brown and Marvel were up to with this series should not strike us as outlandish.

Each *Armory* features a short essay by Brown. "My goal has been to delve into the needs of such a man," he explains, "to present the specialists' feeling in a reasonably clear fashion."[170] These pieces strived for realism and even-handedness: "Just because we know his motives and what made him into a vigilante doesn't mean that his actions are right,"[171] he warns. By the eighth issue, Brown announced that "I recently joined the National Rifle Association." Because "I make my living reading, investigating, talking and drawing guns," it "seemed hypocritical not to." Besides, "each side of the 'gun issue' has its fair share of shrill, slanted and illogical thinking."[172] In the very next issue, Brown praises Castle for

"fighting a grass-roots moral battle for the country," suggesting that "in his own crooked-path way, the Punisher is trying to make America a safer place for the children of tomorrow."[173]

The Punisher Armory presents something of a paradox. On the one hand, it celebrates a character who nominally leans in a communitarian direction. Frank Castle is pro-military, pro-police, and pro-family, and the criminals he confronts are often moral relativists. Yet, as *The Punisher Armory* makes plain, the character's everyday routine is bitterly antisocial. Since the series lacked a letter column, it is difficult to know whether and how readers might have commented on these issues. *PWZ* however published a note from a fan who described *Armory* as "unique for a couple of reasons":

> This type of artwork is perfect. No characters, just hardware. I love it! The Punisher's thoughts on each weapon are not only informative, but they're a lot of fun to read to find out why Frank Castle uses some weapons more than others and how each one works in the environment.[174]

Fun, perhaps; informative, certainly. *The Punisher Armory* constitutes a training manual: how to look after weapons, build safe houses, and take people down. The extremism of the content underscores the main lesson of the character's journey in the 1980s and 1990s: that an extended campaign of anticriminal violence will spiral out of control. Between *Circle of Blood* and "Countdown" the Punisher goes from having allies to being friendless. In the 1980s, when he came into his own as an A-lister, he possessed the magical superpower of killing only the guilty. By the mid 1990s, he sent tourists fleeing from his gunfire. In *Punisher: The Prize* he fantasizes about building a normal life. At the end of "Countdown," he is catatonic.

The abasement of the Punisher during the era of his greatest popularity was by no means inevitable. Those responsible could have pushed in other directions. They could have had him join forces with S.H.I.E.L.D. or V.I.G.I.L., which is pretty much what happened to Mack Bolan—but that would have diluted his anti-establishment message. They could also have adopted the "oneiric climate" that Umberto Eco identifies with the Superman comics of the 1950s and 1960s, "where what has happened before and what has happened after appear extremely hazy." In these types of stories, the "narrator picks up the strand of the event, as if he had forgotten to say something and wanted to add details to what had already been said."[175] But this strategy offers a better fit with a deity who floats above history rather than with the product of an epoch that creators and readers are still processing. While Superman's arrival intersected with the Depression, producers and consumers have long considered the narrative to be escapist rather

than pointed. It is telling that DC's response to the rising tide of the vengeance genre was motivated by a similar sense of pessimism.

Marv Wolfman and George Pérez's *Vigilante* (1983–88) presents the tale of Adrian Chase, a former New York City District Attorney who became the second member of the DCU to assume the Vigilante mantle. Like Frank Castle's, Chase's family was killed by criminals—in his case, "gang bosses"—and, like Castle, he dons a black costume with white boots, works with a computer genius, and carries a gun. "Sometimes the law is *hamstrung*. There are times you've got to step *around* red-tape legalities," he says, sounding a lot like Castle.[176] At the start of his campaign, however, Chase vows to avoid taking life except in self-defense. "I'm *not* a killer," he insists, "and I can't let myself become one." His aim instead is to "make certain the *guilty* pay for crimes and the *innocent* not be made to suffer." He also admits that "I fully expect that sooner or later I will *die* being the Vigilante."[177]

In an editorial note, Wolfman explains that

> The Vigilante is obviously a protagonist whose methods are questionable, but he does not use his gun unless he has to. The character, his unique perspective of the law—having once been a District Attorney—and his method of operations make him different from virtually all other characters of this type in pulp novels or in comics. We hope this difference will make him more interesting than those other one-note characters.[178]

Chase "knows he is not above making mistakes,"[179] and as the series progresses, he wavers back and forth between escalating his tactics and pulling out of the vengeance game altogether. Sometimes he assists the police in the manner of a Spider-Man or Daredevil; other times he is uncomfortably reckless. Correspondent Miranda B. noted that *Vigilante* is a comic "where the struggle between right and wrong goes on within one individual," and suggested that "the struggle between good and evil is not some cosmic battle which we watch as casual spectators; rather, it is a dilemma which each of us faces daily."[180] Others focused on whether Chase "is too soft or too cold."[181] Reader Paul F. argued that the Vigilante should kill "people who are obviously corrupt and evil,"[182] while Rick P. insisted that "anyone using mercenary tactics to fight crime is not much better than a criminal."[183] "Correct me if I'm wrong," observed David B., "but I think your intention is to portray a man who realizes he's falling into a Dirty Harry mentality, and his moral struggle to stop the transition."[184]

In the end, Adrian Chase's inner monologue resolves itself in favor of retributive violence. "It had taken me a while," he admits, to "see clearly what my *mission* was."[185] But as he revs up his campaign, he develops a hair-trigger temper, pushes away friends, and drives his girlfriend to the brink of insanity. Another vigilante

admiringly refers to him as "the man with the .44 magnum *answer*," which would have been unthinkable in earlier storylines.[186] After committing a series of abusive acts, Chase stares into a mirror and admits that "I had been going about this all wrong ... I was supposed to rid the streets of killers and madmen, wasn't I?" Holding a revolver to his head, he says, "No more thinking ... not ever again." He then takes his own life, off-panel.[187] "This is probably the first instance," notes comics journalist Brian Martin, "of a costumed hero committing suicide in such a calculated manner. Warlock and Phoenix had killed themselves previously, but both of those suicides were in the heat of battle."[188] Frank Castle is sometimes depicted as a depressive, but his visibility and cross-media appeal mean that the character can never commit suicide—unless of course he promptly returns to the land of the living, which is what happens in the fourth *Punisher* series. Adrian Chase, on the other hand, is navigating the afterlife.

Political psychology

Punisher comics published during the first production cycle constitute an ambitious grand narrative about a hardboiled vigilante whose anger and frustration render him unstable and self-destructive. Echoing themes that are laid out in Barry Malzberg's *Lone Wolf* series and Brian Garfield's *Death Sentence*, this epic storyline is pessimistic and melancholic. The contours of Castle's negative dialectic are perhaps easier to discern in retrospect than they would have been at the time. But it is a more interesting and provocative narrative than one which assumes that a man like Frank Castle could do what he does, month after month and year after year, without any consequences. If the Punisher was the property of a storyteller, rather than a corporation, the saga would logically conclude with his incapacitation or death—and that would be that. Indeed, DC's second Vigilante traveled this basic story arc, but from the standpoint of DC Comics, the valuable property is the Vigilante rather than Adrian Chase. For Marvel, on the other hand, Frank Castle and the Punisher remain coterminous.

David Lieberman's (first) death represents a crucial juncture in the metanarrative. When we first meet Micro, his relationship with Frank Castle is testy but productive. They have a shared set of values and their skill sets are complimentary. When Louis joins their team Micro acts like a proud father. And when Junior dies Micro is thrown off his game. Rather than lending a sympathetic ear, Frank Castle assumes that Micro will be able to carry on as if nothing has happened. As their emotional distance grows, the Punisher becomes increasingly paranoid about his partner's allegiances. This deterioration in his closest relationship mirrors his relationship with the MU writ large. The situation devolves to the point where the

Punisher breaks off the connection entirely. When Micro tries, somewhat clumsily, to steer his friend in a more positive direction, Castle decides that he must put down his former partner. And he would have carried it through were it not for the unexpected intervention of a third party who wants the Punisher dead but takes out Micro instead. Rather than mourning the passing of his friend, Castle revels in it.

Some aspects of this production cycle are unexpected, such as the acknowledgement of the Savings and Loan crisis and the recognition of how difficult it is for the Punisher even to recognize white-collar crime as a problem. Punisher's tone-deaf attitude towards hip-hop, and his over-the-top eco-freak bashing, are amusingly dated. His preoccupation with street crime and the drug trade is intertwined with his political psychology and its connection to the extended urban crisis. Muggers, dealers, and gang bosses represent the character's recurrent fixations from the 1970s to the early twenty-first century.

In the wake of September 11th, the narrative focus shifts to transnational crime networks and religiously motivated terrorists. But before we take up the question of how the character's approach to crime and justice would evolve in the new century, we need to consider the curious phenomenon of the Punisher parody and the ways in which creators grappled with the problem of keeping things fresh as violent crime rates in New York City and elsewhere started to climb down during the second half of the 1990s.

NOTES

1. Ted Lewis, *Get Carter* (London: Allison & Busby, [1970] 1992), 181.
2. See Andrew R. Gertzfeld, "What Would Freud Say? Psychopathology and the Punisher," in Robin S. Rosenberg, ed. *The Psychology of Superheroes: An Unauthorized Exploration* (Dallas: Benbella Books, 2008).
3. The second production cycle dates to 2000–09, when Garth Ennis was the character's main scribe and Steve Dillon his most important penciller. We will return to the Ennis-Dillon cycle in Chapter 6.
4. Zoë Wallin, *Classical Hollywood Film Cycles* (New York: Routledge, 2019), 3.
5. Wallin, *Classical Hollywood Film Cycles*, 5.
6. Carl Potts and Jim Lee, *Punisher War Journal* #1.9 (New York: Marvel, October 1989), 2.
7. Ronald Reagan, "President Reagan's Farewell Address to the Nation — 1/11/89," January 11, 1989, https://www.youtube.com/watch?v=UKVsq2daR8Q. The transcript reads "freedom requires protection," but in the video the President clearly says "production."
8. "My war on drugs is going just fine," Castle snarls at one point. "Thanks for asking." Chuck Dixon and Russ Heath, *The Punisher* #1.89 (New York: Marvel, April 1994), n.p.
9. Ronald Reagan, "Text of President's speech on Drive Against Crime," October 15, 1982, https://www.nytimes.com/1982/10/15/us/text-of-president-s-speech-on-drive-against-crime.html:

> The American people are reasserting certain enduring truths: The belief that right and wrong do matter, that individuals are responsible for their actions, that evil is frequently a conscious choice and that retribution must be swift and sure for those who decide to make a career of preying on the innocent. [...] Can we honestly say that America is a land "with justice for all" if we do not now exert every effort to eliminate this confederation of professional criminals, this dark, evil enemy within?

10. Lee Lescaze, "Reagan Blames Crime on 'Human Predator,'" *Washington Post*, September 29, 1981, https://www.washingtonpost.com/archive/politics/1981/09/29/reagan-blames-crime-on-human-predator/2892636f-d176-48fb-b06b-39012eace1f4/. Reagan added that police chiefs defend "the thin blue line that holds back a jungle which threatens to reclaim this clearing we call civilization."
11. Les Daniels, *Marvel: Five Fabulous Decades of the World's Greatest Comics* (New York: Abrams, 1991), 203.
12. Brian Cronin, "Comic Book Legends Revealed," CBR, February 26, 2009, https://www.cbr.com/comic-book-legends-revealed-196. The limited series was plotted by Steven Grant, written by Steven Grant and Jo Duffy, and penciled by Mike Zeck (1–4) and Mike Vosburg (5).
13. Dugan Trodglen, "Inside the Circle of Blood," *Marvel Spotlight: Punisher Movie (Inside the World of Frank Castle)* (New York: Marvel, 2008), n.p.
14. Trodglen, "Inside the Circle of Blood," n.p.
15. Steven Grant, "War Files," *Punisher Anniversary Magazine* #1 (New York: Marvel, February 1994), 22.
16. Matt Brady, "Punisher Plus 25: Anatomy of a Comic-Book Craze," *Comics Buyer's Guide* 1344, August 20, 1999, 39.
17. Grant, "War Files," 23.
18. Steven Grant and Mike Zeck, *The Punisher: Circle of Blood* (New York: Marvel, 1988), 35.
19. Grant and Zeck, *The Punisher: Circle of Blood*, 43.
20. Grant and Zeck, *The Punisher: Circle of Blood*, 79.
21. Grant and Zeck, *The Punisher: Circle of Blood*, 97.
22. Grant and Zeck, *The Punisher: Circle of Blood*, 117.
23. Grant and Zeck, *The Punisher: Circle of Blood*, 94.
24. Grant and Zeck, *The Punisher: Circle of Blood*, 43.
25. Grant and Zeck, *The Punisher: Circle of Blood*, 55.
26. Grant and Zeck, *The Punisher: Circle of Blood*, 56.
27. Grant, "War Files," 23.
28. Trodglen, "Inside the Circle of Blood," n.p.
29. We will revisit this issue in Chapter 5. Yvonne Tasker, *Spectacular Bodies: Gender, Genre, and the Action Cinema* (New York: Routledge, 1993), 2.
30. Carl Potts, "Forward," *The Punisher: Circle of Blood* (New York: Marvel, 1989), 6.

31. Mike Baron, "Afterword," *The Punisher: Circle of Blood*, 139. Castle is terser: "Don't bother me with rights," he tells two arresting officers. Grant and Zeck, *The Punisher: Circle of Blood*, 99.

32. Jordana Greenblatt, "I for Integrity: (Inter)Subjectivities and Sidekicks in Alan Moore's *V for Vendetta* and Frank Miller's *Batman: The Dark Knight Returns*," *ImageText* 4, no. 3 (2009), http://imagetext.english.ufl.edu/archives/v4_3/greenblatt/.

33. Geoff Klock, *How to Read Superhero Comics and Why* (New York: Continuum, 2002), 3.

34. Greenblatt, "I For Integrity."

35. Mike Baron, "War Files," *Punisher Anniversary Magazine #1* (New York: Marvel, February 1994), 34. One hundred and four issues of the first unlimited series appeared between 1987 and 1995. Baron scripted all but a couple of the first 61 issues. From #62 onwards, the main writers were Chuck Dixon, Steven Grant, and the team of Dan Abnett and Andy Lanning, although Baron scripted #76.

36. Mike Baron and Mark Texeira, *The Punisher* #1.37, n.p. He is shown reading Wilhelm Reich's *Listen, Little Man!* and a Duke Ellington biography, among other titles.

37. Castle's future lovers will include police officers, assassins, hoteliers, Mafia princesses, sex workers, a cultist, a movie star, a Hawaiian goddess (!), the ninja assassin Elektra, and Black Widow.

38. *The Punisher* #2.13 (New York: Marvel, May 1988), n.p.

39. James William Gibson, *Warrior Dreams: Violence and Manhood in Post-Vietnam America* (New York: Hill and Wang, 1994), 62, 32. See also Klaus Theweleit, *Male Fantasies Vols. 1–2* (Minneapolis: University of Minnesota Press, [1977] 1987).

40. George Caragonne and Eric Fein, "The Killing Season!" *The Punisher Holiday Special* #1.2 (New York: Marvel, January 1994), n.p. He adds: "We're linked by the fact that we've both lost our families to the *criminal element*."

41. The most vigorous expression of their friendship can be found in a 1990 graphic novel, in which Castle rescues his confederate from a kidnapper: "The war doesn't allow friendships. Micro is the exception. I couldn't keep his son from getting killed. I'm not letting that happen to Micro." Gregory Wright and Tod Smith, *The Punisher: No Escape* (New York: Marvel, 1990), n.p.

42. Mike Baron and Whilce Portacio, *The Punisher* #1.9 (New York: Marvel, June 1987), 27.

43. 'Punishing Mails', *The Punisher* #1.13 (New York: Marvel, November 1988), 31.

44. The latter is about Jake Gallows, "an entirely different person than Frank Castle." *The Punisher 2099* #1.10 (New York: Marvel, November 1993), 31. Set in the 2099 universe, the first 29 issues of *The Punisher 2099* were scripted by *Judge Dredd* veterans Pat Mills and Tony Skinner (Chuck Dixon penned 30–34). Jake Gallows' goal is to "track down and wipe out all the criminal scum in this city ... no matter how high up they are." Pat Mills, Tony Skinner, and Tom Morgan, *The Punisher 2099* #1.2 (New York: Marvel, March 1993), 14. His world is filled with "anti-grav particle streams," "molecule disintegrators," and "quick spore grenades," and over time the title became even more SF-oriented. As Pat

Mills explained, "the Punisher of today is much more a straightforward vigilante where the emphasis is more on the action rather than the supporting cast." Stephen Vrattos, "Punishing Evolution: Pat Mills and Simon Coleby on the Savage Future," *2099: World of Doom Special* #1 (New York: Marvel, May 1995), 21. Since this study is about Frank Castle, I must relegate Jake Gallows to a lowly footnote. A project for another day, perhaps.

45. In four Summer specials, he catches bank robbers, plays paintball with bullets, and prevents terrorists from killing tourists at Disneyland. In three Back to School specials, he confronts drug dealers, arms merchants, and high-school gangs. And in three Winter Holiday specials, he tutors street criminals, armed Santas, and mobsters who like to party. These gritty titles gave editors a chance to reward established creators with extra assignments as well as to experiment with new teams of writers and artists.

46. The first pin-up page can be found in Chuck Dixon and Tod Smith, *The Punisher* #1.45 (February 1991), 29–30. The first equipment page is Eliot R. Brown, "*Punisher War Journal* Equipment Page," *Punisher War Journal* #1.2 (New York: Marvel, December 1988), n.p.

47. Tim J., "Punisher War Journal Entries," *Punisher War Journal* #1.46 (New York: Marvel, September 1992), n.p.

48. The Statement of Ownership, Management and Circulation published in *The Punisher* #1.34 (June 1990) reports that the "actual number of single issue [sales] nearest to the filing date" was 328,150. In *The Punisher* #1.100 (March 1995), the figure was 135,100. For *Punisher War Journal*, the key figures were 317,625 (May 1990) vs. 41,800 (March 1995). *The Punisher 2099* held on until November 1995: in January 1994, the title's "actual number of single issue [sales] nearest to filing date" was 285,600, but in April 1995 the figure was 59,075.

49. "You call that a knife?," taunts an Aussie villain. "Now *here's* a knife," he says, reprising a famous line from 1986's *Crocodile Dundee*. Mike Baron and Drake Stroman, *The Punisher* #1.24 (New York: Marvel, May 1989), 24.

50. Mike Baron and Bill Reinhold, *The Punisher: Empty Quarter* (New York: Marvel, 1994). He also forges an alliance with a ninja clan known as the Shadowmasters, whose venerable master, Hatsu Yakamoto, invites Castle to help him establish a U.S. branch. "I'm honored, but I'm afraid it's impossible," Castle responds. "I'm an outlaw. I exist outside society." This makes Yakamoto smile. "Quite proper. The great ninja masters have always been outlaws." But the Punisher is unmoved. "Sorry, Mr. Yakamoto. I'm a loner by nature." Mike Baron and Erik Larsen, *The Punisher* #1.24 (New York: Marvel, October 1989), 11. The Shadowmasters feature in *The Punisher* #1.22–1.25, *Punisher War Journal* #1.8–1.9, and in a four-part miniseries, *Shadowmasters* (New York: Marvel, October 1989–January 1990).

51. Mike Baron and Whilce Portacio, *The Punisher* #1.14 (New York: Marvel, December 1988), 8–9. Some readers might assume that the plot borrows from *The Substitute* (1996), a Tom Berenger action movie that spawned three sequels, but the issue came out nearly a decade beforehand.

52. "Boxing's a sport that won't go away no matter how loud and long the liberals bray. It won't go away because it's an essential part of human nature. Men are animals – animals fight." Mike Baron and Erik Larsen, *The Punisher* #1.21 (New York: Marvel, July 1989), 1.

53. "It's obvious to anyone who understands biology that men – and women – were designed to ingest meat." Mike Baron and Mark Texeira, *Punisher War Journal* #1.28 (New York: Marvel, March 1991), n.p. Yet these words are spoken by an agribusiness tycoon who turns out to be a deranged crackhead.

54. "They's lots on death row who should have been sent straight to their reward long ago," a truck stop waitress tells Castle. "I hear that, lady," he responds. Baron and Portacio, *The Punisher* #1.12, 13.

55. Baron and Portacio, *The Punisher* #1.12, 3.

56. Mike Baron and Klaus Janson, *The Punisher* #1.3, 9.

57. Mike Baron and Mark Texiera, *The Punisher* #1.42, 8.

58. Mike Baron and Whilce Portacio, *The Punisher* #1.8 (New York: Marvel, May 1988), 30.

59. Chuck Dixon and Gary Kwapisz, *Punisher War Journal* #1.52 (New York: Marvel, March 1993), n.p.

60. In one Baron story, Castle storms the home of a "perennial right-wing libertarian candidate for president" who has been stockpiling "biological counter-threats." Mike Baron and Neil Hansen, *The Punisher Annual* #3 (New York: Marvel, 1990), 15 and 17.

61. Mike Baron and Mark Texeira, *Punisher War Journal* #1.26 (New York: Marvel, January 1991), n.p.

62. Mike Baron, Carl Potts, and Louis Williams, *The Punisher: The Origin of Microchip* #1 (New York: Marvel, July 1993), n.p.

63. Baron and Portacio, *The Punisher* #1.8, 2.

64. Baron and Hanson, *The Punisher* #1.44, n.p.

65. Baron and Hanson, *The Punisher* #1.44, n.p. As far as I am aware, this is the only reference to Hubert Brooks in the entire corpus.

66. Baron and Hanson, *The Punisher* #1.44, n.p.

67. "Punishing Mails," *The Punisher* #1.49 (New York: Marvel, June 1991), 31.

68. "Punishing Mails," *The Punisher* #1.46, 31.

69. "Punishing Mails," *The Punisher* #1.33 (New York: Marvel, May 1990), 31.

70. "Punishing Mails," *The Punisher* #1.24 (New York: Marvel, October 1989), 30.

71. "Punishing Mails," *The Punisher* #1.38 (New York: Marvel, September 1990), 31.

72. "Punishing Mails," *The Punisher* #1.63 (New York: Marvel, May 1992), n.p.

73. "Punishing Mails," *The Punisher* #1.19 (New York: Marvel, May 1989), 31.

74. Steven S., "Punisher War Journal Entries," *Punisher War Journal* #1.62 (New York: Marvel, January 1994), n.p.

75. Dan Abnett, Andy Lanning, and Dougie Braithewaite, *The Punisher* #1.66 (New York: Marvel, July 1992), n.p. "Eurohit" takes place in *The Punisher* #1.64–70 and *The Punisher Annual* #7 (1994).

76. "Things are looking up for Punisher fans," wrote one reader. "The Eurohit story was absolutely great!" said another. "Keep on putting out action-packed comics and you will always get my business," wrote a reader from Canada. "Eurohit is the best multi-part series in a long time," commented Murad A. "I enjoyed it a lot!" enthused Rick C. "The best comic book in the whole Marvel Universe!" opined David M. Only Ron M. expressed misgivings. "You have battled and creamed drug dealers, drug bosses and drug users," he complained. "Now give me one good reason why you can't fight other criminals such as serial killers, terrorists or thieves?" "Punishing Mails," *The Punisher* #1.74 (New York: Marvel, January 1992), n.p.

77. Dan B., "Punishing Mails," *The Punisher* #1.81 (New York: Marvel, August 1993), n.p. "Now don't get me wrong: killing people is definitely not good, but a comic book isn't for real!" noted Pat F., in "Punisher War Journal Entries," *Punisher War Journal* #1.53 (New York: Marvel, April 1993), n.p.

78. Todd S., "Punishing Mails," *The Punisher* #1.86 (New York: Marvel, January 1994), n.p.

79. Paolo V., "Punishing Mails," *The Punisher* #1.98 (New York: Marvel, January 1995), 31.

80. Mike Gold, "Vigilante Grams," *Vigilante Annual* #2 (New York: DC, 1986), 45.

81. Carl Potts and Jim Lee, *Punisher War Journal* #1.12 (New York: Marvel, December 1989), 12.

82. Mike Baron and Whilce Portacio, *The Punisher* #1.18 (New York: Marvel, April 1989), 31.

83. Jim Starlin and Tom Grindberg, *The Punisher: Ghosts of Innocents*, Book I (New York: Marvel, 1993), n.p.

84. Chuck Dixon and Gary Kwapisz, *Punisher War Journal* #1.61 (New York: Marvel, December 1993), n.p.

85. Steven Grant and Hugh Haynes, *The Punisher* #1.85 (New York: Marvel, December 1993), n.p.

86. "Anything else is surrender. Anything else and you may as well lie down and die." Chuck Dixon and Russ Heath, *The Punisher* #1.92 (New York: Marvel, July 1994), n.p.

87. Chuck Dixon and Rod Whigham, *The Punisher* #1.101 (New York: Marvel, April 1995), 14.

88. "Today I witnessed firsthand the blasphemous outrage of vigilante action," the Congressman states. "Can we hazard a guess as to your primary target?" asks a reporter. "I think we all know who that'll be," he responds. Vigilante Infraction General Interdiction and Limitation (V.I.G.I.L.) is formed shortly thereafter. Dan Abnett, Andy Lamming, and Doug Braithwaite, *The Punisher* #1.72 (New York: Marvel, November 1992), n.p.

89. Dan B., "War Correspondence," *Punisher War Zone* #1.26 (New York: Marvel, April 1994), n.p.

90. "Punisher War Journal Entries," *Punisher War Journal* #1.62 (New York: Marvel, January 1993), n.p.

91. Brian A., "Punishing Mails," *The Punisher* #1.87 (New York: Marvel, February 1993), n.p.

92. This is a garbled reference to the infamous 1957 mob summit that was held in Apalachin, New York.

93. Dixon and Kwapisz, *Punisher War Journal* #1.61, n.p. This is by no means their first argument. In a 1992 story, Castle complains when Micro is unable to pull up a shipping manifest

on his computer. "*You're* such an expert, Frank? *You* do it! What, if you can't go around shooting off your *guns*, you shoot off your *mouth*?" "All right, all right," Castle says. "I'm sorry if I'm annoying sometimes." "Yeah, like when you're *awake*," Micro replies. Peter David and Steven Butler, *Punisher Annual* #5 (1992), n.p.

94. Chuck Dixon and Gary Kwapisz, *Punisher War Journal* #1.63 (New York: Marvel, February 1994), n.p.

95. "Punisher War Journal Entries," *Punisher War Journal* #2.62 (New York: Marvel, January 1994), n.p.

96. "Punisher War Journal Entries," *Punisher War Journal* #1.64 (New York: Marvel, March 1994), n.p.

97. Don Daley, "Punishing Mails," *The Punisher* #1.91 (New York: Marvel, June 1994), n.p.

98. Chuck Dixon and Gary Kwapisz, *Punisher War Journal* #1.64, n.p.

99. Chuck Dixon and Rod Whigham, *The Punisher* #1.98 (New York: Marvel, January 1995), 1.

100. Dixon and Whigham, *The Punisher* #1.97, 11.

101. Chuck Dixon and Rod Whigham, *The Punisher* #1.99 (New York: Marvel, February 1995), 23 and 29.

102. Dixon and Whigham, *The Punisher* #1.99, 30.

103. "Uh-oh!" he blurts. Chuck Dixon and Rod Whigham, *The Punisher* #1.101 (New York: Marvel, April 1995), 28.

104. Chuck Dixon and Douglas T. Wheatley, *Punisher War Journal* #1.79 (June 1995), n.p.

105. Chuck Dixon and John Hebert, *Punisher War Journal* #1.45 (New York: Marvel, August 1992), n.p. Micro lives on in the MAX version of the Punisher, which is outside of official continuity.

106. Readers later find out that Bullseye was responsible for their deaths. "*Why* did I kill them?" he asks. "I knew *you'd* be blamed. Heh!" See John Ostrander and Tom Lyle, *The Punisher* #2.1 (New York: Marvel, November 1995), n.p. The initial, more ambiguous version might have been retconned to make the Punisher seem more heroic.

107. Chuck Dixon and Rod Whigham, *The Punisher* #1.104 (July 1995), n.p.

108. Chuck Dixon and Douglas T. Wheatley, *Punisher War Journal* #1.80 (July 1995), n.p.

109. Untitled editorial comment, *Punisher War Journal* #1.72 (November 1994), n.p. Chuck Dixon, who wrote the first *PWJ* series along with Mike Baron, Steven Grant, and Carl Potts, described the Punisher as "my favorite comic book character of all time." Karl Bollers, "Pro Files: Chuck Dixon," *Punisher Anniversary Magazine* #1 (New York: Marvel, February 1994), 7. Dixon penned most of the *PWZ* stories, with artwork by such luminaries as John Buscema, Joe Kubert, and John Romita, Jr.

110. "Punisher War Journal Entries," *Punisher War Journal* #1.6 (New York: Marvel, June 1989), 33. Readers were divided about Micro. David G. argued that "Micro was there for Frank through thick and thin," and hoped "to see Frank and Micro on speaking terms again," but Dave P. encouraged Marvel to "get rid of Micro, he's annoying." "War Correspondence," *Punisher War Zone* #1.4 (New York: Marvel, June 1992), n.p.

NEGATIVE DIALECTICS

111. Carl Potts, John Wellington, and Jim Lee, *Punisher War Journal* #1.4 (New York: Marvel, March 1989), 18.

112. Carl Potts and Tod Smith, *Punisher War Journal* #1.22 (New York: Marvel, September 1990), 27.

113. Carl Potts and Jim Lee, *Punisher War Journal* #1.17 (New York: Marvel, April 1990), 17.

114. Carl Potts and Jim Lee, *Punisher War Journal* #1.11 (New York: Marvel, November 1989), n.p. As Castle tells a seductive heiress who is "willing to do ... *anything*": "*Grow up*. Stop taking drugs." Pat Mills, Tony Skinner, and Dave Hoover, *The Punisher Annual* #6 (New York: Marvel, 1993), n.p.

115. Chuck Dixon and Gary Kwapisz, *Punisher War Journal* #1.41 (New York: Marvel, April 1991), n.p. "Green Planet" is a dig at Greenpeace.

116. "It could have been good for us," Rose whispers, when she thinks they won't make it out alive. He later tells her, "if I was ever going to settle down and do the middle class trip, it would be with someone like you." "Someone *like* me?" she teases. When last seen together they are heading to Qatar in a jeep. "We can't go on meeting like this," Rose coos. For once, the Punisher seems happy. Baron and Reinhold, *The Punisher: Empty Quarter*, n.p.

117. The other main threat to the world's ecosystems in the Punisherverse is the Architect of Annihilation, a criminal mastermind who uses nefarious acts of industrial sabotage to extort money from large corporations. See "The Jericho Syndrome," *Punisher War Zone* #17–19 (New York: Marvel, July–September 1993).

118. Mike Baron and Ron Wagner, *Punisher War Journal* #1.33 (New York: Marvel, August 1991), n.p.

119. Mike Baron and Mike Harris, *Punisher War Journal* #1.37 (New York: Marvel, December 1991), n.p.

120. André J., "Punisher War Journal Entries," *Punisher War Journal* #1.40 (New York: Marvel, March 1992), n.p.

121. Mike Baron and Neil Hanson, *Punisher War Journal* #1.16 (New York: Marvel, March 1990), 3, 27.

122. Chuck Dixon and Gary Kwapisz, *Punisher War Journal* #1.64 (New York: Marvel, March 1994), n.p.

123. Carl Potts and Tod Smith, *Punisher War Journal* #1.22 (New York: Marvel, September 1990), n.p. Further examples: "Enough of this vacation! Time to get back to New York for a rest," he says, after taking down a cartel amid Mayan ruins; and "New York's going to seem like Disneyland after this trip [to Sarajevo]." See Carl Potts and Tod Smith, *Punisher War Journal* #1.24 (New York: Marvel, November 1990), 30; and Chuck Dixon and Joe Kubert, *Punisher War Zone* #1.36 (New York: Marvel, February 1995), n.p.

124. "The Punisher's Battle Van," *The Punisher Annual* #1 (New York: Marvel, 1988), 55–56.

125. Baron and Texeira, *Punisher War Journal* #1.25, n.p.

126. Chuck Dixon and Ron Wagner, *Punisher War Journal* #1.38 (New York: Marvel, January 1991), n.p.

165

A CULTURAL HISTORY OF THE PUNISHER

127. Chuck Dixon and Gary Kwapisz, *Punisher War Journal* #1.61 (New York: Marvel, December 1993), n.p.

128. Steven Grant, Melvin Rubi, and Frank Percy, *Punisher War Journal* #1.74 (New York: Marvel, January 1995), n.p.

129. Steven Grant and Melvin Rubi, *Punisher War Journal* #1.73 (December 1994), n.p.

130. Steven Grant, Chuck Dixon, and Hugh Haynes, *Punisher War Journal* #1.75 (February 1995), n.p.

131. Grant, Dixon, and Haynes, *Punisher War Journal* #1.75, n.p.

132. Chuck Dixon, Melvin Rubi, and Paul Martin, *Punisher War Journal* #1.78 (May 1995), n.p.

133. Jacob G., "War Correspondence," *Punisher War Zone* #1.29 (New York: Marvel, July 1994), n.p.

134. Jacob G., "War Correspondence," *Punisher War Zone* #1.33 (New York: Marvel, November 1994), n.p.

135. Cindy L., "Punisher War Journal Entries," *Punisher War Journal* #1.75, n.p.

136. Jacob G., "War Correspondence," *Punisher War Zone* #1.33 (New York: Marvel, November 1994), n.p.

137. Skip K., "Punisher War Journal Entries," *Punisher War Journal* #1.4 (New York: Marvel, March 1988), 30.

138. Jon R., "War Correspondence," *Punisher War Zone* #1.24 (New York: Marvel, February 1993), n.p.

139. Shyldon S., *The Punisher* #7.4 (New York: Marvel, June 2009), n.p.

140. Roz L., Chris G., Uncle Elvis, and Don Daley, "Punisher War Journal Entries," *Punisher War Journal* #1.45, n.p.

141. "Welcome ... to the War Zone," *Punisher War Journal* #1.2 (New York: Marvel, April 1992), n.p.

142. http://www.marvunapp.com/Appendix/maxrottw.htm. Max first turns up in *The Punisher* #1.54 (New York: Marvel, November 1991).

143. Eliot R. Brown, untitled editorial comment, *Punisher Armory* #1.7 (New York: Marvel, September 1993), n.p.

144. Bonnie Mann, *Sovereign Masculinity: Gender Lessons From the War on Terror* (New York: Oxford University Press, 2014), 212.

145. Chuck Dixon and Joe Kubert, *Punisher War Zone* #1.36 (New York: Marvel, February 1995), n.p.

146. Chuck Dixon and John Romita, Jr. *Punisher War Zone* #1.1 (New York: Marvel, March 1992), n.p.

147. Ty M., "War Correspondence," *Punisher War Zone* #1.23 (New York: Marvel, January 1994), n.p.

148. Jason H., "War Correspondence," *Punisher War Zone* #1.7 (New York: Marvel, September 1992), n.p.

149. James S., "War Correspondence," *Punisher War Zone* #1.9 (New York: Marvel, November 1992), n.p.

150. Will C., "War Correspondence," *Punisher War Zone* #1.9, n.p.

151. These words are said by Mike "Ice" Philips. "Come down off the hardboiled vet act. We *all* got messed up in that war. Yeah. But some of us got over it and went on." Chuck Dixon and John Buscema, *Punisher War Zone* #1.29 (New York: Marvel, July 1994), n.p.

152. Larry Hama and John Buscema, *Punisher War Zone* #1.23, n.p.

153. Dixon and Kubert, *Punisher War Zone* #1.36, n.p.

154. Steven Grant and John Hebert, *Punisher War Zone* #1.40 (New York: Marvel, June 1995), n.p.

155. Frankie T., "War Correspondence," *Punisher War Zone* #1.14 (New York: Marvel, April 1993), n.p.

156. Victor L., "War Correspondence," *Punisher War Zone* #1.22 (New York: Marvel, December 1993), n.p.

157. Jody H., "War Correspondence," *Punisher War Zone* #1.21 (New York: Marvel, November 1993), n.p.

158. Other examples include Frank Miller and Klaus Janson, *Daredevil and the Punisher: Child's Play* (New York: Marvel, 1988); Carl Potts and Jim Lee, *The Punisher/Wolverine African Saga* (New York: Marvel, 1989); and Carl Potts and Jim Lee, *The Punisher: An Eye for an Eye* (New York: Marvel, 1992).

159. See John Wagner and Phil Gascoine, *The Punisher: Die Hard in the Big Easy* (New York: Marvel, 1992); Alan Grant, John Wagner, and Cam Kennedy, *Punisher: Blood on the Moors* (New York: Marvel, 1991); Chuck Dixon and John Buscema, *The Punisher: A Man Named Frank* (New York: Marvel, 1994); and Don Lomax and Alberto Saichann, *The Punisher Invades The 'Nam* (New York: Marvel, 1994).

160. Chris Henderson and Mike Harris, *Punisher: The Prize* (New York: Marvel, 1990), 62.

161. Jo Duffy and Jorge Zaffino, *The Punisher: Assassin's Guild* (New York: Marvel, 1988); Mike Baron and Bill Reinhold, *The Punisher: Intruder* (New York: Marvel, 1989); and Chuck Dixon and Jorge Zaffino, *The Punisher: Kingdom Gone* (New York: Marvel, 1990).

162. Steven Grant and Mike Zeck, *The Punisher: Return to Big Nothing* (New York: Marvel, 1989).

163. Jim Starlin and Bernie Wrightson, *Punisher P.O.V. Book One: Foresight* (New York: Marvel, 1991).

164. Starlin and Grindberg, *The Punisher: The Ghosts of Innocents*, Book I, n.p.

165. "The truth is those kids are going to be with me for a long time to come." Jim Starlin and Tom Grindberg, *The Punisher: The Ghosts of Innocents*, Book II, n.p.

166. Eliot R. Brown, untitled editorial comment, *Punisher Armory* #1.1 (New York: Marvel, July 1990), n.p.

167. In a 1983 essay on "Masculinity as Spectacle," Steven Neale distinguishes between the "voyeuristic look" and the "fetishistic gaze," which is "captivated by what it sees" and

"has much more to do with the display and the spectacular." Cited in Tom Brown, *Spectacle in "Classical" Cinemas: Musicality and Historicity in the 1930s* (New York: Routledge, 2016), 42.

168. Marvel even planned on issuing a "one-shot spoof of the Punisher's arsenal of destruction," to be titled *Not the Punisher Armory*. "Hey, if you can't make fun of a guy with a grenade launcher and an Uzi, who can you make fun of?," a promotional announcement asked. At the height of his popularity the trigger-happy option remained on the table, even if the project itself never came to fruition. See Jerry A. Novick, "New Year's Revolutions," *Punisher Anniversary Magazine* #1 (New York: Marvel, February 1994), 13.

169. https://www.survivalistboards.com/showthread.php?t=168131.

170. Brown, *Punisher Armory* #1.1, n.p.

171. Eliot R. Brown, untitled editorial comment, *Punisher Armory* #1.5 (New York: Marvel, February 1993), n.p.

172. Eliot R. Brown, untitled editorial comment, *Punisher Armory* #1.8 (New York: Marvel, December 1993), n.p.

173. Eliot R. Brown, untitled editorial comment, *Punisher Armory* #1.9 (New York: Marvel, April 1994), n.p.

174. Warren S., "War Correspondence," *Punisher War Zone* #1.31 (New York: Marvel, September 1994), n.p.

175. Umberto Eco, "The Myth of Superman," in Jeet Heer and Kent Worcester, eds., *Arguing Comics: Literary Masters on a Popular Medium* (Jackson: University Press of Mississippi, [1972] 2004), 153.

176. Marv Wolfman and Keith Pollard, *Vigilante* #5 (New York: DC, April 1984), 4.

177. Marv Wolfman, Keith Pollard, and Pablo Marcos, *Vigilante* #3 (New York: DC, February 1984), 23, 5.

178. Marv Wolfman, "Vigilante Grams," *Vigilante* #2 (New York: DC, January 1984), 24.

179. Wolfman, "Vigilante Grams," *Vigilante* #2, 24.

180. Miranda B., "Vigilante Grams," *Vigilante* #9 (New York: DC, August 1984), 24.

181. Stephen N., "Vigilante Grams," *Vigilante* #28 (New York: DC, April 1986), n.p.

182. Paul F., "Vigilante Grams," *Vigilante* #15 (New York: DC, March 1985), 24.

183. Rick P., "Vigilante Grams," *Vigilante* #9, 25.

184. David W., "Vigilante Grams," *Vigilante* #16 (New York: DC, April 1985), 24.

185. Paul Kupperberg and Tod Smith, *Vigilante* #41 (New York: DC, May 1987), 27.

186. Paul Kupperberg and Steve Erwin, *Vigilante* #50 (New York: DC, February 1988), 3.

187. Kupperberg and Erwin, *Vigilante* #50, 24.

188. Brian Martin, "Who *Were* Those Masked Men? The Vigilante Story," *Back Issue!* 102 (Raleigh: TwoMorrows, February 2018), 34.

5

The Narratological Impasse

He is empty who believes anything is ridiculous other than the bad.

—Plato, *The Republic* (*c*.380 BCE)[1]

Once the Punisher became the go-to vigilante in comics, knock-offs, lampoons, and loose reimaginings followed. The violent antihero construct proved an irresistible target for commentary and appropriation. Other Marvel heroes feared and teased him; competing publishers sniped at and took lessons from him. Both templates are part of this story. The grim iteration spawned imitators and nudged existing characters in a hardboiled direction. The trigger-happy version, on the other hand, provided a sure-fire formula for the satires that accompanied Castle's four-color heyday.

This chapter visits a moment in time—not so long ago but very different from our own—when the spectacle of murderous vigilantism was central to comics discourse. In the wake of *Circle of Blood*, and the success of Mike Baron's unlimited *Punisher* series, the Punisher became influential, controversial, and within the confines of the subculture nearly ubiquitous. Once Marvel realized that it had a hit on its hands, editors and creative teams were encouraged to crank out as much product as the marketplace could handle. Reactions were divided. For many comics fans, Frank Castle was a breath of fresh air. For others, he was hilariously misguided. Some found the character unsettling or offensive, or were puzzled by his popularity. The Punisher gave readers something to argue about. And he gave pros and would-be pros something to make comics about.

Zeitgeist follies

The crime-control archetype was never universally acclaimed. "I have never understood the popularity of the Punisher," complained one fan, whose online handle was *fuzzydice8*. "The Punisher fighting low-life thugs and mob bosses

never appealed to me. Yet the character has garnered movies, multiple series, and during the 1990s was on about as many covers as Wolverine and Spider-Man."[2] In Mark Waid and Alex Ross' *Kingdom Come*, Superman bemoans the proliferation of "self-styled 'heroes' *unwilling* to preserve *life*."[3] One of *Kingdom Come*'s new-gen capes sports a mask composed of human bones—a sly Frank Castle reference. For some, spoofing the criminal killer represented a way of taking aim at the zeitgeist itself. We have already seen how some of Marvel's own writers, such as Bill Mantlo (in *Spectacular Spider-Man* #81–83), pushed the character's tough-on-crime stance to extremes in order to subvert the law-and-order world-view.

Punisher parodies are part of this vigilante-curious conjuncture. Arguably, they constitute a mini-production cycle of their own. These graphic short stories did not always favor the same approach, however. Some of the more obvious satires, such as those that featured the Penalizer (1991) and Big Shot (1994), are acerbic. Others, including tall tales about the Punfisher (1988) and the Retaliator (1991), are plain silly. The most caustic involves an outlandish sociopath named the Persecutor, from Pat Mills and Kevin O'Neill's delightfully mean-spirited *Marshal Law Takes Manhattan* (1989). As these varied examples suggest, the high watermark of the Castle parody broadly corresponds to when Punisher posters were plastered all over the walls of comics shops. Not surprisingly, the quality of these and other parodies is uneven. A few are inspired, and others are lazy. But every parody renders a verdict on the source material.

For some creators and readers, the Punisher has always been *outré*. At first, his battle uniform included white boots and white gloves—hardly ideal for night work—and in his inaugural appearance, he takes his marching orders from a crazed manimal. His political philosophy places an inordinate weight on the quality of his own judgment and the efficacy of mass murder. His behavior is often reckless and sometimes suicidal. It is little wonder that other costumed heroes diss him. "Who's the broad with the *mouth*?," he whines when he first meets Dakota North, the private investigator. "Name's *North*—Dakota North," she sasses. "What's *yours*? The skull-chested *goofball*?," Dakota then wonders whether "the size of one's gun relates directly to the size of one's—muscles?" "If you don't quit running your mouth," Castle retorts, "I might have to put you over my knee to teach the kids a lesson about wising [sic] off to their elders." "Promises, promises!," she teases.[4]

The fact that the Punisher can be made fun of does not mean that everything he does is funny. In a 2013 story by Marc Guggenheim, Castle executes an emaciated junkie as part of a crackdown on drugs in lower Manhattan. A bystander reports:

> He was chokin' this poor woman, chokin' the life outta her. Her mouth was open, gaspin', and he was putting a gun in it. And he said—he said, "I'm sorry about this. I really am." Then he shot her.[5]

This scene—and there are others like it—is morbid and admonitory rather than comedic or sardonic. But the "hard-boiled pulp fiction for the masses"[6] iteration is no more or less authentic than the teasing version. In this context, it is telling that *Strange Tales* (2010), an offbeat anthology that showcases "the heroes and villains of the Marvel Universe as you've never seen them before,"[7] includes two very different versions of the same Frank Castle. Jonathan Jay Lee's mangaesque story concludes with Castle heroically drenched in blood, whereas Johnny Ryan's cartoony strip has Castle draw a gun on a teenager who would rather play video games than finish his homework.[8] The first story is grim; the second is trigger-happy. *Strange Tales* includes multiple appearances by several of Marvel's biggest names, but only the Punisher is presented in such dramatically divergent ways. Some creators and readers remain thrilled by Castle's assuredness. Others find it ridiculous.

That the brand went through a rough patch after the Punisher's self-destructive nature was exposed is suggestive of a kind of narratological impasse. Throughout the first production cycle, his writers and editors latched onto the notion that Castle's campaign carries with it the seeds of its own destruction. This frank acknowledgement had a destabilizing impact on the stories that followed. The shifting politics of representations of crime and policing in the wake of declining crime rates further contributed to this impasse, as did the industry's tendency towards overproduction. As the cartoonist Fred Hembeck suggests in a 1999 comic strip, the Punisher "suffered from overkill." The strip depicts Hembeck and Castle deep in conversation:

> Hembeck: "Face it—back in the eighties you suffered from overkill—both literally and figuratively. Why else would you've been co-starring with Archie, fer gawrsh sakes?? Guns a-blazing, you were killing everyone in sight, while the Marvel execs, spin-offs and crossovers piling ever on, finally wound up killing you, their golden goose."
> Punisher: "... Dolph Lundgren didn't help ..."
> Hembeck: "No, he didn't, but remember this: Matt Salinger didn't put the kibosh on Captain America's career.[9] Face it, Frank, you're just not a franchise character! You need to be used sparingly to be effective."[10]

The veteran writer Joe Quesada similarly argues that the Punisher

> was not a character that deserved eight (or however many he had) monthly titles [...] Some were good, some were not so good, but it's tough to dredge up that much material from one character who in essence was just a vigilante with no super-powers.

"By the mid-'90s," Quesada adds, "Punisher stories seemed to be as weary and confused as the character himself."[11] This crisis of overproduction helps explain why the second half of the 1990s is the least compelling segment of the character's recorded history. It took time for the creative workforce to figure out how to handle a murderous vigilante in an era when crime stats were no longer front-page news. The company had overplayed its hand so far as its hardboiled product line was concerned. If violent crime in New York City had still been rising, of course, the overexploitation of the character would not have been quite as problematic.

"Sparingly" has never been part of Marvel's vocabulary, of course. Punisher comics continued to pour out of the House of Ideas even after Marvel and its competitors had exenterated the character's shoot-first ethos. Rather than knocking the character off his stride, the parody wave confirmed the brand's power. The homages and rip-offs underscored the idea that Frank Castle was worth taking seriously and provided opportunities for writers and artists to weigh in on his antisocial campaign. Repetitive vigilante burlesque extended the parameters of the character's justice discourse and confirmed the Punisher's status as a major league player.

Parody has been defined by the literary historian Linda Hutcheon as "a form of repetition with ironic critical distance, marking difference rather than similarity." Because "parody always implicitly reinforces even as it ironically debunks, it will always be ideologically suspect,"[12] she says. If, as Hutcheon argues, parody offers "a method of inscribing continuity while permitting critical distance," then there is a "tension between the potentially conservative effect of repetition and the potentially revolutionary impact of difference."[13] The ironic ambivalence that Hutcheon sees as a hallmark of a "pervasively parodic culture"[14] is a key aspect of the material under review, as is the tension between repetition and distance. Punisher parodies handle this tension in various ways. Sillier efforts emphasize continuity and repetition; antagonistic ones are marked by a greater sense of critical distance.

Cake out of crumbs

In the land of the web-spinner, everything Castle does has a comical quality. In *The Amazing Spider-Man* #353 (1991), the Punisher pins a hippie against a wall and yells, "Now talk to me!" "Unk! Easy, Man! I don't know nothing!" "By using that double negative," Castle says, "you're saying you do know something. Something new about the Secret Empire for instance?" "Secret umpire? Hey, man, I ain't no baseball fan!" "There's that pesky double negative again!" He smacks the guy and warns, "watch those double negatives in the future!"[15] A grammar-fixated Punisher is precisely the sort of incongruity that Peter Parker always finds amusing.

It is difficult to think of another prominent costumed hero who generates quite as much mockery from his own cultural brethren.

Another ready source of Marvel humor is the fear and anxiety that the Punisher inspires. In *Agent X*, the eponymous hero freezes when he meets Castle. "I'm a bleeder, and this is such a nice carpet," he pleads.[16] In *Ant-Man*, a group of costumed villains solemnly agree that "the only thing scarier than the Punisher' is "the I.R.S."[17] The character's moral rigidity offers an amusing contrast with the palaver of others. And his *nom de guerre* presents opportunities for badinage, with one villain referring to Castle as "the Excruciator."[18] But not everyone is afraid of Frank Castle. In 1990, Castle is kissed on the lips by a "little green man—with a pointed head" who is grateful for the opportunity to watch a gun battle. An alien shapeshifter known as the "Impossible Man" tosses whipped cream pies at the Punisher when he responds to the unwanted kiss with gunfire. "I can't believe my eyes!," Castle complains. "Little green men from Mars are the stuff of funny books! Kid stuff that has no place in the real world!"[19]

The first Punisher parody dates to the character's formative years. In a memorable Howard the Duck story from 1976, Steve Gerber introduces a vigilante named Fred Hovel, aka the Spanker. ("Fred," of course, sounds a lot like "Frank." A "hovel" is the opposite of a castle. Spanking is a form of punishment.) Fred Hovel is the "former headmaster of an exclusive private *prep* school" who was "wrenched from my position for administering excessive *corporal punishment*." When we first meet him, the Spanker is hanging out in Central Park with a group of costumed misfits known as the Band of the Bland. As uniformed police officers attempt to arrest the group for roasting marshmallows over an open fire, the Spanker assaults one of the officers with a ping pong paddle. Whacking the man's rear end, he tells him, "I learned that if justice is to triumph—a man must sometimes take the law into his own hands and over his *knee*!"[20] Gerber's point about the control freakery of the hardboiled vigilante presumably reflects how many creators in and around Marvel regarded the Punisher in the period before *Circle of Blood*.

Damage Control offers an equally sarcastic take. Castle convinces himself that "the Marvel Universe's No. 1 Cleanup Crew"[21] is in cahoots with Wilson Fisk.[22] His "stealth and reconnaissance" mission goes haywire, however, when he blasts a hole in Damage Control's ceiling and no one in the office reacts. "Is this some kind of joke?," Castle wonders.[23] He later shows up at the home of Damage Control's Director of Operations, as he is certain that she is the link between Damage Control and organized crime. He calmly explains, "I'm going to kill you, then work my way up the ladder, until either I'm killed or everyone else in the Kingpin's organization is dead." "Listen to me, Frank. You need *help* ..." she

responds. Finally convinced that the well-intentioned Ms. Chapel is not working for Fisk, he says to himself, "I'm glad she was telling me the truth. I wouldn't have enjoyed killing her."[24] Here the Punisher is daffy but monstrous.

The Punisher *What If...?* Stories are similarly off-the-wall.[25] In "What If the Punisher Didn't Use Guns?," he firmly tells a terrorist, "An' no TV for a week!" In "What If the Punisher was a Stern but Fatherly Type?," Castle sends Doctor Doom to the corner and says, "You're going to stay right there and *think* about what you've *done* until I *tell* you you can move!" And in "What If the Punisher Was a Hall Monitor?," he threatens elementary school kids with his "field-grade Casull .454 revolver!"[26]

In the best of these stories, "What if Frank Castle Was a Bleeding Heart?," our hero is a tone-deaf mansplainer who claims that "'criminal' is such an emotional label and only engenders a negative response from society." When he tries to prevent a mugging by pointing out that "ninety percent of America's wealth is owned by the top one percent of the population," the muggers shoot him. As he bleeds out, Woke Punisher moans, "Bullets tearing—knife through hot butter—some people can't even afford butter—have to settle for spread."[27]

Crazier still is Marvel's Frank Carple, aka the Punfisher, and Frank Casket, aka the Pulverizer. The Punfisher is a talking shark who teams up with Spider-Ham to defeat Doctor Octopussycats' plot to seize control of New York City's plumbing services.[28] The Pulverizer offers another unsubtle swipe at hardboiled vigilantism. Having once worked as a veterinarian in Vietnam, where he heals "tigers, vipers, and water buffalos," the Pulverizer returns to the United States and decides that "crime would stop if he could kill all the criminals." His best friend is Nacho-chip, and he can survive being sliced in half. His arsenal consists of anti-tank missiles, a portable ICBM, a pizza cutter, and "good guy bullets that don't miss their intended targets."[29] Many readers would have appreciated that "good guy bullets" is a veiled reference to the mercy bullets that were so incongruent with the Punisher's angry man praxis.

In John Layman and Fabiano Neves' *Marvel Zombies Vs. Army of Darkness* (2007), the artwork is grimier but the sense of ironic detachment remains undiminished. In this gory miniseries, Castle and the rest of the Marvel Universe confront an undead invasion. When Ash Williams from the *Evil Dead* movies asks for Castle's assistance in tracking down the "Sumerian Book of the Dead—the *Necronomicon*," the Punisher insists on first killing Wilson Fisk, Hammerhead, and other prominent supervillains. "Are you supposed to be one of the *good* guys [...] or *what*?," Ash naively asks. "*Exactly*," the Punisher helpfully replies. Castle's weapons prove more effective against familiar baddies than against the Deadite menace, however. Within a few panels, the champion of the impromptu death penalty has been turned into an entrée for the newly undead.[30] Deadites and

zombies vs. Frank Castle: the evil dead vs. the dead man walking.[31] The sense of critical distance is palpable.

Punisher parodies even turned up in the pages of his own gritty titles. In a Mike Baron-scripted issue of *Punisher War Journal*, Castle meets his B-movie doppelganger, the Retaliator, whose idiotic catchphrase is "Retaliation is Mine!" Needless to say, Castle is not impressed.[32]

Pulled the trigger

Some of the parodies issued by rival companies are similar in tone to the light-hearted approach taken by *Damage Control* and *What If...?* Others are more in keeping with the version of the Punisher presented in *Marvel Zombies Vs. Army of Darkness*—unhinged, un-self-aware, and ultraviolent. DC Comics, Marvel's perennial rival, has published both varieties. A magnificent example of the former is Grant Morrison's Beard Hunter. Ernest Franklin was born with "a hormone deficiency that prevented him from growing a beard." This naturally compels him to launch a one-man war on men with facial hair. The Beard Hunter lurks on rooftops, favors guns over fisticuffs, and keeps a war diary.[33] Morrison presumably had someone in mind when he came up with the character.

Less preposterous perhaps is the aptly named Jon Payne—a Vietnam veteran who was experimented on by the CIA and who unleashes his anger at longhairs and foreign-built automobiles. Even as Batman attempts to reason with Payne, a government assassin guns him down. While the story calls out Payne's nativism, it turns out that the real problem is the deep state. "You make me *sick*!," Batman exclaims to an intelligence officer. "You called him the *Ugly American*, but the truth is, you and your goons are the *real* ugly Americans!"[34] As in *Punisher and Captain America: Blood and Glory*, right-wing characters can be treated with a measure of sympathy in stories that tilt in a leftist direction.

Another right-leaning antihero is the Penalizer, who appears in several issues of DC's *Animal Man*. The Penalizer is the hawkish hero of the eponymous comic book that is the favorite reading material of Animal Man's son, Cliff. While sweet-natured Buddy Baker uses his animal-based powers to defend the natural world, his son prefers reading about the adventures of a military veteran whose targets include "junkies, space-heads, rat-boys, psychos, suzzbags, creeps, swacks, rapers, hairbags, kleptos, mustard chuckers, spazoids n' morf zombies."[35] When Cliff's mom lands a job as a colorist on her son's favorite comic, she learns just how jingoistic and violent *The Penalizer* can be. She is similarly creeped out by her boss, Don Daley stand-in Les Daniels, who tells her that "I'm in charge of a line of kid comics ... I mean *real* mean 'n' tasty *comic books* ... for real *kids*."[36] Daniels

himself maintains a side gig as a vigilante, which lends these stories an extra layer of meta. DC's editorial staff may have felt that their company was above publishing titles like *Punisher Armory*, and perhaps not without justification.

Smaller companies cashed in on the parody trend. There were short-lived outlets that published nothing *but* superhero parodies. Parody Press, for example, issued a black-and-white anthology called *The Pummeler* (1992). As a promotional flyer promised, "Once you've read *The Pummeler*, you'll have a trigger happy day!"[37] The issue is overly reliant on puns but offers a fully realized satire, and features cover art by Sam Kieth (Figure 5.1) and back cover art by Ty Templeton. The inside pages feature graphic short stories, plus comic strip parodies with titles like *Castle and Mobbes*, *The Family Slaughter*, and *The War Side* (aka *Calvin and Hobbes*, *The Family Circus*, and *The Far Side*). The Pummeler's costume is identical to Castle's, except for the fact that his chevron has a smiley face and in some stories he wears a diaper.

The main story, by the prolific Mike Baron, opens with the Pummeler taking on drug dealers, street vendors, and Phil Donahue. Reminding Phrank that, "You declared war on criminals, not liberal talk show hosts," Vanilla Chip drives his friend to a mob hangout where a Rabbi plots to take over the East Coast rackets. "Hold it!" interjects an official from the Comics Code Authority. "You can't have a Rabbi who's a gangster!" Villains "must be white, upper middle class, heterosexual, male managerial types." Both conservatives and liberals are lambasted in this period piece, which is capably rendered by the storyboard artist Sam Agro.[38]

Less coherent is Spoof Comics' *The Punish-Her Score Journal* (1993). David Johnson's cover is competent, but the script and interior art are a mess. Frankie Tower, aka the Punish-Her, is "the great equalizer in a world run by those who have more than everybody else." She foils a plot by the evil Micro-Dot to slip hallucinogens into beauty products but spends most of her time punching and kickboxing her way through poorly drawn approximations of NYC. In the final panel, she plays a video game in cutoffs and a brassiere. Her closing line has a Mickey Spillane ring to it: "Killkillkillkillkillkillkill."[39] Another "prize turkey"[40] is *Reagan's Raiders* (1986), three issues of which were released by the short-lived, Brooklyn-based Solson Publishers. "It's time to party!" cries the 39th President, as he leaps from a helicopter garbed in star spangles and a Rambo-style bandana.[41] Action movie heroics and comic book tropes are the targets rather than the Punisher *per se*, but leaping out of helicopters seems like something that a hardened vigilante might try, not the President of the United States.

Frank Castle is more directly lampooned in the beloved animated series *The Tick* (1994–96), which features a secondary character named Big Shot whose costume, mission, and weaponry closely match the Punisher's. In his inaugural appearance, Big Shot "fires upon nearby structures (such as chimneys) and reduces

THE NARRATOLOGICAL IMPASSE

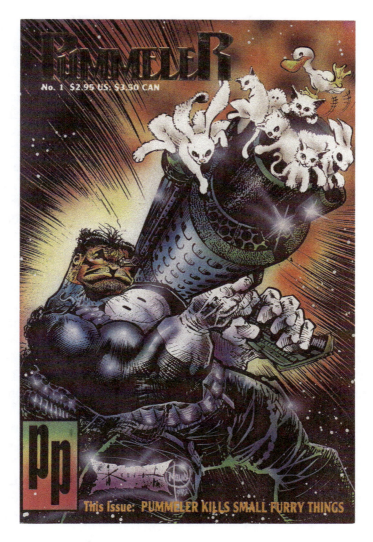

FIGURE 5.1: Sam Kieth, *The Pummeler* #1, cover illustration, 1992. © Parody Press.

them to skull-shaped sculptures resembling the Punisher's skull emblem." Following this problematic workplace event, Big Shot is asked to work with an anger management therapist who helps him learn to be more sensitive to the needs and feelings of others around him. "Far more stable, he is now unable to say the word "guns" without stammering and twitching."[42] Clearly, Big Shot is not the hero that he imagines himself to be. The same may be said of Bob Violence, an "ultraviolent holographic vigilante" who stars in an animated television series that is depicted in

the pages of Howard Chaykin's *American Flagg!* (1983–89). Each week, Bob "is blown to smithereens" only to return the following week "without a scratch."[43] Another animated parody is "The Pun-isher," who tells one lawbreaker that crime is "no way to get ahead" as he decapitates the poor goon.[44] The "Pun-isher" presents a rare example of an antihero parody that dates to the current century.

An unusually biting satire can be found in Pat Mills and Kevin O'Neill's *Marshal Law*.[45] "After the Big One destroyed San Francisco," the city of San Futuro became home to hundreds of genetically modified soldiers. "Crazed by war and their strange powers," the narrator explains, "many were totally out of control. Somebody had to deal with them." San Futuro's Police Department recruits the most moralistic of these individuals, Marshal Law, to keep the peace. "He costs a *fraction* of the price of *really* policing the inner city, and reassures the public something's being done."[46] As Kiernan Cashell and John Scaggs note, the series exhibits an "implacably negative attitude towards the genre," which reflects the fact that "for the creators of *Marshal Law* a critique of the superhero necessarily involves a political critique of American society."[47] Or as Mills himself admits in his 2017 memoir, "Any reader of *Marshal Law* knows my feeling on these wretched Corporate Gods. They represent and promote establishment values I despise."[48]

In *Marshal Law Takes Manhattan*, the Marshal learns that his nemesis, the Persecutor, is seeking asylum in a facility for disturbed super soldiers. The Persecutor is a former CIA officer who once trained South American police officers in the fine arts of torture. After gunmen killed his family, he "developed a persecution complex … that terrorists … subversives … mobsters … were out to destroy an America as innocent as he."[49] But the inmates reject his application on the grounds that, like Frank Castle, the Persecutor lacks special powers. "I wouldn't call having a bow a superpower," the armed vigilante retorts, pointing to an ersatz Hawkeye. "We've tightened up the rules since we let our archery friend in," explains the Reed Richards look alike. "I'm a *serial killer*! Isn't that good enough for you?!" the Persecutor pleads.[50] An impressive amount of MU history is squeezed into Mills' savage, revisionist script.

Frustrated by his inability to gain access to the facility, the Persecutor complains that they "sound like *bleeding heart liberals*." "Men are animals," he says. 'Killing is beautiful!" The inmates reluctantly rally around him when their common enemy, Marshal Law, arrives on the scene. "Okay, assholes—*assemble*!" Marshal Law taunts. "Such a carnival of *empty* … Such a pageant of *non-entities* … So many exotic variations on *nothing*," he adds, in what is possibly the most abrasive description of the Marvel line-up ever committed to print.[51] The Marshal handcuffs the Persecutor and dumps him at a cannibal encampment. "I promise I won't let the liberals make me feel guilty about it," he teases. As the Persecutor roasts on

THE NARRATOLOGICAL IMPASSE

a spit fueled by San Futuro's version of the Human Torch, the Torch screeches, "No! You mustn't abuse my powers like this!"[52]

The skewering of the Punisher and other costumed heroes in Mills and O'Neill's pages makes other parodies seem repetitive and complacent by comparison. There is a spirit of what can only be described as vengeance—directed not only against Frank Castle but against the entire genre—in their work that is quite unlike anything that we have encountered so far. Just what would be a truly mean-spirited use of powers like those possessed by the Human Torch? Turning other heroes into cooked food, of course. This is a parody that takes on the audience as well as the character(s). Most of the parodies are mere time capsules. *Marshal Law Takes Manhattan* retains its sting.

But while Mills and O'Neill's graphic novel is delightfully over the top, it cannot be described as profound. As it happens, the most thought-provoking dissection of the comics vigilante is rarely recognized as such: Dan Clowes' *The Death-Ray*, which appeared in comic book form in 2004 and as a graphic novel in 2011. It postdates the parody trend but takes inspiration from it. As in the case of *Marshall Law Takes Manhattan*, *The Death-Ray* chides rather than celebrates men's adventure tropes. But whereas Mills and O'Neill are scathing in their treatment of costumed crusaders, Clowes is ruminative. He leaves room for the reader to make up his or her own mind about the story and its players, offering no fewer than three possible endings for readers to choose from. Working on the cultural history of the Punisher has given me an even greater appreciation for Clowes' dry commentary than I had when I first picked it up at Big Apple Comics.

The Death-Ray tells the unlikely tale of a high school student named Andy who tries a cigarette for the first time and discovers that he has acquired superhuman strength as a result of "some kind of experimental hormone thing" that his deceased father "treated him with." Spurred on by his friend Louie, Andy dons a homemade costume and hunts for criminals. "I feel I have to do my part," Andy explains, "to help out humanity, or at least the good, decent members of society."

Andy then learns that his father has also gifted him a magical death-ray that can make any object disappear. This grants him more power than he can handle. By the third act, Andy has trained his zap gun on a succession of marginal individuals, from adulterers and litterbugs to bullies and pot dealers. He also zaps Louie, who is a bit of a know-it-all but is also a protective friend. There is a great deal of loneliness in these pages, and unarticulated feelings, as well as mind games, power trips, and casual racism. As the story progresses, Andy becomes more self-confident and much more powerful, but he does not become any wiser. Vigilante parodies are rarely this tragic.

All three of the story endings that Clowes supplies are baleful. In the first, Andy "zaps everyone in the world." The empty panel implies that his last act was to

179

zap himself. In the second, he "turns the gun on himself" but allows the rest of humanity to carry on. And in the final ending he endures a lonely existence; killing a few people with his ray-gun but not very many. None of these resolutions can be described as optimistic, but each has its counterpart in the Punisher corpus.[53] While the back cover promises a thrilling yarn about a masked vigilante who "stalks city streets and school hallways, wielding nicotine-fueled superpowers in defense of the righteous," both the artwork and storyline are pointedly drab and depressing. While *The Death-Ray* is replete with ambiguity, Clowes' overarching point is unambiguous: murderous costumed heroism is not all that it is cracked up to be.[54]

The Pummeler, the Punish-Her, the Penalizer, the Persecutor, the Retaliator, the Pun-isher, and similar characters epitomize parody-as-ridicule. Each of these parodies takes the trigger-happy version of the character and turns up the dial just about as far as it will go. As Hutcheon suggests, to some extent parodies of this type also challenge "the very idea of ownership."[55] Marvel may not have been pleased at how much their intellectual property made for other publishers. For the creators of these parodies, the Punisher is a story box from which one can borrow catchphrases, costume designs, character traits, plot points, and so on. Yet none of the resulting efforts cuts very deep, *The Death-Ray* excepted. Whereas most parodies ironize the central character as either witless or melodramatic or both, Clowes treats costumed vigilantism as a miserable form of self-alienation. His approach captures the antisocial aspect of the crime-control construct and the heavy toll that a prolonged campaign of retributive violence would exact on friends, families, and the community at large. As the cultural theorist Jean Baudrillard once noted, "it is dangerous to unmask images, since they dissimulate the fact that there is nothing behind them."[56] A few Punisher parodies hint at this but most take the construct for granted.

For heaven's sake

In the 1980s and 1990s, there was an explosive growth in the ranks of comic book antiheroes who emulated rather than laughed at the Punisher. Establishing a causal link between Frank Castle and other antiheroes can be difficult, but the proliferation of amoral headbangers in the wake of *Circle of Blood* is striking.

Examples of established characters who became significantly less inhibited over time about deploying lethal means include Deadshot (1950), a DC character whose 1988 limited series includes a scene where a pedophile's plea, "I need ... help!!!" is met with "You need a grave;"[57] the Peacemaker (1966), a Charlton Comics character whose 1988 DC miniseries features such lines as, "I'm *Peacemaker* ... and I'll kill to keep the peace!";[58] and Marvel's Scourge (1985), who targets

supervillains.[59] DC's Slade Wilson, aka Deathstroke the Terminator, is a mercenary for hire who was first introduced in 1980 and who gained his own series a decade later. According to one source, "the success of the Punisher" explains DC's decision to green-light a standalone Deathstroke series.[60] DC's Huntress offers another twist on this theme of retributive escalation: Helena Wayne was far less violent than Helena Bertinelli, the second Huntress, who inherited her costume, but not her personality or backstory. There is also First Comics' Jon Sable, who was introduced to readers in 1983. His publisher described him as the "first of the new breed of heroes," despite the fact that both Castle and Wolverine preceded Sable by nearly a decade.[61]

Another antihero who shot from tame to terrifying is Foolkiller (1973). The first two Foolkiller iterations were comical, while recent versions employ "tried and true methods for achieving the zen of slaughter."[62] The first Foolkiller refers to his "sacred *crusade*"[63] as he hunts down industrialist F. A. Schist (which is another way of spelling "fascist"). After accusing Schist of having "only *contempt* for the Lord—you *desecrate* his works by draining this *swamp*," the entrepreneur retorts, "Cripes—they guy's an ecology nut *and* a religious fanatic! I can't *take* it."[64] This Foolkiller accidentally kills himself in a later issue when his "purification ray" unleashes "jagged shards of inch-thick plexiglass," one of which gets lodged "deep in his heart."

More recent Foolkillers commit acts of violence that would have been inconceivable in an earlier era. The miniseries *Fool's Paradise* (2008), features gang rape, mass hangings, and severed body parts. "The more blood I let," this Foolkiller admits, "something funny started to happen. I started to like it."[65] In *White Angels* (2009), the character joins forces with the Punisher. "He's everything I've heard he is," he swoons. "Colder than a dying breath."[66] Writer Gregg Hurwitz describes Foolkiller as a

> flawed man who wants to rid society of the evil—of the fool—that lies within [...] What Garth Ennis has done with Frank Castle really is what made me realize what comic books could do. The Foolkiller is obviously different in a number of ways from the Punisher, but he's also perhaps the closest thing the Marvel Universe has to him.[67]

More recently, Max Bemis' 2017 miniseries pits tough guy Kurt Gerhardt against combustible Greg Salinger, who proves that a ready willingness to kill trumps musculature. "'Frank Castle and his kind really make this seem easy', Salinger thinks to himself. 'You see him at work and it's like he's doing math homework.'"[68]

The new wave of antiheroes who arrived after *Circle of Blood* included Dark Horse's The American (1987), "a one-man army standing tall for Freedom, Justice, and the American Way";[69] Marvel's Mark Hazzard (1987), a Vietnam vet who

"hated what his country had turned into" while he was serving overseas;[70] DC's Wild Dog (1987), a "gun-toting nut-job"[71]; Marvel's Cardiac (1988), a surgeon who "set out to avenge the deaths of innocents at the hands of individuals who were untouchable by the law";[72] Marvel's Savage Steel (1991), a battle suit based on Stark Enterprises tech that allows New York Police Department officers to permanently erase criminals—"a Punisher who's *controlled* by *cops*";[73] Image's SuperPatriot (1992), the "ultimate killing machine";[74] Dark Horse's Enemy (1994), "the last patriot";[75] and Image's the Crush (1996), therapist by day and vigilante by night.[76] Punisher scribes even worked on these competing titles. Steven Grant was Enemy's creator, while Mike Baron came up with the Crush.

The growing popularity of the hardboiled construct in this period, and its impact on existing characters as well as new ones, reflected above all else the shifting tides of political ideology. Antiheroes like Wild Dog, Cardiac, and the Scourge registered the pro-death penalty, law-and-order beliefs and feelings that were motivating millions of people in an era of deindustrialization, steepening crime rates, liberal paralysis, and emboldened revanchism. Yet the politics of the urban crisis left its mark on comic book storytelling long after crime rates started climbing back down. Crime and justice narratives not only allowed readers to interrogate and process events that were taking place around them but past and possible future events as well. Yet it would be a mistake to assume that vigilante entertainment points in a single direction. The fact that the embittered version of the genre was shaped by wider debates does not mean that stories about justice and vigilantism offered identical arguments. A comparison of the two most famous graphic novels of the 1980s—*Dark Knight Returns* and *Watchmen*—underscores this point.

While Frank Miller's *Dark Knight Returns* suggests that lawless Gotham will always need a Batman, Alan Moore's equally influential *Watchmen* raises pointed objections to the psychology and social consequences of costumed adventurers. *Dark Knight Returns* is unequivocal in its treatment of Batman as the story's true hero, whereas Moore deconstructs his characters and asks *quis custodiet ipsos custodes* ("who watches the watchmen"), a phrase taken from Juvenal, the second-century poet. Despite their differences, these landmark works are often discussed in tandem and have come to serve as signifiers of a shift towards "mature" and "adult" modes of storytelling in comics. Within the confines of the superhero genre, both graphic novels advanced the case for a greater sense of seriousness and self-awareness on the part of creators and readers while at the same time eschewing any sense of literary realism. The main characters still wear capes and talk and act in ways that build on generic tropes. What makes these works of interest from the standpoint of this study is the fact that Miller and Moore use the superhero genre to confront questions of crime and politics.

Punisher stories intersect with both approaches. There are similarities between Miller's take on Bruce Wayne and Steven Grant's take on Frank Castle, in that they both tell stories about brooding melancholics who have been traumatized by violence against their families and who are compelled to do good for reasons of political psychology. Writers of Punisher stories are obliged to assume that the social fabric is torn and that the supply of vicious criminals is bottomless, which is also a hallmark of Batman's storyverse. But for Miller and Grant the connection is closer, in that their heroes operate in environments in which elites are malevolent and allies are hard to find or trust.

Castle combines aspects of two of *Watchmen*'s most flawed characters—the bravado and physical mass of Moore's Comedian, and Rorschach's obsessive-compulsive rage. The overlap between the three characters is considerable. Alan Moore derived the Comedian from Charlton Comics' Peacemaker, who predates the Punisher but whose development has subsequently been shaped by the Punisher's commercial success. And Moore based Rorschach on Steve Ditko's Mr. A and the Question, two of Castle's ancestors.[77] Rorschach, the Comedian, Peacemaker and Castle are indicators of the poor health of the social order: judgmental, implacable, and hopelessly self-destructive.

Hero is exposed

Some Punisher tales are misfires—an apt term given the character's preoccupation with firearms. Over the years the character has endured a fair share of storylines that are misconceived or even cringeworthy.[78] A notorious example is Mike Baron's multipart story from 1991-1992, "Final Days," in which Castle undergoes reconstructive surgery, "so my best friend wouldn't know me." His doctor, a delicensed physician turned "hooker with a habit,"[79] uses her knowledge of "tissue regeneration and melanin" to transform Castle into an African-American. "You *said* you didn't want anyone to recognize you," she quips.[80] Both the doctor and the Punisher—and perhaps the creators—somehow assume that a short medical procedure can recast a person's social identity.

On the run from Wilson Fisk, Blackface Castle heads for Chicago. After driving nineteen hours he falls asleep at the wheel and attracts unwanted attention from state troopers. "What you doing in this fine car, boy?," asks one of the deputies. "I had no patience for bigots when I was white," Castle thinks to himself. "Now that I'm black I don't like it any better." Before the troopers can give him a beatdown, Luke Cage shows up and the odds shift in their favor. They then join forces to take down a local gang led by a Machiavellian yuppie. For Cage, cleaning up the neighborhood is "about self-respect," notes Castle. "For me it's simpler. *Life* and

death." Cage insists on using fists rather than guns even as Castle posits there is "only one best, *final* cure."[81] Their alliance unravels when Castle's skin fades back "to white, leaving me to explain to Cage, and this neighborhood, why I've been masquerading as black." Cage tells him, "So you're the Punisher. Nice disguise, till you lost your tan." "Had *you* fooled," Castle snarls, as he walks out the door.[82]

This *Black Like Me* pastiche is not only clumsy but minstrelsy. Presumably, it started out as an effort to elevate the Punisher's—and the reader's—awareness of the power of racialized categories. But the result lacked not only good taste but plausibility. The idea that a middle-aged Italian American could present himself as African-American after an improvised medical procedure speaks to a kind of carelessness about lived experience that the internet will be mocking for years to come.[83] Marvel evidently grasped it had a public relations snafu on its hands since, starting with the second issue, "black writer (and then-Marvel staffer) Marc McLaurin was brought in to handle all the African-American dialogue."[84] According to one cultural journalist, "it's still a mystery as to where the [initial] idea came from," especially since Baron himself has always claimed that he was "just following orders."[85]

Miscalculations on this scale were unknown before the mid 1990s, but routine during the decade's second half. In the late 1990s, readers were presented with one credulity-stretching storyline after another. Costume heroism has a hallucinatory quality by definition. But during the second half of the decade, it seemed as if creators had become bored by the challenge of anchoring the Punisher's actions in any sort of character logic. A quick summary should make this clear. First, in a crossover series titled "Over the Edge," a drug-addled Frank Castle hunts down and kills his one-time protector, Nick Fury. Only after a couple of years do readers find out that Castle had actually shot up an unusually realistic Life Model Decoy (LMD). After returning to his senses, the Punisher becomes the head of a crime syndicate and begins to feel as if he has found his place in the world. He then gets amnesia, falls into an emotional slump, and commits suicide. He returns to Earth as Heaven's avenging agent, armed with a bottomless supply of mystical weapons. Hero-killer, crime boss, morbid depressive, sword-of-angels: each of these improbable storylines has an inadvertently parodic aspect.

This interregnum between the first and second production cycles speaks to the larger hurdles facing Marvel at the end of the century. Sales figures plunged in the mid 1990s as the world's largest superhero publisher grappled with fan burnout, comic book overproduction, a hypercompetitive marketplace, and the inflated expectations of collectors and shareholders. As one journalist noted, the "collecting bubble burst in 1995, and customers were no longer running around to every comic book specialty store to hoard extras of every issue."[86] The "great comics crash"[87] pushed distributors and specialty stores out of business, even as

newsstand sales dried up. Facing a mountain of debt and a deteriorating stock price, the Marvel Entertainment Group filed for bankruptcy in 1997. "Wall Street is very fickle," noted staffer Mary McPherran. "*Ha-ha, isn't this trendy; look at you colorful comic-book artists!*—and then their focus turns away, and we're left with all these print runs of the same comics with different covers when it crashes."[88]

Marvel's financial troubles wreaked havoc on its internal operations. The company had already been placed on the defensive by the departure of high-profile creators in the early 1990s, several of whom went on to launch Image, a creator-owned company.[89] Rather than competing with DC, Image, and others on the basis of quality product, Marvel's corporate brass invested in card companies, merchandise ventures, and gimmicks such as crossover events, enhanced covers, and collectors' editions. The company also sank money into a poorly managed distribution company, Heroes World, in an effort to place its competitors on the defensive and squeeze more money out of retailers. Few of these initiatives bore fruit.[90] For the first time since the 1950s, the company began drawing up plans for cutting back on staff and in 1994 the company laid off dozens of employees. "The environment at Marvel itself became increasingly chaotic," notes Sean Howe, "with the skeleton-crew editorial staff taking on a multiplied workload, and freelancers feeling jerked around."[91] By 1996, "after Marvel tallied a loss of $48 million for the [preceding] year," the company announced "that 40 per cent of the workforce was going to be eliminated"—nearly 300 staff positions in total.[92]

During this process of retrenchment, writers and editors who had been responsible for steering the character throughout his first production cycle—Mike Baron, Don Daley, Chuck Dixon, Steven Grant, and Carl Potts among others—were sidelined by a younger cohort that seemed more interested in taking the road less travelled[93] than in logic and coherence. Novelty and inconstancy became the norm for a character whose obduracy had long been a defining feature. "I'm not sure about what I'm doing anymore," Castle confides to Leslie Geraci, a "brainy and tough"[94] love interest. "I'm not sure about anything."[95] Or as he admits to a group of S.H.I.E.L.D. agents, "I used to be someone sick and twisted by hate. Whatever I am, I am no longer *that*."[96]

The new cohort also confronted the challenge of storyworld exhaustion. For nearly a decade after *Circle of Blood*, the Punisher metanarrative organized itself around a single, overarching theme: that the vigilante's campaign is inherently self-destructive and can only end in tragedy. Once this storyline reached its logical terminus—as indicated by Frank Castle's catatonia and imprisonment—the character's creators decided to set off on tangents rather than return to basics. Their efforts largely drove away existing readers without attracting new ones. "Sometimes in a marketplace where sales determine success, some books get canceled quite a bit sooner than expected," editor Mark Bernardo conceded at the end of

the third *Punisher* series (1995–97). "Who knows," he added, "if enough of you demand it, he may even get another shot at an ongoing series."[97] The demand was not forthcoming, however. It was not until the arrival of Garth Ennis that the company was able to successfully reconceive and reboot the franchise.

The well-publicized decline in violent crime in NYC contributed to this narratological impasse. As the urban crisis gave way to gentrification, financialization, and large-scale development projects, the notion that the nation's most crowded city needed a murderous savior became somewhat less compelling. Violent crime in New York finally started dropping in the early 1990s. It would continue to drop for the next two decades. As of 2017, the city's murder rate was "among the lowest of major cities in the United States. In 2017 there were 290 homicides, the lowest number since the 1940s."[98] The following year the number had fallen even further, to 287.[99] The numbers then started picking up again: 318 in 2019 and 322 in 2020.[100] They will likely rise further in the era of Covid.

In percentage terms, the sharpest spikes were in the 1980s, while the largest plunges were in the 1990s. The official murder rate was 1,946 in 1993, 1,561 in 1994, and 1,177 in 1995. By 1999, this number had fallen to 671. Over the course of a single decade, the city's reported homicide rate had dropped by more than two-thirds. The only significant counter-trend was the World Trade Centre attack on September 11th, 2001. There are ways of telling compelling Punisher stories in an era of declining crime, but the baroque tales of the late 1990s missed their mark.

Peoples are petrol

When we last checked in with Frank Castle, he was under the supervision of S.H.I.E.L.D. It was never likely he would remain locked up for long. The Punisher's return is mapped in "Over the Edge," an erratic miniseries that was part of the short-lived Marvel Edge imprint (1995–96). Marvel Edge housed Daredevil, Dr. Strange, Ghost Rider, the Hulk, and the Punisher under one editorial roof. "What we're trying to do here in the Marvel Edge group," explained editor Bobbie Chase,

> is to create a line of books that will work as single entities, and have their very own unique stories to tell. These guys don't sit around at a common kitchen table and share intimate secrets. What they do share is a common universe, and a common attitude.[101]

In the first issue of "Over the Edge," the Hulk's psychiatrist, Doctor Samson, visits Castle at the safe house. He tells him, "we can take you back to the moment that *made you into the Punisher*, and we can *unmake* you" with the aid of "a psychedelic alkaline used in conjunction with hypnosis to induce a controlled *regression*."

Just as the Doctor starts the procedure, Rosalie Carbone's hired guns drop a laser-guided bomb on the safe house. Castle crawls away, but only after he has been manipulated into thinking that the man who ordered the hit on his family was none other than Nick Fury. (It later transpired that Fury's enemies inside S.H.I.E.L.D. used the Punisher as a means of getting to Fury.) "It won't be hard to track down a one-eyed man named *Fury*," the delusional Castle vows, "and when I do ... he'll learn the *real* meaning of the word!!"[102]

The remaining issues map their deadly game of cat-and-mouse. During one encounter, Fury subdues Castle with the help of Daredevil and tells him, "Ease up, Frank. I've killed *too many* men in my life—and I *really* don't wanna add you to the list."[103] But Castle sneaks away when Fury spies his son, Scorpio, tied up on a fence. Thankfully, Daredevil detects a pulse: "Punisher must have been using a variation on his old mercy bullets. Wanted to simulate death—make you *think* you'd lost your son."[104] When they next meet, Castle escapes with the aid of the Hulk, who tells Fury, "My gut instinct is to trust the Punisher, *not* you, and I *always* trust my gut."[105] While other members of the Marvel Edge stable prove less willing to give Castle any benefit of the doubt,[106] S.H.I.E.L.D. is unable to prevent the Punisher from tracking down and executing Fury, to the general irritation of Marvel fandom.[107]

As the third Punisher series opens, S.H.I.E.L.D. operatives watch as Castle is strapped to the electric chair. "I want to see the man who killed my father die!" roars Scorpio. En route to the execution chamber, Castle receives "celestial comfort" from Bullseye, who is disguised as a priest. "You know that lovely family you killed in Central Park?," he taunts. "Here's the gag—*you* didn't kill them—*I* did ... And now, of course, you can't do anything about it!" When Bullseye steps out of the room the warden asks, "What the heck did you say to him, Padre? He seemed calm and resigned, and now he's pulling on those restraints like a wild animal!"[108]

It took three years for the collective MU to discover that Frank Castle merely dispatched one of Tony Stark's LMDs. Trapped in a pocket dimension for what must have seemed an eternity, Fury claws his way back to the Marvel Universe with help from Sharon Carter.[109] Until his return, Fury's compatriots shun the vigilante who "killed a great man."[110] But Castle's death sentence is secretly commuted at the instructions of Don Mario Geraci, who "made certain there was only enough electricity flowing through the chair to stun you ... The morgue will get ... another body ... close to your type. No one will ask questions."[111] Frank Castle is indomitable.

Policing the neighborhood

Having eschewed drugs and prostitution in favor of "protection, gambling, influence," the Geraci syndicate was one of the tri-state area's smaller crime families.

A CULTURAL HISTORY OF THE PUNISHER

The Punisher knew of their existence but never made them a priority. He certainly never imagined he would become responsible for their welfare. Yet, after hitting rock bottom at the end of "Countdown," he is ready for a change. After smuggling the vigilante's body out of the morgue, the Don takes the Punisher on a tour of his territory. During their walk the old man boasts, "There are no drugs sold on these streets, Mr. Castle. No prostitution. No gangs." How does the neighborhood remain peaceful? "It is *I* ... Mario Geraci ... who make it so." What becomes of this neighborhood, of my family, when I am no longer here to defend them? What *then*, eh?"

While Castle is naturally reluctant to fill the Don's shoes, he willingly acknowledges that his own anti-crime campaign has not enjoyed as much of an impact as he might have hoped. Then, seemingly out of nowhere, Bullseye puts a bullet in Geraci. This abrupt act of violence underscores Geraci's fears about his weakening grip on the old neighborhood. When Castle catches Bullseye the vigilante injures his hands. "You've *crippled* me!," the assassin cries. "In the old days, I would've just *killed* you, Bullseye! But these aren't the old days ... and I'm no longer who I was." This disclosure somehow convinces Castle to switch sides. "Don Geraci," he says, "I've decided to *accept* your offer."[112]

Over the next few months, the Punisher settles into the crime boss routine. Moving into the family's Westchester compound, Castle learns that the Don has a retinue of lieutenants and enforcers and a *consiglieri* who is "like an *uncle* to the kids." When some of these men object to Castle's leadership, Don Geraci tells them to take the fight outside. Once the country's most famous mobster killer cracks a few skulls, the Geracis seem to accept Castle's leadership. "Now if we're done playing games, it's time we started taking care of *business*."[113] This entails settling family disputes and fighting off the Yakuza, the Russian mob, and the Carbones. The Geracis are a quarrelsome bunch, and there is something unsettling about Castle using his brains, brawn, and charisma to corral a crime cartel into uniting against its enemies. But he proves adept at keeping rival groups at bay. "Don't know what surprises me more," says Daredevil, when they reconnect on a Manhattan rooftop. "That you're alive or that you're working for the mob." "My *general* plan," Castle admits, was to "infiltrate the gang and bring it down." But "something's changed ... I've discovered I'm good at this." The Don "was right about me," he adds:

> I *was* burned out! I really had accomplished nothing! And I do have a chance to achieve something—to *protect* this neighborhood, just like you protect Hell's Kitchen. And ... I want to *save* this family, if I can. The way I couldn't save my own.

Or as he tells Daredevil when they meet for a second time, "It's my chance to accomplish something. Save a neighborhood ... save a family ... maybe save

myself. But I can't go back to what I *was*. That's not what I *am*. Does that make any sense?" Daredevil thinks it does, for some reason, telling him, "I believe in second chances, Castle, I've had a few myself."[114] Encouraged by their conversation, the Punisher feels as if he has found a safe space for the first time since his family was murdered. The tenor of his justice discourse shifts. "Things have changed for me," he thinks:

> I rule from the inside and control the way things go down ... with more power and effectiveness than I ever had on the outside looking in. More innocents are saved this way. I control where every bullet goes. I head the Geraci family now, and God help me, I'm becoming content. Every day that passes I get closer to feeling content with the Geracis. Every day that passes I feel like I'm home.[115]

The main threat to Castle's sense of security is posed by his old flame Rosalie Carbone, who continues to nurse a massive grudge. "You're such a *pig*, Castle," she tells him. "You got me to fall in love with you just to infiltrate my *family*. You *used* my love like another gun to kill everyone else I loved!" Rosalie later instigates a furious gun battle when the tri-state crime families gather to induct the new Geraci boss into their fraternity. "We're not inclined to accept Castle in any case, *but* we will not be *dictated* to by a *woman*," Tombstone insists only moments before the fireworks go off. After dozens of mobsters are slain by Carbone's body-armored minions, Rosalie Carbone helplessly stands by as Leslie Geraci and her lieutenants mount a counter-offensive using armor-piercing bullets. "Maybe we *deserve* each other," Rosalie says as she and Castle face off for the last time. "Goodbye baby," she whispers, as she prepares to kill her former lover. But Don Geraci's granddaughter manages to plug the love-sick Rosalie in the back. "Never mistake me for Rosalie," Leslie warns Castle afterwards. "That trick won't work twice."[116]

Letter writers were determined to give the new creative team a chance. "Frank working with the mob is a great idea and it really helps him in the new direction of *Punisher*," wrote Mike M. An "intriguing concept," chimed in Bob O. "This series has set a course for itself. Believe me, it's a sunny, cloudless sky out there."[117] Reader John B. commended writer John Ostrander and artist Tom Lyle for bringing "the Punisher back from the dead." Andy O. pronounced himself "amazed and astonished" by the creative team, "especially in regards to the way he is currently torn between loyalty to his newfound 'family' and a burning desire to destroy everything they stand for." Ben H. praised the creators for lending the character a renewed sense of focus: "Having Frank Castle join the Geraci crime family will put him into situations that he has never been in, to say the least. Ah, a breath of fresh air after all this time."[118]

But change is the only constant. Even as these sunny comments appeared in print, the Geraci family was besieged by a phalanx of villains and goons, led by Tombstone and Castle's old nemesis Jigsaw. Rosalie Carbone would have loved the spectacle, had she lived to see it. "It's open season on the Geracis!" Jigsaw shouts, as he aims a grenade launcher at the family compound. Most of the family's associates are killed in the ensuing firefight, and Leslie ends up in a coma. The onslaught was instigated by none other than Geraci himself, who was jealous of the loyalty that his associates had showered on Frank Castle. "They gave *you* the respect that should've been *mine!*,"[119] he whines. As the Punisher reflects on his time as a crime boss, he thinks to himself,

> I'm a different man now than when I waged war on crime. To be honest, I'm not sure right now where I fit in. I know this—I'm a soldier, a warrior. I define myself by the battles I fight. I just have to find what I'm fighting for.[120]

An even more basic question is why it ever made sense in the first place to have a crime-control vigilante lend his skill to an outfit whose business model centered around "protection, gambling, influence."

Once the Geraci storyline wrapped up, the powers-that-be folded his unfinished personal drama into a company-wide crossover series known as "Onslaught." The Punisher is pressed to lend his assistance as S.H.I.E.L.D. battles an anti-mutant terrorist group. "Forget it! I'm no S.H.I.E.L.D. agent," he insists. But G.W. Bridge reminds him, "You killed Nick Fury when he was trying to help you. Yeah, you were drugged out of your mind, all that," but "you do owe S.H.I.E.L.D.!"[121] Reminded of his debt of honor, Castle becomes involved in an effort to protect "the first major religious or political figure to come out in favor of *mutant rights*."[122] The terrorists' leader, Simon Trask, assumes that Castle must also hate mutants. "In the upcoming genetic war for the soul of America," Trask explains, "we intend to be the *victors*."[123] But Castle only hates criminals. When he takes the anti-mutant leader into custody—"You're going to be humiliated. That's why I'm letting you *live*. That's your *punishment*'—the incredulous fanatic sets off an explosion. "I'll see us *all* dead first!," he cries.[124] Castle makes it out of the building but Trask is not so lucky. As a result of the explosion, our hero gets amnesia and takes refuge in Manhattan's Alphabet City, where "the streets have no names, only letters—where everything is very poor, very violent, very nearly without hope."[125] This description of the Lower East Side's eastern edge would have seemed hyperbolic in the early 1980s, let alone the late 1990s.

As the third series closes, Castle defends a single mother from an abusive boyfriend. He may not remember his name, but he's an urban vigilante once more. Reader Michael P. appreciated the extent to which the series helped the character

become "a more integral part of the mainstream Marvel Universe,"[126] but judging from sales figures most fans were unmoved by the amnesia storyline as well as the other twists and turns of the third series. A year after the series ended, Castle is still struggling with memory loss, living in "an abandoned building where the streets have no name." As the narrator of *Heroes for Hire* #9 (1998) wryly points out, "Isn't it amazing how many abandoned warehouses, et al., seem to be in Manhattan?"[127]

Sword of angels

The series that follows was the slimmest *Punisher* to date—a four-issue miniseries penned by Christopher Golden and Tom Sniegoski, and penciled by the co-creator of DC's *Swamp Thing*, Bernie Wrightson. Wrightson (1948–2017) excelled at drawing horror comics, and this tale of angels vs. demons features some striking imagery, even if Castle's role does not add up.

As the series opens, we are introduced to a supernatural Punisher who sports a sigil on his forehead that "burns bright." While this iteration of Frank Castle "remembers his family," he does not recall "how he died."[128] He discovers that he was resuscitated by the angel Gadriel, who wanted to give Castle "a chance at redemption" as a way of making amends for failing to protect Castle's family. "I was their guardian angel," Gadriel confesses.[129] But Gadriel needs Castle's assistance in "*the* war, the eternal one."[130] Angels across the globe are being attacked by a demon who has lined up an entire army of lesser demons to assist him. Castle remains angry with the angels for failing to protect his family but regards their cause as just.

As Castle joins this epochal battle, he begins to recall his life after the events of Onslaught. The most troubling recollection has to do with the way he died—in a dim alleyway with a loaded revolver. What he now realizes is that, even as he was filled with rage and despair, he was surrounded by invisible demons. "Go ahead, Frank," implores one. "Make the hurt stop. It's all been for nothing." "They're still dead," adds a second, referring to his family.[131] "Lost in blackness," he pulls the trigger. But just as the darkness begins to envelop his soul, it lifts. "Rise, Frank. Come forth," chants Gadriel. "Take of my strength, my essence. Own you now, the key to the sword of angels, the power of Heaven." Fueled by divine power, and armed with esoteric weapons, Castle joins the posthuman demi-world.

From crime lord to amnesiac to suicidal drifter to supernatural entity, all in the span of a few years. As far as the Castle odyssey is concerned, this period offers one awkward corrigendum after another. By the end of the fourth series, Castle learns that he has been a lab rat for angels and demons and that the death of his

family was part of a diabolical scheme to create "an engine of death and sacrifice" that would grant a disgraced ex-angel enormous power. Angered by the demon's heartlessness, alienated by Gadriel's failure to protect his family, and crushed by the knowledge that his life was spared at the same time that his wife and children were taken from him, Castle lashes out at both ends of the cosmological spectrum. "Heaven or hell, what does it matter? They've both jerked me around! I'm not going to be anybody's pawn anymore!" He vows to take charge of his own destiny. "It used to be about vengeance," he tells himself. "But vengeance is selfish. Now it's about something else entirely. Redemption."[132]

He sets out on this path in *Wolverine/Punisher: Revelation* (1999), which tends to be omitted from lists of Punisher series. Christopher Golden and Tom Sniegoski shared scripting duties, with pencils by Pat Lee. Lee's mangaesque visuals are in a style that proved popular in the 1990s. His approach yields a much younger-looking Frank Castle, as well as kinetic action, futuristic landscapes, and stylized motion lines. Unfortunately, the story is not as engaging as the artwork. When Castle is summoned by the "Council of Thrones," a conclave of angels who operate out of a Dobbs Ferry mansion, he learns that "Gadriel, of the Grigori, gave you power, so that you might also seek redemption." As "a soldier of Heaven, you must swear allegiance to the Council of Thrones." Castle has other plans, however. "I've been used by everyone from the Lords of Hell to the Mafia to those self-righteous S.O.B.s at S.H.I.E.L.D. I'm through being anybody's soldier."[133]

The angels then watch as Castle and Wolverine work to resolve the city's latest crisis, the awakening of a powerful mutant who, as Wolverine explains, emits "some kind o' death aura that'll kill every livin' thing for miles if we let her reach the surface."[134] Wolverine and the Punisher discover that the mutant does not intend to hurt others and in fact needs their help, which speaks to the humanism of Marvel's approach to the question of mutant rights.

From the perspective of the Council of Thrones, the Punisher's actions during the Revelation crisis constitute a test he must pass to retain his heavenly powers. At the end of the series Castle is told that the "Council has decided to allow you to continue upon your journey without interference." The angels leave open the possibility that one day Frank will be reunited with his family in heaven—not the Geracis, but his real family. "I have faith," an angel tells him, "that you will attain the forgiveness you seek, and have the reward you so desire." But for now, "there is much for you to do" on earth.[135] Whether there was ever an audience for a Manga-style Punisher series whose lead character seeks redemption is unclear. The fourth *Punisher* series and the Revelation miniseries seem more like curiosities rather than fresh departures.

Once the company launched its fifth *Punisher* series, which was penned by Garth Ennis and drawn by Steve Dillon, these clunky tales were forgotten. The

THE NARRATOLOGICAL IMPASSE

title of Ennis' inaugural issue seems apt: "Welcome Back, Frank." Certainly, Ennis did not try to reconcile his approach to that of his predecessors. At the end of the series' first issue, Castle stands on top of the Empire State Building, preparing to toss a mobster onto the streets below. "I caught a glimpse of heaven once," he says. "The angels showed me. The idea was I'd kill for them. Clean up their mistakes on earth. Eventually redeem myself. Tried it. Didn't like it. Told them where to stick it":

> I was cast down. Back to a world of killers, rapists, psychos, perverts. A brand new evil every minute, spewed out as fast as men can think them up. A world where pitching a criminal dwarf off a skyscraper to tell his fellow scum you're back is a *sane and rational act*. The angels thought it would be hell for me. *But they were wrong.*[136]

A suitably dramatic opening for the series that would revive the franchise. The following chapter explores the impact that Garth Ennis and others who followed in his wake have had on the Punisher and comic book antiheroes more generally. The point here is that Ennis and his collaborators found a way out of the trap in which the character had been placed. Ennis' pulpy stories returned Castle to his gritty roots as a death-dealing crime fighter. There would be no more talk of angels and demons. The character would no longer find himself working on behalf of higher beings, or tricked into hunting down A-list heroes. This time around, Castle could only answer "no" when social worker Jen Cooke insisted that she would like to "burn the world clean like an angel with a fiery sword …!" and then asks, "But there are no angels, are there?"[137] This version of Castle dwells in a noirish environment where the very concept of the transcendental is suspect. Ennis had no interest in locating the character in a cosmological framework. Nor was he inclined to revisit the grand narrative of the late 1980s and early 1990s, which assumes that the path of the Punisher leads to madness or death.

Garth Ennis' stylistic flourishes gave the storyverse a new lease on life. Ennis is an unusual commercial author in that he comfortably switches between convoluted plotting, rapid-fire poetics, and crass vulgarity. He is also an equal opportunity offender when it comes to left vs. right. The innovation that Ennis and his collaborators introduced was to combine two modes of antihero storytelling that at first blush seemed incompatible. Ennis' Punisher is gritty but parodic. He is violent, sometimes shockingly so, and yet there is a strain of pure comedy in Ennis' approach. Parodic takes on the character before 2000 were trigger-happy, with an emphasis on ham-fisted action, ludicrous dialogue, and crazy costumes. In the comics of Garth Ennis and Steve Dillon, the costumes are sleek, the dialogue is tough, and the action is gory. But there is a level of heightened cartoonishness that previous grim and gritty approaches had eschewed. Violence *as* comedy, in other words.

193

A sense of Garth Ennis' distinctive take can be gleaned from a *Wizard* interview that appeared a couple of weeks before *Punisher* 5.1 hit the stands. Frank Castle, Ennis says, is the

> kind of character who appeals to me. He reminds me a little bit of some of the characters I grew up reading in comics, characters like Judge Dredd, Strontium Dog, RoboHunter. They're guys with guns basically. They don't have that silly superhero thing. They're more sort of gunfighter, gunslinger-type characters and that's something I can relate to a lot better.

Castle, he said, is "a lot of fun to write because there is a hint of dark gallows humor in the character." The new series is a "really action-packed book. You know, like *Die Hard, Lethal Weapon*—once the bullets start flying, you're gonna have a lot of fun."[138]

Anxious laughter

When Gerry Conway introduced a Mack Bolan analogue into the Marvel Universe he was intrigued by the possibilities that the archetype had to offer. Neither Conway nor his collaborators were infatuated with vigilantism or hoped to use Castle to steer superhero discourse in a pro-death penalty, pro-tough-on-crime direction. Yet Conway and others at Marvel lived and worked in the country's most densely populated metropolis, and they were walking the same streets and watching the same news programs as their neighbors. Anxieties forming in the hearts and minds of urban residents in the 1960s had become politically consequential by the 1970s. Problematic emotions such as anger, shame, and fear are embedded within the Punisher mythos precisely because there was such a tremendous sense of rage and discontent within the larger social ecosystem in which the character was incubated.

And yet, in his first decade the Punisher was a hyped-up figure who took himself too seriously and provoked eyerolls from other costumed heroes. His real job was to make mainstream types look good. In the wake of *Circle of Blood*, his gritty aspect became accentuated. But Castle's war on criminality provoked skepticism and derision even at the apex of his comics popularity. If the Punisher was mostly treated with sympathy by writers and artists in the period from the mid 1980s to the mid 1990s, he was mocked and teased by other comics creators, whether they worked for Marvel or one of its rivals. The resulting parodies were sometimes gentle, sometimes ferocious. His growing prominence pushed existing characters in a hardboiled direction and encouraged publishers to try out new antiheroes as well. It is difficult to think of another comic book character who inspired quite as many satires and imitations within such a short timeframe.

Creators and readers found comedy in the Punisher in part because the character is inherently melodramatic and overwrought. Frank Castle's oft-stated goal of killing all criminals is not only genocidal, it is also absurd. At one point or another everyone commits a crime, as defined by one public or spiritual authority or another. His ambitions are utopian and nightmarish. Crime-control vigilantism on a scale that results in the deaths of tens of thousands of people would generate horrific secondary outcomes and produce the very chaos that the Punisher invokes to legitimize his own crimes.

Crime and justice each have their own complexities and nuances. As Wendy Kaminer points out, "Our notions of accountability are confused in part because we have immodest expectations of justice. We want it to be clear and final and true. We want people to be either victims or victimizers, without recognizing that many of us are both, without knowing when and how to punish guilty victims."[139] The Punisher's assumption that crime and justice are unambiguous categories can serve comedic ends as well as dramatic ones.

Laughter, of course, is sometimes anxious. The parodies and jokes aimed at the Punisher in the 1980s and 1990s were rooted in anxiety as well as irony. This helps explain why there was such a sharp drop-off in vigilante humor after the mid 1990s. After all, the character and his campaign remained as over-the-top as ever. If anything, given the storylines we considered in this chapter, Frank Castle offered a riper target than before. But the jittery compulsion to make light of the hardboiled vigilante archetype had begun to dissipate.

NOTES

1. Plato, *The Republic* (New York: Basic Books, 1991), 452e.
2. Fuzzydice82, https://boardgamegeek.com/thread/784745/why-do-people-punisher.
3. Mark Waid and Alex Ross, *Kingdom Come* #2 (New York: DC Comics, 1996), n.p.
4. Terry Austin and Whilce Portacio, *Power Pack* #46 (New York: Marvel, May 1989), n.p.
5. Marc Guggenheim and Leinil Francis Yu, *Punisher: Trial of the Punisher* #1 (2013), reprinted in *Punisher and Bullseye: Deadliest Hits* (New York: Marvel, 2017), n.p.
6. "My name's Castle. A lot has been written about me over the years. Most of it's pure bunk, hard-boiled pulp fiction for the masses." Tom DeFalco and Ron Frenz, *The Spectacular Spider-Girl* #1 (New York: Marvel, July 2010), 1.
7. Jennifer Grünwald, ed., *Strange Tales* (New York: Marvel, 2010), back cover.
8. See Jonathan Jay Lee, "The Punisher" and Johnny Ryan, "Scared Smart," in *Strange Tales*, ed. Grünwald, n.p. *The Punisher* parody in Ryan's *The Comic Book Holocaust* (Oakland, CA: Buenaventura Press, 2006), n.p. is coarser but equally unsubtle.
9. The son of author J. D. Salinger, Matt Salinger starred in the low-budget movie *Captain America* (1990), as well as *Revenge of the Nerds* (1984) and *What Dreams May Come* (1998).

10. Fred Hembeck, "Dateline: @!!?*" *Comics Buyer's Guide* #1344 (August 20, 1999), 24.

11. Quoted in Matt Brady, "Punisher Plus 25: Anatomy of a Comic-Book Craze," *Comics Buyer's Guide* #1344 (August 20, 1999), 40.

12. Linda Hutcheon, *A Theory of Parody: The Teachings of Twentieth-Century Art Forms* (Urbana: University of Illinois Press, 2000), xii.

13. Hutcheon, *A Theory of Parody*, 20, xii.

14. Hutcheon, *A Theory of Parody*, xiii.

15. Al Milgrom and Mark Bagley, *The Amazing Spider-Man* #353 (New York: Marvel, November 1991), 15–16.

16. Gail Simone and Udon Studios, *Agent X* #2 (New York: Marvel, October 2002), n.p.

17. Nick Spencer and Brent Schoonover, *The Astonishing Ant-Man* #8 (New York: Marvel, July 2016), n.p.

18. John Figueroa and Alberto Ponticelli, *Marvel Knights* #2.4 (New York: Marvel, August 2002), n.p.

19. Jim Valentino, "A Night to Remember," *The Impossible Man Summer Vacation Spectacular* #1 (New York: Marvel, 1990), 38.

20. Steve Gerber, Sal Buscema, and Klaus Janson, *Marvel Treasury Edition* #1.12 (New York: Marvel, 1976), 4–5.

21. Dwayne McDuffie, Ernie Colón, Kyle Baker, and Salva Espin, *Damage Control: The Complete Collection* (New York: Marvel, 2015), back cover.

22. McDuffie, Colón, Baker, and Espin, *Damage Control*, 139.

23. McDuffie, Colón, Baker, and Espin, *Damage Control*, 143–44.

24. McDuffie, Colón, Baker, and Espin, *Damage Control*, 156–60.

25. *What If…?* appeared in 1977–84 and 1989–98. More recent iterations have appeared as one-offs.

26. *What If…?* #2.7 (New York: Marvel, December 1989), 28; and *What If…?* #2.34 (New York: Marvel, February 1992), n.p. Issue 34 also features a one-page gag which asks, "What If … Frank Castle had Died … But His Family had Lived?" The answer is that they would become "The Punisher Family," complete with "Bullets the Wonder Pup."

27. Mark Millar and Jim Mahfood, "What if the Punisher Was a Bleeding Heart?" *Wha … Huh* #1 (New York: Marvel, 2005), n.p.

28. Carple first appears in "Plumb(ing) Tuckered Out," by Michael Eury and Alan Kupperberg, *Marvel Tales* #2.212 (New York: Marvel, June 1988).

29. http://marvel.wikia.com/wiki/Frank_Casket_(Earth-9047). The Pulverizer's inaugural appearance also dates to 1988: Peter B. Gillis and Hilary Barta, "Accounts Overdrawn – Checks Returned for Lack of Funds," *What The--?!* #1.1 (New York: Marvel, August 1988).

30. John Layman and Fabiano Neves, *Marvel Zombies vs. Army of Darkness* (New York: Marvel, 2007), chap. 2, n.p. Castle fares better in *Marvel Universe vs. the Punisher* (2010), in which a zombie outbreak is caused by scientists who tried to "alter the basic chemistry of the body to allow the survivors [of a nuclear war] to breathe the polluted air and to eat just

about anything." It's a fine premise but the execution is derivative. Jonathan Maberry and Goran Parlov, *Marvel Universe vs. the Punisher* (New York: Marvel, October 2010), n.p.

31. Deadites have been possessed by demons and can be restored to full health, whereas zombies are the walking dead. Both deadites and zombies are undead but only zombies eat the living.

32. Mike Baron and Jimmy Palmiotti, *Punisher War Journal* #1.35 (New York: Marvel, October 1991).

33. Grant Morrison and Vince Giarrano, *Doom Patrol* #45 (New York: Marvel, June 1991).

34. Alan Grant and Dan Jurgens, *Batman: Shadow of the Bat* #6 (New York: Marvel, November 1992), 23.

35. Tom Veitch and Steve Dillon, *Animal Man* #2.38 (New York: Marvel, August 1991), 3.

36. Tom Veitch and Brett Ewins, *Animal Man* #2.44 (New York: Marvel, February 1992), 19.

37. *Parody Press! Parade* (advertorial), December 1992.

38. Mike Baron and Sam Agro, "Pummeler Bore Journal," *The Pummeler* #1 (Eureka: Parody Press, December 1992), n.p. Parody Press's *The Pummeler $2099* (1993) is set in a world where crime is rampant and a 32-page comic book costs $2099. Publisher Don Chin also promised a "shoot 'em up extravaganza" called *Pummeler & Sgt. USA* that never materialized.

39. Swan Segler and Shannon Londin-Gallant, *The Punish-Her Score Journal* #1 (Melville: Personality Press, May 1993), 2, 3, 23, 24.

40. Donald Markstein, "Reagan's Raiders," http://www.toonopedia.com/reagan.htm#cont.

41. Monroe Arnold and Rich Buckler, *Reagan's Raiders* #1 (Brooklyn: Solson Publications, 1986), n.p.

42. http://tick.wikia.com/wiki/Big_Shot. See also "Big Shot Has Issues," https://www.youtube.com/watch?v=5xG59cPyxb4.

43. Brannon Costello, *Neon Visions: The Comics of Howard Chaykin* (Baton Rouge: LSU Press, 2017), 52.

44. Anthony Domanico, "Meet Pun-isher, the Punniest Superhero of Them All," Cnet, May 5, 2015, https://www.cnet.com/news/the-pun-isher-is-the-punniest-superhero-of-them-all/.

45. This irregularly published title was "originally published by Marvel as part of their Epic creator owned line" and which then travelled to "Apocalypse, Dark Horse, Cool Beanz, and Image Comics before being acquired by DC." Rich Johnston, "DC Comics to Publish Marshal Law?" Bleeding Cool, December 21, 2010, https://www.bleedingcool.com/2010/12/21/dc-comics-to-publish-marshal-law.

46. Pat Mills and Kevin O'Neill, *Marshal Law* (New York: DC Comics, 2014), 19, 155, 105.

47. Kiernan Cashell and John Scaggs, "Transvestite Logic: Pat Mills and Kevin O'Neill's *Marshal Law* and the Superhero Genre," *Iowa Journal of Cultural Studies* 6 (Spring 2005), 9.

48. Pat Mills, *Be Pure! Be Vigilant! Behave! 2000AD and Judge Dredd: The Secret History …* (Malaga, Spain: Millsverse, 2017), 93.

49. Mills and O'Neill, *Marshal Law*, 208–10.

50. Mills and O'Neill, *Marshal Law*, 212.

51. Mills and O'Neill, *Marshal Law*, 227–28.

52. Mills and O'Neill, *Marshal Law*, 243–44. Mills penned a 2002 miniseries called The Redeemer, about a character "whose catchphrases include 'Scourge and Purge' and my favorite: 'If it doesn't hurt, it doesn't count.'" Mills, *Be Pure! Be Vigilante! Behave!*, 123. The Redeemer's dogmatism, relentlessness, and violent proclivities seem oddly familiar. Pat Mills, Debbie Gallagher, and Wayne Reynolds, *The Redeemer (Warhammer 40,000)* (London: The Black Library, 2003).

53. The first follows the path laid out by *The Punisher Kills the Marvel Universe* (1995); the second bears similarities to the 1998–99 Christopher Golden/Tom Sniegoski limited series; and the third summarizes the default narrative of most Punisher stories.

54. Daniel Clowes, *The Death-Ray* (Seattle: Fantagraphics, 2011), 13, 22, back cover.

55. Hutcheon, *A Theory of Parody*, xii, xv.

56. Jean Baudrillard, *Simulations* (New York: Semiotext[e], 1983), 9.

57. John Ostrander, Kim Yale, and Luke McDonnell, *Deadshot* #3 (New York: DC, Winter 1988), 21. After ending the pedophile's life, Deadshot says to himself, "Not enough. It's not enough. They *all* gotta die!" Curiously, before he assumed the role of Deadshot, Floyd Lawton joined the Communist Party "to get back at his family." Bob Greenberger, *Deadshot* #1 (New York: DC, November 1988), 24.

58. Paul Kupperberg and Tod Smith, *Peacemaker* #1 (New York: DC, January 1988), 6.

59. Readers learn that an entire organization, the Scourge of the Underworld, is devoted to this specialized task.

60. Doug Zawisza, "Deathstroke the Terminator," *Back Issue!* #102 (Raleigh: TwoMorrows, February 2018), 9.

61. Cover text to Marv Wolfman, *Sable: The Return of the Hunter* #2.1 (Chicago: First Comics, March 1988).

62. Max Bemis and Dalibor Talajić, *Foolkiller: Psycho Therapy* (New York: Marvel, 2017), n.p.

63. Steve Gerber and Val Mayerik, *The Man-Thing* #3 (New York: Marvel, March 1973), 14.

64. Gerber and Mayerik, *The Man-Thing* #3: 17. Steve Gerber and Val Mayerik, *The Man-Thing* #4 (New York: Marvel, April 1973), 32.

65. Gregg Hurwitz and Lan Medina, *Foolkiller: Fool's Paradise* (New York: Marvel, 2008), n.p.

66. Gregg Hurwitz and Paul Azaceta, *Foolkiller: White Angels* (New York: Marvel, 2008), n.p.

67. Aside from Frank Castle himself, obviously. Matt Brady, "Gregg Hurwitz Talks Foolkiller," Newsarama, https://web.archive.org/web/20071029033839/http://forum.newsarama.com/showthread.php?t=120557.

68. Bemis and Talajić, *Foolkiller: Psycho Therapy*, n.p.

69. Mark Verheiden, *The American* (Milwaukie: Dark Horse, 2005), back cover.

70. "Then the war was over," his girlfriend recalls, as Hazzard glares at protesters with signs that read, "Welcome Home Babykillers" and "Out Assassins." Doug Murray and Vincent Waller, *Mark Hazzard: Merc* #1 Annual (New York: Marvel, 1987), n.p.

71. Marc Buxton, "Flashback: Wild Dog," *Back Issue!* #102 (Raleigh: TwoMorrows, February 2018), 38.

72. http://marvel.wikia.com/wiki/Elias_Wirtham_(Earth-616).

73. Danny Fingeroth and Mike Manley, *Darkhawk* #1.4 (New York: Marvel, June 1991), 30.

74. Eric Larsen, Keith Giffen, and Dave Johnson, *SuperPatriot* #1.3 (Portland: Image Comics, October 1993), n.p.

75. Steven Grant and Christopher Schenck, *Enemy* #1 (Milwaukie: Dark Horse, May 1994), 28.

76. Mike Baron and N. Steven Harris, *The Crush* #1 (Portland: Image Comics, January 1996), n.p.

77. According to Alan Moore, Steve Ditko once told a fan that Rorschach "was like Mr. A, but he's insane." *In Search of Steve Ditko* (London: BBC, 2007), https://www.youtube.com/watch?v=L5kPNfUAC3I.

78. Numerous web articles address this topic, e.g., Michael Hollan, "Smooth Move, Frank: The Punisher's 15 Dumbest Decisions," CBR, June 5, 2017, https://www.cbr.com/smooth-move-frank-the-punishers-15-dumbest-decisions/.

79. Mike Baron and Hugh Haynes, *The Punisher* #1.59 (New York: Marvel, January 1992), n.p.

80. Mike Baron, Marcus McLaurin, and Val Mayerik, *The Punisher* #1.60 (New York: Marvel, February 1992), n.p.

81. Mike Baron, Marcus McLaurin, and Val Mayerik, *The Punisher* #1.61 (New York: Marvel, March 1992), n.p.

82. Mike Baron, Marcus McLaurin, and Val Mayerik, *The Punisher* #1.62 (New York: Marvel, April 1992), n.p. Jessica Jones teases Luke Cage about his relationship with the Punisher. "I know you *love* him," she says, "because he 'clears the herd of idiots.'" "I feel about him like I feel about coyotes," Cage retorts. Brian Michael Bendis and David Marquez, *The Defenders* #1.3 (New York: Marvel, September 2017), n.p.

83. Examples are easily accessible via Google; there are even YouTube videos devoted to the topic.

84. Barry Dutter, *Marvel Vision* #15 (New York: Marvel, March 1997), quoted in Brian Cronin, "Comic Book Legends Revealed 567," CBR, March 18, 2016, https://www.cbr.com/comic-book-legends-revealed-567/3/.

85. Chris Sims, "That's What's Up: When the Punisher and Lois Lane were Black," Looper, February 2, 2018, www.looper.com/108000/thats-whats-punisher-lois-lane-black/?utm_campaign=clip.

86. Dan Raviv, *Comic Wars: How Two Tycoons Battled Over the Marvel Comics Empire ... and Both Lost* (New York: Broadway Books, 2002), 39.

87. https://tvtropes.org/pmwiki/pmwiki.php/UsefulNotes/TheGreatComicsCrashOf1996.

88. Sean Howe, *Marvel Comics: The Untold Story* (New York: HarperCollins, 2012), 356.

89. George Khoury, *Image Comics: The Road to Independence* (Raleigh: TwoMorrows Publishing, 2007).

90. These developments are outlined in Adam Bryant, "Pow! The Punches that Left Marvel Reeling," *New York Times*, May 24, 1998, https://www.nytimes.com/1998/05/24/business/pow-the-punches-that-left-marvel-reeling.html?_r=0.

91. Howe, *Marvel Comics*, 369.

92. Howe, *Marvel Comics*, 375.

93. Referring to the 1998–99 "Angelic Punisher" story arc, writers Christopher Golden and Tom Sniegoski promised they would be "taking the road less traveled, bringing the Punisher to a place he's never been, and at the same time, exploring a part of the Marvel Universe where others have feared to tread." *Marvel Knights Tour Book* (New York: Marvel, 1998).

94. John Ostrander and Tom Lyle, *The Punisher* #2.2 (New York: Marvel, December 1995), n.p.

95. John Ostrander and Tom Lyle, *The Punisher* #2.9 (New York: Marvel, July 1996), n.p.

96. John Ostrander and Tom Lyle, *The Punisher* #2.7 (New York: Marvel, May 1996), n.p.

97. "We think (and we hope you agree) that we had an interesting little story forming here, but alas, market reality has nipped us in the bud." "Bullet Proofs," *The Punisher* #2.18 (New York: Marvel, April 1997), n.p.

98. https://en.wikipedia.org/wiki/Crime_in_New_York_City.

99. Tyler Pager, "Reports of Rape and Hate Crimes Rise in 2018, But New York Remains Safest Big City," *New York Times*, December 31, 2018, https://www.nytimes.com/2018/12/31/nyregion/crime-nyc-rapes-murders.html.

100. https://criminaljustice.cityofnewyork.us/wp-content/uploads/2021/01/2020-Shootings-and-Murder-factsheet_January-2021.pdf.

101. Bobbie Chase, "Marvel Edge," *Mega Marvel Catalog* #507 (New York: Marvel, 1995), 20.

102. J. M. DeMatteis and Ron Wagner, *Daredevil* #1.344 (New York: Marvel, September 1995), n.p.

103. Wagner and DeMatteis, *Daredevil* #1.344, n.p.

104. Wagner and DeMatteis, *Daredevil* #1.344, n.p.

105. Peter David and Terry Dodson, *The Incredible Hulk* #1.433 (New York: Marvel, September 1995), n.p.

106. Howard Mackie and Salvador Larroca, *Ghost Rider* #2.65 (New York: Marvel, September 1995), and Warren Ellis, Todd Dezago, Mark Buckingham, and Key F. Sutherland, *Doctor Strange, Sorcerer Supreme* #1.81 (New York: Marvel, September 1995).

107. John Ostrander, Kim Yale, and Douglas T. Wheatley, *Double Edge: Omega* (New York: Marvel, October 1995), n.p. For a taste of how fandom responded to these events, see Brian Cronin, "Remember to Forget – That Time the Punisher Killed Nick Fury," CBR, March 19, 2016, https://www.cbr.com/remember-to-forget-that-time-the-punisher-killed-nick-fury/.

108. John Ostrander and Tom Lyle, *The Punisher* #2.1 (New York: Marvel, November 1995), n.p.

109. Terry Kavanagh and Ramon Bernado, *Fury/Agent 13* #1 (New York: Marvel, June 1998).

110. These words are spoken by G. W. Bridge, a high-ranking S.H.I.E.L.D. agent. John Ostrander and Tom Lyle, *The Punisher* #2.7 (New York: Marvel, May 1996), n.p. "I could probably legitimately blow your brains out right now and probably get a commendation from my superiors," warns another agent as she levels a handgun at Castle's neck. John Ostrander and Tom Lyle, *The Punisher* #2.12 (New York: Marvel, October 1996), n.p.

111. Ostrander and Lyle, *The Punisher* #2.1, n.p.

112. Ostrander and Lyle, *The Punisher* #2.1, n.p.

113. John Ostrander and Tom Lyle, *The Punisher* #2.2 (New York: Marvel, December 1995), n.p.

114. John Ostrander and Tom Lyle, *The Punisher* #2.4 (New York: Marvel, February 1996), n.p

115. Ivan Velez, Jr. and Stephen B. Jones, *Over the Edge* #5 (New York: Marvel, March 1996), n.p.

116. John Ostrander and Tom Lyle, *The Punisher* #2.5 (New York: Marvel, March 1996), n.p.

117. Andy O., "Bullet Proofs," *The Punisher* #2.8 (New York: Marvel, June 1996), n.p.

118. Ben H., "Bullet Proofs," *The Punisher* #2.10 (New York: Marvel, August 1996), n.p.

119. John Ostrander and Tom Lyle, *The Punisher* #2.9 (New York: Marvel, July 1996), n.p.

120. John Ostrander and Tom Lyle, *The Punisher* #2.10 (New York: Marvel, August 1996), n.p

121. John Ostrander and Tom Lyle, *The Punisher* #2.11 (New York: Marvel, September 1996), n.p.

122. John Ostrander and Tom Lyle, *The Punisher* #2.12 (New York: Marvel, October 1996), n.p.

123. John Ostrander and Tom Lyle, *The Punisher* #2.15 (New York: Marvel, January 1997), n.p.

124. John Ostrander and Tom Lyle, *The Punisher* #2.16 (New York: Marvel, February 1997), n.p.

125. John Ostrander and Tom Lyle, *The Punisher* #2.17 (New York: Marvel, March 1997), n.p.

126. Michael P., "Bullet Proofs," *The Punisher* #2.16, n.p.

127. John Ostrander and Pascual Ferry, *Heroes for Hire* #1.9 (New York: Marvel, March 1998), n.p.

128. Christopher Golden, Tom Sniegoski, and Bernie Wrightson, *The Punisher* #3.1 (New York: Marvel, November 1998), n.p.

129. Golden, Sniegoski, and Wrightson, *The Punisher* #3.1, n.p.

130. Christopher Golden, Tom Sniegoski, and Bernie Wrightson, *The Punisher* #3.2 (New York: Marvel, December 1998), n.p.

131. Christopher Golden, Tom Sniegoski, and Bernie Wrightson, *The Punisher* #3.3 (New York: Marvel, January 1999), n.p.

132. Golden, Sniegoski, and Wrightson, *The Punisher* #3.4, n.p.

133. Tom Sniegoski, Christopher Golden, and Pat Lee, *Wolverine/Punisher: Revelation* #1 (New York: Marvel, June 1991), n.p.

134. Tom Sniegoski, Christopher Golden, and Pat Lee, *Wolverine/Punisher: Revelation* #3 (New York: Marvel, August 1991), n.p.

135. Tom Sniegoski, Christopher Golden, and Pat Lee, *Wolverine/Punisher: Revelation* #4 (New York: Marvel, September 1999), n.p.

136. Garth Ennis and Steve Dillon, *The Punisher* #4.1 (New York: Marvel, April 2000), n.p.

137. Garth Ennis and Leandro Fernandez, *The Punisher* #7.27 (New York: Marvel, January 2006), n.p.

138. Christopher Lawrence, "Garth Ennis: The *Wizard* Q&A," *Wizard* #101 (February 2000), 53.

139. Wendy Kaminer, *It's All the Rage: Crime and Culture* (Reading: Addison Wesley, 1995), 23.

6

From Print to Screen to Icon

It is not easy to represent in art the true reality of modern violence.

—Fredric Wertham, *A Sign for Cain* (1966)[1]

In 2024, the Punisher celebrates his fiftieth anniversary. New comics and repackaged old ones will mark the occasion, along perhaps with a rebooted streaming series and fresh video game content.[2] If his early creators found it difficult to envision the character becoming a comics mainstay, it is close to impossible they could have imagined his serving as the international symbol for the idea and cause of putatively just extralegal violence. The civic emergency that inspired Gerry Conway and his colleagues to introduce a murderous vigilante into the Marvel Universe ended years ago. But the debates and anxieties that the crisis encouraged and provoked are still with us. If anything, the politics of vengeance has metastasized.

The persistence of the archetype and the democratization of the visual arsenal suggest that many people find significant meaning and value in the concept of Punisher-style vigilantism. While Castle's trauma loop does an emphatic disservice to New York City's real-world social history, layers of lived experiences with and arguments about crime, policing, the death penalty, and the justice system are nevertheless etched into his storyverse. The Punisher's commercial accomplishments, his earnings potential, and his embeddedness in the culture speak not only to the appeal of the vigilante genre but to the *longue durée* of what we reductively refer to as "the seventies."

The Punisher has certainly endured his share of mishaps. He has headed a crime syndicate, dined with Archie Andrews, taught social studies, defended flag-burning, passed as African American, suffered amnesia, committed suicide, sought redemption from angels, dismantled a government conspiracy to turn cocaine into legal tender, and shot at cabbies for running red lights. He has been seduced by lunatics and chomped by zombies. He disdains the efforts of other crime fighters but often works alongside them. He has gone from mercy bullets to semi-automatics to shotguns and machine guns. In the late 1970s, the narrator improbably

terms him the "Ebony Executioner," and in his inaugural appearance, the Punisher tries his best to murder Spider-Man. What would have happened had Frank Castle succeeded? An entire issue of *What...If?* is devoted to this very question.[3]

Despite the vagaries of serial fiction, recent Punisher stories hew closely to earlier iterations. Plot twists, lively visuals, and updated pop culture references disguise the familiar, even ritualistic nature of the underlying discourse. No one who picks up a recent collection after they stopped following the character in the 1990s will find themselves lost at sea. There is what the philosopher Louis Althusser terms a "teeth-gritting harmony" to the drama.[4] The returning reader might miss earlier styles of linework, but it is unlikely she would be puzzled by the character's rhetoric or behavior. While there have been changes in creative personnel, distribution channels, and publishing formats, the formulary remains constant. "The one truth about Frank Castle," notes the writer Matthew Rosenberg, is that "he never changes."[5] Even more than the Hulk, Castle is Marvel's "ginormous rage monster."[6] Hunt and hunt again is his *modus operandi*, his pietism, his apothegm.

This tightly constrained ensemble of cultural relations is not entirely immutable. In particular, there have been stylistic adjustments. The sideburns of the 1970s disappeared in the 1980s, and the puffy coiffure of the 1980s was tamed by the 1990s. Castle's boots and gloves are no longer white, and the please-don't-look swimsuit he modeled in the *Marvel Swimsuit Special* (1993) has been thankfully forgotten.[7] The shape of the chevron and the mix of greys and blacks in his costume have been tweaked and revised. Movies, animation, and streaming services all contribute to a growing storehouse of morbid yet kinetic imagery, as do licensed and unlicensed products. But they are mostly variations on a theme, that of righteous anger. Castle himself acknowledges that "As every year goes by, I just get *meaner*."[8]

If the archetype remains steadfast, Marvel itself has been transformed beyond recognition. From the 1930s through the 1960s the company was a family-owned concern. In 1968, Martin Goodman sold Marvel Comics to the Perfect Film and Chemical Corporation for a reported price tag of $15 million.[9] Jack Kirby dismissed this as "less than the value of Ant-Man alone." According to the comics writer Mark Evanier, "Jack would point to the reported amount as proof that Goodman was a man lacking vision: 'I could never get what I was worth out of him because he had no idea what his company was worth.'"[10] By the time *The Amazing Spider-Man* #129 hit the stands, Marvel was ensconced in a midsized conglomerate whose products included vitamins and health aids. Having evinced little interest in the company's day-to-day operations, Cadence then sold the Marvel Entertainment Group to New World Pictures in 1986, reportedly for $46 million.[11] In the same year that Castle gained his first limited series, the company became part of a multimedia enterprise with extensive film and television properties. It was a plausible fit and the future seemed bright.

The synergy between New World's existing holdings and its new acquisition was highlighted by the release of *The Punisher* (1989). Produced for around nine million dollars, the New World picture went straight to video in the United States and Australia but opened in theaters in most other markets. Shortly before the film was released, however, New World tried to address its underlying financial problems by offloading Marvel to MacAndrews & Forbes for $82 million.[12] MacAndrews & Forbes' owner, Ron Perelman, then took the Marvel Entertainment Group public, viewing it as "a platform for selling junk bonds."[13] As we have seen, the company then dumped millions of dollars into trading cards, an excessively ambitious distribution system, and schemes such as "embossed covers, holographic covers minted in aluminum, and copies sold in sealed bags containing 'exclusive' supplements (including trading cards and posters)."[14]

These gambits accompanied and to some extent encouraged a downturn in comic book sales that had "deleterious effects for all players in the market."[15] Many specialty stores closed and several publishers folded. MEG filed for Chapter 11 at the end of 1996, but in the following year, Toy Biz stepped in and turned things around. By 2004, "Marvel was employing statistical analyses to feed information about creator and character performances into algorithms that determined launches, cancellations, and frequencies of publication."[16]

Feature writers began taking an interest in Stan Lee in the 1960s, but the business press only took the company seriously when heavy hitters on Wall Street like Ron Perelman, Carl Icahn, and Ike Perlmutter got involved in the 1990s. Journalists and scholars have subsequently generated a shelf's worth of books on Marvel's business history, internal workings, and transnational reach.[17] With every sale and corporate takeover, the pressure to squeeze greater returns has intensified. If Marvel started out as a cheapjack operation with a tendency to imitate rather than innovate, in recent years it has scaled the heights of global entertainment. The Punisher franchise contributes to and benefits from Marvel's ascendancy, of course. The Netflix version would not have been possible without it, for example.[18] But in recent years their paths, which were once synonymous as if by definition, have started to diverge.

Remember that murder

Approximately 300 Punisher titles were issued between 2000 and 2020, nearly three-quarters of which were monthly comic books. The remainder were graphic novels, one-shots, and reprint volumes. The latter were increasingly expensive and handsomely produced, and represented a growing portion of print sales as a whole. Modified and unlicensed imagery—stencil art, stickers, tattoos, textiles, and so on—also became increasingly popular. This was the case not so much among

comic book fans, who were already being catered to by licensed merchants, but more controversially pro-police groups, gun-rights groups, militia groups, and the alt-right. The proliferation of vendors producing unlicensed merchandise, some of them non-profits and not all of them US-based, complicates Disney's ability to confront this form of copyright infringement.[19]

Pointedly political uses of the franchise—as signified by the shoulder patches on the Unite the Right marchers in Charlottesville, Virginia, the proliferation of Punisher/Blue Lives Matter merchandise, the brouhaha over decals on police vehicles, and the prominence of Punisher imagery at the January 6, 2021 Capitol Hill protests—generated international headlines and struck a nerve at Marvel. *Newsweek* suggested "he's too popular with the wrong people," and Gerry Conway was quoted as saying, "I could definitely see it might be time for him to step back for a bit. Not because there's anything necessarily wrong with the character, but given where we are right now in our society." With regard to Marvel's mounting problems with unlicensed products, Conway suggested that the "promoters of these are all fly-by-night, you know, Etsy kind of companies, and it would be like whack-a-mole" to pursue legal damages.[20]

Prior to these Trump-era controversies, creators confronted a different set of challenges: that of hitching Frank Castle's old-school persona to a neoteric social climate. Although Castle rails that "the world's been going to hell in a handbasket my whole life,"[21] violent crime in New York City and other major metropolitan areas was significantly lower in the first two decades of the twenty-first century than the closing decades of the twentieth. This welcome trend fostered a new-found willingness on the part of voters and politicians to reconsider tough-on-crime policies. Support for the death penalty, for example, "reached a forty-year low in 2016."[22] Attitudes towards the war on drugs softened. Entire categories of villains—couriers, dealers, growers—no longer yielded reflexive antipathy on the part of most readers. As a result of these broad shifts, the character's conception of what constitutes criminal activity evolved, even if his stance towards crime as an abstract problem remains fixed.[23]

Sex trafficking, for example, was for many years barely on Frank Castle's radar and yet inspired "the darkest Punisher story ever,"[24] Garth Ennis and Leandro Fernandez's "The Slavers" (2005–06). While this six-parter has flashes of humor and moments of vengeance, it mainly offers a bleak look at a business in which "a person can be sold and resold, used indefinitely."[25] Rather than emphasizing wrath's power, the story highlights compassion. It ends not with the hero but with Viorica, a waitress in Brooklyn. Her "old life took its toll," the narrator explains. "Some days are good. Some days aren't. All she can do is live what life they left her."[26] Human cruelty is an important theme in vengeance entertainment, both as an incitement to vigilantism and as a weapon in the vigilante's toolbox. But what counts as cruelty is a moving target.

Politically motivated crime, part of the storyverse from the outset, has only grown in importance. Before the *Circle of Blood*'s Trust, there was the International Industrial Alliance. Before Humans Off Planet, there was Green Planet. Religiously motivated terrorism arrived in a 1988 two-parter in which a "pair of Arabs" conspire to drop a dirty bomb on Times Square and "blow a hole in the American dream."[27] "Long live the revolutionary jihad!," their ringleader shouts.[28] With an assist from Rose Kugel, Castle foils their scheme with mere seconds to spare. In the more typical stories from this period, the chief threat to domestic tranquility was posed by heroin and cocaine traffickers who sometimes partnered with high-ranking officials. These villains tended to be secular and capitalistic in their thinking, and self-destructive in their behavior. This way of framing geopolitics would come to seem outdated by the early 2000s.

While only a handful of Punisher stories reference the fall of the Twin Towers, the franchise benefited from fears and anxieties that the 9/11 attacks engendered. At the very least, religiously motivated terrorism and its destabilizing impact on international relations became a convenient plot point. Few readers would have supposed that a lone wolf could wipe out a dispersed adversary like al-Qaeda. But the group's catastrophic acts of terrorism handed Frank Castle thousands of new reasons to unleash his inner id. If in an era of declining crime rates and the Global War on Terror, Marvel had simply recycled drug war and street crime storylines from the days of Baron and Dixon, readers would have felt cheated. As the Punisher himself notes during a late-night perambulation:

> Times Square is filled with tourists. The park is filled with cops. Not five years back I could've gone to either and been up to my eyes in scum. Tonight I may as well've stayed at home. Giuliani's got a lot to answer for.[29]

Yet, only a few months later, Castle lets a neighbor know that she's "right about this city." It is indeed "a bad place. Bad things do happen."[30] He then muses about how "the old New York is waiting just below the surface." Giuliani "chased away the monsters—chased them out to Brooklyn and the Bronx. Don't think this place has changed."[31] "New York has always been hell," Castle concludes. "And every once in a while it's a weirder, worse hell 'cause of %$@# from someone in a cape."[32] Or as Nick Fury scornfully observes in a *PunisherMAX* title,

> There may be fewer hookers in Times Square, but the same wheels of vice and murder that turned before are still turning now. The rich are richer and more crooked than

ever. Corruption is still the rule of the day. The strong still strangle the weak every fucking chance they get. And nobody does a goddamn thing about it.[33]

So much, then, for America's Mayor.

Getting the joke

The second production cycle centered around Garth Ennis and his collaborators, artist Steve Dillon, editor Nanci Dakesian, editor/writer Jimmy Palmiotti, and editor/artist Joe Quesada. While their version of Frank Castle still preferred decisive lethality over due process, the character now manifested an absurdist aspect that previous creators had eschewed. The first cycle achieves a kind of pulpish modernist realism, until its final act at least, whereas Ennis and Dillon opt for cheeky jokes, glossy visuals, and postmodern bombast. Their storyverse offers a giddy fantasia in which sadism, machismo, and gore serve comedic rather than ideological ends, and the grim and trigger-happy templates are fused.

Ennis himself described his approach as "a kind of souped-up Road Runner cartoon with added Armalites."[34] Readers were mostly delighted with the Ennis-Dillon run, with exceptions. *Front Page Magazine* fumed that

> Ennis and Marvel prefer to live in a vulgar world of leftist fantasy, where an evil American government allied with greedy multinational corporations is the enemy of humanity. If such self-hating beliefs are allowed to permeate the popular culture unchallenged, if our strength of will is sapped before we defeat our real enemies, our very survival may be jeopardized.[35]

The fan-favorite fourth series pits the hardboiled vigilante against adversaries who map the zoological extremes of human behavior rather than the decomposition of civil society. "Welcome Back, Frank" was not only the title of its inaugural issue but a window onto the creators' ambitions. No more seraphs, demons, or memory loss: this Castle was out for blood. "No one knows better than I do that everything must be viewed in its appropriate sociopolitical context," the Northern Irish writer deadpanned. "I can see why Frank's little hobby *might* be viewed as requiring *some* kind of justification." But "only by morons," he added:

> That's what I'm going for with this series, folks. Entertainment. Plain and simple. No complex analysis of the causes of crime, not a portrait of one man's tragic descent into murderous psychosis, not an in-depth examination of the vigilante down the

ages. Not the recipe for Coca-Cola either, come to that. Just a laugh, a thrill, and plenty of sustained automatic weapons fire for your buck.[36]

Intent on sending a message to the criminal underworld, the "warrior who has shed more blood than almost any other man"[37] goes after the grisly Gnucci syndicate. He tosses one Gnucci off the Empire State Building and traps the family matriarch in the polar bear exhibit at the Central Park Zoo. "Let's just pause to savor the moment," he jests, as the bears advance on the terrified crime boss.[38] Once Ma Gnucci recovers from her injuries, the now-limbless mafioso hires the best mercenaries she can afford, most notably the Russian, "a walking death camp."[39] The Russian delivers a pounding, but our hero rallies. He severs the Russian's head, storms the Gnucci compound, and dropkicks Ma into a burning building.[40]

These freakish set pieces are offset by a kindly supporting cast—the Punisher's neighbors, Joan, Spacker Dave, and Nathaniel Bumpo, along with detectives Molly von Richthofen and Martin Soap, who are assigned to the Punisher Task Force. All five are saddled with eccentricities. Joan is longanimous yet attracted to Castle's grit, Spacker Dave is an extrovert with facial piercings, genial Mr. Bumpo has health issues, and von Richthofen is a wiseass. Soap is a walking punchline and the butt of most of the humor. In the fifth series, Soap hooks up with his sister and has an affair with his alcoholic mother. The fact that he propositions von Richthofen, an uncloseted lesbian, only adds to his pathos. In the epilogue, he finds redemption as "a major star in the adult film industry."[41] This helps Soap to move on from the guilt of having spent two years feeding "police intelligence on the mob" to the ostensible target of his Task Force.[42]

While this eccentric cast provides ample scope for comic relief, Joan and the others also serve to remind Castle (and perhaps readers) that there are still good people in this world. Carl Schmitt, after all, never argued that friendship is an illusion or that hell is other people. The nihilistic assumption that "we spin hopelessly on this violent rock"[43] is the Punisher's, not Schmitt's.[44]

But if neighbors can be allies, the same cannot be said of those who aspire to follow in Castle's footsteps. His attitude towards his would-be imitators is pitiless. Consider his treatment of a trio of New Yorkers who label themselves the "Vigilante Squad." The "smooth and well-spoken"[45] Elite protects his neighborhood's real estate values; Payback executes corporate honchos in their "fancy boardrooms;"[46] and the Holy hacks "a man to death in the confessional."[47] Joining forces, the three men set out to "lead a crusade to cleanse this city of its sin."[48] But they squabble over the root cause of crime. Is it the lazy poor, the greedy rich, or our fallen nature? When the Punisher tracks them down he offers his own theory of justice by killing them. *"Isn't this exactly what you want?!,"* the Holy pleads before Castle opens fire. "No," he curtly responds.[49] As the Punisher observes

FROM PRINT TO SCREEN TO ICON

elsewhere: "Vigilantes. Last thing this city needs. Some psychotic playing judge, jury, and executioner."[50] Ironically enough, this is something that DC's softhearted hero Animal Man might also say, especially since his storyworld is haunted by the specter of Punisher-style vigilantism, as reflected in Brian Bolland's cover illustration for *Animal Man* #38 from August 1991 (Figure 6.1).

Readers largely embraced Ennis' synthesis of "violence and humor."[51] "I loved issue #1," wrote Michael L., especially "the page where Frank twists that thug's neck, pours gasoline all over everything and blows up the building!" Tim D. was

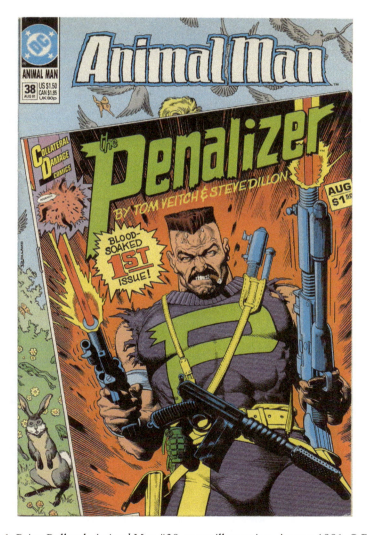

FIGURE 6.1: Brian Bolland, *Animal Man* #38, cover illustration, August 1991. © DC Comics.

209

equally enthused: "*$#*@ YEAH!*"[52] "I just wish that Marvel would allow a little more bloodshed," griped Sam B., "but besides that everything is OK."[53] "This is definitely the best writing that Frank Castle has seen in a long time," chimed Bryant M.[54] "Frank is back on his game," concurred Karl K., and "no spiderfolk, daredevils, kingpins, or any other socialist heroes/villainous scumbags can stop him from practicing his own brand of urban renewal."[55] The phrase "socialist heroes" is suggestive but imprecise. In some contexts, "socialist" would refer to militant, class-centered politics. Here it most likely refers to the commitment of heroes like Spider-Man and Daredevil to universalistic values such as human rights and the rule of law. Ironically, Castle is generally quite responsive to a class conscious perspective; it is universalism he finds unpersuasive.

Another reader, who went by the name Trifunkle, was far more critical about what Ennis and Dillon were up to:

> You're glorifying violence. I know you don't mean to, but let's be honest. You really are. Everything in this book is funny. Every time the Punisher or someone else shoots somebody, it's funny. Every time he breaks somebody's neck, it's funny. Violence isn't funny. Yeah, it's fun to watch when it's not real, but still, I think you should be taking the Punisher theme a little more seriously.

"What Garth and Steve do is called black humor and something sorely lacking in today's comics," Nanci Dakesian responded. "You get the joke; do you feel that others won't?"[56] The first production cycle has an earnest quality; the second exhibits a cynical undertow.

What I resemble

Joan, Spacker Dave, and Detective Soap return in the fifth Punisher series (2001–04), as does the Russian, whose lifeless head was somehow attached by a "secret paramilitary agency" to a headless female body coated in a hard alloy. "Soon, I am built like Kazakhstan outhouse!," the resuscitated villain boasts.[57] An exhausted Castle finally straps the Russian to a nuclear bomb and drops them on an island full of "mercenaries, criminals, psychos, whatever."[58] "You and I have much in common," the Russian happily exclaims, moments before the device detonates. "Both always popping up when we are least expected!"[59]

Carnival mischief supplies the comedy, but New York is at the series' heart— more so than in the Baron years, certainly. Returning Castle to his native habitat was the savviest decision Ennis and company could have made. Ennis writes about the city with a condemnatory affection, skewering its yuppies and con artists,

delighting in its energy. His heartfelt story "Do Not Fall in New York City" reached stores just after the NYC "got hit harder than it ever has in its existence, and stared into the abyss, and shuddered."[60] Ennis admits to thinking, *"you'll never be a real New Yorker,"* but then says, "After the last two weeks I'm really not so sure."[61] To date, "Do Not Fall in New York City" has been overlooked by the secondary literature on cultural responses to 9/11, due perhaps in part to the Punisher's unappetizing reputation.[62]

Tim Bradstreet's cover offers two perspectives on Manhattan—right-side up, and upside down—with only the Towers to connect them. As the story opens, the Punisher is navigating the crowds of midtown. Busy urbanites pay no attention to a homeless man who cries, "I just want to go *hooomme*." "No one cares about you when you're damned," Castle thinks to himself. "It's the discomfort and disgust that your misery awakens in them." He spends the remainder of the issue tracking down a war buddy who gunned down his ex-wife and their three children. His friend

> never became a junkie, or a whiner, or a nutball loner with a cabin full of guns in Arkansas. Or a vigilante, who might have got a taste for something bad that night on the hill. He fought his war and came back home, and he tried and he tried and he tried for thirty years until he'd nothing left inside him ... Nothing to show for it ... Nothing to help him slam the brakes on when the darkness fell.[63]

Playing a hunch, Castle tracks him down at the Statue of Liberty. The vigilante shoots but then hugs him, saying, "It's okay, Joe. I caught you."[64] Punishment leavened not with mercy but the empathy of brotherhood. The invocation of catching and falling was inspired, of course, by the tragic spectacle of office workers jumping to their deaths from the burning Towers. Since 2001 when letter columns started disappearing from comic books—a victim of the internet—it is difficult to gauge how fans responded to this issue.[65] Yet it holds up better than many of the graphic narratives whose 9/11 references were explicit rather than implied.

Mature readers

The sixth series (2004–09) wields a gloomier palette than the Gnucci arc but is just as corrupt and shameless. It constitutes the brooding second half of the second production cycle. Garth Ennis penned most of the sixth series. The main pencilers are Dougie Braithwaite, Laurence Campbell, Leandro Fernández, Lewis Larosa, and Goran Parlov. Their artwork is more sedate and realistic than Dillon's, even if the scripts still have an exaggerated, larger-than-life aspect.

The series introduces Barracuda, who ranks with Jigsaw as a Punisherverse villain of the first order. If Jigsaw mirrors Castle's fractured psyche, Barracuda echoes his brutishness. This formidable character also reflects Ennis' signature taste for anti-PC comedy. Barracuda has an easy smile, a rapacious appetite, and a shocking indifference to the suffering of others. The blogger David Brothers describes Barracuda as "one of those characters that you can call 'problematic'. 'Stereotypical'. 'Ignorant'. 'Racist'":

> the essence of the mandingo: hypersexed, hyperviolent, and just waiting for a chance to put his hands on everything you hold dear and taint it. He is every "black male" on your evening news, every "big black guy" your friend ever told you about fighting, every bogeyman who ever broke into your house or stole your car, and every dude that ever made your mother clutch her purse in an elevator. You remember all those stories about the Superdome after Katrina? He was behind all of it. He's even built like a big gorilla, all muscles and glower.

"The problem," Brothers writes, "is that Barracuda is probably the best black villain in years. That may be damning with faint praise, since I can't think of another single significant black villain in mainstream comics, but it's still true."[66] Barracuda does indeed have a memorable quality, even if the list of black villains in superhero comics is surprisingly (or perhaps not surprisingly) long.[67]

Punisher writers often go out of their way to avoid anything that might be construed as having a domestic racial dimension, even when their treatment of, say, Central Americans or Middle Easterners is cavalier. In this context, racial animus is not so much jettisoned as muffled and transferred. This helps explain why images of white punks with mohawks "balance" equally offensive but far more loaded portraits of non-white gang members, and why African-Americans feature in respectable yet underwritten roles such as shopkeepers, police officers, and public officials. The social worker Jennifer Cooke, who treats Castle with wary and intelligent respect, is arguably Ennis' most successful attempt to create an African-American character who is nearly as fully realized as the main protagonist. To say that Barracuda presents a more complicated case than Cooke would be an understatement.

When asked about the character, Ennis acknowledges that Barracuda has "a big personality" and that "he sometimes tends to dominate events, even overshadowing Frank to some extent."[68] Ennis' aim with the character seems to have been to ridicule stereotypes by ratcheting them up so that the reader has no choice but to confront them. Ennis may have assumed that his status as a non-American lent him an objective vantage point from which to assess and mock the pretensions and hypocrisies of the Yanks. "These are your stereotypes, not mine," seems to be his general attitude. It nevertheless seems unlikely that Marvel would greenlight these comics today, even though the Barracuda stories have all been reprinted and remain in stock.

The Punisher first meets this glowering bogeyman in Miami, where he learns about a company that is planning to "black out Florida" in order to cash in on energy futures. Seasoned readers will already be aware that Frank Castle believes that "corporate crime is a long way from the street."[69] But when he encounters Barracuda, the company's hired mercenary, his interest is piqued. Their first fight offers one of the most gruesome brawls in the entire Punisher corpus. Barracuda pounds away at Castle's face and torso, while Castle chops off a couple of Barracuda's fingers and knifes one of his eyeballs. "It is *on* now, muthafucka,"[70] Barracuda promises, as he tosses our hero into shark-infested waters.

After leading a sordid *coup d'état* in *The Punisher Presents Barracuda* (2007), Barracuda is keen to "pay a visit to a certain skull-wearin' muthafucka in New York."[71] He tracks down and kidnaps the daughter that Castle unknowingly conceived with former CIA agent Kathryn O'Brien. O'Brien is the most consequential of Castle's liaisons. They hook up in New York, and later in Afghanistan. After they spend their last night together, she steps on a landmine and bleeds out in his arms. "Right when I was starting to like her," he says, with the requisite note of stoicism.[72] Kidnapping O'Brien and Castle's baby girl proves a fatal mistake, which Barracuda finally grasps when he gets shot in the face. After spending a few precious hours with his young daughter, Castle realizes that "Whatever it was that let me disconnect was gone. Here—instead—was how it felt to be a parent. To be a human being." He reluctantly leaves Sarah with her Aunt and drives off into "the shadows of America. Through the long, cold dark night that I've made of my life."[73]

The production cycle's final entry is the 2009 miniseries that brings back Molly von Richthofen and a gaggle of pretend Ma Gnuccis. Obsessed with the "man who killed my father,"[74] the son of the Vigilante Squad's Elite is just as annoying as his late patriarch. "God, how I hate poor people," he gripes. "Standing in my path with hands stretched out, expecting me to give them money: my money, the money I inherited from dad."[75] This scion of privilege tries to break Castle psychologically by manufacturing pseudo-Gnuccis out of "accident victims, Iraq war vets" and women who were "just *born* like that."[76] "Some of 'em needed a little, uh, *extra pruning* on toppa the plastic surgery an' the silicone implants," a complicit doctor explains. "But with what he was paying their families, they could give a crap, you know?"[77] Von Richthofen cheekily asks if Castle's "ever been in a firefight with a lesbian before," as they take on creepy Elite Jr. and his crew. "Here's your chance to show me what I've been missing,"[78] he smirks. Their scenes are not quite parodic and yet they reach for laughs in a way that would have been unthinkable in the era of Baron, Dixon, and Grant.

Garth Ennis dives further into Frank Castle's tangled relationship with sexuality, violence, and rage in a trio of graphic novels that anchor the second cycle.

In *Punisher/Painkiller Jane* (2001), Castle becomes entangled with the femme fatale Jane Vasko. "What was it about him that made me go weak at the knees?," she asks. "Was it the rugged good looks that seemed to 've come from a baseball bat? The cold lifeless glint in the eyes?" She pesters Frank until he succumbs to her charms. "If you get what you want, will you go away and never bother me again?" "Yeah!" she says, delightedly. The next morning, she smiles into her coffee cup. "I'd never see him again. But I knew that in my heart he'd always be mine. My Punisher, now and forever." For Castle, the whole thing seems like a bit of an imposition.[79]

In *Punisher: The Cell* (2005), the Punisher instigates a prison riot at Rikers in order to toy with and then gut the men who orchestrated the deaths of his family. "It's because of you," he says as he gets to work, "that it is a war. Men like you, arrogant enough to think the streets are yours." A reasonable sentiment, perhaps, but the comic itself mostly offers torture porn.[80] The first graphic novel hints at what the second makes plain, which is that Castle finds greater satisfaction in violent retribution than anything else, including sex.

The deepest of the three cuts, *Punisher: The Tyger* (2006), opens with our hero on a Brooklyn rooftop, preparing to execute "the entire top echelon of New York's foremost crime family." It is his first rubout. "They'll blame it all on Vietnam," he thinks. "And they'll be right. And they'll be wrong." He flashes back to the summer of 1960, and his first crush, Lauren Buvoli, who "belongs in my old life, when the world was still a thing worth fighting for." He later discovers that Lauren had "take[n] a razor blade and open[ed] up her arm from wrist to elbow" after she was raped by a mob-connected lowlife named Vincent. One summer evening, while spying on Vincent, he watches as Lauren's older brother kidnaps the fledgling gangster, tosses him in an empty grave, and sets him alight. "I know what the world needs now," Castle vows. "Same thing it's needed all along." He takes out the echelon and utters a chilling closing line: "And I show the world a face not made by God."[81]

Price to pay

The writers who followed Ennis framed the Punisher's relationship to the MU in various ways. Matt Fraction and Rick Remender "grounded Mr. Castle's handsome visage in the Marvel Universe proper,"[82] while Nathan Edmondson, Matthew Rosenberg, and Greg Rucka sprinkled special guests into their stories. Jason Aaron, on the other hand, placed Castle at the center of Marvel's non-canonical and superhero-free MAX universe, which is a "different, and quite filthy, universe."[83] Referring to the Punisher's relationship to the two universes, the MU

and MAX, Iron Man muses about how it is "almost like he inhabits two worlds, one where heroes can capture him and one where they can't, and he can slip from one to the other with ease."[84] Meanwhile, Becky Cloonan kept the Marvel *and* MAX universes at bay. The voices of individual creators are in evidence, but there is a *pro forma* quality to this era. A once-vibrant connection between plot threads and political events had frayed.

If the highs were not quite as high, the lows were not as low, in terms of both scripting and artwork. Steve Dillon was only one of several capable artists who tackled the character in this period.[85] But there was a great deal of creative turnover. The 2007–09 *Punisher War Journal* relied on seven artists, and Remender's *Punisher* (2009–10) used ten.[86] While the inconsistencies can be jarring, both series have their flashpoints. In the seventh, Castle runs up against Hate-Monger, who proclaims that "*America* is for *Americans*."[87] Castle is in his Captain Punisher phase. His costume includes "flame-retardant light armor plating ... ceramic plating for some real basic psionic interference, jerry-rigged sensor scramblers wired up the back ... thermal and night vision." Steve Rogers "may have hated my guts," Castle admits, "but I guarantee he'd have hated a warped little *Nazi* like *Hate-Monger* even more."[88] Before stabbing the neofascist in the chest, Castle endures a boatload of supremacist rhetoric:

> This place used to mean something back before you tortilla-loving *race-traitors* decided that living here was a *right* and not a privilege. And you dare to call yourself a *patriot*. You're more like a *pimp*, Frank. You and your kind *whore out* everything that makes America—that makes the *white race*—great and powerful and holy. Did you think putting on your little *costume* would change that?[89]

As before, the presence of a supremacist ideologue underscores the Punisher's antipathy towards ideology in all its many forms. There is nothing Castle despises more than a murderer with an agenda, even if his own storied career points in the same direction. Remender's villains are mostly apolitical, however. His priorities are reflected in the supplement to the first issue, which recounts Castle's run-ins with costumed adventurers but says nothing about his war on crime.[90]

The series' least predictable aspect is Castle's testy relationship with a hacker named Henry, who espouses a straight edge lifestyle. "All I have to look forward to most days is ending the life of a violent perpetrator—and my morning beer," Castle pleads, which makes him come across like a high-functioning alcoholic. (This idea is far from outlandish but it is also inconsistent with earlier incarnations of a character who displays a remarkable degree of self-discipline.) "It's a *crutch*, man," Henry retorts. "It's a drug. Same as caffeine, cocaine or pot. Didn't you

used to spend a lot of time hunting drug dealers?" As Henry pours out Castle's last can, their conversation gets testy:

> "No morning beer but I get another unsolicited self-righteous ... what do you call it? ... *straight-edge* lecture? Next up is the PETA speech?"
>
> "I'm not looking to give you some list of *rules*, especially about *animal rights*. Hell, you kill *people* without compunction ... What hope does a cow have?"
>
> "*None*. Now *pack in* the limp-wristed public service announcement and give me today's schedule."

When Castle discovers that Henry is none other than "*Jigsaw's bastard kid*," he severs their partnership.[91] This proves a mistake. When Henry tries to warn him that Norman Osborn has placed the Punisher on his hitlist,[92] Castle decides that the kid might be "in on it" and deposits the hacker in a dumpster. His stubbornness proves fatal when Osborn's prized assassin, Akihiro—also known as Daken, who is Wolverine's son—carves him like a turkey. "Maria watches from someplace," the fading hero muses. "She's waiting for me." "Bleeding out, *far from home*," Daken taunts. "If I didn't know better ... I'd say you look *relieved*."[93]

The Punisher's second in-canon fatality proves as short-lived as the first. Morbius the Living Vampire uses a magical bloodstone to reconnect Castle's body parts and transform him into a Frankenstein monster. Morbius' aim is to create "a tactician—a soldier"[94] who can protect his friends from those who would rid the world of goblins, mummies, mermaids, werewolves, dragons, and black lagooners. "Humans go to *great lengths* to slaughter those who are *different*," one mummy explains. Yet "*most* of all ... we want to be *left alone*." "That's *one thing* we've got in *common*," Castle admits. "I only ever wanted to rid the world ... of monsters," the chief monster-hunter pleads before Castle tosses him into Limbo. "All you did was create new ones," replies one of the monsters, which holds true for the Punisher as well, broadly speaking.[95]

Franken-Castle divided fandom. Remender himself boasted that, "We have made *Punisher* a terrific comic book that is willing to allow imagination and unpredictability to dictate its course as opposed to producing more of the same thing we've seen a million times before."[96] But reader Deacon T. was unconvinced: "Here is the shark. Here is Frankenstein Castle. Jumping o'er said shark."[97] Letter writer K. A. admitted, "I tried to be open-minded about this and I can't wrap my mind around it. Even in a comic book universe, certain things do not make sense for certain characters."[98] David W. predicted that Franken-Castle "is destined to become at best irrelevant—simply filling in the space between Frank's death at the hands of Daken and his inevitable resurrection and return to more traditional surroundings and methods."[99]

David W. may have been onto something. Editor Sebastian Girner promised that "you won't see Frank waking up one morning in his skull-jammies to find out it was all a dream,"[100] but given how quickly the writers dropped any mention of Franken-Castle it might as well have been. Conflicts with other heroes, on the other hand, are a perennial fan favorite. After fighting alongside the Legion of Monsters, Castle once again battles his would-be tormentor Daken. And since Daken has his father's healing powers, and Franken-Castle is composed of metal, bone, and rage, their fight is savage. "You're a hack, an aging B-list starlet," Daken roars. "Reputation coattail rider, dressed up like someone else, lecturing me about overcompensation," Castle spits back.[101] His plan to drown Daken in wet concrete goes south once papa Wolverine shows up and Daken makes his escape. "I can't have you killin' my boy," Logan explains.[102] Daken has subsequently battled the Avengers, the Fantastic Four, the Runaways, and his own father. His inevitable rematch with Castle has yet to take place.

Thanks to the miraculous bloodstone, Castle's features are restored by the time he returns to the Big Apple.[103] Before he can get back to business, however, Jigsaw manages to lock him in a room with a reanimated version of Micro (!). "When [skilled sorcerer] the Hood offered to bring back our kids, your wife ... I really thought you'd be happy," Micro whimpers. "Figured we'd all be having a barbecue poolside, our kids playing."[104] Castle slips out of his chains and slits the morally compromised tech genius's throat. Afterwards, Castle tells Henry, "You're weak. Easily duped ... If I ever see you again—I'll kill you." Only later does he appreciate that Castle is actually doing him a favor.[105]

Pick up the pieces

At the core of the Aaron/Dillon *PunisherMAX* series is its unsettling depiction of Frank Castle's family life following his final tour of duty. As Jason Aaron points out, Castle's "home life has always been idealized."[106] Aaron is one of the first of Castle's writers to suggest that the decorated Marine might have felt estranged from his loved ones and suffering from PTSD. "I moved through the house like an astronaut lost in an alien landscape," Aaron's version of Castle recalls. "My family were bizarre creatures I didn't know how to communicate with."[107] In this iteration, Castle was on the brink of asking for a divorce when his family were gunned down:

> The thing that haunts me now isn't the moment they died. The moment my daughter's belly exploded and my son's brains came out the back of his head. No, it's the moment right before that. When I had everything ... and I threw it all away. There

was a time when I wished I'd died with them that day. But I know the reason I survived. It wasn't so I could seek revenge in their name. So I could wage my little war. It was so I could suffer.[108]

These intriguing questions about the vigilante's motives were dropped by successor series in favor of carefully paced action sequences and predictable quarrels. In Greg Rucka's tightly wound eighth series, Castle takes down conspirators with an interest in high-tech weaponry. He is aided by the grieving widow Rachel Cole-Alves, the sole survivor of a wedding party shootout and the "third woman to be awarded the Silver Star since World War II."[109] Cole-Alves becomes the second female Punisher—or the third if we count Marvel's "Geisha from Hell" who protects Tokyo from gangsters and bandits[110]—and she expresses none of the ambivalence that keeps Lynn Michaels from fully committing herself to the cause.[111] Frank Castle's true protégé bravely calls him a "good boy" when he shoots right through her in order to hit Baron Nemo, who is holding her hostage at the time.[112]

Rucka also penned a limited series in which Spider-Man tells his fellow Avengers that, "this has gone on for too long, guys!"[113] and convinces the illustrious group to hunt Castle down. Frank eludes the Black Widow, but Thor tracks him to a remote village in Indonesia. "Your *life* is battle and *nothing* more," Thor tells him. "The *blood* roars in your *ears* and the *song* of it plays in your heart. What *began* in *pain* and *rage* is now *lost* in that *sound*." Castle insists that "I fight in a *war*," but Thor retorts, "You have made a *war* so you may *murder*,"[114] As the series closes, Castle is sealed in an underwater prison designed by Tony Stark, "500 meters below Lake Michigan."[115]

The published letters were positive. "I'd compare Rucka's take on the Punisher to a natural disaster. You watch in awe at the incredible destruction but respect its lethal presence," wrote Aaron. Eric O. delighted in the ninth series' "perfect mix of good, old-fashioned comic action with just enough visible violence that you know what title you are reading." K. A. described the writing as "smart and action packed and suspenseful."[116] "Very gritty," enthused Alyn H.[117] Marc G. said that "Rucka moves soft on his shoes like a great fighter,"[118] and Richard A. praised the series' "raw and gritty violence."[119] "We don't get much negative mail about Punisher," noted editor Stephen Wacker,[120] but he did publish one letter that complained about Castle's "well maintained hipster beard."[121]

The Punisher next turns up in the 2013–14 *Thunderbolts* series. General Ross puts together a group that can strike "without consideration for *political allegiance* or *stature*."[122] Deadpool dubs them "the selfish Avengers."[123] When they fall apart, he gets the last word. "You put together a team of loners!," Deadpool tells Ross. "A team! Of. *Loners*! What a terrible idea!"[124] *Thunderbolts* features

Castle's longest romantic relationship since Maria—a sexually charged affair with Elektra that lasts for a full 25 issues. "From the first time I saw her, sticking her *sai* through Figsy Goleano's skull, I couldn't get Elektra out of my head," he recalls. "I felt something I can't remember the last time I felt. She was like a hurricane." The feeling is mutual. "For an unstoppable engine of violence, you can be very sweet," she whispers.[125]

By the ninth series (2014–15), Frank Castle is trailing a drug cartel with access to weapons-grade chemicals. The cartel shuts down the Los Angeles electrical grid and foments riots in hopes of uniting "the gangs of the United States under one banner."[126] The police are helpless against this "foreign army."[127] Castle learns that high-ranking officials have been giving the cartel weapons. Under torture, the Secretary of Defense admits that Americans needed to be "reminded why they need the government." "Murder is an unjust killing that serves no end," Castle says, as he leaves the traitor bleeding in Arlington National Cemetery.[128] He then decides to focus on the "stratum of criminals too small for the heroes, too vicious for the police."[129] It is all a bit of a muddle.

The series' most striking aspect is its heavy-handedness. "The crooks on the street, they feel more and more bold with each cop killed," complains one police officer, before the rioting starts.[130] "Rehabilitation. What a joke," snorts Castle. Prisoners are "animals" who "don't deserve to be treated as people anymore."[131] "The have-nots think their time has come," he later says, with contempt in his voice,[132] and the criminal class 'needed an excuse, an excuse that became *their* banner, a banner of anarchy and avarice."[133] With one exception—a police officer who is driven insane by the gang violence that she blames on Frank Castle—the soldiers and police are uniformly heroic, while the villains are white liberals and Hispanic thugs. Any semblance of ambiguity or nuance is bleached out. Mike Baron and Chuck Dixon, who like Edmondson identify as conservatives, handled political themes with a lighter touch. Reader Eli B., who criticized the Edmondson run as "misguided and vaguely jingoistic," pointed out that the "memorability of Mike Baron and Garth Ennis' tenures on the title are tied to how those writers related America's national loss of innocence in Vietnam to the bitterness and sorrow fundamental to Frank Castle's character."[134]

Becky Cloonan's tenth series revolves around a crime syndicate whose toxic compound "gives its users enhanced strength, reflexes, and insensitivity to pain."[135] While the drug angle does not exactly break new ground, the setting provides a change of pace. Cloonan told an interviewer that "I grew up in New Hampshire," and she enjoyed the opportunity to "take the Punisher and fans through New England and the countryside." The scene in which locals try to ambush Castle is strangely gratifying. "Punisher ain't so tough, dealing with &$#%-ass city-boy gangsters. Let's see how he handles a *country* throw-down, boasts one of the men.

"He thinks he can take us? On *our* turf?! Not on my watch," the townie rants, moments before hot metal smacks him in the head.[136]

This scene is somewhat atypical of the Cloonan series, however, in that she mostly has Castle use found objects such as broken bottles and cinder blocks to deal with his opponents. "I'm not a gun person or know much about them," Cloonan admitted. "I really wanted to see what would happen if you took Frank Castle out of New York and away from his guns. He gets very creative with his use of weapons."[137] Reader Taylor Y. suggested that "Becky's Castle sits somewhere between classic Punisher and Ennis' vision of him,"[138] while Allen V. praised Cloonan for knowing "how to deliver the gore, violence, humor and even $%&@ (LOL) in every issue."[139]

Matthew Rosenberg, the writer of the eleventh and twelfth series (2017–18; 2018–19), grew up after the era of

> *The Warriors, Death Wish*, or *Taxi Driver*. My New York was still full of guns, drugs, and violence, but it was also a place where parents didn't have to be afraid to let a nerdy little %$@# like me go to the comic book shop by myself every week.[140]

The eleventh and twelfth series feature artwork by Guiu Vilanova and Stefano Landini respectively, both of whom excel at drawing faces, machinery, and desolate landscapes. "I spent over two years of my life with the Punisher living inside my head," Rosenberg says. "In all that time I don't think I learned any more *about* Frank Castle than what I knew as a kid. But sometimes I worry I learned a lot *from* him." He "scares the hell out of me," he added, but it is "impossible not to respect him."[141]

Real or showbiz

The brand is always extending. The print volumes alone present a wealth of options. There are now Complete Collections, Epic Collections, Essentials, MAX titles, team-ups, standalone graphic novels, guest appearances, and flimsily-bound collections from the 1980s and 1990s. And there are many different *kinds* of Punisher stories. Between 2010 and 2020, the character was a soldier, mobster, monster, bartender, Geisha, team player, and the last man on earth. He climbed mountains, served time, tripped his brains out, nuked an island, pursued relationships, navigated jungles, killed a marine buddy out of love, wore futuristic tech, and drop-kicked a limbless woman into a burning building. He inspired imitators, tortured politicians, killed ideologues, and denigrated humanity. He navigated the Marvel, the MAX, *and* the Ultimates universes. Although his stories

were sometimes fantastic, his status in the subculture was secure. Furthermore, his visibility beyond the subculture was growing.

Bricolage and pastiche are integral to the recent phase of the character's print-based adventures. Even before the advent of the multiverse, it was possible to write and draw Punisher comics in which the character dressed up as a cowboy, vampire hunter, or futuristic cop.[142] In recent years, the variations and reimaginings have gone in all sorts of directions.

In the 2005 House of M storyline, for example, Frank Castle saves his family from mutated mobsters and lands a job with the FBI's organized crime unit. "The news is calling you the *Punisher*,"[143] his recruiter crows. In *Punisher Noir* (2010), it is 1935. When grocer Frank Castle loses his family to a mob hit he dons a mask. Dutch Schultz is the city's top gangster, Martin Soap is the city's top detective, and Jigsaw and the Russian do their thing. *Space Punisher* (2012) is about "one man's quest for *vengeance* across a galaxy different than our own!" This Castle searches for the "six capos" who "secretly run the whole show."[144] He flies through space with a robot named Maria. His enemies include Dr. Octopus, the Green Goblin, and the Hulk. *Punisher: Nightmare* (2013) features a vigilante named Jake Niman whose wife Denise and daughter Natalie are gunned down in Central Park. "The names are different," the narrator admits, "but the story's pretty much the same. It's like an echo."[145] In *Battleworld* (2015), Doctor Strange "hitched his soul wagon to my body after some vampires took a bite out of him,"[146] and in *Cosmic Ghost Rider* (2018) "a time-displaced *Frank Castle*" has "been infused with the *cosmic powers* befitting a *herald of Galactus!*"[147] In these stories the familiar mixes with the unexpected to produce something that looks fresh but feels samey.

Moving parts

For most of the character's history, comics and graphic novels—even minor efforts like *Battleworld* and *Space Punisher*—were synonymous with the metanarrative itself. To appreciate the character one had to keep up with the comics. Any other way of situating Frank Castle in relation to his cultural ecosystem would have seemed fanciful. Printed stories were where important events were recorded and debated. They were where cast members were introduced and killed off. Storylines, titles, and creative teams inspired ancillary product lines that in turn promoted the comics. Extended narrative allowed room for polemic and debate alongside the usual bombast and gun fights. Sometimes there were flashes of the unexpected.

In the twenty-first century, the once-inviolate hegemony of print-based sequential storytelling faces challenges on two main fronts, at least so far as the Punisher

is concerned. The first has to do with screens and the second with images. On the one hand, the success and appeal of Jon Bernthal's interpretation of the Punisher, the Disney/Netflix roster of Marvel streaming content, and rise of the Marvel Cinematic Universe itself has given rise to a new fan culture that is independent of and largely indifferent to the Marvel Universe as it exists on paper and in digital form.

While the character's printed history obviously offers a thicker backstory than either the movies or the streaming series, there is enough substance to the Disney/ Netflix version to satisfy the requirements of many fans. In contrast to the feature-length movies, which are disconnected from and tonally dissimilar to each other, the streaming version offers an immersive storytelling environment that connects Frank Castle to Daredevil, Jigsaw, Karen Page, Kingpin, Micro, and by implication Iron Fist, Jessica Jones, and Luke Cage. The 26 episodes of two seasons of *Punisher* (2017–19), plus twelve out of thirteen episodes of season two of *Daredevil* (2016), represent three dozen hours or so of commercial-free programming. This is in addition to the hundreds of hours of streaming series and movies that feature other Marvel characters. And of course, the potential profits are greater with screen narratives than with sequential ones.[148]

Equally dramatic is the growing reach and impact of the Punisher as unfiltered symbolism, detached from the demands of both narrative and brand management. While the shift from comics to screen affects how stories are created, distributed, and consumed, it does not threaten the power of storytelling or the authority of the storyteller. The emergence of the Punisher as a global icon is arguably a different matter, as it compromises the ability of Marvel and its personnel to sculpt the narrative or benefit from its dispersal. Autonomous imagery that insists that certain forms of violence are righteous by definition has the potential to eclipse serial narrative altogether, which at least potentially allows room for the clash of perspectives via letters columns, fan reviews, and creative turnover.

Ideologically charged decals, patches, and bumper stickers circulate in far greater numbers than ever before and have come to define the character. If this does not quite hold true for long-time comics readers then it applies to almost everyone else. The cultural meaning of the Punisher has been appropriated by political and commercial actors who have cunningly détourned the brand and its iconography. This "relinquishing of narrative control to society"[149] suggests that the ancillary has become primary, and the primary has become ancillary. In relation to the comics subculture, Frank Castle matters less than he used to, but in terms of wider political debates, he matters far more. Castle used to offer a kind of subcultural shorthand. He was sometimes a punchline. Today he augurs a bitterly contentious future.

Moving pictures

The triumph of the MCU means that all manner of MU properties represent potential cash cows. This applies almost as much to secondary cast members like Barracuda or Jigsaw as a feature player like the Punisher, who has sustained multiple series and is much better known. Even the most obscure and generic of properties have gained value in the wake of the triumph of the MCU. If a filmmaker decides, for whatever reason, that they like to include a youthful hacker in an upcoming Marvel movie—one whose father is a criminal and who craves the respect of the film's hardhearted antihero—he or she would not need to invent one. Henry already exists.

From the standpoint of companies like Marvel and DC, comics is a legacy and feeder medium that allows companies to rehearse scripts, plots, jokes, characters, set designs, costume designs, and adversaries without expending significant sums. As Jim Lee, DC Comics' Chief Creative Officer and Publisher, told an interviewer,

> Comics serve a lot of different purposes and one of them is it's a great way to incubate ideas and create the next great franchises. We want to continue that. Why would you want to stop that? Why would you want to stop creating great content that could be used across the greater enterprise?[150]

That said, none of the three feature films that have appeared to date—*The Punisher* (1989), *The Punisher* (2004), and *Punisher War Zone* (2008)—was a box office smash. From the perspective of the "greater enterprise," the most successful was probably the 2004 version, which had a $33 million budget, an opening weekend of just under $15 million, and worldwide box office revenues of around $55 million.[151] The first film had a modest budget ($9–10 million), and went straight to video in several major markets (including the United States). If we include non-U.S. box office receipts, licensing and broadcast fees, and physical media sales, the 1989 film grossed somewhere in the range of $30 million. With a budget of $35 million, *Punisher War Zone* had an opening weekend of less than $5 million and a global box office just north of $10 million.[152] In all three cases, physical media sales combined with broadcast/streaming rights generated more revenue than ticket sales.

For many critics and fans, the Netflix iteration is the most noteworthy, even if its relationship to the company's ratings and share price is difficult to determine.[153] Jon Bernthal's committed interpretation of the character was first introduced in 2016 as the "big bad" of the second season of *Daredevil*. His portrayal of an emotionally battered Frank Castle received favorable notices from both critics and fans. In fact, the first *Punisher* season is rated more highly by audiences on *rottentomatoes*.

com than any other Disney/Marvel show that premiered on Netflix. For many fans, Bernthal's interpretation of the character is the definitive version.

The 1989 *Punisher* movie is mainly remembered for Dolph Lundgren's wooden performance and for the fact that the character's familiar chevron only turns up on the handles of his throwing knives. The film was written by Boaz Yakin and directed by the veteran film editor Mark Goldblatt. In its opening scene, a news broadcast reveals that police officer Frank Castle and his family were murdered five years earlier and that since that time "125 mysterious gangland murders" have been "attributed to a shadowy figure known as the Punisher." Public officials insist there *is* no vigilante, but as a result of Castle's campaign, local mobsters are on the ropes and the Yakuza seize control over the city's crime networks. Car bombs detonate, strip clubs are shot up, and dozens of gangsters and Ninjas die from gunshot wounds. Castle himself drives a motorcycle and hides out in the sewers. Violent but not very angry, *The Punisher* is an overcooked B-movie that creates its own parody-ripe diegetic reality.

"I have never sat through the whole thing," Gerry Conway told one interviewer.

> Just the idea of Dolph Lundgren as the Punisher, please! It was shot in Australia, so it lacked the American feel. I still wonder how they could do such an over-the-top, comic book character and not have him wear his costume! That's what separates him from everybody else. I'm always amazed by studio execs.

Screenwriter David S. Goyer similarly complained that

> *The Punisher* was awful. He should have been the easiest Marvel character to film, you wouldn't have to change anything. I will never understand how they screwed him up—they didn't even keep his skull outfit. That was so stupid![154]

Equally questionable is the script's tossed-off quality: "Come on God, answer! Why are the innocent dead and the guilty alive? Where is justice? Where is punishment?"[155] If Marvel films come in two categories—those made by people who feel some emotional investment, and those who do not —then Lundgren's *Punisher* belongs in the second camp.

The 2004 reboot was directed by the filmmaker Jonathan Hensleigh in the vein of an urban western.[156] It features convincing performances by Thomas Jane, Will Patton, and Laura Herring, among others. In this iteration, Frank Castle (Thomas Jane) is an FBI agent whose efforts to take down a smuggling operation result in the death of the son of mob boss Howard Saint (John Travolta). The scene in which Castle's extended family—husbands, wives, aunts, uncles, grandparents, and grandkids—are killed in retribution is grueling. Castle gets his revenge in

ways that are ingenious, but viewers never really gain the sense that Jane's version of the character would devote himself to the cause of vengeance on a permanent basis. The idea that Jane's Castle would go after his family's killers seems plausible. The suggestion that the character would then wage war against criminals everywhere does not.

The Thomas Jane *Punisher* movie was filmed in Tampa, Florida to save money, just as the first movie was filmed in Sydney, Australia. It is shot in a "stark, graphic style" and in a "near monochrome," which is "established with the film's main title sequence, in which animated black-and-white drawings depict falling shell casings, which give way to expressionistic white blood cascading down."[157] "What we wanted to do with this," the director explained, "was take action movies back to what they were like in the 1970s and 1980s, without all the special effects, and make a real-life gritty picture."[158] The film recovers several characters from the second production cycle, including Joan, Spacker Dave, Mr. Bumpo, and the Russian. Thomas Jane's interpretation of the eponymous antihero is less sullen than Dolph Lundgren's and somewhat closer in spirit to the character's paraliterary roots. The graphic adaptation closes with the same lines as the movie: "Those who do evil to others, the killers, the rapists, the sadists, you will come to know me well. *Frank Castle* is dead. Call me ... the *Punisher*."[159]

Punisher War Zone (2008) reported the lowest box office receipts of any recent Marvel movie. It has become something of a cult film. Although *Punisher War Zone* (PWZ) is sometimes mistakenly referred to as part of the MCU, it was in fact a Marvel Studios production that was released a couple of months ahead of the launch of the Marvel Cinematic Universe with the first *Iron Man* movie. It features the Northern Irish actor Ray Stevenson in the title role, along with Wayne Knight as Micro and Dominic West as Jigsaw. Written by Art Marcum, Matt Holloway, and Nick Santora, it was directed by a female director, Lexi Alexander, a one-time martial arts champion.

This version of the Punisher is a former Marine who only derives pleasure from tracking down and killing mobsters. Ray Stevenson's Punisher is methodical, detached, and sluggish. His emotional palette is duller than Thomas Jane's Punisher, if less dour than Dolph Lundgren's. Castle is often given a laconic aspect and in this film he does not utter a single line until the movie is a third of the way over. It is light on justice discourse and heavy on brutality. The late Roger Ebert described *PWZ* as "one of the best-made bad movies I've seen," and the actor Patton Oswalt described it as

> the best time I've had at the movies this year. I've seen better films. [...] But I didn't feel like standing up on my chair and cheering. None of them made me cackle like a railyard hobo who's found half a cigar and a can of beans.[160]

It is by far the goriest of the three Punisher movies.[161]

The Disney/Netflix version of the character initially shows up in the second *Daredevil* season (2016), and subsequently in two standalone seasons (2017–18). The writers pay closer attention to issues of justice and morality than their movie counterparts, and both series play up the many differences between Matt Murdock and Frank Castle. This version mines the veteran angle by exploring the possibility that Castle suffers from Post-Traumatic Stress Disorder. It borrows several characters from the comics, including Billy Russo (Jigsaw) and William Rawlins. Actor Jon Bernthal carries himself like a fighter, and spits lines like, "happy is a kick in the balls waiting to happen," and "I'm not the one that dies; I'm the one that does the killing."[162] His fierce interpretation impressed the critics and brought Castle's disturbed psychosocial underpinnings into focus. The soundtrack for Netflix's *Punisher* features an earthy blues guitar, which lends the show a mournful quality and underscores the character's generational positionality as a Boomer.

The kill count associated with the Netflix series, and the three movies, has been catalogued on YouTube. The videos "The Punisher Season One Carnage Count" and "The Punisher Season Two Carnage Count" show that 90 onscreen murders are committed in the first Netflix *Punisher* season, for a KPM ("kills per minute") of 0.131, while 103 onscreen murders are committed in the second, for a KPM of 0.147.[163] This suggests that the second series is slightly more violent than the first, assuming kills-per-minute offers a meaningful metric for onscreen violence more generally.

YouTube's "Carnage Count" series reports that the figure for "total kills" in the 1989 Dolph Lundgren movie is 91, for a KPM of 1.022; that the "total kills" for the 2004 Thomas Jane movie is 45, for a KPM of .366; and that the "total kills" for the 2008 Ray Stevenson movie is 109, for a KPM of 1.069.[164] The three movies combined have a shorter running length than either of the Netflix seasons, but a significantly higher kill count. Even the least violent of the full-length movies, the 2004 iteration, is approximately three times as violent as the Netflix series. To date, the most violent onscreen iteration is *Punisher War Zone* (2008). The least violent Punisher appearances are in animated television programs that are aimed at younger viewers, such as *Spider-Man* (1994) and *The Super Hero Squad Show* (2009), in which Castle uses nonlethal weapons.

The Punisher is an adaptive and resilient construct with unlimited earnings potential. A virtual reality game that permits users to navigate an immersive, crime-ridden version of the five boroughs in the guise of Frank Castle could easily prove a megahit in the coming decades. From the standpoint of character logic, the Punisher should have expired long ago. Populism, fan culture, and commercial imperatives all conspire to keep the apologue going.

NOTES

1. Fredric Wertham, *A Sign For Cain: An Exploration of Human Violence* (New York: Warner Paperback Library, [1966] 1973), 326.

2. In early 2022, entertainment websites were reporting that Jon Bernthal's Frank Castle was being rebooted by Hulu. https://www.small-screen.co.uk/jon-bernthal-new-mcu-punisher-series-hulu/.

3. Chuck Dixon and Gordon Purcell, "The Day I Killed Spider-Man," *What If...?* #2.58 (New York: Marvel, February 1994).

4. Cited in Dick Hebdige, *Subculture: The Meaning of Style* (London: Methuen, 1979), 133.

5. Matthew Rosenberg, "Frank Answers," *The Punisher: War Machine* #1 (New York: Marvel, 2018), n.p.

6. Mark Zambrano, "Fifteen Superpowers You Never Knew the Punisher Had," Screen Rant, posted on November 17, 2017. https://screenrant.com/the-punisher-superpowers-has-had-didnt-know/.

7. Jason Cohen, "Fashion Victim: The Punisher's 8 Best Costumes (And His 7 Worst)," CBR, August 31, 2017, https://www.cbr.com/the-punisher-best-and-worst-costumes/.

8. Pat Mills and Mike McKone, "Rough Cut," *The Punisher Summer Special* #1.2 (New York: Marvel, August 1992), n.p.

9. Roy Thomas, *75 Years of Marvel: From the Golden Age to the Silver Screen* (Cologne: Taschen, 2014), 328.

10. Mark Evanier, *Kirby: King of Comics* (New York: Abrams, 2008), 150.

11. Thomas, *75 Years of Marvel*, 653.

12. Thomas, *75 Years of Marvel*, 658.

13. Dan Raviv, *Comic Wars: How Two Tycoons Battled Over the Marvel Comics Empire* (New York: Broadway, 2002), 29.

14. Jean-Paul Gabilliet, *Of Comics and Men: A Cultural History of American Comic Books* (Jackson: University Press of Mississippi, 2010), 150.

15. Gabilliet, *Of Comics and Men*, 146.

16. Sean Howe, *Marvel Comics: The Untold Story* (New York: Harper, 2013), 424.

17. See, *inter alia*, Bob Batchelor, *Stan Lee: The Man Behind Marvel* (New York: Rowman and Littlefield, 2017); Blake Bell and Michael J. Vassallo, *The Secret History of Marvel Comics: Jack Kirby and the Moonlighting Artists at Martin Goodman's Empire* (Seattle: Fantagraphics, 2013); Danny Fingeroth, *A Marvelous Life: The Amazing Story of Stan Lee* (New York: St. Martins, 2019); Martin Flanagan, Andy Livingstone, and Mike McKenny, *The Marvel Studios Phenomenon: Inside a Transmedia Universe* (London: Bloomsbury, 2016); Richard Hack, *When Money Is King: How Revlon's Ron Perelman Mastered the World of Finance to Create One of America's Greatest Business Empires, and Found Glamour, Beauty, and the High Life in the Bargain* (New York: Newstar, 1996); Howe, *Marvel Comics*, 2013; Jordan Raphael and Tom Spurgeon, *Stan Lee and the Rise and Fall of the American Comic Book* (Chicago: Chicago Review Press, 2003); Raviv, *Comic Wars*, 2002; Thomas, *75 Years*

of Marvel, 2014; Reed Tucker, *Slugfest: Inside the Epic, 50-Year Battle Between Marvel and DC* (Boston: Da Capo Press, 2017); Matt Yockey, ed., *Make Ours Marvel: Media Convergence and a Comics Universe* (Austin: University of Texas Press, 2017).

18. The rights to *Daredevil, Punisher,* and other Marvel-Netflix programs such as *Jessica Jones* reverted to Disney in 2022.

19. Jon Jackson, "Marvel's Punisher Problem," *Newsweek*, March 10, 2021, https://www.newsweek.com/marvels-punisher-problem-1574579.

20. Henry Varona, "Punisher Co-Creator Theorizes Why Marvel Won't Crack Down on Illegal Punisher Merchandise," CBR, https://www.cbr.com/punisher-gerry-conway-illegal-merch-marvel/.

21. Gerry Duggan and Juan Ferreyra, *Punisher Kill Krew* (New York: Marvel, 2020), n.p.

22. Baxter Oliphant, "Public Support for the Death Penalty Ticks Up," Pew Research, June 11, 2018, http://www.pewresearch.org/fact-tank/2018/06/11/us-support-for-death-penalty-ticks-up-2018/.

23. In a 1987 advert, Castle vows that "If You're Guilty ... You're Dead." But the storyverse has always privileged certain forms of "guilt" over others. *Mark Hazzard: Merc* #10 (New York: Marvel, August 1987), n.p.

24. Alliterator, "*The Slavers* is the Darkest Punisher Story Ever," io9, September 21, 2017, https://observationdeck.kinja.com/the-slavers-is-the-darkest-punisher-story-ever-1818609132 [link no longer available].

25. Garth Ennis and Leandro Fernandez, *The Punisher* #7.27 (New York: Marvel, January 2006), n.p. These chilling words are spoken by social worker Jen Cooke in a public lecture on sex trafficking.

26. Garth Ennis and Leandro Fernandez, *The Punisher* #7.30 (New York: Marvel, April 2006), n.p.

27. Mike Baron and David Ross, *The Punisher* #1.7 (New York: Marvel, March 1998), 1.

28. Baron and Ross, *The Punisher* #1.7, 6.

29. Garth Ennis and Steve Dillon, *The Punisher* #5.5 (New York: Marvel, August 2000), n.p.

30. Garth Ennis and Steve Dillon, *The Punisher* #5.9 (New York: Marvel, December 2000), n.p.

31. Garth Ennis and Steve Dillon, *The Punisher* #5.6 (New York: Marvel, January 2002), n.p.

32. Gerry Duggan and Marcelo Ferreira, *The War of the Realms: The Punisher* (New York, Marvel, 2019), n.p.

33. Jason Aaron and Steve Dillon, *PunisherMAX* #1.22 (New York: Marvel, April 2012), n.p.

34. Garth Ennis, "A Note From the Writer," *The Punisher* #5.6, n.p.

35. Michael Lackner, "Hate America Superhero?," https://freerepublic.com/focus/f-news/1134145/posts.

36. Garth Ennis, "In Defense of the Punisher," *The Punisher* #4.1 (New York: Marvel, April 2000), n.p.

37. Gerry Duggan and Mike Deotato, Jr., *Savage Avengers: City of Sickles* (New York: Marvel, 2019), n.p.

38. Garth Ennis and Steve Dillon, *The Punisher* #4.4 (New York: Marvel, July 2000), n.p.

39. Ennis and Dillon, *The Punisher* #4.9, n.p.

40. Garth Ennis and Steve Dillon, *The Punisher* #4.12 (New York: Marvel, March 2001), n.p.

41. Garth Ennis and John McCrea, *The Punisher* #5.37 (New York: Marvel, February 2004), n.p.

42. Garth Ennis and Steve Dillon, *The Punisher* #5.32 (New York: Marvel, November 2003), n.p.

43. Duggan and Ferreyra, *Punisher Kill Krew*, n.p.

44. Schmitt himself claimed that nihilism stemmed from "the disconnection of the global order from its European, Christian origins." Jon Wittrock, "The Social Logic of Late Nihilism: Martin Heidegger and Carl Schmitt on Global Space and the Sites of Gods," *European Review* 22, no. 2 (May 2014), 244.

45. Garth Ennis and Steve Dillon, *The Punisher* #4.6 (New York: Marvel, September 2000), n.p.

46. Ennis and Dillon, *The Punisher* #4.5, n.p.

47. Ennis and Dillon, *The Punisher* #4.5, n.p.

48. Garth Ennis and Steve Dillon, *The Punisher* #4.11 (New York: Marvel, February 2001), n.p.

49. Ennis and Dillon, *The Punisher* #4.12, n.p.

50. Garth Ennis and Darick Robertson, *The Punisher* #5.16 (New York: Marvel, November 2002), n.p.

51. Clayton C., *The Punisher* #4.11, n.p.

52. Michael L. and Tim D., *The Punisher* #4.2 (New York: Marvel, May 2000), n.p.

53. Sam B., *The Punisher* #4.3 (New York: Marvel, June 2000), n.p.

54. Bryant M., *The Punisher* #4.12, n.p.

55. Karl K., *The Punisher* #4.4, n.p.

56. Trifunkle and Dakesian, *The Punisher* #4.8, n.p.

57. Garth Ennis and Steve Dillon, *The Punisher* #5.1 (New York: Marvel, August 2001), n.p.

58. Garth Ennis and Steve Dillon, *The Punisher* #5.3 (New York: Marvel, September 2001), n.p.

59. Garth Ennis and Steve Dillon, *The Punisher* #5.5 (New York: Marvel, December 2001), n.p.

60. Ennis, "A Note From the Writer," *The Punisher* #5.6, n.p.

61. Ennis, "A Note From the Writer," *The Punisher* #5.6, n.p.

62. See, *inter alia*, Jeff Birkenstein, Anna Froula, and Karen Randell, eds. *Reframing 9/11: Film, Popular Culture, and the "War on Terror"* (New York: Continuum, 2010); Véronique Bragard, Christophe Dony, and Warren Rosenberg, eds. *Portraying 9/11: Essays on Representations in Comics, Literature, Film and Theatre* (Jefferson: McFarland, 2011); Ted Gournelos and Viveca Greene, eds. *A Decade of Dark Humor: How Comedy, Irony, and Satire Shaped Post-9/11 America* (Jackson: University Press of Mississippi, 2013); and Kent Worcester, "New York City, 9/11, and Comics," *Radical History Review* 111 (September 2011).

63. Ennis and Dillon, *The Punisher* #5.6, n.p.

64. Ennis and Dillon, *The Punisher* #5.6, n.p.

65. Letters columns returned when editors realised they promoted a sense of community among readers. The seventh, eighth, and tenth series include letters pages, as do some issues of the ninth series.

66. David Brothers, "The Fear of Mandingo," 4thletter!, http://4thletter.net/2009/02/black-history-month-09-06-the-fear-of-mandingo/.

67. The website worldofblackheroes.com maintains a database of nearly 300 Black supervillains in comics, some of whom are reasonably prominent within the Marvel Universe, such as Erik Killmonger, Sphinx, and Tombstone. See http://worldofblackheroes.com/category/black-supervillains/.

68. Dave Richards, "The Long, Cold Dark: Garth Ennis Talks Punisher 50," CBR, July 11, 2007, https://www.cbr.com/the-long-cold-dark-garth-ennis-talks-punisher-50/.

69. Garth Ennis and Goran Parlov, *The Punisher* #6.32 (June 2006), n.p.

70. Garth Ennis and Goran Parlov, *The Punisher* #6.33 (July 2006), n.p.

71. Garth Ennis and Goran Parlov, *The Punisher Presents Barracuda* #5 (New York: Marvel, August 2007), n.p.

72. Garth Ennis and Goran Parlov, *The Punisher* #6.41 (New York: Marvel, January 2007), n.p.

73. Garth Ennis and Goran Parlov, *The Punisher* #6.54 (New York: Marvel, March 2008), n.p.

74. Ennis and Dillon, *Punisher War Zone* #2.1, n.p.

75. Ennis and Dillon, *Punisher War Zone* #2.1, n.p.

76. Ennis and Dillon, *Punisher War Zone* #2.1, n.p.

77. Garth Ennis and Steve Dillon, *Punisher War Zone* #2.6 (New York: Marvel, March 2009), n.p.

78. Garth Ennis and Steve Dillon, *Punisher War Zone* #2.5 (New York: Marvel, March 2009), n.p.

79. Garth Ennis and Joe Jusko, *Punisher/Painkiller Jane* (New York: Marvel, January 2001), n.p.

80. Garth Ennis and Lewis Larosa, *Punisher: The Cell* (New York: Marvel, July 2005), n.p.

81. Garth Ennis and John Severin, *Punisher: The Tyger* (New York: Marvel, February 2006), n.p.

82. Rick Remender, untitled editorial comment, *The Punisher* #7.1 (New York: Marvel, March 2009), n.p.

83. "Marvel's New Rating System ... Explained!" CBR, July 5, 2001, https://www.cbr.com/marvels-new-ratings-system-explained/. The relationship between the MU and the MAX universes has a metaphysical aspect that some readers find vexing. See, *inter alia*, https://forums.superherohype.com/threads/is-max-always-out-of-616-continuity.309341/; http://www.chronologyproject.com/phpbb2/viewtopic.php?t=6138; https://www.reddit.com/r/thepunisher/comments/2bcuxh/is_microchips_death_in_the_max_line_canon_does_he/.

84. Anthony Flamini and others, *Civil War Files* #1 (New York: Marvel, 2006), n.p.

85. Dillon contributed pencils to the *PunisherMAX* series (2010–12) and to the first seven issues of the Cloonan series (2016–17) before his untimely passing.

86. The first eighteen *PWJ* issues were scripted by Matt Fraction, while the remaining eight were coscripted by Fraction and Rick Remender, who went on to compose all 21 issues of the eighth series. *PWJ* 2 features work by Ariel Olivetti (1–3, 5–10, 12); Mike Deodato (4); Leandro Fernández (11); Cory Walker (13); Scott Wegener (14,15); Howard Chaykin (16–25); and Andy MacDonald (26). *The Punisher* #8 features work by Jerome Opeña (1–5); Tan Eng Huat (6–10); Tony Moore (11–14, 16, 19, 20); Roland Boschi (15 and 17); Jefte Palo (18); Paco Diaz (20); John Lucas (20); and Dan Brereton (21). The sixteen issues

of *Punisher* 8 utilize six pencilers: Marco Checchetto (1–5, 8, 10, 12, 15, 16); Matthew Southworth and Matthew Clark (6); Michael Lark (7); Mirko Colak (8 and 11); and Mico Suayan (13, 14). In *PWJ Annual* (January 2009), by Simon Spurrier and Werther Dell'Edera, Castle rescues a hostage while coping with powerful hallucinogens. In *The Punisher Annual* #1 (November 2009), by Remender and Jason Person, he battles a pair of malevolent strippers. In both cases, it is the social environment rather than the protagonist that evinces a trigger happy aspect.

87. Matt Fraction and Ariel Olivetti, *Punisher War Journal* #2.6 (New York: Marvel, June 2007), n.p.

88. Matt Fraction and Ariel Olivetti, *Punisher War Journal* #2.8 (New York: Marvel, August 2007), n.p.

89. Fraction and Olivetti, *Punisher War Journal* #2.7, n.p.

90. Rick Remender and Jerome Opeña, *The Punisher* #7.1 (New York: Marvel, March 2009), n.p.

91. Rick Remender and Tan Eng Huat, *The Punisher* #7.4 (New York: Marvel, September 2009), n.p.

92. Brian Michael Bendis and Marko Djurdjevic, *Dark Reign: The List – Avengers* (New York: Marvel, November 2009), n.p.

93. Remender and Romita, Jr., *Dark Reign: The List – Punisher*, n.p.

94. Rick Remender and Roland Boschi, *The Punisher* #7.11 (New York: Marvel, January 2010), n.p.

95. Rick Remender and Tony Moore, *The Punisher* #7.16 (New York: Marvel, June 2010), n.p.

96. Rick Remender and Tan Eng Huat, *The Punisher* #7.10 (New York: Marvel, December 2009), n.p.

97. Rick Remender and Tony Moore, *The Punisher* #7.13 (New York: Marvel, March 2010), n.p.

98. K. A., *The Punisher* #7.14 (New York: Marvel, April 2010), n.p.

99. David W., *The Punisher* #7.15, n.p.

100. Sebastian Girner, *The Punisher* #7.16, n.p.

101. Rick Remender and Tony Moore, *The Punisher* #7.20 (New York: Marvel, November 2010), n.p.

102. Rick Remender and Tony Moore, *The Punisher* #7.19 (New York: Marvel, September 2010), n.p.

103. Rick Remender and Dan Brereton, *The Punisher* #7.21 (New York: Marvel, November 2010), n.p.

104. Rick Remender and Roland Boschi, *Punisher: In the Blood* #4 (New York: Marvel, April 2011), n.p.

105. Rick Remender and Roland Boschi, *Punisher: In the Blood* #5 (New York: Marvel, May 2011), n.p.

106. Dave Richards, "Aaron Speaks Frankly About PunisherMAX," CBR, August 8, 2011, https://www.cbr.com/aaron-speaks-frankly-about-punishermax/.

107. Jason Aaron and Steve Dillon, *PunisherMAX* #1.13 (New York: Marvel, July 2011), n.p.

108. Jason Aaron and Steve Dillon, *PunisherMAX* #1.16 (New York: Marvel, October 2011), n.p.
109. Greg Rucka and Marco Checchetto, *The Punisher* #8.4 (New York: Marvel, December 2011), n.p.
110. Peter David and Lea Hernandez, *Marvel Mangaverse: The Punisher* #1.1 (New York: Marvel, March 2002).
111. When they next meet, Cole-Alves tells Castle that "L.A. needs you" during an urban uprising that makes the 1992 riots look like a bar fight. Nathan Edmondson and Mitch Gerads, *The Punisher* #9.11 (New York: Marvel, December 2014), n.p.
112. Matthew Rosenberg and Szymon Kudranski, *The Punisher: Street by Street, Block by Block* (New York: Marvel, 2019), n.p.
113. Greg Rucka and Carmine Di Giandomenico, *Punisher War Zone* #3.1 (December 2012), n.p.
114. Greg Rucka and Carmine Di Giandomenico, *Punisher War Zone* #3.3 (New York: Marvel, March 2013), n.p.
115. "Food, water, waste disposal, holographic computer interface so he can read any book, watch any show ... exercise room designed to be escape-proof, nothing he can cannibalize to make into a weapon, to make an escape. He's there until we say otherwise, or until somebody comes along and sets him loose." Greg Rucka and Carmine Di Giandomenico, *Punisher War Zone* #3.5 (New York: Marvel, May 2013), n.p.
116. Aaron, Eric O., and K. A., "Let's Be Frank," *The Punisher* #8.3 (New York: Marvel, November 2011), n.p.
117. Alyn H., "Let's Be Frank," *The Punisher* #8.4, n.p.
118. Marc G., "Let's Be Frank," *The Punisher* #8.5 (New York: Marvel, January 2012), n.p.
119. Richard A., "Let's Be Frank," *The Punisher* #8.12 (New York: Marvel, August 2012), n.p.
120. Stephen Wacker, "Let's Be Frank," *The Punisher* #8.12, n.p.
121. Wylie, "Let's Be Frank," *The Punisher* #8.15 (New York: Marvel, November 2012), n.p.
122. Daniel Way and Steve Dillon, *Thunderbolts* #1.2 (New York: Marvel, February 2013), n.p.
123. Charles Soule and Jefte Palo, *Thunderbolts* #1.14 (New York: Marvel, October 2013), n.p.
124. Ben Acker, Ben Blacker, and Kim Jacinto, *Thunderbolts* #1.32 (New York: Marvel, December 2014), n.p.
125. Ben Acker, Ben Blacker, and Jorge Fornés, *Thunderbolts* #1.30 (New York: Marvel, October 2014), n.p.
126. Nathan Edmondson and Mitch Gerads, *The Punisher* #9.12 (New York: Marvel, January 2015), n.p.
127. Nathan Edmondson and Mitch Gerads, *The Punisher* #9.3 (New York: Marvel, May 2014), n.p.
128. Nathan Edmondson and Mitch Gerads, *The Punisher* #9.16 (New York: Marvel, May 2015), n.p.
129. Nathan Edmondson and Mitch Gerads, *The Punisher* #9.17 (New York: Marvel, June 2015), n.p.

130. Edmondson and Gerads, *The Punisher* #9.3, n.p.

131. Nathan Edmondson and Mitch Gerads, *The Punisher* #9.11 (New York: Marvel, December 2014), n.p.

132. Edmondson and Gerads, *The Punisher* #9.12, n.p.

133. Nathan Edmondson and Mitch Gerads, *The Punisher* #9.14 (New York: Marvel, March 2015), n.p.

134. Eli B., "Publish or Perish," *The Punisher* #10.8 (New York: Marvel, March 2017), n.p.

135. Untitled editorial material, *The Punisher* #10.2 (New York: Marvel, August 2016), n.p.

136. Becky Cloonan and Steve Dillon, *The Punisher* #10.3 (New York: Marvel, September 2016), n.p.

137. Sandra Gisi, "Frank Castle is 'Not a Good Guy,'" Birth.Movies.Death., https://birthmoviesdeath.com/2017/11/08/frank-castle-is-not-a-good-guy.

138. Taylor Y., "Publish or Punish," *The Punisher* #10.10 (New York: Marvel, May 2017), n.p.

139. Allen V., "Publish or Punish," *The Punisher* #10.13 (New York: Marvel, August 2017), n.p.

140. Rosenberg, "Frank Answers," *The Punisher: War Machine* #1, n.p.

141. Matthew Rosenberg and Szymon Kudranski, *The Punisher: Street by Street, Block by Block* (New York: Marvel, 2019), n.p.

142. Chuck Dixon and John Buscema, *The Punisher: A Man Named Frank* (New York: Marvel, 1994); *What If...?* #2.24 (New York: Marvel, April 1991); *Punisher 2099* (1993–95).

143. Christos N. Gage and Mike Perkins, *House of M: Avengers* #1.2 (New York: Marvel, February 2008), n.p.

144. Frank Tieri and Mark Texeira, *Space Punisher* #1.1 (New York: Marvel, September 2012), n.p.

145. Scott M. Gimble and Mark Texeira, *Punisher Nightmare* #1.1 (New York: Marvel, March 2013), n.p.

146. Ed Brisson and Josh Williamson, *Secret Wars: Battleworld* #1.1 (New York: Marvel, July 2015), n.p.

147. Donny Cates and Dylan Burnett, *Cosmic Ghost Rider: Baby Thanos Must Die* (New York: Marvel, 2018), n.p.

148. *Avengers: Infinity War* (2018) generated a billion dollars in gross revenues in less than two weeks after its release, https://money.cnn.com/2018/05/05/media/avengers-infinity-war-billion-box-office/index.html.

149. Phillip Ball, *The Modern Myths: Adventures in the Machinery of Popular Imagination* (Chicago: University of Chicago Press, 2021), 350.

150. Julie Muncy, "Jim Lee Says DC Is Still Committed to the Business of Publishing Comics," Gizmodo, August 15, 2020, https://gizmodo.com/jim-lee-says-dc-is-still-committed-to-the-business-of-p-1844736832.

151. https://www.the-numbers.com/movie/Punisher-The#tab=summary.

152. See https://www.the-numbers.com/movie/Punisher-War-Zone#tab=summary.

153. See https://markets.businessinsider.com/news/stocks/netflixs-the-punisher-viewing-down-40-analysis-2019-1-1027891001.

154. Pat Jankiewicz, "Origin of the Species: The Story Behind Marvel's Big Bang Theory!" *Marvel Age* #15 (New York: Marvel, March 1997), 31.

155. https://www.springfieldspringfield.co.uk/movie_script.php?movie=punisher-the. See also Carl Potts and Brent Anderson, *The Punisher Movie Special* (New York: Marvel, 1990).

156. Lorrie Palmer, "The Punisher as a Revisionist Superhero Western," in Charles Hatfield, Jeet Heer, and Kent Worcester, eds., *The Superhero Reader* (Jackson: University Press of Mississippi, 2013).

157. Eric Lichtenfeld, *Action Speaks Louder* (Middletown: Wesleyan University Press, 2007), 305.

158. Lichtenfeld, 306.

159. Peter Milligan and Pat Olliffe, *The Punisher: Official Movie Adaptation* (New York: Marvel, 2004).

160. https://www.rogerebert.com/reviews/punisher-war-zone. http://www.pattonoswalt.com/index.cfm?page=spew&id=90.

161. Pascal Lefévre maintains that a "viewer more likely accepts violence in a drawn medium than in a photographic medium," but this may understate the degree to which the expectations of audiences are molded over time by the interventions of artists and filmmakers. See Pascal Lefévre, "Incompatible Visual Ontologies? The Problematic Adaptation of Drawn Images," in Ian Gordon, Mark Jancovich, and Matthew P. McAllister, eds., *Film and Comic Books* (Jackson: University Press of Mississippi, 2007), 9.

162. https://www.springfieldspringfield.co.uk/episode_scripts.php?tv-show=marvels-the-punisher-2017.

163. See https://www.youtube.com/watch?v=duT--Nxjag0 and https://www.youtube.com/watch?v=2Z0_9aMoK7c.

164. See https://www.youtube.com/watch?v=RB8isNQLhAk, https://www.youtube.com/watch?v=FIpIZYoVpEo, and https://www.youtube.com/watch?v=H_JssO7mRxA.

Conclusion:
Those Who Need Hurting

There is a time with all passions when they are merely fatalities,
when they drag the victim down with the weight of their folly.

—Friedrich Nietzsche, *Twilight of the Idols* (1889)[1]

Stan Lee was right. If Gerry Conway had insisted on retaining his original appellation, the character would be remembered as a 1970s curio. Frank Castle the Assassin might have been revived once or twice but it seems unlikely he would have experienced a dramatic upswing in his fortunes. The key difference is that assassination is a job while punishment is a vocation. The impulse to punish is easier to identify with than the urge to assassinate. Furthermore, the spectacle of righteous punishment can invite a satisfied, even ebullient gaze. This sense of emotional investment is indispensable when it comes to understanding the Punisher's saliency and durability.

The distinction between assassination and punishment brings to mind the "single mother caring for disabled parents" who spoke to the *New York Times* about the impact of the 2019 federal government shutdown on the Florida panhandle. "I voted for him, and he's the one who's doing this," she told the reporter, referring to the 45th President's role in initiating the shutdown. "I thought he was going to do good things. He's not hurting the people he needs to be hurting."[2] In place of "hurting," she could easily have inserted "punishing." But if the interviewee had used "assassinating," the meaning would be very different. "He's not assassinating the people he needs to be assassinating" sounds peculiar rather than vengeful.

Unlike your everyday garden variety hit man, Frank Castle is motivated by hatred rather than economics. The reverse holds true for his publisher. The tension between the two logics lends the franchise a fraught, disruptive aspect. After all, the Punisher seethes in a way that offers a poor fit with anything resembling all-ages entertainment. He personifies the belief, as expressed by the nineteenth-century historian Thomas Carlyle, that the desire for revenge is "forever intrinsically a correct and even a divine feeling in the mind of every man."[3] He brings to mind Hesiod's mythological Fates, who "track down the sins of men/And gods, and

never cease from awful rage/Until they give the sinner punishment."[4] Punishment is the numerator; rage is the denominator. To cite the words of songwriter Perry Farrell, Frank Castle assumes that "some people should die; that's just unconscious knowledge."[5] A worldview that "give[s] the sinner punishment"—and insists that mass murder has its uses—is a troublingly political one, even if it mainly gets articulated in pulp fiction and B-movies.

Whenever creators have pointed the Punisher in an altruistic direction—such as in the 1998 limited series when he commits suicide and is resurrected by celestial beings in order to serve them as an earthbound avenging angel, and in the 2009–10 Franken-Castle misfire, in which the Punisher joins forces with the Legion of Monsters to safeguard Monster Metropolis—editors soon find themselves reaching for the reset button. The angry lone wolf archetype works best within a tightly constrained embedded system, one that is organized around unresolvable emotional issues rather than clearly articulated principles.

Frank Castle may be compulsive, unregulated, and reactionary, but his wrath can be aimed at virtually anyone. From bank robbers to bankers, as it were. An anger rooted in a profound and overwhelming sense of betrayal, humiliation, and shame is the through line. The political implications are the responsibility of writers and creative teams. They in turn work within hard and soft boundaries set by Marvel, fans, the wider culture, and ultimately the legal system. The end result is a thick slab of angry, vividly realized comics and graphic novels about an angry, vividly realized character.

Throughout this study, I have suggested that Punisher comics litigate a specific time and place: New York City from the second half of the 1960s through the 1990s. Introduced on the cusp of the city's fiscal meltdown, it took Frank Castle over a decade to become an important player in the Marvel Universe. By the early 2000s, this sensile indicator of fear and anxiety had become a multimedia transnational icon. Now the Punisher promotes antisocial politics on a stage so large that it defies description.

The Punisher's ascendancy is intriguing but unnerving. It does not herald good times ahead. In the apt words of Karl Marx, punishment is "nothing but a means of society to defend itself against the infraction of its vital conditions, whatever may be their character." Marx then asks: "Now, what a state of society is that which knows of no better instrument for its own defense than the hangman," and "proclaims its own brutality as eternal law?"[6] The Punisher is a disruptive would-be sovereign who asserts his "right to hang" above all other rights.

It is difficult to establish with any precision to what extent the Punisher incites strong passions or simply mirrors existing social-psychological conditions. Certainly the character's Reagan-era transformation from supporting actor to leading man suggests something about the era itself. His contemporary prominence

as a universal symbol of ideologically motivated mayhem suggests that there is plenty of unfinished business when it comes to justice discourse, sovereign masculinity, and representations of violence.

From a commercial vantage point, the most important thing is how readily the character extends across multiple platforms. The dystopian sensibility that the persona stokes and dines on can be monetized in countless ways. The ranks of those who would like everyone to know that they are angry are far larger than the number of people who already sport a Punisher decal, t-shirt, or shot glass. Furthermore, Frank Castle traverses linguistic and cultural barriers in a way that many pop culture characters do not. "He watched his family die and takes it out on others" is one of the most straightforward metanarratives imaginable. It is the tale of vengeance. It is positively Homeric.[7]

In his early years, the Punisher's contribution to the bottom line was modest. The relevant consideration would have been to what extent, if any, did his appearance in a story or on a cover boost sales. Since then, the proportion of income generated from print vs. non-print sources, such as licensing fees and film and streaming rights, has shifted dramatically. If Marvel were to stop issuing new Punisher comics and graphic novels, the property itself would continue to flourish. The loss of the information-rich environment that these formats offer would result in a less convoluted and idiosyncratic backstory. But from the perspective of shareholders, the difference would be negligible. The brand is self-sustaining. In the terminology of the political scientist Walt Rostow, it has achieved take-off.[8]

As the distillation of a certain way of remembering and interpreting the social history of post-1960s America, the Punisher confronts the prevailing culture rather than conforms to it. He wages war on criminals, but he also picks fights with social workers, police officers, other costumed heroes, and readers. He parses the world around him via thought balloons and word balloons, but he mainly "talks" through his deeds. His campaign has a self-destructive quality that some writers have played up and others have downplayed. Given that his crime-control lifestyle is inherently unsustainable, commercial imperatives rather than writerly autonomy must explain his longevity. The forever middle-aged, forever lucrative Frank Castle represents a historically embedded doctrine of retributive justice that continues to excite some readers and creators and to leave others cold. From the standpoint of quarterly earnings, any misgivings about his damaged aura are inconsequential. Indeed, controversy can be good for business. And yet the example of the Punisher also suggests that controversy can burn a little *too* hot from a corporate relations perspective.

Our internalist history presents us with an avatar of rage that is plastic yet inflexible, mortal yet superheroic, heroic yet unjust, proactive yet pessimistic, grimdark yet comical, mass-produced yet handcrafted. The saga of an aggrieved straight arrow

who wages a one-man war against criminals has inspired a kaleidoscopic variety of plotlines. As editor Jake Thomas notes, "this deceptively simple canvas has enormous potential." Over the years, Frank Castle has been

> a straight-up villain, a good guy, a madman, a tactical genius, a figurative and literal monster, a soldier, a renegade, a loner and a teammate, he's been heartbroken and cold-hearted, torn people apart and helped put people back together, and none of that seems out of character.[9]

As long as the syntax is left untouched, the semantics can vary.

The Punisher's apparent tilt towards a fixed position is at odds with his eclectic and sometimes unmoored recorded history. Punisher comics and graphic novels offer a carnival of simulated violence in which the politics of vengeance is debated, explored, and only sometimes propagated. For every didactic episode, there is another that is ironic, silly, or subversive—or all three at once. The gap between what we think we know about the character, and his paper trail, is considerable. "The truth is concrete," as Georg Wilhelm Friedrich Hegel observed in 1830.[10]

Some observers continue to overlook or minimize the writerly inflections and idiosyncrasies that complicate and confound essentialist models of multiauthored entertainment. This is especially true so far as our paraliterary antihero is concerned. The character continues to inspire not only fannish commentary but brittle structuralist critique. This is connected to the fact that even today it is not uncommon for scholars and journalists to assume that the political orientation of mainstream comics is determined by corporate overlords and that writers and artists who work on a character like the Punisher are part of an apparatus of conformity. This is the position, for example, that is articulated by Ernest Mandel's entertaining but deeply misguided history of the crime novel, *Delightful Murder*. Mandel, it turns out, takes exception not only to stories about vigilantes but to the comics medium itself:

> Specialists in the science of communications are increasingly coming to argue that the replacement of written texts by images, of transparent linearity by opaque space, almost inevitably leads to more primitive content, acts regressively upon the content of communication itself [...] A reversal to non-written language, to what are essentially more primitive forms of communication, must stimulate pre-logical, ahistorical, and indeed anti-historical, more and more primitive forms of thinking as well. The regression represented by the *série noire* and its comic-strip heirs, suffused as they are with an inhuman sadism and preoccupied with the most repellent forms of human behavior, strikingly bears out the correctness of this hypothesis.[11]

CONCLUSION

FIGURE C.1: Andy Kubert, *The Punisher* #44, cover illustration, 1991. © Marvel Comics

It seems unlikely that Mandel could have anything positive to say about the dense imagetexts that I have canvassed, and occasionally even championed, over the course of this study (Figure C.1).

I started working on this manuscript shortly after the 2016 U.S. presidential election. For most of the time that I was at work on this project, the president wielded a rhetoric of brutality and retribution that all too often seemed lifted from the pages of a men's adventure story from the 1970s.

"Maybe hate is what we need if we're gonna get something done," the future president argued in 1989.[12] On the campaign trail in Cedar Rapids, Iowa, Donald Trump told audience members he would pay their legal fees if they engaged in violence against protesters. "If you see somebody getting ready to throw a tomato, knock the crap out of them, would you? Seriously, OK? Just knock the hell ... I promise you I will pay for the legal fees. I promise, I promise." Later that month, "he said security guards were too gentle with a protester. 'He's walking out with big high-fives, smiling, laughing', Trump said. 'I'd like to punch him in the face, I'll tell you.'"[13] His widely reported claims that he "could stand in the middle of Fifth Avenue and shoot somebody and I wouldn't lose voters,"[14] that "any guy who can do a body slam, he is my type,"[15] and that "torture works,"[16] offer further examples of the former President's flippant and erotic relationship with violent, sometimes murderous language.

To the extent that the spirit of the Trumpisher hovers over this project, it reflects the curious fact that the former President's outlook and persona are rooted in the very same historical conjuncture that spawned and nourished Frank Castle and other paraliterary vigilantes. Trump and Castle are products of the same exact generational and cultural moment. They even hail from the same outer borough, Queens. While the former president looks back on midcentury America with nostalgic tenderness, it was the urban drama that taught him everything he thinks he knows about crime, politics, and human nature. "The seventies" is his mental shortcut, his availability heuristic. The same of course holds for the Punisher. As the journalist Alexander Hurst suggests, Trump was the country's first vigilante president—our Punisher surrogate. Hurst points out that

> President Donald Trump has often flaunted the brawn of his supporters, adding a baseline of menace to his increasingly embattled presidency. "Law enforcement, military, construction workers, Bikers for Trump ... These are tough people," he said at a 2018 campaign event in St. Louis, Missouri. "These are great people. But they're peaceful people, and antifa and all—they'd better hope they stay that way. I hope they stay that way." Six months later, in an interview with *Breitbart News*, Trump made the threat of violence from his supporters more explicit. "I have the tough people, but they don't play it tough, until they go to a certain point," he said. "And then it would be very bad, very bad."[17]

It should not come as a surprise that one of the former president's favorite movies is *Death Wish*.[18] A taste for vigilantism and vigilante entertainment is part of the package. Indeed, a Donald Trump biography could be organized along the same lines as this monograph:

Chapter 1: The postwar urban backdrop that engenders intense feelings of humiliation, betrayal, and rage.

Chapter 2: Competing paradigms: steely and steadfast versus erratic and mercurial: supporters emphasize the former, while detractors emphasize the latter.

Chapter 3: Frenemies with larger-than-life personalities try to reason with our stubborn Schmittian.

Chapter 4: The dialectical interaction between political ideas, social experiences, and individual psychopathology.

Chapter 5: How competitors have mocked, argued with, and reproduced the values and arguments of the protagonist.

Chapter 6: The improbable survival of the world's most reckless antihero.

Conclusion: Proposing that a political biography of the 45th President of the United States could be laid out along the same lines as a study of a fictional, pseudoheroic serial killer.

The full-page adverts that the real estate developer placed in four New York City dailies in 1989, in which Trump called for applying the death penalty to the group of teenagers who were falsely accused of raping and beating the woman known as the Central Park jogger, are as authentically Trumpian as anything he has said or done since. The former president yearns to go to war against his enemies, in other words. As Carl Schmitt writes, "it is sufficient for his nature that he is, in a specially intense way, existentially something different and alien, so that in the extreme case conflicts with him are possible."[19] Or as the journalist Adam Serwer argues, it is "not just that the perpetrators of this cruelty enjoy it; it is that they enjoy it with one another. Their shared laughter at the suffering of others is an adhesive that binds them to one another, and to Trump."[20] "Anger," Martha Nussbaum concludes, "is a popular emotion."[21]

For the former president and his supporters, just as for the Punisher, the postwar urban crisis never ended. Consider the now famous passage from his Presidential Inaugural Address, which is often attributed to Trump advisors Stephen Miller and Steve Bannon:

> Americans want great schools for their children, safe neighborhoods for their families, and good jobs for themselves. These are the just and reasonable demands of a righteous public. But for too many of our citizens, a different reality exists: Mothers and children trapped in poverty in our inner cities; rusted-out factories scattered like tombstones across the landscape of our nation; an education system, flush with cash, but which leaves our young and beautiful students deprived of knowledge; and the crime and gangs and drugs that have stolen too many lives and robbed our country of so much unrealized potential. This American carnage stops right here and stops right now.[22]

A problem for his advocates is that while Donald Trump campaigned like a feisty warrior, he proved desultory in office. In a handful of areas, such as judicial appointments, immigration policy, and the natural environment, his approach was steadfast and grim. In others, such as diplomacy, fiscal policy, monetary policy, and public health, his approach was erratic and trigger-happy. It is difficult to say which of the two was more disconcerting.

A final envoi. In response to the mass social protests sparked by the murder of George Floyd, Gerry Conway launched a website in June 2020 that allows Black Lives Matters supporters to purchase clothes that combine the Punisher logo and the BLM slogan. "For too long," Conway announced,

> symbols associated with a character I co-created have been co-opted by forces of oppression and to intimidate black Americans. This character and symbol was never intended as a symbol of oppression. This is a symbol of a systematic failure of equal justice. It's time to claim this symbol for the cause of equal justice and Black Lives Matter.[23]

During the Trump years, it sometimes seemed as if the Punisher's forever war properly belonged to police officers, military personnel, and the alt-right. Conway's effort to reclaim the Punisher's skull-and-bullets chevron for radically different purposes makes the case once more for the relative autonomy of the hardboiled archetype. Jason Aaron's 2022 limited series can also be seen as an effort to sever or at least weaken the link between Marvel's hardcore vigilante intellectual property and the populist uses to which the IP has been put. By presenting Frank Castle in a thoroughly unflattering light, this most recent series is saying, in effect, that the "real" or "true" Punisher is not someone that anyone in their right mind would want to associate with. But it is not clear whether there is much that either Conway or Marvel can do to wrestle back control over the Punisher's imagery and narrative from populist politics and the far right.

For despite Conway's audacious initiative, the notion of a pro-BLM Frank Castle remains counterintuitive for many readers and professionals. The fact that the history of the character encourages polysemic readings does not mean that this is what the mass audience is rooting for. When Mike Baron was asked in 2022 how he would tackle the character today, his populism pointed in a very different direction than Conway's:

> We all know where the Punisher would be right now. On the southern border dealing with coyotes, snake heads, terrorists, and child molesters pouring across the giant invitation mat laid out by the present administration. I have always wanted to send

CONCLUSION

him after crooked politicians as well. Can you imagine the fury that would ignite? Can you imagine criminals patterned after members of the current administration, or people who have been in Congress for thirty years and have only managed to line their own pockets?[24]

NOTES

1. Friedrich Nietzsche, *Twilight of the Idols* (New York: Penguin, [1889] 1988), 42.
2. Patricia Mazzei, "A Florida Town Grapples with a Shutdown After a Hurricane," *New York Times*, January 7, 2019, https://www.nytimes.com/2019/01/07/us/florida-government-shutdown-marianna.html.
3. Quoted in Brand Blanshard, "Retribution Revisited," in *Philosophical Perspectives on Punishment*, eds. Edward H. Madden, Rollo Handy, and Marvin Farber (Springfield: Charles C. Thomas Publishers, 1968), 70.
4. Hesiod, "Theogony" [*c*.750 BCE] in Hesiod/Theognis, *Theogony and Works and Days/ Elegies* (London: Penguin, 1973), 30.
5. Jane's Addiction, "Pigs in Zen," *Nothing's Shocking* (Warner Brothers, 1988).
6. Karl Marx, "On Punishment" [1853], reprinted in Gertrude Ezorsky, ed. *Philosophical Perspectives on Punishment* (Albany: SUNY Press, 1972), 358–59.
7. On ancient texts and vengeance, see John Kerrigan, *Revenge Tragedy: Aeschylus to Armageddon* (Oxford: Clarendon Press, 1998).
8. Walt Rostow, *The Stages of Economic Growth: A Non-Communist Manifesto* (Cambridge: Cambridge University Press, 1991).
9. Jake Thomas, "Writing on the Castle Walls," *The Punisher* #9.1 (New York: Marvel, April 2014), n.p.
10. https://www.marxists.org/reference/archive/hegel/works/sl/slintro.htm.
11. Ernest Mandel, *Delightful Murder: A Social History of the Crime Story* (Minneapolis: University of Minnesota Press, 1984), 95–96.
12. Andrew Kacyynski and Jon Sarlin, "Trump in 1989 Central Park Five Interview: 'Maybe Hate is What We Need,'" CNN, October 7, 2016, https://www.cnn.com/2016/10/07/politics/trump-larry-king-central-park-five/index.html.
13. Meghan Keneally, "A Look Back at Trump Comments Perceived by Some as Encouraging Violence," ABC News, October 19, 2018, https://abcnews.go.com/Politics/back-trump-comments-perceived-encouraging-violence/story?id=48415766.
14. Jeremy Diamond, "I Could 'Shoot Somebody and I Wouldn't Lose Voters,'" CNN, January 24, 2016, https://www.cnn.com/2016/01/23/politics/donald-trump-shoot-somebody-support/index.html.
15. Emily Cochrane, "'That's My Kind of Guy', Trump Says of Republican Lawmaker Who Body-Slammed a Reporter," *New York Times*, October 19, 2018, https://www.nytimes.com/2018/10/19/us/politics/trump-greg-gianforte-montana.html.

16. Clyde Haberman, "No, Mr. Trump, Torture Doesn't Work," *New York Times*, December 13, 2017, https://www.nytimes.com/2017/12/13/opinion/trump-torture-guantanamo.html.

17. Alexander Hurst, "The Vigilante President," *The New Republic*, November 6, 2019, https://newrepublic.com/article/155579/trump-vigilante-president-supporters-violence.

18. Josh Rottenberg, "President Trump Isn't Happy About the Oscar for *Parasite*: What Movies Does He Like?," *Los Angeles Times*, February 21, 2020, https://www.latimes.com/entertainment-arts/movies/story/2020-02-21/president-trump-favorite-movies-parasite-oscar.

19. Carl Schmitt, *The Concept of the Political* (New Brunswick: Rutgers University Press, [1932] 1976), 27.

20. Adam Serwer, *The Cruelty is the Point: The Past, Present, and Future of Trump's America* (New York: One World, 2021), 103.

21. Martha Nussbaum, *The Monarchy of Fear* (New York: Simon and Schuster, 2018), 69.

22. Donald Trump, Presidential Inaugural Address, January 20, 2017, https://www.whitehouse.gov/inaugural-address.

23. https://www.customink.com/fundraising/black-lives-matter-skulls-for-justice-presented-by-gerry-conway.

24. John F. Trent, "Prolific Punisher Writer Mike Baron Blasts Marvel's New Direction With the Character as Asinine," https://boundingintocomics.com/2022/01/05/prolific-punisher-writer-mike-baron-blasts-marvels-new-direction-with-the-character-as-asinine/.

Appendix

PUNISHER SERIES

This section lists publication dates, issue numbers, and key personnel for limited and ongoing series. I have included the definite article for the thirteen *Punisher* series, *The Punisher Magazine*, and seasonal titles like *The Punisher Summer Special*. I have left it out for the *Punisher 2099*, *Punisher Armory*, *Punisher War Journal*, and *Punisher War Zone* series.

The Punisher. 1986. #1–5. Key personnel: Steven Grant and Mike Zeck.

The Punisher. First unlimited series. 1987–95. #1–104 plus seven annuals. Key personnel: Mike Baron, Chuck Dixon, Russ Heath, Jr., and Klaus Janson.

The Punisher (Marvel Edge). Second series. 1995–97. #1–18. Key personnel: John Ostrander and Tom Stanford Lyle.

The Punisher (Marvel Knights). Third series. 1998–99. #1–4. Key personnel: Christopher Golden and Bernie Wrightson.

The Punisher (Marvel Knights). Fourth series. 2000–01. #1–12. Key personnel: Garth Ennis, Steve Dillon, and Jimmy Palmiotti.

The Punisher (Marvel Knights). Fifth series. 2001–04. #1–37. Key personnel: Garth Ennis, Tom Peyer, Steve Dillon, and Cam Kennedy.

Punisher MAX. Sixth series. 2004–09. #1–75 plus annual. Key personnel: Garth Ennis, Greg Hurwitz, and Steve Dillon.

The Punisher. Seventh series. 2009–10. #1–16 plus annual. Key personnel: Rick Remender and Tony Moore.

The Punisher. Eighth series. 2011–12. #1–16. Key personnel: Greg Rucka and Marco Checchetto.

The Punisher. Ninth series. 2014–15. #1–20. Key personnel: Nathan Edmondson and Mitch Gareds.

The Punisher. Tenth series. 2016–17. #1–17 plus annual. Key personnel: Becky Cloonan, Steve Dillon, and Matt Horak.

The Punisher. Eleventh series. 2017–18. #218–28. Key personnel: Matthew Rosenberg and Guiu Vilanova. A Marvel Legacy title, the first issue is listed as #218 on the grounds that the number of issues published under previous series, with the exception of the sixth and seventh series, but including annuals, adds up to 217. This suggests that the 2001–04 *Punisher Marvel Knights* and the 2004–09 *Punisher MAX* series are non-canonical.

The Punisher. Twelfth series. 2018–19. #1–16. Key personnel: Matthew Rosenberg and Szymon Kudranski.

The Punisher. Thirteenth series. 2022. #1–8. Key personnel: Jason Aaron, Paul Azaceta, and Jesús Saiz.

Punisher 2099. 1993–95. #1–34. Key personnel: Chuck Dixon, Pat Mills, Simon Coleby, and Tom Morgan.

Punisher Armory. 1990–94. #1–10. Key personnel: Eliot Brown.

The Punisher Magazine. 1989–90. #1–16. Early Punisher stories reprinted in black-and-white.

Punisher War Journal. First series. #1–80. 1988–95. Key personnel: Mike Baron, Chuck Dixon, Steven Grant, Carl Potts, and Jim Lee.

Punisher War Journal. Second series. 2007–09. #1–26 plus annual. Key personnel: Matt Fraction, Howard Chaykin, and Ariel Olivetti.

Punisher War Zone. First series. 1992–95. #1–41 plus two annuals. Key personnel: Chuck Dixon, Larry Hama, Joe Kubert, and John Romita Jr.

Punisher War Zone. Second series. 2009. #1–6. Key personnel: Garth Ennis and Steve Dillon.

Punisher War Zone. Third series. 2012–13. #1–5. Key personnel: Greg Rucka and Carmine Di Giandomenico.

Punisher MAX. 2010–12. #1–22. Key personnel: Jason Aaron and Steve Dillon.

Thunderbolts. 2013–14. #1–32 plus annual. Key personnel: Charles D. Soule, Daniel Way, Steve Dillon, and Phil Noto.

THE PUNISHER IN MOVIES, TELEVISION, AND VIDEO GAMES

Avengers Confidential: Black Widow & Punisher, Kenichi Shimizu (dir.) (2014), USA: Madhouse. Animated film.

Daredevil (2016, second season), USA: Netflix. Streaming series.

Iron Man: Rise of Technovore, Hiroshi Hamasaki (dir.) (2013), USA: Madhouse. Animated film.

The Punisher, Mark Goldblatt (dir.) (1989), USA: New World. Feature film.

The Punisher (1990), USA: Nintendo. Video game.

The Punisher (1990), USA: MicroProse. Video game.

The Punisher (1993), USA: Capcon. Video game.

The Punisher, Jonathan Hensleigh (dir.) (2004), USA: Lionsgate. Feature film.

The Punisher (2005), USA: Volition, Inc. Video game.

The Punisher (2017–18), USA: Netflix. Streaming series.

The Punisher: Dirty Laundry, Phil Joanou (dir.) (2012), USA: Raw Studios. Short film.

The Punisher: No Mercy (2009), USA: Zen Studios. Video game.

The Punisher: Ultimate Payback! (1991), USA: Game Boy. Video game.

Punisher War Zone, Lexi Alexander (dir.) (2008), USA: Lionsgate. Feature film.

HARDBOILED VIGILANTE FILMS

Above the Law, Andrew Davis (dir.) (1988), USA: Warner Brothers.

APPENDIX

Alley Cat, Victor M. Ordonez (dir.) (1984), USA: Multicon Entertainment.

Badge 373, Howard W. Koch (dir.) (1973), USA: Paramount Pictures.

Billy Jack, Tom Laughlin (dir.) (1971), USA: National Student Film Corporation.

Billy Jack Goes to Washington, Tom Laughlin (dir.) (1977), USA: Taylor-Laughlin.

The Born Losers, Tom Laughlin (dir.) (1967), USA: American International Pictures.

Breaker! Breaker! Don Hulette (dir.) (1977), USA: Paragon Films.

Challenge, Martin Beck (dir.) (1974), USA: E.O. Corporation.

Code of Silence, Andrew Davis (dir.) (1985), USA: Orion.

Coffy, Jack Hill (dir.) (1973), USA: American International Pictures.

Dark Sunday, Jimmy Huston (dir.) (1976), USA: Intercontinental Releasing Corporation.

The Dead Pool, Buddy Van Horn (dir.) (1988), USA: Warner Brothers.

Deadly Hero, Ivan Nagy (dir.) (1975), USA: City Time Partners.

The Death Squad, Harry Falk (dir.) (1974), USA: Twentieth Century Fox.

Death Sentence, James Wan (dir.) (2007), USA: Twentieth Century Fox.

Death Wish, Michael Winner (dir.) (1974), USA: Dino De Laurentiis.

Death Wish, Eli Roth (dir.) (2018), USA: MGM.

Death Wish 2, Michael Winner (dir.) (1982), USA: Golan-Globus.

Death Wish 3, Michael Winner (dir.) (1985), USA: Cannon Films.

Death Wish 4: The Crackdown, J. Lee Thompson (dir.) (1987), USA: Cannon Films.

Death Wish 5: The Face of Death, Allan A. Goldstein (dir.) (1994), USA: Twenty-First Century Film Corporation.

Defiance, John Flynn (dir.) (1980), USA: American International Pictures.

Dirty Harry, Don Siegel (dir.) (1971), USA: Warner Brothers.

The Enforcer, James Fargo (dir.) (1976), USA: Warner Brothers.

The Equalizer, Antoine Fuqua (dir.) (2014), USA: Sony Pictures.

The Equalizer 2, Antoine Fuqua (dir.) (2018), USA: Sony Pictures.

The Evil that Men Do, J. Lee Thompson (dir.) (1984), USA: Tri-Star Pictures.

The Exterminator, James Glickenhaus (dir.) (1980), USA: Interstar Pictures.

Exterminator 2, Mark Buntzman (dir.) (1984), USA: Cannon Film.

An Eye for an Eye, Steve Carver (dir.) (1981), USA: Embassy Pictures.

Falling Down, Joel Schumacher (dir.) (1993), USA: Warner Brothers.

Fighting Back, Lewis Teague (dir.) (1982), USA: Dino De Laurentiis.

Firecracker, Cirio H. Santiago (dir.) (1981), USA: New World Pictures.

A Force of One, Paul Aaron (dir.) (1979), USA: American Cinema Productions.

Forced Vengeance, James Fargo (dir.) (1982), USA: MGM.

Foxy Brown, Jack Hill (dir.) (1974), USA: American International Pictures.

Framed, Phil Karlson (dir.) (1975), USA: Paramount Pictures.

Get Carter, Mike Hodges (dir.) (1971), UK: MGM.

The Gladiator, Abel Ferrara (dir.) (1986), USA: Warner Brothers.

Good Guys Wear Black, Ted Post (dir.) (1978), USA: American Cinema Releasing.

Gordon's War, Ossie Davis (dir.) (1973), USA: Twentieth Century Fox.

Hard to Kill, Bruce Malmuth (dir.) (1990), USA: Warner Brothers.

Harry Brown, Daniel Barber (dir.) (2009), USA: Lionsgate.

Hit List, William Lustig (dir.) (1989), USA: New Line Cinema.

The Hit Man, Aaron Norris (dir.) (1991), USA: Cannon Films.

The Human Factor, Edward Dmytryk (dir.) (1975), UK: Rank Films.

I Spit on Your Grave, Meir Zarchi (dir.) (1978), USA: The Jerry Gross Organization.

Joe, John G. Avildson (dir.) (1970), USA: Cannon Films.

Kinjite: Forbidden Subjects, J. Lee Thompson (dir.) (1989), USA: Cannon Films.

Law and Disorder, Ivan Passer (dir.) (1974), USA: Columbia Pictures.

Lone Wolf McQuade, Steve Carver (dir.) (1983), USA: Orion.

Magnum Force, Ted Post (dir.) (1973), USA: Warner Brothers.

Marked for Death, Dwight H. Little (dir.) (1990), USA: Twentieth Century Fox.

McQ, John Sturges (dir.) (1974), USA: Warner Brothers.

Messenger of Death, J. Lee Thompson (dir.) (1988), USA: Cannon Films.

Mr. Majestyk, Richard Fleischer (dir.) (1974), USA: United Artists.

Ms. 45, Abel Ferrara (dir.) (1981), USA: Rochelle Films.

Murphy's Law, J. Lee Thompson (dir.) (1986), USA: Cannon Films.

Naked Vengeance, Cirio H. Santiago (dir.) (1985), USA: Concorde Pictures.

Out for Justice, John Flynn (dir.) (1991), USA: Warner Brothers.

The Outfit, John Flynn (dir.) (1973), USA: MGM.

The Protector, James Glickenhaus (dir.) (1985), Hong Kong, USA: Golden Harvest/Warner Brothers.

Remo Williams: The Adventure Begins, Guy Hamilton (dir.) (1985), USA: Orion.

Rolling Thunder, Paul Schrader (dir.) (1977), USA: American International Pictures.

Rolling Vengeance, Steven Hilliard Stern (dir.) (1987), USA: Apollo Pictures.

Savage Streets, Danny Steinmann (dir.) (1984), USA: Motion Picture Marketing.

Steele Justice, Robert Boris (dir.) (1987), USA: Atlantic Entertainment Group.

Street Law, Enzo G. Castellari (dir.) (1974), USA: Capital Film.

Sudden Impact, Clint Eastwood (dir.) (1983), USA: Warner Brothers.

Taxi Driver, Martin Scorsese (dir.) (1976), USA: Columbia Pictures.

T.N.T. Jackson, Cirio H. Santiago (dir.) (1974), USA: New World Pictures.

Trackdown, Richard T. Heffron (dir.) (1976), USA: United Artists.

The Trial of Billy Jack, Tom Laughlin (dir.) (1974), USA: Warner Brothers.

Vendetta, Bruce Logan (dir.) (1986), USA: Concorde Pictures.

Vigilante, William Lustig (dir.) (1982), USA: Artists Releasing Corporation.

Vigilante Force, George Armitage (dir.) (1976), USA: United Artists.

Walking Tall, Phil Karlson (dir.) (1973), USA: Cinerama Releasing Corporation.

Walking Tall: Part 2, Earl Bellamy (dir.) (1975), USA: American International Pictures.

Walking Tall: Final Chapter, James Starrett (dir.) (1977), USA: American International Pictures.

Welcome Home Brother Charles, Jamaa Fanaka (dir.) (1975), USA: Crown International Pictures.

Bibliography

Agamben, Giorgio. *State of Exception*. Chicago: University of Chicago Press, 2005.

Armstrong, Michael. *They Wished They Were Honest: The Knapp Commission and New York City Police Corruption*. New York: Columbia University Press, 2012.

Bainbridge, Jason. "Spider-Man, the Question and the Meta-Zone: Exception, Objectivism, and the Comics of Steve Ditko." *Law Text Culture* 12 (2012): 217–42.

Baker, Kevin. "'Welcome to Fear City': The Inside Story of New York's Civil War, 40 Years On." *The Guardian*, May 18, 2015, https://www.theguardian.com/cities/2015/may/18/welcome-to-fear-city-the-inside-story-of-new-yorks-civil-war-40-years-on.

Ball, Philip. *The Modern Myths: Adventures in the Machinery of the Popular Imagination*. Chicago: University of Chicago Press, 2021.

Barry, Mike. *The Lone Wolf: Night Raider*. New York: Berkley, 1973.

Baudrillard, Jean. *Simulations*. New York: Semiotext(e), 1983.

Bentley, E. C. *Trent's Last Case*. Oxford: Oxford University Press, [1913] 1995.

Blanshard, Brand. "Retribution Revisited." In Edward H. Madden, Rollo Handy, and Marvin Farber, eds. *Philosophical Perspectives on Punishment*. Springfield: Charles C. Thomas Publishers, 1968: 58–71.

Brevoort, Tom and Tom Kanterovich. "Why is the Punisher So Cool? Or, Hey, Didn't This Guy Used to Shoot Jaywalkers?" *Marvel Year-in-Review '92*. New York: Marvel, 1992: 28–30.

Brown, Richard Maxwell. *Strain of Violence: Historical Studies of American Violence and Vigilantism*. New York: Oxford University Press, 1975.

Bukatman, Scott. "A Song of the Urban Superhero." In Charles Hatfield, Jeet Heer, and Kent Worcester, eds. *The Superhero Reader*. Jackson: University Press of Mississippi, [2000] 2013: 170–98.

Bukatman, Scott. *Matters of Gravity: Special Effects and Supermen in the 20th Century*. Durham: Duke University Press, 2003.

Burrough, Bryan. *Days of Rage: America's Radical Underground, the FBI, and the Forgotten Age of Revolutionary Violence*. New York: Penguin, 2016.

Campbell, John. *The Hero With a Hundred Faces*. Princeton: Princeton University Press, [1949] 1973.

Cassuto, Leonard. *Hard-Boiled Sentimentality: The Secret History of American Crime Stories*. New York: Columbia University Press, 2009.

Cawelti, John G. *Adventure, Mystery, and Romance: Formula Stories as Art and Popular Culture*. Chicago: University of Chicago Press, 1976.

Charteris, Leslie. *The Saint: The Happy Highwayman*. New York: Avon, [1935] 1939.

Child, Lee. *Killing Floor*. New York: Penguin, [1997] 2012.

Chute, Hillary. *Disaster Drawn: Visual Witness, Comics, and Documentary Form*. Cambridge: Harvard University Press, 2016.

Cliff, Tony. *The Crisis: Social Contract or Socialism*. London: Pluto, 1975.

Cline, John. "Bernie's *Deathwish*: History and Transgression in New York City." In Robert G. Weiner, ed. *Cinema Inferno: Celluloid Explosions from the Cultural Margins*. Lanham: Scarecrow Press, 2010: 145–56.

Cocca, Carolyn. *Superwomen: Gender, Power, and Representation*. New York: Bloomsbury, 2016.

Comtois, Pierre. *Marvel Comics in the 1970s: An Issue By Issue Field Guide to a Pop Culture Phenomenon*. Raleigh: TwoMorrows, 2011.

Connelly, Michael. *City of Bones*. New York: Grand Central Publishing, 2002.

Coogan, Peter. *Superhero: The Secret Origin of a Genre*. Austin: MonkeyBrain, 2006.

Council for Public Safety. "Welcome to Fear City: A Survival Guide for Visitors to the City of New York." New York: Council for Public Safety, 1974. http://untappedeities. com/2013/09/17/1970s-anti-tourist-guide-to-nyc-welcome-to-fear-city/.

Costello, Brandon. *Neon Visions: The Comics of Howard Chaykin*. Baton Rouge: LSU Press, 2017.

Costello, Matthew J. *Secret Identity Crisis: Comic Books and the Unmasking of Cold War America*. New York: Continuum, 2009.

Costello, Matthew J. and Kent Worcester. "Symposium: The Politics of the Superhero." *PS: Political Science and Politics* 47, no. 1 (2014): 85–124.

Cowie, Jefferson. *Stayin' Alive: The 1970s and the Last Days of the Working Class*. New York: New Press, 2010.

Daniels, Les. *Marvel: Five Fabulous Decades of the World's Greatest Comics*. New York: Abrams, 1991.

Darda, Joseph. *How White Men Won the Culture Wars: A History of Veteran America*. Berkeley: University of California Press, 2021.

Davidow, Mike. *Cities Without Crises: The Soviet Union Through the Eyes of an American*. Moscow: Novosti Press Agency Publishing, 1974.

Davis, Kenneth C. *Two-Bit Culture: The Paperbacking of America*. Boston: Houghton Mifflin, 1984.

De Quincey, Thomas. "The Avenger" (1838), reprinted in Thomas De Quincey, *On Murder*. New York: Penguin, 2006.

Debose, Mike S. "Holding Out for a Hero: Reaganism, Comic Book Vigilantes, and Captain America." *Journal of Popular Culture* 40, no. 6 (2007): 551–71.

DiPaolo, Marc. *War, Politics, and Superheroes: Ethics and Propaganda in Comics and Film*. Jefferson: McFarland, 2011.

BIBLIOGRAPHY

Dittmer, Jason. *Captain America and the Nationalist Superhero: Metaphors, Narratives, and Geopolitics*. Philadelphia: Temple University Press, 2013.

Draper, Hal. "Cops, *Dirty Harry*, and Junious Poole." *KFA Commentary*, 1972, http://www.marxistfr.org/archive/draper/1972/01/cops.htm.

Dugan, Sally. *Baroness Orczy's The Scarlet Pimpernel: A Publishing History*. London: Routledge, 2016.

Dumas, Alexandre. *The Count of Monte Cristo*. New York: Bantam, [1844] 1981.

Earle, Harriet. *Comics, Trauma, and the New Art of War*. Jackson: University Press of Mississippi, 2017.

Eco, Umberto. "The Myth of Superman" (1972). In Jeet Heer and Kent Worcester, eds. *Arguing Comics: Literary Masters on a Popular Medium*. Jackson: University Press of Mississippi, 2004: 146–64.

Evanier, Mark. *Kirby: King of Comics*. New York: Abrams, 2008.

Ezorsky, Gertrude, ed. *Philosophical Perspectives on Punishment*. Albany: SUNY Press, 1972.

Faludi, Susan. *The Terror Dream: Fear and Fantasy in Post-9/11 America*. New York: Metropolitan, 2007.

Foucault, Michel. *Discipline and Punish: The Birth of the Prison*. New York: Pantheon, 1979 [1975].

Freeman, Joshua. *Working Class New York: Life and Labor Since World War II*. New York: The New Press, 2000.

Friedenthal, Andrew J. "'The Punishment of War': Marvel Comics The Punisher and the Evolving Memory of Vietnam." *Journal of Comics and Culture* 1 (2016): 124–49.

Gabilliet, Jean-Paul. *Of Comics and Men: A Cultural History of American Comic Books*. Jackson: University Press of Mississippi, 2010.

Garfield, Brian. *Death Wish*. New York: Overlook Press, 2013 [1972].

Garfield, Brian. *Death Sentence*. New York: Overlook Press, 2014 [1975].

Gavaler, Chris. *On the Origin of Superheroes: From the Big Bang to Action Comics No. 1*. Iowa City: University of Iowa Press, 2015.

Getzfeld, Andrew. R. "What Would Freud Say? Psychopathology and the Punisher." In Robin S. Rosenberg, ed. *The Psychology of Superheroes: An Unauthorized Exploration*. Dallas: BenBella Books, 2008: 163–74.

Gibson, James W. *Warrior Dreams: Violence and Manhood in Post-Vietnam America*. New York: Hill and Wang, 1994.

Giddens, Thomas. *Graphic Justice: Intersections of Comics and Law*. New York: Routledge, 2015.

Goodman, Alicia M., Matthew J. McEniry, Ryan Cassidy, and Robert G. Weiner, eds. *Judge, Jury and Executioner: Essays on The Punisher in Print and on Screen*. Jefferson: McFarland, 2021.

Gordon, Michael. *Sick Cities: Psychology and Pathology of American Urban Life*. New York: Penguin, [1963] 1965.

Graeber, David. *The Utopia of Rules: On Technology, Stupidity, and the Secret Joys of Bureaucracy*. New York: Melville House, 2015.

Greenfield, Steve, Guy, Osborn, and Peter, Robson. *Film and the Law: The Cinema of Justice*. Oxford: Hart Publishing, 2010.

Grünwald, Jennifer, ed. *Strange Tales*. New York: Marvel, 2010.

Hague, Ian, Ian Horton, and Nina Michwitz, eds. *Contexts of Violence in Comics*. New York: Routledge, 2019.

Hall, Stuart and Whannel, Paddy. *The Popular Arts*. Durham: Duke University Press, [1964] 2018.

Haslem, Wendy, Angela Ndaliani, and Chris Mackie, eds. *Super/Heroes: From Hercules to Superman*. Washington, DC: New Academy Publishing, 2007.

Hatfield, Charles, Jeet Heer, and Kent Worcester, eds. *The Superhero Reader*. Jackson: University Press of Mississippi, 2013.

Haut, Woody. *Pulp Culture and the Cold War*. London: Serpent's Tail, 1995.

Hay, Douglas et al. *Albion's Fatal Tree: Crime and Society in Eighteenth-Century England*. New York: Pantheon, 1975.

Hebdige, Dick. *Subculture: The Meaning of Style*. London: Methuen, 1979.

Heer, Jeet and Kent Worcester, eds. *Arguing Comics: Literary Masters on a Popular Medium*. Jackson: University Press of Mississippi, 2004.

Heer, Jeet and Kent Worcester, eds. *A Comics Studies Reader*. Jackson: University Press of Mississippi, 2008.

Hirschman, Albert O. *The Rhetoric of Reaction: Perversity, Futility, Jeopardy*. Cambridge: Harvard University Press, 1991.

Holland, Tom. *Dynasty: The Rise and Fall of the House of Caesar*. New York: Anchor, 2015.

Hobsbawm, Eric. *Bandits*. London: Weidenfeld & Nicolson, [1969] 2000.

Hofstadter, Richard and Michael Wallace, eds. *American Violence: A Documentary History*. New York: Knopf, 1970.

Howe, Sean. *Marvel Comics: The Untold Story*. New York: Harper, 2012.

Hurst, Alexander. "The Vigilante President," *The New Republic*, November 6, 2019, https://newrepublic.com/article/155579/trump-vigilante-president-supporters-violence.

Jackson, Gordon M. "The Weirdest Spy Action Novels Ever Published," io9, February 11, 2015, https://io9.com/the-weirdest-spy-action-novels-ever-published-168529336.

Jacobs, Ron. *The Way the Wind Blew: A History of the Weather Underground*. New York: Verso, 1979.

Jankiewicz, Pat. "Origin of the Species: The Punisher!" *Marvel Vision* 15 (1997): 30–31.

Jenson, Darren, Stuart Vandal, and Jeph York. *Punisher: Official Index to the Marvel Universe*. New York: Marvel, 2012.

Kaminer, Wendy. *It's All the Rage: Crime and Culture*. Reading: Addison-Wesley, 1995.

Katznelson, Ira. *City Trenches: Urban Politics and the Patterning of Class in the United States*. Chicago: University of Chicago Press, 1981.

BIBLIOGRAPHY

Kermode, Frank. *The Sense of an Ending: Studies in the Theory of Fiction*. New York: Oxford University Press, 1966.

Kittredge, William and Steven M. Krauzer, eds. *The Great American Detective*. New York: New American Library, 1978.

Klock, Geoff. *How to Read Superhero Comics and Why*. New York: Continuum, 2002.

Knopf, Christine. "The Queen of Burlesque: The Subtle (as a Hammer) Satire of *Bomb Queen*." In Michael Goodrum, Tara Prescott, and Philip Smith, eds. *Gender and the Superhero Narrative*. Jackson: University Press of Mississippi, 2018: 101–22.

Kropotkin, Peter. *Organised Vengeance Called Justice*. London: Freedom Press, [1902] 1948.

Lefèvre, Pascal. "Incompatible Visual Ontologies? The Problematic Adaptation of Drawn Images." In Ian Gordon, Mark Jancovich, and Matthew P. McAllister, eds. *Film and Comic Books*. Jackson: University Press of Mississippi, 2007: 1–12.

Lewis, Tom. *Get Carter*. London: Allison & Busby, [1970] 1992.

Lichtenfeld, Eric. *Action Speaks Louder: Violence, Spectacle, and the American Action Movie*. Middletown: Wesleyan University Press, 2007.

Lovell, Jarret S. "Nostalgia, Comic Books, and the 'War Against Crime!' An Inquiry into the Resurgence of Popular Justice." *Journal of Popular Culture* 36, no. 2 (2003): 215–35.

Mahler, Jonathan. *Ladies and Gentlemen, the Bronx is Burning: Baseball, Politics, and the Battle for the Soul of a City*. New York: Farrar, Straus, and Giroux, 2005.

Mandel, Ernest. *Delightful Murder: A Social History of the Crime Story*. London: Pluto Press, 1984.

Mann, Bonnie. *Sovereign Masculinity: Gender Lessons from the War on Terror*. New York: Oxford University Press, 2014.

Marx, Karl. "Punishment and Society." In Gertrude Ezorsky, ed. *Philosophical Perspectives on Punishment*. Albany: SUNY Press, [1853] 1982: 358–59.

McCloud, Scott. *Understanding Comics: The Invisible Art*. Northampton: Tundra, 1993.

McCulley, Johnston. *The Curse of Capistrano*. New York: Summit, [1919] 2013.

McDuffie, Dwayne, et al. *Damage Control: The Complete Collection*. New York: Marvel, 2015.

Mengel, Brad. *Serial Vigilantes of Paperback Fiction: An Encyclopedia from Able Team to Z-Comm*. Jefferson: McFarland, 2009.

Mickwitz, Nina, Ian Horton, and Ian Hague, eds. *Representing Acts of Violence in Comics*. New York: Routledge, 2019.

Miller, Frank. *The Dark Knight Returns*. New York: DC Comics, 1986.

Mills, Pat. *Be Pure! Be Vigilant! Behave! 2000AD and Judge Dredd: The Secret History …* Malaga: Millsverse, 2017.

Mollenkopf, John H. *A Phoenix in the Ashes: The Rise and Fall of the Koch Coalition in New York Politics*. Princeton: Princeton University Press, 1994.

Moody, Kim. *From Welfare State to Real Estate: Regime Change in New York City, 1974 to the Present*. New York: The New Press, 2007.

Moore, Alan and Dave Gibbons. *Watchmen*. New York: DC Comics, 1987.

Moore, Alan and David Lloyd. *V for Vendetta*. New York: DC Comics, 1989.

Morrell, David. *First Blood*. New York: Fawcett, 1972.

Morrison, Grant. *Supergods: What Masked Vigilantes, Miraculous Mutants, and a Sun God from Smallville can Teach Us About Being Human*. New York: Spiegel & Grau, 2011.

Mumford, Lewis. *The Culture of Cities*. New York: Harcourt, Brace, Jovanovich, [1938] 1970.

Ndalianis, Angela, ed. *The Contemporary Comic Book Superhero*. New York: Routledge, 2009.

Nietzsche, Friedrich. *Twilight of the Idols*. New York: Penguin, [1889] 1988.

Nussbaum, Martha C. *The Monarchy of Fear*. New York: Simon and Schuster, 2018.

Orczy, Baroness Emma. *The Scarlet Pimpernel*. New York: Puffin, [1905] 1997.

Page, Norvell. *The Spider: Master of the Flaming Horde*. Bordentown: Bold Venture, [1937] 2001.

Palmer, Lorrie. "The Punisher as Revisionist Superhero Western." In Charles Hatfield, Jeet Heer, and Kent Worcester, eds. *The Superhero Reader*. Jackson: University Press of Mississippi, [2007] 2013: 279–94.

Peaslee, Robert M. and Robert Weiner, eds. *The Supervillain Reader*. Jackson: University Press of Mississippi, 2020.

Pendleton, Donald. *The Executioner: War Against the Mafia*. New York: Pinnacle, 1969.

Perlstein, Rick. *Nixonland: The Rise of a President and the Fracturing of America*. New York: Scribner, 2009.

Peterson, Richard A., ed. *The Production of Culture*. Beverly Hills: Sage, 1976.

Phillips, Nickie D. and Staci Strobl. *Comic Book Crime: Truth, Justice, and the American Way*. New York: New York University Press, 2013.

Phillips-Fein, Kim. *Fear City: New York's Fiscal Crisis and the Rise of Austerity Politics*. New York: Metropolitan, 2017.

Plato. *The Republic*. New York: Basic Books, [*c*.380 BCE] 1991.

Pollard, Tom. *Hollywood 9/11: Superheroes, Supervillians, and Super Disasters*. Boulder: Paradigm, 2011.

Pratt, Ray. *Projecting Paranoia: Conspiratorial Visions in American Film*. Lawrence: University Press of Kansas, 2001.

Raphael, Jordan and Tom Spurgeon. *Stan Lee and the Rise and Fall of the American Comic Book*. Chicago: Chicago Review Press, 2003.

Raviv, Dan. *Comic Wars: How Two Tycoons Battled Over the Marvel Comics Empire – And Both Lost*. New York: Broadway Books, 2002.

Reagan, Ronald. "Farewell Address to the Nation." 1989, https://reaganlibrary.gov/major-speeches-index/37-archives/speeches/1989/8236-011189i.

Regalado, Aldo J. *Bending Steel: Modernity and the American Superhero*. Jackson: University Press of Mississippi, 2015.

Robin, Corey. *Fear: The History of A Political Idea*. New York: Oxford University Press, 2004.

Robin, Corey. *The Reactionary Mind: Conservatism from Edmund Burke to Donald Trump*. New York: Oxford University Press, 2018.

BIBLIOGRAPHY

Roblou, Yann. "Complex Masculinities: The Superhero in Modern American Movies." *Culture, Society and Masculinities* 4 (2012): 76–91.

Rosenbaum, H. Jon and Peter C. Sederberg. *Vigilante Politics*. Philadelphia: University of Pennsylvania Press, 1976.

Rubin, Lillian B. *Quiet Rage: Bernie Goetz in a Time of Madness*. New York: Farrar, Straus, and Giroux, 1986.

Sacks, Jason, Eric Hoffman, and Dominick Grace, eds. *Jim Shooter: Conversations*. Jackson: University Press of Mississippi, 2017.

Sandbrook, Dominic. *Mad as Hell: The Crisis of the 1970s and the Rise of the Populist Right*. New York: Anchor, 2011.

Schatz, Thomas. *Hollywood Genres: Formulas, Filmmaking, and the Studio System*. New York: McGraw-Hill, 1981.

Schmitt, Carl. *The Concept of the Political*. New Brunswick: Rutgers University Press, [1932] 1976.

Schmitt, Carl. *Constitutional Theory*. Durham: Duke University Press, [1928] 2008.

Schmitt, Carl. *Dictatorship*. London: Polity, [1921] 2013.

Scott, Cord. "The Alpha and the Omega: Captain America and the Punisher." In Robert Weiner, ed. *Captain America and the Struggle of the Superhero: Critical Essays*. Jefferson: McFarland, 2009: 125–34.

Scott, Cord. "Anti-Heroes: Spider-Man and the Punisher." In Robert M. Peaslee and Robert Weiner, eds. *Web-Spinning Heroics: Critical Essays on the History and Meaning of Spider-Man*. Jefferson: McFarland, 2012: 120–27.

Scully, Tyler and Kenneth Moorman. "The Rise of Vigilantism in 1980s Comics: Reasons and Outcomes." *Journal of Popular Culture* 46, no. 3 (2014): 634–53.

Server, Lee. *Danger is My Business: An Illustrated History of the Fabulous Pulp Magazines, 1896–1953*. San Francisco: Chronicle, 1993.

Server, Lee. *Over My Dead Body: The Sensational Age of the American Paperback: 1945–1955*. San Francisco: Chronicle, 1994.

Serwer, Adam. *The Cruelty is the Point: The Past, Present, and Future of Trump's America*. New York: Random House, 2021.

Sexton, Jared Y. *The People are Going to Rise Like the Waters Upon Your Shore: A Story of American Rage*. Berkeley: Counterpoint, 2017.

Siegel, Fred. *The Prince of the City: Giuliani, New York and the Genius of American Life*. New York: Encounter Books, 2007.

Sleeper, Jim. *The Closest of Strangers: Liberalism and the Politics of Race in New York*. New York: Norton, 1990.

Slotkin, Richard. *Gunfighter Nation: The Myth of the Frontier in Twentieth-Century America*. Norman: University of Oklahoma Press, 1998.

Sorel, George. *Reflections on Violence*. Cambridge: Cambridge University Press, [1908] 1999.

Spanalos, Anthony P. "Hell's Kitchen's Prolonged Crisis and Would-be Sovereigns: Daredevil, Hobbes, and Schmitt," *PS: Political Science and Politics* 47, no. 1 (2014): 94–97.

Spillane, Mickey. *I, The Jury, in The Mike Hammer Collection, Volume 1*. New York: New American Library, [1947] 2002.

Starr, R. *The Rise and Fall of New York City*. New York: Basic Books, 1985.

Stewart, Rebecca. "Editor's Introduction." In Fiona Peters and Rebecca Stewart, eds. *Antihero*. London: Intellect, 2016.

Sue, Eugène *The Mysteries of Paris*. London: Penguin, [1842–43] 2015.

Tasker, Yvonne. *Spectacular Bodies: Gender, Genre, and the Action Cinema*. New York: Routledge, 1993.

Theweleit, K. *Male Fantasies, Vol 1: Women, Floods, Bodies, History*. Minneapolis: University of Minneapolis Press, [1977] 1987.

Theweleit, K. *Male Fantasies, Vol. 2: Male Bodies – Psychoanalyzing the White Terror*. Minneapolis: University of Minneapolis Press, [1977] 1987.

Thomas, Roy. *75 Years of Marvel: From the Golden Age to the Silver Screen*. Cologne: Taschen, 2014.

Thompson, Robert J. *Adventures on Prime Time: The Television Programs of Stephen J. Cannell*. New York: Praeger, 1990.

Wallin, Zoe. *Classical Hollywood Film Cycles*. New York: Routledge, 2019.

Wandtke, Terence R. *The Dark Night Returns: The Contemporary Resurgence of Crime Comics*. Rochester: RIT Press, 2015.

Wertham, Fredric. *Seduction of the Innocent*. Laurel: Main Road Books, [1954] 2004.

Wertham, Fredric. *A Sign for Cain: An Exploration of Human Violence*. New York: Warner Paperback, [1966] 1973.

Wister, Owen. *The Virginian: A Horseman of the Plains*. Mineola: Dover, [1902] 2006.

Worcester, Kent. "New York City, 9/11 and Comics." *Radical History Review* 111 (2011): 139–54.

Worcester, Kent. "The Punisher and the Politics of Retributive Justice." *Law Text Culture* 16 (2012): 329–52.

Worcester, Kent. "The Punisher: Marvel Universe Icon and Murderous Antihero." In Fiona Peters and Rebecca Stewart, eds. *Antihero*. Bristol: Intellect, 2015: 30–45.

Worcester, Kent. "Comics, Comics Studies, and Political Science." *International Political Science Review* 38, no. 5 (2017): 690–700.

Worcester, Kent. "Graphic Narrative and the War on Terror." In Tatiana Prorokova and Nimrod Tal, eds. *Cultures of War in Graphic Novels*. New Brunswick: Rutgers University Press, 2018: 41–57.

Worcester, Kent. "To Shame its Inadequacy: The Punisher and His Critics." In Alicia M. Goodman, Matthew J. McEniry, Ryan Cassidy, and Robert G. Weiner, eds. *Judge, Jury, and Executioner: Essays on the Punisher in Print and Screen*. Jefferson: McFarland, 2021: 15–26.

Worcester, Kent, Sally A. Bermanzohn, and Mark Ungar, eds. *Violence and Politics: Globalization's Paradox*. New York: Routledge, 2002.

Wright, Bradford W. *Comic Book Nation: The Transformation of Youth Culture in America*. Baltimore: Johns Hopkins University Press, 2001.

Young, Paul. *Frank Miller's Daredevil and the Ends of Heroism*. New Brunswick: Rutgers University Press, 2016.

Žižek, Slavoj. *Violence: Six Sideways Reflections*. New York: Picador, 2008.

Index

A

A-Team, The 46
Aaron, Jason ix, 71, 214, 217, 242
Agamben, Giorgio 99
Alexander, Lexi 225
Althusser, Louis 203
American, The 181
Andrews, Archie 108
Andru, Ross 68–69, 74, 76, 87, 138, 140
Animal Man/Baker, Buddy 175, 209
Arc Light 144

B

Baker, Kevin 30
Ball, Philip 16
Bandits (Hobsbawm) 4
Bannon, Steve 241
Barker, Martin 15
Baron, Mike 12, 48, 67, 74, 134–35, 140–45,
 149, 176, 182, 183–84, 185, 242
Barracuda 212–13, 223
Batman 42
Bauer, Jack 103
Beard Hunter/ Franklin, Ernest 175
Beati Paoli 37
Bemis, Max 181
Bernardo, Mark 185
Bernthal, Jon 2, 222–24, 226
Big Shot 177
Birth of a Nation 40

Black Liberation Army 37
Black Lives Matter 3, 242
Blackheart 110
Blanshard, Brand 1
Blue Lives Matter 3, 18, 205
Bolland, Brian 209
Bradstreet, Tim 211
Braithwaite, Dougie 211
Brothers, David 213
Brown, Eliot 154–55
Brown, Richard Maxwell 39
Buckler, Rick 139
Bukutman, Scott 104–05
Bullseye 80, 102, 146, 187–88
Burrough, Brian 37

C

Cadence 203
Cage, Luke 183
Callahan, Harry 5
Campbell, Laurence 211
Cannell, Stephen J. 46
Captain America/Rogers, Stve 10, 79, 100–02,
 111, 112–16, 171, 175, 215
Carbone, Rosalie 151, 187–90
Cardiac 182
Carlyle, Thomas 235
Cashell, Kiernan 178
Cassuto, Leonard 11
Charteris, Leslie 97

Chase, Bobbie 186
Chaykin, Howard 178
Child, Lee 104
Circle of Blood 5, 72, 80, 134, 137–41, 155, 173, 180–81, 185, 194, 206
Clarke, Stuart 107
Cloonan, Becky 215, 219–20
Clowes, Dan 179–80
Cole-Alves, Rachel 118, 218
Columbia University 35
Comedian/Blake, Edward Morgan 183
Conway, Gerry 4, 43, 68, 72, 74, 83, 194, 202, 205, 224, 242
Coogan, Peter 7
Cooke, Jennifer 10, 193, 212
Coteral gang 37
Crush/Mason, Elizabeth 182

D
Daken/Akihiro 216–17
Dakesian, Nanci 207, 210
Daley, Don 7, 71, 105, 134, 147, 149, 151, 175, 185
Daly, Carroll John 41
Damage Control 173
Daniels, Les 82, 136, 175
Daredevil (TV series) 222–23
Daredevil/Murdock, Matt 80, 99, 101–02, 107, 111–12, 115–19, 186–89, 210, 222, 226
Dargis, Manohla 8
Dark Knight Returns 182
Darkhawk/Christopher Powell 108
David, Peter 107
Davidow, Mike 29
De Quincey, Thomas 39
Deadpool/Wilson, Wade 72, 102, 109, 218
Deadshot/Lawton, Floyd 180
Death Wish (film) 44, 220, 240
Death Wish (novel) 44–45, 47

Deathlok 109
Deathstroke the Terminator/Wilson, Slade 181
Derrick, Lionel 46
DeZuniga, Tony 83, 86–87, 138, 140
Diamonelle/Michaels, Lynn 107, 147, 150–51, 218
Dillon, Steve ix, 192–93, 205–11, 215, 217
DiPaolo, Marc 14
Dirty Harry 5, 42–47, 140, 156
Disney Corporation 205, 222–24, 226
Ditko, Steve 74, 105–06, 140, 183
Dittmer, Jason 113
Dixon, Chuck 72, 134, 143, 185, 206, 213, 219
Dixon, Thomas 40
Dockery, James 46
Doctor Octopus/Octavius, Otto 104
Doctor Strange/Strange, Stephen 11, 104, 108–09, 121, 186, 221
Draper, Hal 42
Duhigg, Charles 65
Dumas, Alexandre 40

E
Earle, Harriet 36
Ebert, Roger 225
Eco, Umberto 155
Edelman, Murray 17
Edmondson, Nathan 70, 73, 214, 219
Elektra/Natchios, Elektra 102, 219
Elite 208
Enemy 182
Ennis, Garth ix, 16, 18, 65, 67, 70–71, 118, 181, 192–94, 205–14, 219–20
Evanier, Mark 203
Executioner, The (Pendleton)/Mack Bolan 6, 41, 43, 48–50, 54–55, 77, 155, 194
Exterminator, The 45

INDEX

F

Faludi, Susan 45
Farrell, Perry 236
Fernández, Leandro 205, 211
Ferris, Graham 115
Floyd, George 242
Foolkiller/Salinger, Greg/Gerhardt, Kurt 67, 181
Foucault, Michel 97
Fraction, Matt 12, 214
Freeman, Joshua 32, 34
Friedenthal, Andrew 70
FrontPage Magazine 207
Fury, Nick 9, 148, 184, 187, 190, 206
Fussell, Sam 31

G

Garfield, Brian 36, 44
Gavaler, Chris 40
Geraci, Don Mario 187–88, 190
Gerber, Steve 173
Ghost Rider 68
Ghost Rider/Blaze, Johnny 109–10, 186, 221
Giacoia, Frank 139
Gibbons, Dave 141
Gibson, James William 47, 142
Girner, Sebastian 217
Giuliani, Rudolph 206–07
Glickenhaus, James 45
Gnucci, Ma 208
Goetz, Bernie 53
Goldblatt, Mark 224
Golden, Christopher 191, 192
Goldmark Jr., Peter 35
Goodman, Martin 203
Goodwin, Archie 69, 72, 83, 86–87
Gordon, Mitchell 32
Goyer, David 224
Graeber, David 12

Grant, Steven 5, 106, 134, 137–41, 182–83, 185
Green Goblin/Osborn, Norman 74–75, 216
Greenblatt, Jordana 141
Gruenwald, Mark 74
Guardian Angels 53
Guggenheim, Marc 170
Gunnell, John 15
Guthrie, Woody 40

H

Hall, Stuart 41
Hama, Larry 74
Hammer, Mike 6, 41–42
Hardt, Michael 98
Hate-Monger 215
Hazzard, Mark 181
Heath Jr., Russ 134
Hegel, G.W.F. 238
Hembeck, Fred 171
Hensleigh, Jonathan 224
Herring, Laura 224
Hesiod 235
Hobbes, Thomas 13, 97–98, 143
Hobsbawm, Eric 4, 97
Hofstadter, Richard 52
Holloway, Matt 225
Hood, Robin 37
Howard the Duck 173
Hulk/Read Hulk/Banner, Bruce 9, 64, 67–68, 102, 108, 186–87
Huntress/Wayne, Helena/ Bertinelli, Helena 181
Hurst, Alexander 239
Hurwitz, Gregg 181
Hutcheon, Linda 172, 180

I

Icahn, Carl 204

J

Jameson, Jonah 104
Jane, Thomas 224, 226
Janson, Klaus 134
Jewett, Robert 114
Jigsaw/Russo, Billy 78–80, 102, 142–43, 146, 190, 212, 214, 216–17, 221–23, 225–26
Johnson, David 176
Judge, Jury, and Executioner (Goodman et al.) 15

K

Kaminer, Wendy 53, 195
Katznelson, Ira 32
Kersey, Paul 5
Kieth, Sam 176
Kingpin/Fisk, Wilson 80, 102, 104, 119, 146, 148, 173, 210, 222
Kirby, Jack 203
Kittredge, William 6
Klock, Geoff 75, 79, 141
Knapp Commission 33
Knight, Wayne 225
Krauzer, Steven 6
Kreiner, Rich 7
Kropotkin, Peter 105
Kubert, Joe 134
Kudranski, Szymon ix

L

Lacan, Jacques 36
Landini, Stefano 220
Lapham, David 117
Lapham, Lewis 5
Larosa, Lewis 211
Lash, Batton 108
Lawrence, John Shelton 114
Layman, John 174
Lee, Jim 134, 223
Lee, Jonathan Jay 171

Lee, Pat 192
Lee, Stan 68–69, 74, 235
Lewis, Ted 134
Lichtenfeld, Eric 43
Lindsay, Mayor John 34
Litsey, Ryan 102
Locke, John 13, 97–98
Lodge, Veronica 108
Lone Ranger/Reid, John 41
Lundgren, Dolph 171, 224, 226
Lunt, Cleo 115
Lustig, William 45
Lyle, Tom 189

M

MacAndrews & Forbes 204
Malzberg, Barry 49–51, 157
Mandel, Ernest 88, 238–39
Mann, Bonnie 17, 98, 121
Mantlo, Bill 170
Marcum, Art 225
Marshal Law/Gilmore, Joe 178–79
Martin, Brian 157
Marvel
 Edge 186
 Entertainment Group 185, 203–04
 MAX 66, 214
 Studios 225
 Ultimates 66
Marvel Preview 72–73, 83–86, 87
Marvel Super Action 72, 86–87
Marvel Swimsuit Special 203
Marvel Zombies Vs. Army of Darkness 174
Marx, Karl 236
Masters, Doug 47
McCloud, Scott 65–66
McCulley, Johnston 41
McLaurin, Mark 184
McPherran, Mary 185

INDEX

Microchip/Lieberman, David 142–45,
 147–49, 151–52, 157, 217, 222
Millar, Mark 67
Miller, Frank 80, 115–117, 141, 182–83
Miller, Stephen 241
Mills, Pat 68, 170, 178–79
Mollenkopf, John 33
Moon Knight/Spector, Marc 1, 68, 107, 109–10
Moore, Alan 141, 182–83
Morrison, Grant 5, 175
Mr.A/Graine, Rex 105, 183
Mumford, Lewis 32
Murdoch, Rupert 52
Murphy, Warren 47

N
Nails, Mike 8
Negri, Antonio 98
Netflix 2, 204, 222–23, 226
Neves, Fabiano 174
New World Pictures 203–04
Newfield, Jack 33
Nietzsche, Friedrich 235
Nixon, Richard 5
Nussbaum, Martha 64, 240

O
O'Neill, Kevin 68, 170, 178–79
Official Handbook of the Marvel Universe 7
Orczy, Baroness Emma 41
Ostrander, John 189
Oswalt, Patton 225

P
Painkiller Jane/Vasko, Jane 214
Palmiotti, Jimmy 207
Parlov, Goran 211
Parody Press 176
Patton, Will 224
Payback/Franklin, Kevin 208

Payne, Jon 175
Peacemaker/Smith, Chris 180, 183
Penalizer 175
Pendleton, Don 6, 43, 47, 49
Perelman, Ron 204
Pérez, George 156
Perlmutter, Ike 204
Perlstein, Rick 37
Persecutor 178–79
Phillips-Fein, Kim 34
Plato 169
Potts, Carl 16, 20, 105, 134, 137, 140, 145, 185
Powell, Nate 3
Power Pack 108
Pulverizer/Frank Casket 174
Pummeler 176
Pun-isher 178
Punfisher/Frank Carple 174
Punish-Her/Frankie Tower 176
Punisher (TV series) 222–23
Punisher 2099 143
Punisher Armory 143, 154–55
Punisher Noir 221
Punisher O.V. 153
Punisher Presents Barracuda, The 213
Punisher War Journal 143, 148, 150, 215
Punisher War Zone 143, 150–52
Punisher War Zone (film) 223, 225
Punisher, The (film [1989]) 223, 224
Punisher, The (film [2004]) 223–25
Punisher: Assassin's Guild 153
Punisher: Intruder 153
Punisher: Kingdom Gone 153
Punisher: The Ghosts of Innocents 154
Punisher: The Prize 153
PunisherMAX 217

Q
Quesada, Joe 171, 207
Question, The/Sage, Vic 105, 183

R

Ralston, Gilbert 47
Rand, Ayn 105
Reacher, Jack 104
Reagan, Ronald 136–37
Reagan's Raiders 139, 176
Regulators, the 38
Reinhold, Bill 153
Remender, Rick 105, 214, 215
Repetto, Thomas 31
Return to Big Nothing 153
Richthofen, Molly von 208, 213
Rorschach/Kovacs, Walter 183
Romita Sr., John 68–69, 74, 134
Rosenbaum, H. Jon 12, 54
Rosenberg, Matthew ix, 203, 214, 220
Rosenberger, Joseph Rupert 46
Ross, Alex 170
Rostow, Walt 236
Rousseau, Jean-Jacques 13, 143
Roussos, George 7
Rucka, Greg 214, 218
Russian, The 208, 210, 221
Ryan, Johnny 171

S

Sable, Jon 181
Salinger, Matt 171
Santora, Nick 225
Sapir, Richard 47
Saunders, Ben 119
Savage Steel 182
Scaggs, John 178
Scarlet Pimpernel/Blakeney, Percy 41
Schatz, Thomas 42
Schmidt, Helmut 64
Schmitt, Carl 10, 13, 52, 98–100, 208, 241
Scourge, The 180
Sederberg, Peter 12, 54

Server, Lee 41
Serwer, Adam 241
Siegel, Don 42
Sienkiewicz, Bill 7
Simmel, Georg 12
Sliwa, Curtis 53
Slotkin, Richard 39
Sniegoski, Tom 191, 192
Soap, Martin 107, 208, 221
Space Punisher 221
Spanakos, Peter 99
Spider-Man 81–82
Spider-Man/Parker, Peter Ix, 1, 5, 9–11, 42–44, 64, 68–82, 88, 111–12, 119–120, 172, 174, 203, 210, 218, 226
Spillane, Mickey 6, 41, 47, 86
Starlin, Jim 153–54
Starr, Roger 31
Stettner, Edward 13
Stevenson, Ray 225–26
Stewart, Rebecca 6
Strange Tales 171
Sue, Eugène 39–40
Sugar, Andrew 47
Superman/Kent, Clark 6, 42, 155, 170
SuperPatriot/Armstrong, John 182
Symbionese Liberation Army 37

T

T.J. Hooker 46
Tasker, Yvonne 139
Taskmaster/Masters, Tony 10
Tell, William 37
Templeton, Ty 176
Thomas, Jake 238
Thomas, Roy 69, 74, 83
Thor 64, 218
Thunderbolts 218
Travolta, John 224
Trump, Donald 3, 52, 239–42

INDEX

U
Unite the Right 3, 18, 205

V
Vendicatori 37
Vietnam War 3–5, 16, 18, 48–49, 64–65, 70, 101, 113–14, 153, 174–75, 181, 214, 219
Vigilante (film) 44
Vigilante/Chase, Adrian et al. 42, 156–57
Vigiles Urbani 37
Vilanova, Guiu 220
Violence, Bob 177

W
Wacker, Stephen 2, 35, 218
Waid, Mark 170
Wallace, Michael 52
Wallin, Zoë 135
Watchmen 75, 141, 182–83
Watkins, Brian 51
Weather Underground 37
Wein, Len 69, 83

Welcome to Fear City 29–31
Wertham, Fredric 12, 202
West, Dominic 225
Whannel, Paddy 41
What If … ? 174–75
Williams, Ash 174
Winner, Michael 44–45
Wolfman, Marv 83, 156
Wolverine/Logan 10, 64, 68, 109–11, 170, 181, 192, 217
Wolverine/Punisher: Revelation 192
Wrightson, Bernie 191

Y
Yakin, Boaz 224
Young, Paul 115

Z
Zaffino, Jorge 37–38, 153
Zeck, Mike 5, 137–40, 153
Žižek, Slavoj 67
Zorro/de la Vega, Don Diego 41